Henry Moore

text by Giulio Carlo Argan

translated by Daniel Dichter

Henry Moore

Harry N. Abrams, Inc. Publishers New York

LIBRARY OF CONGRESS CATALOGING IN PUBLICATION DATA

Moore, Henry Spencer, 1898–
 Henry Moore.

 I. Argan, Giulio Carlo.
NB497.M6A8213 730'.92'4 72–4443
ISBN 0–8109–0328–8

Library of Congress Catalogue Card Number: 72–4443
Copyright 1971 in Italy by Fratelli Fabbri Editori, Milan
Harry N. Abrams, Incorporated, New York
Printed and bound in Italy

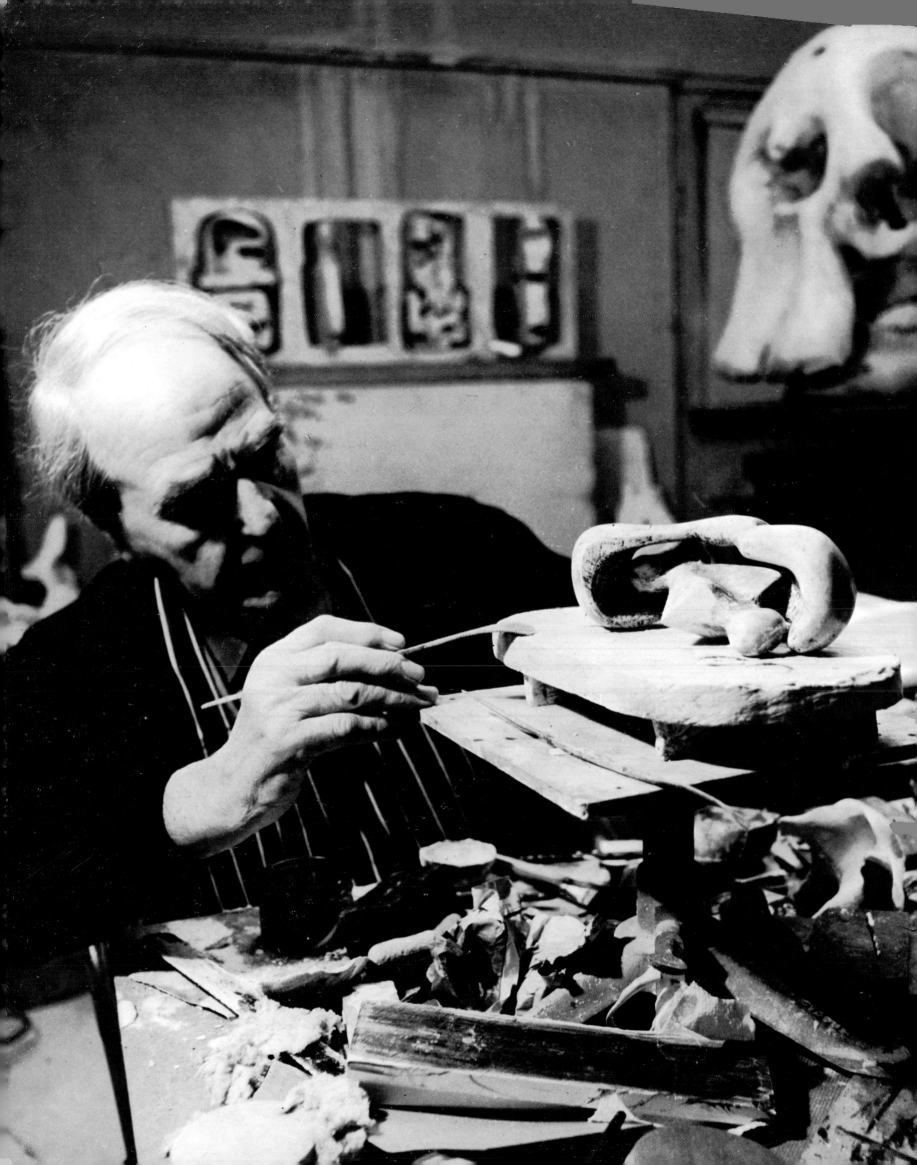

Henry Moore is a classicist in the terms in which the question "What is classical?" is posed for the art of our century: not in the sense of a modernized, formal classicism such as is traceable from Rodin to Maillol or Despiau, but in the sense of a classicism that is immune to stylistic bias and inherent in the intrinsically historical nature of art. This is true provided, of course, one recognizes this historical quality, as have Matisse, Picasso, Brancusi, and even Giacometti—changing the sign from positive to negative. A classical and, consequently, intrinsically historical art is one in which representation of form epitomizes an inclusive conception of the world, an (historical) experience involving space and time, nature and man. Nonclassical art is one that shuns historical experience and starts out by experimenting, examining above all the condition of an experiment, as well as the procedure and the instruments of activity. Classical art postulates its own inseparability from the unitarian system of culture, conceding that the system's contingent aspects may change with place and time, but not its substance or structure. It shows history as consciousness of the value and order of occurrences. Since nonclassical art does not possess this certitude, it cannot be a model of values; instead, its tempestuous immediacy appears to be the reason—as yet unproved—for its survival and function in a given society.

The artistic climate in the first half of our century is characterized by the coexistence and contradiction of these two theses, by the dialectical alternative of the classical, as representation, and the nonclassical, as function. This divergence implies two different judgments of the present world situation. Indisputably, scientific and technological progress has been the determining fact of our century's culture. It is unclear, however, whether it is to be interpreted as the coherent development of the entire historical process or as a new phenomenon, marking the end of historical civilization and the beginning of a different civilization—one no longer based on historical probability with the ethical choices it involves, but on science with its objective laws. The role of art in the civilization we historically recognize is known; what remain to be seen are the meaning and function art might have in a society based on science and technology, and what transformation art must undergo in order to perform this function. The tension between the first tendency, historical-humanistic, and the second, topical and futuristic, is felt in content and message but still more in technique, since technology, in its broadest meaning, is the central problem of our time insofar as it is the praxis of human action. The question is whether technology is part of the historical order or, by issuing from it, renders it obsolete. The

assumption that it is obsolete was held by the avant-garde movements that formed in Europe around 1910. Predictably, an opposing avant-garde came into being, insisting upon the legitimacy of a classical-modern conception. Aiming at a new functionalism for art in the mechanics of the system, the avant-garde groups declared traditional techniques outmoded and attempts to update them useless, since their cycle had closed forever. They proceeded by hypothesis and proof, thus adapting artistic method to scientific experimentation, the guiding methodology of modern culture. Artists who did not renounce the idea of value or of representation of form employed traditional techniques instead, attempting to renew them without altering their original and essential structure, to which at times they proposed to return.

Like Picasso, Henry Moore was not convinced by the revolutionary projects of the avant-garde groups. By 1922, when he began his activity as a sculptor, they had already spent their ideological force (except in Russia, where a great revolutionary process was under way) and appeared, instead, to be committed to rationalizing the artistic quest in order to place it on a level with scientific and technological research. Moore declared his dissatisfaction with the archaism of his technique and sided with Surrealism against the Constructivist trends, all of which were more or less dependent on the avant-garde groups, if for no other reason than because Surrealism affirmed the psychological as opposed to the rational genesis of the artistic act. He could not accept the unilateral perspectives offered by programs that necessarily restricted the epistemological and ethical horizon of art, assigning to it contingent and specific functions; he conceived of art as a humanistic discipline, fruit of an experience brought to maturity, elaborated, and finally communicated to society for the purpose of heightening its self-awareness, of educating it. Thematically, figuratively, technically, his sculpture remained sculpture. Indeed, he has resolved to recover the true essence of sculpture. Following—perhaps unwittingly—a typically humanistic thought of Leon Battista Alberti, Moore conceives of sculpture as statuary, and he practices high and low relief, in

which projection onto a pictorial plane is reproduced through the technical means of sculpture, only rarely and with certain mental reservations. Moore accompanies his plastic investigation with graphic studies, deepening the relationship between the two modes of inquiry almost as if to demonstrate that the artist's activity is equally intellectual and manual, and that his historical task in the present cultural conditions is precisely that of rehabilitating the contextual meaning of the two factors, which the industrial organization of labor disavows and nullifies.

It is obvious that Moore's work, while having historical and neo-humanistic dimensions, deeply penetrates the problems of today. To ignore the crises and contradictions of the present situation and to suggest abstention or escape rather than involvement would not be historicism but a low form of traditionalism. It is true that Moore views human life within the sphere of cosmic life, almost as a grandiose natural phenomenon. But for the very reason that the bond between the natural and the human is increasingly contradicted and compromised with each passing day, the reaffirmation of this bond implies a judgment and a precise will to act. Bearing this in mind, we should accept with reservation Erich Neumann's otherwise acute analysis, which traces Moore's representational style back to a motionless world of archetypes, identifying its origin in an indefinite state, almost of magical animism.

The relationship between cosmic and historical reality is neither perennial nor absolute; in fact, it is in a crisis. Investigating how this relationship is posed today—and with how many difficulties and at what cost—Moore realizes that the crisis is so advanced now that modern man cannot grasp the authentic meaning of life if he does not grasp death, its dialectical opposite. Indeed, the two themes—life and death—seem interwoven. This can be seen in the leitmotiv of the Reclining Figures, which can be interpreted both as a return to the earth and a resurrection from the earth. The same ambiguity can be perceived in all the figures, which could be said to be endowed with a double nature, or caught by surprise while crossing the threshold from a

known dimension to an unknown but equally terrestrial one.

Anyone charting the course of Moore's sculpture and graphics, paying more attention to the variables than to the constant factors, will readily observe that the oscillations are greater and more frequent during World War II and in the years following. In that period the dramatic drawings of the *Shelter Sketch Book* compensate for the relative lack of sculptural activity. The world's immense space is reduced to the winding tunnels of the London subway, which cling to the figures like a wet sheet. The search for a principle of relationship or for a structural factor common to both the organic and the inorganic rises to the surface. The study no longer focuses on the morphological analogy between bone and pebble but rather on surface tension, or the ripples of a veil. In the group *King and Queen* (1953), the flattened bodies curve like sails under the wind's pressure. The mutilated and dismembered *Warrior* is a fragment of a body existing within a space trying to expel it. The *Seated Woman* (1957–58) is a disjointed mass on the point of decomposition. The dominant motif is always that of coalescence-decomposition, two moments of a single life cycle. As early as 1934, if not before, one encounters works where form is not self-contained but lies in the correlation of two forms, like voice and echo, almost as if to say there is no existence without coexistence. The artist first focuses on the phase of coalescence, in which the forms tend to reunite with one another; the space between them could be said to be traversed by invisible magnetic currents of attraction. Later he turns to the phase of decomposition. The forms resemble torn fragments destined never again to be reassembled, each one seeking its own raison d'être in the direct, almost brutal relationship between its material reality and the cosmic substance of light and air.

Moore's trip to Greece in 1951 and the consequent experience that he had not only with Classical sculpture but with his own living space very probably helped to effect the transition from the investigation of fundamental analogies to the discovery of existential coincidences. Moore understood—possibly with the help of reading Fuseli—that Greek sculpture was not a Platonic harmony of proportions, but a dramatic conflict of forces: the struggle of form to attain equilibrium and consistency within a space structured by the immensity of the horizon, the violence of the incident light, and the bite of the air. Indeed, the iconic theme he carried with him from Greece was that of the Warrior, derived from Scopas more than from Phidias. The fact is that the direct knowledge of the Classical world pushed him to the threshold of aformalism; that is, it confirmed his belief that, in the present world situation, a state of essential classicism can be attained only by granting large concessions to the nonformal character of existential space and by contenting oneself to freeze form momentarily as it approaches its dissolution. For this reason, Moore's work is better understood if we bear in mind the contemporary work of Giacometti, although it is morphologically very different. The common problem is this: how much of itself must plastic form give up in order to acquire the right to exist in space?

Moore's sculpture is by definition open-air sculpture. The form appears worn by long, age-old exposure to air and light, by a complete familiarity with the changing aspects of the landscape.

It is impossible to understand the classical basis of Moore's work without touching on the unnecessarily thorny question of the representational and nonrepresentational. The entire body of Moore's work is representational, even when there is no apparent analogy between its form and the shape of real objects. But no other modern artist has so firmly made the point that form is form only in that it is figure. Just as form cannot be described as such if its process of becoming form, or formation, is not reconstructed, figure is unrecognizable if the process of its configuration is not reconstructed. And the term configuration, itself, refers to the unity the figure realizes of at least two elements, one of which is the object, the other space. In other words, inasmuch as it is configuration, figure is both the shape of the object and of space, or of the object reduced to a component of spatial representation. Even forms devoid of reference to natural objects are figures; a distinction cannot be drawn between the figure of a person and the figure of an object. The

process of conformation or configuration is a process of the mind and hand of man—a historical process. If the dynamism of man's activity is part of cosmic activity, history is nothing more than the most advanced and conscious phase of the evolution of natural reality. Without history, not only the life of mankind but nature itself would come to a halt.

The problem of history, or of the relationship between past and present, is as central to Moore's thinking as it is to Picasso's, but the meaning the two artists give to the relationship is different. Picasso is responsible for the Cubist turning point, which radically transformed the essence, procedure, and purpose of art, and which became the point of departure for every avant-garde movement. After Cubism no tradition can be valued as legal tender; the past and the present are equally current when judged in terms of value. When Picasso takes a painting of Poussin or Velázquez or Manet and remakes it according to a system of contemporary symbols of Cubist origins, he is not only translating it from the old to the new but is also demonstrating that formal invention loses none of its value when the language with which it is communicated changes. Language is tradition; value is above tradition. Picasso knows that the idea of history is undergoing crisis and sees the reason in what he thinks is the erroneous identification of history with tradition. For him, the emotional hold of tradition must be eliminated, since it impedes the formulation of a firm and lucid judgment of value.

For Moore on the other hand, judgment is the cause of the crisis, for it blocks tradition by investing it with the force of precept. The rationality of judgment holds true within the rationalistic culture that established it and may not survive it. On the other hand, the transmission down through the centuries of experience and memory, their settling into the unconscious, and the internal pressure whereby they condition and determine action, cannot come to an end while mankind still exists. Thus, the feeling of authentic tradition must be recovered—of a tradition not of formed and transmitted opinions (and, consequently, of prejudice), but of the need to act in order to exist, of work. Moore therefore re-turns to the principle of history, to the connection between art and work extant in primitive, non-European civilizations. But this would merely be a nostalgic return had the original tradition not latently survived beneath the overlying strata of more complex cultures.

Moore studies Sumerian, Egyptian, Aztec, and Negro art on the one hand, Masaccio and Michelangelo on the other. The clarity of his intellect evidently does not destroy his deep intuition of the meaning of the world and of life. The iconic, thematic, and typological constants in his work can thus be explained. Precedents for the recurring theme of the Reclining Figure can be found in Aztec art, in the pediments of Aegina and Olympia, in Etruscan sarcophagi, and in the Roman divinities of the waters, down to the allegories of the Medici tombs. The specific meaning changes with the religious belief, but the underlying meaning is always the same: the twofold, earthly and heavenly nature of existence; the coexistence and conflict of the principle of matter and the principle of life. The theme of fertility may be expressed in organic-symbolic forms evoking the egg, the womb, the breast, or it can develop into the classical and, later, Christian motif of the mother with child, and even expand into the social motif of the family and tribe. But, at the root, it is always the fundamental plastic theme of form expanding, dividing, and repeating itself. It is not a question of archetypal or original ideas to which multiform experiences have been added, but of essential nuclei that waning, disparate experiences have deposited in the depths of memory.

Despite the vastness of his historical horizon, Henry Moore is deeply rooted in his country's traditions. The problem of history is the problem of society, and also the problem of nature, since everything on earth can be reduced to a continual process of uniting, separating, reuniting—to a continual and difficult search for a state of coexistence. Contemporary society possesses no logical structure; it is but the primitive tribe's extension in time and space. To break away from one's own original nucleus means to cut the ties with tradition, to block the flow of memory.

Moore came to modern art from a traditional English cultural background. The idea that art is not a revelation of metaphysical truth, but a social and educational task, goes back to Hogarth and the first establishment of English artistic culture. In his treatise *The Analysis of Beauty*, written in 1753, Hogarth states that the root of all form—in nature, in society, and in art—is the curved, undulating, serpentine line, which reveals the process of becoming or "growth." The configuration of space itself is not the perspective cube, formed of straight lines, but an extensive and animated field in which all is motion and relationship. Hogarth also writes that, ideally, the artist should not stand before objects and contemplate them. Rather, he should imagine himself *within* each one of them, as though they were empty shells, and from there observe the infinite relationships that, like so many threads, connect their surfaces and weave animated space, pregnant with life. Similarly, Moore's plastic forms, generally conceived to stand in the open, are more than objects to be seen; they are points of vision, figure-places in which the observer is psychologically induced to position himself so as to look *outward* into the unlimited surrounding space. And, if the figures have eyes, they are not eyes that see but holes or apertures from which to see. In the group of Internal and External Forms, and especially in the Helmet series, the external form is a covering that seals and protects, while the internal form is an extended eye or antenna probing space to establish a relationship. This withdrawal into and emergence from oneself in order to enter into a relationship with another are the two essential movements of organic and social life, of the plant growing in the woods and of the individual in the community. Space does not exist as a given; all space consists of incessant palpitation, of systole and diastole, with which living things expand and contract, open and close.

From its very beginnings English artistic culture, grounded in empiricism and the Enlightenment, acknowledged that the reality of nature and the reality of society are animated by the same oscillating movement. The poetics of the picturesque, for which each individual dissolves into the infinite variety and incessant movement of totality, finds its dialectical counterpart in the poetics of the sublime, for which the individual tragically gains awareness of his own solitude and denies the affinity that binds him to the infinity of creations in order to reproach the Creator for having driven him from heaven. Thus we have Milton's paradise lost and Blake's fallen angels. These two poetic themes become historical themes with Carlyle, for whom man's destiny on earth depends on two fundamental "types." One is the worker fully integrated within nature and society; the other is the hero, thinker, or poet, who is the clear-sighted—and, thus, lonely and tormented—leader of the blind multitude. In Ruskin's thought the two types become one: the artist—worker and poet. This is undoubtedly the model Moore resolved to follow beginning with his school years.

The historical background, however, is no longer the reclaimed Middle Ages of Ruskin and Morris. The new collectivistic and mechanistic conception of labor calls into question the meaning of the individual's very existence in nature and society. Moore's plastic morphology reflects an anguished uncertainty as to what "human" means. The forms spontaneously associate themselves with the appearance of natural objects; the sculpture always respects and stresses (and this, too, was one of Ruskin's precepts) "the genuine nature of materials." Nevertheless, those forms appear to be embryos growing and vaguely tending to assume the shape of human beings; but once they have reached the threshold of the subhuman, they immediately pass on to the equally ambiguous dimension of the superhuman. Signs of an unmistakable human "drama" can be glimpsed only in rather recent works, such as the *Warrior*, dating after World War II, but the human element has the tragic aspect of a fragment of material wandering in an incompatible nature, in a space not its own.

If the human element is muted, then the human element is the problem. How is this problem posed? Study the figures: they lack clear physiognomical or anatomical characterization; their movements are nothing more than the sluggish expansion and contraction of a growing organism. The still-undefined forms reflect the confused notion we have

of the body, of its being and movement within an environment. Its movements externalize the internal and unconscious movements of the bones and viscera. There is space outside ourselves that we see and within which we must situate ourselves, and there is space within ourselves that we confusedly and sometimes disturbingly experience. External space pushes against every point of the body, as if to break open the shell, while internal space resists the pressure and attempts to expand and merge with its counterpart. The difference between the two dimensions and the push-pull of the two thrusts cause the travail of life. The interior of the body is taboo; there resides the center of life. To break open the shell and bring what lies within to the light is death.

When Moore decisively chose Surrealism in 1936, he could not have regarded the unconscious as the other side of rational consciousness. English culture, unlike French, was not of Cartesian origin. According to Moore's empirical view, the unconscious was simply the dark, unknown side of existence. In other words, the subjective was nothing other than the organic. But if the taboo of the unconscious-organic is the cause of anxiety, it must be expunged, and this can be done only by rendering it visible by figurative means. Hence there is the necessity of art within the very context of existence, that is, of an activity that reveals the natural quality of human life by showing its fundamental material similarity to natural life. By so doing it does not sublimate the terror of existence into the sacred, but simply removes it.

Neumann correctly notes Moore's intimate knowledge of the *idola specus* of tribal man; Moore, however, is the tribe's builder, not its witch doctor. As the embryonic forms of the organic evolve into figures, one may readily observe how the obscure convulsions of the visceral movement become refined into explicit directions and tensions, balanced opposing weights and thrusts, fulcrums, and rotational rhythms. It is not a case—as with Picasso in his Surrealist period—of the light of consciousness suddenly penetrating the darkness of the unconscious, but of the transition from the nonintentionality to the intentionality of existence. One must act

if one wishes to live: this is the link uniting biological dynamism with the dynamism of labor, the organic phase with the historical phase of mankind's existence. Moore's conception of the organic, therefore, is not a late version of the Surrealist conception of the unconscious, but rather an elaboration of it. It is not a coincidence that the poetics of the organic has been proclaimed a possible solution to the increasingly difficult problem of art in the post-World War II years, at a time when Europe has discovered (or rediscovered) and expectantly hailed the poetics of Frank Lloyd Wright's organic architecture. Wright and Moore can therefore be regarded as the two bridgeheads joining the American and European artistic cultures following the war.

The immense prestige Moore enjoys in his own country, almost as if he were the poet laureate, cannot be explained if one is unmindful of the situation of the English artistic culture of which Moore is not the sole protagonist. The other is a painter, Ben Nicholson, whose position is diametrically opposed to Moore's. Throughout its entire history, up to Roger Fry and Herbert Read, English aesthetic thought rejects the idealistic thesis of the unity of art; each individual art is defined by its own technique, and each technique is a particular method of experiencing reality. The structural renewal of Cubism represented a point of departure for both Moore and Nicholson, but their paths then diverged; Moore moved in a Surrealist direction while Nicholson turned toward Constructivism. Nicholson, a painter, viewed the problem in the rigorously intellectual terms of projection onto a plane. Since the basic problem was establishing a new perspective, he looked to fifteenth-century Italian painting—that of Piero della Francesca and Paolo Uccello—for his historical references. His search for a rigorous visual language followed the English doctrinal tradition that identifies and studies language as the most evolved, graded, and significant product of civilization. At times, Nicholson's search extends into sculpture, just as Moore's graphics extend into painterly representation on a plane. However, Nicholson's plastic art demonstrates that even matter consists of lines and planes in mathematical proportions, and Moore's graphics reduce even the geo-

metric plane of paper and penstroke to matter and color.

In painting, Nicholson represents the humanistic tradition of the Oxford and Cambridge philologists. Moore belongs to another social class—of workers, not of intellectuals; the heavy manual labor which is part of a sculptor's work ties him to his proletarian origins. He doesn't hide this fact, but fully accepts it as a principle and condition of artistic activity. The cultural rise of the working class in England has distant origins in the ideas of Smith and Ricardo, the founders of the "socialism" that later, with Ruskin and Morris, placed the problem of art at the center of its program for social regeneration. Naturally, as a producer of culture, the working class must not conform to the schema of the intellectual elite. Its original contribution is its experience with the world through direct contact with material reality, that is, its contact with manual labor. For this reason, too, Moore reformed the academic technique of sculpture, guiding it back to the original and more autonomous methods. He modeled his craft on the archaic trades of the stonemason, woodcutter, kilnman, and smelter. He wanted to revive the source of an ethic of labor that was not formulated in precepts but realized in practice. Ruskin's and Morris's sermons about the ethical quality of work, which had been honored in moderation by the Pre-Raphaelites in Victorian England, profoundly affected Moore's development. Sculpture, considered as art-labor, brought into English artistic culture a factor that had originated with the common people. It was Moore who founded the "English school" of sculpture, unquestionably the most vital one of postwar European art. It was Moore who, during the war, became the interpreter of the English people's obstinate and victorious resistance.

The Englishness of Moore's cultural formation is the condition but not the limit of his importance on a European scale. During his first trips to Paris (1923 and 1925) he noted that the Cubist sculpture of Lipchitz, Archipenko, and Laurens transposed and applied to plastic art the formula of the decomposition of form in space, just as Rodin had attempted to convey in sculpture certain formal aspects of Impressionist painting. The new meaning the Cubists attributed to artistic procedure and, consequently, to technique, did not admit that the same order of result could be reached through two traditionally distinct operations such as painting and sculpture. Collage, the new technique the Cubists established as most suited to their investigations, abridged and surpassed the two traditional techniques, integrated the image with a real, nonillusionistic spatial dimension, and transformed the surface of a painting from a projectional plane into a plastic plane. Brancusi founded the new sculpture, just as Picasso and Braque had founded the new painting. Although, in its method and aim, Brancusi's investigation distinctly diverged from that of Cubist painters, it also complemented it. The Cubists considered form to be the result of a complex of relationships for which the single object dissolves into the unitary structure of space. Brancusi considered form to be an object endowed with its own absolute spatiality, which resolves in itself the ambient space, creating the void.

Moore's contact with Brancusi was decisive. He credits Brancusi (and not the sculptors converted to Cubism) with eliminating the painterly or impressionistic modeling of the surface, the aura of sensitized and vibrant light and atmosphere forming the ambient space. If plastic form must have autonomous and absolute meaning, it is senseless to naturalize form or formalize nature. Notwithstanding his adherence to this principle, which is documented by several works clearly influenced by Brancusi, Moore's position is critical of his teacher: the impossibility of fusion does not signify the impossibility of relationship. Lacking relationship, sculpture cannot fulfill its educational purpose. Brancusian form does not communicate; it confines to itself its own symbolic significance, and the procedure that generates it—technique—assumes a magical or ritual character. Its essence is labor, but labor invested with a charismatic rather than ethical quality. For Moore, however, the artist is a worker, not a priest. Brancusi's plastic forms evidently exist within an ambient space, but their hermetically sealed cores shut it out and their mirror-like surfaces

repulse it. For Moore, the ambience is not only the antithesis of form; it constitutes an aformal universe in which form is engendered and which it progressively appropriates as it grows and develops. There is a reciprocal and alternating relationship of attack and defense between form and its surroundings. Sculpture must not only stand in the open air; it must be worked on there. This essential point of Moore's idiom is probably due to his intolerance for the traditionally decorative function of sculpture, according to which sculpture—be it monument or knick-knack—could not be conceived if not in relationship to preformed, architectonic space.

Landscape is open, free, constantly changing—a field of different, unpredictable, stirring natural phenomena. Its movement is animated, at times stormy, as in the paintings of Constable and Turner, who remain the patron saints of English art. The movements of the craftsman who cuts, carves, shapes, and polishes material are completely different; they are ordered and rhythmic. Nature finds in art a higher order. It is the final stage of its evolution—the stage it attains only through the presence, intelligence, and work of man.

Moore's tendency to recover the condition of primitivism can be explained by his conception of society as a single, great tribe. He had been interested in Negro sculpture even before visiting Paris and meeting Brancusi, after reading a famous essay by Roger Fry in which, for the first time, Negro art was studied for its intrinsic formal quality. For Fry, plastic form in Western sculpture of Classical origins is the result of successive cross sections, of profiles obtained from different viewpoints; in Negro sculpture, however, form is realized as a plastic whole. Two conclusions follow: in regard to meaning, Western sculpture is a representation that can be justified only by reference to the idea of the represented object, while Negro art creates intrinsically meaningful objects (for example, a statue of Zeus or Christ is an image of the divine, whereas a Negro idol is the divine); in regard to technique, sculpture in the Classical tradition employs material as a *means*, while for Negro sculpture it is the *substance* of the image.

Brancusi was unquestionably the first Western artist to realize a plastic wholeness similar to that of Negro sculpture without, however, repeating its iconic themes, that is, without trying to reproduce the condition of primitivism under the present circumstances of time and place. For Brancusi, the sacred has an unquestionable and indestructible world presence. But Moore's entire cultural formation goes against this connection between art and sacredness and the symbolism deriving therefrom. Negro, Cycladic, and Aztec sculpture interests him because it was fashioned by men, men who belong to our human society and whose history is thus inseparable from ours. The connection, which is impossible on the level of imagery or mythology, moves to the technical level. For Moore, as for Negro and primitive civilizations in general, the primary technique of sculpture is not the classical procedure of modeling, but that of carving the material. It is the means of laying bare the material's internal and vital substance in contact with light and air. Subsequent operations (refining, smoothing, polishing) serve to define the surface's mode and degree of reaction to its surroundings.

Picasso is the other reference point, essential throughout almost the entire course of Moore's activity as an artist. In the crisscrossing of trends that characterized the European artistic scene following the First World War, Picasso maintained an independent position. He moved in different directions at the same time, with sudden jumps from one to another. It is not that he believed the trends were insubstantial and that genius was above programs; with his characteristically lucid historical judgment, he understood that what distinguished the situation was the dialectical contradiction of the trends. Not until 1925, when he conditionally joined the Surrealist movement, did he make a decision with motives that, at that point, were already probably political. He denounced the Constructivist trends, whose abstract, utopian rationalism placed art outside historical reality and discouraged any revolutionary commitment. Since Surrealism placed the original artistic impulse within the psychic sphere of the unconscious, Picasso felt its motives were identical to those of ethical-political action. Finally,

only Surrealism could resume and carry forward the revolutionary undertaking initiated by Cubism, which, precisely through an excess of rationalism, had resulted in the ambiguity of Kandinsky's and Mondrian's geometrism and spiritualism. Picasso's conversion to Surrealism, begun in 1925 with the *Three Dancers* and culminated in 1929 with the *Bathers* of the Dinard period and with the drawings of *An Anatomy* (fundamental for Moore), marks the beginning of a new morphology, with archetypes that are no longer intellectual or geometrical, but physiological. This new morphology was undoubtedly linked, at a distance, to Duchamp's polemics against the "Cartesianism" of analytic Cubism.

If, for Picasso, history is an eternal conflict between creative and destructive forces, for Moore it is a gradual evolution from the natural to the human. Material is not humiliated or transcended, but developed from indistinctness to the point of establishing relationships, from expansion to spatiality, from inertia to motion, and from formlessness to form. Conscious of the political situation, Picasso is aware that a terrifying regression toward the fateful myths of *Blut und Boden* is taking place in the guise of technological progress. The images he unflinchingly reveals are the demons and monsters of the unconscious illuminated by the last flicker of consciousness. The classical allegories—those in which Matisse believed to the very end—harden into obscure symbolism as they retreat from history to become myth. By superimposing itself on reality, the symbol disintegrates it and empties it of meaning. For Moore, there is no such regression; through the age-old praxis of labor, he relives in the present the archaic, mythical conception of the world. It is the intrinsic dynamism of labor that transforms superstitious terror into a positive *religio* founding and uniting the community. Moore admires Picasso's heroic frenzies and courageous intervention, for he realizes that when art is regarded as the aesthetic component of rational thought, it interests only an elite and not the entire society. And since he has faith in society's vital and self-creating forces, he proceeds to investigate their deepest sources.

The transition from morphology modeled on the geometric symbols of reason to morphology modeled on the reality of the organic world could already be seen immediately following the First World War in the work of Arp. For several years he wavered between the programmatic authority of Dadaism and the Neo-Plasticists' investigation of perceptual and intellectual primal form. Through his work in colored wood, Arp came to identify form as, above all, an expanding nucleus. Different parallel planes superimposed on each other corresponded to different shades of color, which, for the first time, was considered a plastic and spatial entity. In Arp's thought, organic form modeled on the expansion and contraction of curved lines could attain perceptual and intellectual clarity equaling that of Mondrian's geometric form.

Arp's plastic forms, which originate as splotches of color and, starting around 1930, gradually loosen the bonds tying them to the geometric plane, appear stretched, light, soft, and delicately shaded as if modeled on clouds suspended in the sky. Arp, poet and painter, was probably spurred to become a sculptor by the idea that the visual image is bound to the geometric plane only by the preconception that the mind is a plane on which visual sensations are projected. Instead, a multidimensional image, or even an image independent of spatial definition, is possible. Arp passed summary judgment on the ideal meanings and pseudomeanings traditionally held to be implicit in sculpture, which, for no good reason, distinguished it from the predominant visual emotionality of painting. His plastic art is biomorphic, not on the basis of profound symbology, but on that of its obvious analogy. The principle of similarity is valid in a realm of universal eroticism: one goes from form to form by means of a simple play on perceptual affinities; for example, a breast is also a flower or fruit (they bloom), a wave or cloud. If symbolism is present, it is superficial, not profound, as in Miró's paintings of the same period.

Since for Moore, as well, the original model for form is organic reality, with its internal rhythm of growth and reproduction, the erotic-sexual motif is fundamental and even obsessive. As Neumann has observed, the figures are often fleshless, reduced to the essential reproductive organs. Moore's plastic forms consist of cavities to be penetrated, wombs

that harbor growth, tension and relaxation, orifices to be filled, tentacles that grasp. Visual perception is only one factor in a complex relationship that is also acoustic, tactile, prehensile, and possessive. The work of the sculptor reproduces or reconstructs the mechanics governing that relationship; its goal is not so much representation as it is inquiry—digging deeply to reach the sole, primal source of erotic, moral, and social instinct. Moore's sculpture insistingly treats a limited number of themes, and their concatenation, which leads from the organic to the moral, the religious, and the social, is also an evolutionary progression: from the original organic nuclei, referring to the pure biological reality of sex, birth, and growth, to the symbols of universal fertility; and from these to the ethical-social themes of the mother-child relationship, the family group, the tribe with its totems, the king and queen as mother and father to the community. At the same time, the ambivalent theme of the Reclining Figure, bound to the earth as to a nuptial couch and tomb by the twofold nexus of life and death, persists and returns. The artist's work in different natural materials develops a wide range of elective affinities, for which it could well be said that the artisan's labor both follows upon and fosters cosmic creativity: there are affinities between stone and bone, between bone and manufactured object, between the body's internal cavities and the subterranean caverns and galleries, between the flow of rivers and the flow of lymph and blood.

Beginning in 1939, a series of objects clearly evoking utensils or equipment appears in Moore's work: for example, baskets, traps, or primitive musical instruments that have, however, lost their utilitarian connotation. Evidently, the artist wished to demonstrate that even those objects man fashions in order to adapt his physical surroundings to his needs also depend on organic, not intellectual or geometric, models. Significantly, however, the plastic nucleus is integrated by aligned and taut strands, like the strings of musical instruments. The inevitable mental association of sonority with the hollow spaces gives the plastic nucleus the suggestion of a resonance chamber. Spatial distances are perceived acoustically as well as visually. Later, in the Open-

work cycle, the form appears to be a shell; indeed, one is tempted to strike it with one's knuckles in order to ascertain that it is uncracked and hollow inside. And always, but especially in the Reclining Figures, the rhythm of formal development has the continuity of a wavelength's oscillations or an echo's reverberation. In any case, the taut strands of the stringed Figures suggest vibrational hum and amplification of sound in the hollow spaces; at the same time, they are gossamer signs endowed by the solid mass with the consistency and value of plastic form reduced to the essential—the pure distance traversed by an invisible electric current.

It is not difficult to fit into the mainstream of English art and aesthetics this attempt to devisualize form and deprive the image of any intrinsic revelational nature. If the image is an autonomous psychic reality, it is not born of the subject-object relationship. Moore's plastic art does not originate from the study and interpretation of the material's intrinsic qualities, although it is certainly true that in the course of the artistic process the material is not degraded to the level of a mere means of representation.

For Moore, graphic activity is bound up with sculpture, but it constitutes its first, technical elaboration, and not the moment of conception or planning. The principle of drawing remains line or stroke; nevertheless, Moore's stroke is not an intellectual code to which sensory experience is reduced. Like the spider's web or the silkworm's fiber, the stroke is a delicate substance produced by the imagination to give body to its own images and render them visible. The progression of strokes does not follow the outline of the observed or imagined object, but obeys internal, rhythmic impulses. Rather than foreshadowing the image, it anticipates and prepares the artist's movements as he undertakes to act in real space upon a solid material. Often the sketches are done in grease pencil on paper primed with tempera. The sheet of paper is not an abstract projectional plane, but a layer or membrane of material with its own density, its own implicit spatiality, its own organic tissue, which can present clots, lumps, thinness, and lacerations. The sheet's pliant material is streaked with marks like the nerve fibers

or capillaries of organic tissue. The image is sketched within the material's tensional potentialities—its organic elasticity. If attention is directed to the quality of the colors, one immediately notes that they bear no resemblance to colors found in nature. Their cold and inflamed luminescence reveals the activity of the life force that bathes the tissue and traverses the dark internal cavities of a body of unknown finite dimensions.

In short, drawing is a vital but still intrauterine phase of form. The moment will come when the image that has been forming will be sufficiently mature to be transferred to solid material and spatiality. It will lose color, since phosphorescent glow is no longer needed to reveal the secret conduits and fittings through which life flows, but traces of that first phase of coalescence will almost always remain in the sculpted form. In their mature sculptural phase, all of Moore's figures retain some of the incompleteness of the embryo or foetus. External space differs from internal space only in its dimensions, and nature is only a womb so vast as to comprehend all humanity, with the unending travail of its becoming, of its advance toward a second birth. The pervading theme in all of Moore's work is expectation—the slow and anguished awakening from nightmare-ridden torpor.

There is a period in which graphic investigation prevails: it is the period of the Second World War, with the drawings of miners and anti-aircraft shelters. Moore owes his nationwide reputation as a national artist to the latter, which were collected and published in the *Shelter Sketch Book*. The English people recognized themselves in those apparitions swarming in the bowels of the subway; they sensed that Moore had interpreted the profound meaning of the determined passive resistance the people of London offered against the destructive violence of German aviation. Moore, who certainly never had a narrator's bent nor found pleasure in reportage, felt morally committed to testify to what was taking place before his very eyes. And what occurred confirmed his idea of history's profoundly ethical character, just as several years earlier the infamous bombing of Guernica had proved Picasso's idea of history as absolute irrationality.

The *Shelter Sketch Book* was unprecedented among the representational arts, but it did have a great literary precursor: Daniel Defoe's *A Journal of the Plague Year*, the anti-novel from which the modern novel was born, which reflects "*l'existence matérielle de l'homme et sa difficulté*" (Maurice Schwob), or "the long struggle for existence, eternal misery and eternal pain" (Elio Vittorini): in short, the feeling of life as the naked will to survive. Moore's testimony is harsh and terrifying, but by whom could it have been given if not the artist who had reduced the exalted poetry of life to the blind, obtuse, obstinate persistence of the life force? And before whom could he have given it if not the many people in the world who doubted the ability of man's vital and moral force to resist mechanized violence? The classical themes of pathos, ethos, and epos are interwoven in the drawings of the *Shelter Sketch Book*. As in Defoe's plague diary, the people of London are the protagonists. In the subway tunnels, a swarm of men and women immersed in a deep sleep are regenerating the forces destroyed by a long day of hardship and anguish. The threatened city becomes protective and maternal; its moist, warm womb gathers in all people, without distinction of class or rank. And since all are faced with the same alternative of life or death, the sacred cohesion of the primitive tribe is restored within those caverns. The shapeless mass results from a rash of strokes, whose animation alone betrays that it is an indistinct agglomeration of living beings. In this amalgam, it is no longer possible to discern the boundaries between figure and space.

Only the prejudice that holds English culture to be insular has prevented critics from recognizing this as one of the prime sources of the movement to end the traditional identification of art with form that took place between 1950 and 1960. At the basis of the poetics of formlessness lies the idea that living space is urban space; that the individual's existential condition is his existence as an atom in the mass; that the object and subject become blurred in the organic indistinctness of material; that each individual being is nothing more than a sign upon the continuum of reality.

Pollock was later fascinated by the labyrinthine

layout of the modern cities, Tobey by their teeming crowds; there is undoubtedly a connection between Moore's graphics and the proliferation of lines in Tobey's White Writings. The arrangement of the lines along contours, which in Moore's drawings prearrange the elastic modulation of form, is often complicated by the alternation of vertical and horizontal strokes evoking the pattern of a latticework screen. There is a symbolic theme—namely, the physical, material affinity between the people and the city. The people of London stand as a wall against the enemy's aggression. But the symbolic theme did not disappear with the occasion that gave rise to it. In later years the spatial theme of the wall appears in several plastic compositions, determining the sole, frontal viewpoint from which they may be studied. There is no longer natural space, but the space-material of architecture that constitutes the environmental dimension—the terms of relationship for form. Later, after having seen the Mexican architecture in Mitla, Moore incorporated sculpture into the facade of buildings, as in the London *Time/Life Screen* (1953) or the *Wall Relief* (1955) for the Bouwcentrum in Rotterdam, works that represent another, symptomatic point of contact between the idiom of Moore's plastic art and the idiom of Wright's architecture.

In the city's mazelike underbelly, encircled humanity no longer feels or remembers free, open space. The *Shelter Sketch Book* drawings mark the end of Moore's naturalistic mythologism, of his interest in the human reality of the individual in the mass. Indistinctness is a condition of necessity, for only thus is the individual instinct to resist in order to survive translated into moral and collective will. Once the condition of necessity no longer prevails, the individual must be restored the consciousness and measure of his existence as a person.

The search for monumentality that derived from this moralistic and pedagogic task certainly does not represent the high point of the artist's work; indeed, it is a serious step backward with respect to the definitive solution apparently indicated by the *Reclining Figure* of 1934 in the final dismemberment of the figure into disjointed and correlated organic-geometric entities. Moore clearly felt

charged with a public and civic function. While he and Picasso shared the same commitment, however, Moore's position increasingly differed from that of Picasso, who, in those years, was again at the forefront of morally and politically committed artists, increasing his polemical thrusts, alternating between triumphal hymns and harsh denunciations of new, insidious hotbeds of violence.

At the time, Moore felt the only advice that could be given to bewildered and frightened mankind was to recover and consolidate the feeling of its own history. The *Madonna and Child* (1944) for the Church of St. Matthew, Northampton, is possibly a poorly conceived work, but it was born of a new process of investigation that has had far-reaching consequences. The series of sketches and trials attests to Moore's analytic study of Romanesque and Gothic precedents. If the work's origins still can be traced to the mythical themes of fertility and of the mother-child relationship, they are by now very distant. It is their historical elaboration that counts—their transformation from myth to ethos, from primitive animism to social *religio*.

This new historicism inevitably led to an updated classicism: the sure deliberation of the statuary figures; rounded forms proferred to enveloping light; lines modeled along the slope of the surfaces. It is no accident that the *Three Standing Figures* in Battersea Park symmetrically correspond to Maillol's three nudes, even in the opposition of the Three Fates to the Three Graces. Perhaps in part due to his friendship with Herbert Read, the moralist and pedagogue of art, Moore during this period was a little like a Dr. Johnson of modern art, committed to educate the people aesthetically and morally by giving form and figure to "social sentiments." He dwelled on family groups, intertwining hieratic and domestic motifs (the Rocking Chair, 1950), and martial and playful motifs (the Helmet Head, 1950). But beyond these conscientious concessions to what Moore considered the artist's social duties, new directions for investigation were opening up, at least in part suggested by his travels in Greece in 1951 and in Mexico in 1953.

By 1950 and 1951, upright, skeletal figures, linked

only indirectly to Picasso's *An Anatomy*, frequently appear in Moore's sketchbooks. The object under investigation is not the fundamental plastic of bone, but the delicate articulations of structure. The analogy with the bone structure of the human body is only apparent; more evident is the affinity with the Stringed Figures, the figure-objects, the animate and sensitive objects. Skeletal tectonics are replaced by different morphological elements: membrane, cartilage, muscle, tendon, nerve. Through careful dissection, the artist isolates and lays bare the structures of sensitivity; he enlarges and generalizes the microanatomy of the eye, ear, vocal chords, and reproductive organs. The external outlines of bodies and faces, as well, are determined by those delicate internal articulations. In the bronze group *King and Queen* (1953), the figures are not integrated into the landscape; they contemplate it, listen to it, experience it, and react to it with the complete sensitivity of their internal organs. The countenances, pointed like a ship's bow, are all eyes and ears; the curved backs catch the breeze like a ship's sail; the arms and hands are slender and sensitive like the antennae of insects.

Even the metaphor of the human figure disappears from the Upright Motives (1956–57), and form evokes the menhir, the idol, and the stele. An analysis of the form reveals all the connotations of a morphology based on sensitivity: earlike lobes and auricles, fibers like exposed nerves, eyeballs, and channels like fallopian tubes. They arise like trigonometric symbols in a privileged point in the landscape, where all of nature's visual and sonic messages seem to flow together. One expects the sculpture at any moment to begin to vibrate, to hum, to ring out.

The memories of the naturalistic mythology of ancient Mexico, of the menhirs of prehistoric Europe, and of the crosses of primitive Irish Christianity are interwoven in the Upright Motives. The new theme of the Warrior was born in Greece, perhaps precisely from that aura of historical terror that the centuries have been unable to dispel from the ruins of Mycenae. Moore was not struck by Greek sculpture in itself—as a young man he had spent hours in the British Museum—but by the ambience, the space in which Greek sculpture arose. He perceived that in that very place, long ago, the structure of the human community had profoundly changed: the tribe had been succeeded by the polis, the state. It was a decisive step in the history of civilization, but it was also the end of the tribal union and of the magical relationship between society and nature. The emblematic personage of the polis was the warrior, the typically unintegrated being whom the community made a hero and a victim, but at the same time exiled, placing him in opposition to natural and moral law. In Moore's bronze he is a truncated, mutilated figure, a fragment torn from its context.

Three years later Moore repeated the theme in the *Falling Warrior* (Walker Gallery, Liverpool), to assert that "historical" death is the violent antithesis of the natural cycle of death and rebirth expressed in the long series of Reclining Figures. The technique has also changed. No longer is it primitive and artisanal carving, or the slow casting of molten metal in hollowed form, as in the first bronzes; it is a modeling technique that amasses and corrodes, exposing torn surfaces, which is followed by the blows of the chisel against the already cold bronze. Here, casting is not a process by which the imprint is taken of an image already formed; it is a process of formal arrangement, as though the image's boundaries were determined by the molten metal's expansion and setting.

In the *Seated Woman* (1956–57) and in other works of the same period, the dilemma of the classical and anticlassical, of form and distortion, is applied to the problem of space. Monumentality becomes gigantism, an almost grotesque exaggeration: if the woman were to stand, her head would touch the clouds. The mass of the bust is spread out and flattened; rotation about the off-center support that is her arm causes the soft mass of the belly to shift in the opposite direction like an unevenly distributed load. The entire figure wavers in the air like an inert, unstable mass, barely restrained by the thick folds in the drapery. Atop the enormous body, the head appears small and distant. Of the face, only

the round, birdlike eye can be seen. The folds in the drapery increase the distance between the closely drawn legs and the head sitting on the horizon. Space flows over the figure like a stream over its bed. Becoming one with the form, it isolates it in a remote, empty, indifferent landscape.

Now that Moore has posed it, the question "What is classical?" is resolved by negating any possible return to classicism—not by restoring the authority of form, but by dissolving form into shapeless mass. On his own, Moore has reached the same conclusions that all the artists who lived this century's cultural crisis reached between 1950 and 1960: the question is no longer one of deciding the geometric or organic model of form, but of the possibility of creating art in opposition to form and beyond it.

From 1934 on, and at the same time that Arp and Giacometti were conducting analogous investigations, Moore had overcome the bias for closed form —the sole, solid nucleus existing in empty and inclusive space. In the figures in two, three, and four pieces, he had sought, beyond the dilemma of the geometric and the organic, a common principle that, above all, would be relational. The problem shifted from the relationship between form and space to space as an interrelationship of distinct formal units. The separated-form motif becomes dominant beginning in 1959. (In the titles of works, as well, the word "motive" often replaces "form" or "figure.") The only parts of reality that can be captured are several fragments of space that, for some unknown cosmic law, separate and fall like meteorites, and become a mysterious presence in the world. A figure is always metaphoric, a form always symbolic; only a fragment is a meaningful sign of a universe whose order—if there is one—escapes us.

With the *Two-Piece Reclining Figure No. 1* Moore attacks the decisive problem: sculpture as nonform or shapeless mass. What permits us to call the two adjacent blocks figures is not their reference to a human archetype; if, at a distance, they appear to be figures, it is only because men tend to animate the universe by finding the features of living things in the shapes of rocks and clouds. Something, however, distinguishes those blocks from the congeries of object, for they are made of bronze, a material not found in nature but created by man. The surfaces are rough, hammered, and chiseled. In their apparent roughness, we are surprised by the systematic way in which they have been worked, as we are surprised to discover that a chip of flint was worked by man in a remote era. Man's intervention has given that unnatural material more than form alone; it has given it a different capacity to react to light. That fragment shines among natural objects with a different light, as if it were drawn from a more direct source. The relationship is no longer one of natural affinity, but of spatial measure. To exist with the awareness of living in space is a more elect way of being in the universe because space, too, is a phenomenon, but one that is more significative than others. Perhaps the artist's task, today as in prehistoric times, is to produce phenomena more significative than others.

David Sylvester, to whom we owe a clear classification of Moore's work according to the fundamental structure of their images, observes that before 1950 the surface tensions are constant, while in the more recent works one can note strong contrasts among parts that appear hard and drawn, or bony, and others that appear soft and yielding, or fleshy. The diversity derives not only from external attributes, but from the arrangement and order the material attains, rising up, maintaining itself, compressing itself. In short, the plastic image results from the manifold directions in which the material obeys or reacts to gravity, or from the contrast among rising and subsiding forces within its own substance. Thus, the configuration assumed by the mass depends on the play of these forces. This can be seen in the taut or relaxed curvature of the planes and in the sharpening of the edges, which increasingly resemble hatchet or knife blades, as if to cleave an opposing, resistant fluid substance. In *Standing Figure: Knife-Edge* (1961), the aggressive penetration of physical space by the plastic mass is evident in its ascending twist, like that of a propeller with cutting blades. In *Knife Edge Two Piece* (1965), the polished masses of bronze are sharp-

ened through imaginary friction with physical space until they attain aerodynamic contours and head on a collision course as if to penetrate one another.

In fact, the subsequent period, the most recent of the artist's work, is characterized by the recurrence of disjointed and reassembled forms; indeed, the forms embed and interpenetrate each other. The protuberances of one body enter the gouged cavities of the other, filling them. The unity of the single block is thus reconstructed, but through a contested integration of positive and negative. Two unified iconic components can be easily recognized in this morphology based on the fitting together of parts: the organic motif of sex and fertility, and the mechanistic motif of the integrated block, of gears, of valves.

The recovery of symbolic implications is clear in the Locking and Interlocking Pieces from 1964 to the present, but the symbol does not explicitly refer back to the idea, for it is not a point of connection; it remains pure duplicity—ambivalence of meaning —and explicit ambiguity, the suspension of judgment. Sexuality, the existent's principle of aggregation and association, is given in the bare functional sense for which even in mechanics the pieces that mesh to form a motor device are called male and female. Conversely, there are curious points in common between the mechanical and the organic. A large part of Moore's work dwells on the theme of closed form that opens, and, by opening, reveals itself as a knot of virtual relationships, resolving itself into the infinite relationality of space. Now, instead, open forms close, and the possibility of relationship is narrowed to equations of reciprocity.

In the organic world, pervaded by the intentionality of existence, Moore recognized the principle of aggregation, which builds society by becoming ethical volition. For this moral imperative alone, he once chose the organic against Constructivist rationalism, which was still a way of making man's labor dependent on intellectual decisions, rather than of interpreting it as the sequel and development in the world, in the living space of the community, of primal and profound vital impulses. Over seventy years old, and perhaps asking himself what might be the artist's sense of his own work in so changed a world, Moore intuits that the conflict between the morphology of the organic and the morphology of the rational or mechanical has vanished. There is a process of adaptation (whatever its outcome may be) by which organic and even human forms tend to assimilate mechanical forms, and the latter to reproduce organic forms, since organic forms, in fact, do not correspond to lucid designs of reason, but to the deep biological and psychic impulses of the unconscious.

Biographical Outline

1898 July 30, Henry Moore born in Castleford, Yorkshire, the seventh of eight children of Raymond Spencer Moore (1849–1921) and Mary Baker (1860–1944). His father, of Irish descent, was a miner; his mother came from Staffordshire.

1902–8 Elementary school at Castleford and Temple Street School. In 1908 wins a scholarship to Castleford Grammar School.

1909–14 Encouraged by his art teacher to develop his talent for drawing and painting. Becomes familiar with Gothic carvings in Yorkshire churches. In 1914 receives his Cambridge Senior Certificate, which qualifies him to enter a Teachers Training College.

1915 Despite his wish to become an artist, he follows his father's advice and attends the Training College.

1916 Begins teaching at Temple Street Elementary School. Makes his first visit to London, visiting British Museum and the National Gallery. Enlists in the Fifteenth London Regiment (Civil Service Rifles). Military training at Wimbledon and Hazeley Downs, near Winchester.

1917–19 Leaves in 1917 for the front in France, where his division goes into action toward the end of the year. Gassed at Cambrai and sent back to a hospital in England for convalescence. After two months becomes a bayonet instructor at Aldershot with the rank of lance-corporal. Volunteers to return to the front and reaches France just before the Armistice in 1918. Demobilized in England in February 1919. Returns briefly to his teaching post in Castleford, and enter Leeds School of Art in September.

1920 First encounter with modern art (Cézanne, Gauguin, Rouault, Matisse, Kandinsky) and African sculpture through the collection of Sir Michael Sadler, Vice-Chancellor of Leeds University. His play *Narayana and Bhataryan* produced by the Castleford Grammar School amateur drama group, with Moore as Bhataryan.

1921 Awarded a scholarship to the Royal College of Art. Studies ancient Mexican sculpture and primitive art at the British Museum. Influenced by Ezra Pound's book on Gaudier-Brzeska, especially by Gaudier's own statements about sculpture quoted by Pound, and by Roger Fry's *Vision and Design*.

1922 Begins carving in stone and wood with Barry Hart, Professor Derwent Wood's assistant at the RCA. Begins the Mother and Child series under the influence of pre-Columbian sculpture.

1923 First visit to Paris, where he is impressed by the Cézanne paintings in the Pellerin collection.

1924 Awarded Royal College of Art Travelling Scholarship. Appointed instructor in the sculpture school for a term of seven years. Carvings include *Mother and Child* (City Art Gallery, Manchester); *Woman with Upraised Arms*; first *Reclining Figure*.

1925 Travels for six months in France and Italy, visiting Paris, Rome, Florence, Pisa, Siena, Assisi, Ravenna, and Venice. Particularly impressed by Giotto, Masaccio, and late Michelangelo. On his return to Lon-

don, appointed assistant to Professor Ernest Cole at the RCA.

1926 First group exhibition, at St. George's Gallery, London. Sets up studio at 3 Grove Studios, Hammersmith. *Reclining Figures.*

1927 Direct carvings in stone and wood; terracottas and bronzes.

1928 First one-man exhibition, at Warren Gallery, London. Art critic of *The Morning Post* describes Moore's sculpture as "immoral" and claims he should be dismissed from the RCA. Commissioned to produce a relief, *North Wind*, for the St. James's Park Underground station.

1929 Marries Irina Radetzky, then a painting student at the RCA. Carves *Reclining Figure* in brown Hornton stone, under the influence of the Mexican Chac Mool carving. First use of a hole in his sculpture.

1930 Elected to the Seven and Five Society, a group of avant-garde artists. Makes five versions of *Mother and Child* and four of *Reclining Figure.*

1931 One-man exhibition at Leicester Galleries, London, with a foreword in the catalogue by Jacob Epstein: "Bound by the severest aesthetic considerations, this sculpture is a liberation of the spirit." Hamburg Art Museum buys a sculpture and several drawings, his first foreign sale. Several versions of *Mother and Child* and *Reclining Figure.* First Biomorphic abstracts.

1932 Leaves the RCA, and begins teaching at the Chelsea School of Art, where he establishes a department of sculpture.

1933 Exhibition at Leicester Galleries. Member of *Unit One*, founded by Paul Nash and others. Contributes to the group's magazine, edited by Herbert Read.

1934 Takes a cottage at Kingston, near Canterbury, where he can work in the open air. Works on sculptures in several parts.

1935 Exhibition at Zwemmer Gallery. Moore contributes an article on Mesopotamian art to *The Listener.* Sculptures approach abstraction but retain the human reference.

1936 Exhibition at Leicester Galleries. Contributes to the International Surrealist Exhibition in London. Visits Madrid, Toledo, Barcelona, and the caves of Altamira. Signs the manifesto of the Surrealist Group in England, to protest the policy of non-intervention in the Spanish Civil War. Completes first opened-out *Reclining Figure* in elm wood started the previous year (Collection Albright Art Gallery, Buffalo). Executes *Reclining Figure* in elm wood (Wakefield City Art Gallery).

1937 Contributes "Notes on Sculpture" to *The Listener.* Contributes to *Circle*, the magazine edited by J. L. Martin, Ben Nicholson, and Naum Gabo. Tendency toward abstract art more pronounced; uses metal struts in stringed figures.

1938 Takes part in Abstract Art Exhibition at Stedelijk Museum, Amsterdam. Carves *Recumbent Figure* in green Hornton stone (Tate Gallery, London), and executes *Reclining Figure* in lead (Museum of Modern Art, New York).

1939 Exhibition at Mayor Gallery, London. Gives up teaching at the Chelsea School of Art and devotes himself entirely to sculpture. Takes on Bernard Meadows as an assistant. Executes the *Reclining Figure* in elm wood (Detroit Institute of Art).

1940 Becomes an official war artist, making drawings of life in London air-raid shelters. Buys farmhouse at Much Hadham in Hertfordshire, where he still lives.

1941 First retrospective exhibition, at Temple Newsam, Leeds. Appointed Trustee of the Tate Gallery for a term of seven years. Continues to work on shelter drawings.

1942 Drawings of miners in Castleford.

1943 Commissioned to provide a sculpture of *Madonna and Child* for the church of St. Matthew in Northampton. First one-man exhibition in the United States, at the Buchholz Gallery (Curt Valentin), New York.

1944 Numerous sketches for the St. Matthew's Church *Madonna and Child* and for a *Family Group* (executed 1954–55 for Harlow New Town). Abandons the idea of reliefs for the University of London after making several sketches. Illustrations for Edward Sackville-West's *The Rescue.*

1945 One-man exhibition at Berkeley Galleries.

Appointed member of the art panel of The British Council. Honorary doctorate from Leeds University. *Madonna and Child* unveiled at St. Matthew's, Northampton. Exhibition in Paris, *Some English Contemporaries*. Meets Brancusi. Executes *Memorial to Christopher Martin*, at Dartington, Devon. Several versions of *Reclining Figure* and *Family Group*. Makes studies for *Three Standing Figures*.

1946 Retrospective exhibition at the Museum of Modern Art, New York (later shown in Chicago and San Francisco). One-man exhibitions at Leicester Galleries, London, and at the Phillips Memorial Gallery, Washington, D.C. Visits the United States. Daughter Mary born.

1947 Traveling exhibition of Moore's work in Australia (Sydney, Melbourne, Adelaide, Hobart, Perth). *Madonna and Child* commissioned for Claydon Church, Suffolk. Executes *Three Standing Figures*, erected in Battersea Park, London.

1948 Exhibition in the English Pavilion, XXIVth Biennale of Venice. Awarded the International Prize for Sculpture. One-man exhibition at Galleria d'Arte, Milan. Appointed to Royal Fine Art Commission. Elected Honorary Associate of the Royal Institute of British Architects, and Foreign Corresponding Member of the Académie Royale Flamande des Sciences, Lettres et Beaux-Arts de Belgique. Travels in Italy.

1949 Retrospective exhibitions at Musée National d'Art Moderne, Paris; Palais des Beaux-Arts, Brussels; City Art Gallery, Wakefield. New seven-year term as a Trustee at the Tate Gallery. *Family Group* unveiled at Stevenage.

1950 Traveling exhibition, Stedelijk Museum, Amsterdam; Berne Kunsthalle; and Hamburg and Düsseldorf in Germany. Exhibition in Mexico. Elected foreign member of Swedish Royal Academy of Fine Arts. *Reclining Figure* commissioned for the 1951 Festival of Britain. *Standing Figure* installed at Shawhead, Dumfries, Scotland.

1951 Retrospective exhibition at Tate Gallery. One-man exhibitions at Leicester Galleries, London; Buchholz Gallery, New York; the Albertina, Vienna; and in Athens. Travels in Greece. Contributes to the second International Exhibition of Sculpture in the Open Air, London, and first International Exhibition of Sculpture in the Open Air, Middelheim Park, Antwerp.

1952 Traveling exhibition in Sweden. Exhibitions in Cape Town, Stockholm, and Linz. Contributes to International Sculpture Exhibition, Sonsbeek Park, Arnhem. Commissioned to make the Stone Screen and the *Draped Reclining Figure* for the Time-Life Building in London. Attends International Conference of Artists in Venice, organized by UNESCO. Travels in Italy. *Leaf Figures* in bronze.

1953 Exhibits at the second Biennale of São Paulo, Brazil; awarded the International Sculpture Prize. Travels in Brazil and Mexico. Traveling exhibition in Germany, Norway, and Denmark. Exhibitions in Antwerp, Rotterdam, and London. Reappointed to Royal Fine Art Commission. Honorary Doctorate of London University. Mural painting by Alfonso Sato Soria at El Eco Museum, Mexico City, from designs by Henry Moore. Moore executes *Draped Torso*, and sketches for *Warrior with Shield* and *King and Queen*.

1954 One-man exhibitions, Leicester Galleries, London, and Buchholz Gallery, New York. Contributes to third International Exhibition of Sculpture in the Open Air, London. Commissioned to design a relief in brick for the Rotterdam Bouwcentrum. Travels in Italy, Germany, and the Netherlands.

1955 Companion of Honour. Appointed Trustee of the National Gallery. Elected foreign Honorary Member of the American Academy of Arts and Sciences. Reappointed a member of the Art Panel of the Arts Council Exhibitions in United States, Canada, Yugoslavia, and at Leicester Galleries, London, and the Kunsthalle, Basle.

1956 *Reclining Figure* commissioned for the UNESCO Building in Paris. Executes *Glenkiln Cross*.

1957 Exhibitions at Galerie Berggruen, Paris, and at Roland, Browse and Delbanco, London. Contributes to fourth International Exhibition of Sculpture in the Open Air, London. UNESCO *Reclining Figure* unveiled in Paris. Prize at Carnegie International, Pittsburgh. Large bronzes of Draped Female Figures.

1959 Participates in Tokyo Biennale; awarded the International Prize for Sculpture. Traveling exhibitions in Japan, Portugal, and Spain. Honorary degrees from Cambridge University and Reading University. Corresponding Academician of Academia Nacional de Bellas Artes, Buenos Aires. Awarded Gold Medal by Society of the Friends of Art, Krakow, Poland. *Two-Piece Reclining Figure No. 1* is executed. (First part of this, with a cast of *Two-Piece Reclining Figure No. 2*, now installed at Lambert Airport, St. Louis, Missouri.)

1960 Retrospective Exhibition at Whitechapel Art Gallery, London. Reappointed to the Royal Fine Arts Commission.

1961 Honorary doctorate from Oxford University. Elected member of American Academy of Art and Letters and Berlin Akademie der Künste. Exhibitions at Marlborough Fine Art, London, and Scottish National Gallery of Modern Art, Edinburgh. Executes *Three-Piece Reclining Figure No. 1* and *Standing Figure: Knife Edge.*

1962 Honorary doctorates from Hull University and the Technische Hochschule, Berlin. Freeman of the borough of Castleford. Honorary Fellow of Lincoln College, Oxford. Appointed member of the National Theatre Board. Exhibitions at Marlborough Fine Art, London; Knoedler Gallery, New York; Ashmolean Museum, Oxford; Gerald Cramer Gallery, Geneva. Commissioned to make a sculpture for the Reflecting Pool at the Lincoln Arts Center, New York.

1963 Order of Merit. Awarded Feltrinelli Prize in Italy. Exhibitions at Marlborough Fine Art; Wakefield City Art Gallery; Ferens Art Gallery, Hull. Honorary Member of the Society of Finnish Artists.

1964 Appointed member of Art Council of Great Britain. Reappointed Trustee of National Gallery. Exhibitions at Marlborough Fine Art, London, and Knoedler Gallery, New York. Traveling exhibitions in Argentina, Brazil, Mexico, and Venezuela. Completes *Locking Piece.*

1965 Honorary Fellow of Churchill College, Cambridge. Honorary degree from the University of Sussex. Exhibitions at Marlborough Fine Art and in Rio de Janeiro and New Orleans. Three *Upright Motives* erected on a hill at the Kröller-Müller Museum, Otterlo.

1966 Honorary doctorates from the Universities of York and Sheffield and from Yale University. Fellow of the British Academy. Exhibitions at Marlborough Fine Art and Philadelphia College of Art. Traveling exhibitions in Eastern Europe. Visits Canada for unveiling of *The Archer* in Nathan Phillips Square, Toronto. Carves *Two Forms* in red Soraya marble, *Three Rings* in Rosa Aurora marble, and large version of *Three Rings* in red Soraya marble.

1967 Elected Professor ad Honorem of Accademia di Belle Arti, Carrara. Honorary degrees from the Royal College of Art, St. Andrew's University, Scotland, and the University of Toronto. Exhibitions at Marlborough New London Gallery, London, and the Museum of Lincoln, Massachusetts. Represented in Montreal World Fair and Guggenheim International Exhibition, New York. Participates in the exhibition "Hommage à Rodin" at the Galerie Lucie Weil, Paris. Executes *Sundial* for *The Times* Building, London.

1968 Erasmus Prize for 1968. Albert Einstein Commemorative Award for the Arts from Yeshiva University, New York. Large retrospective exhibitions at Tate Gallery, Kröller-Müller Museum, Boymans–van Beuningen Museum, Städtische Kunsthalle of Düsseldorf and Städtische Kunsthalle of Baden-Baden, in celebration of Moore's seventieth birthday.

1969 Executes *Three-Piece No. 3: Vertebrae.* Works on *Large Arch*, in polystyrene for bronze, and *Large Two Forms.*

1970 Important exhibitions of recent works at the Knoedler and Marlborough galleries, New York.

List of Exhibitions

drawings)

London: Battersea Park, "First International Exhibition of Sculpture in the Open Air"

1948–49 Exhibition organized by the British Council in Canada, "Contemporary British Drawings" (5 drawings)

1949 *Wakefield:* City Art Gallery

Manchester: City Art Gallery

Toronto: Art Gallery, "Contemporary Art: Great Britain, USA, and France"

London: Institute of Contemporary Art, "40,000 Years of Modern Art"

Arnhem: Sonsbeek 1949, "Europese Beelhawrkunst in de Open Lucht" (2 sculptures)

London: New Burlington Galleries, "Contemporary British Art"

1949–50 Exhibition organized by the British Council: Palais des Beaux-Arts, Brussels; Musée National d'Art Moderne, Paris; Stedelijk Museum; Amsterdam; Kunstverein, Hamburg; Städtischen Kunstsammlungen, Düsseldorf; Kunsthalle, Bern (53 sculptures, 44 drawings)

1950 Exhibition organized by the British Council: Galeria de Arte Mexicana, Mexico City; Galerias Arguitae, Guadalajara (34 drawings)

1951 *London:* Tate Gallery (73 sculptures, 96 drawings)

Athens: Zappeion Gallery (53 sculptures, 44 drawings)

São Paulo: Museum of Modern Art, "Biennial" (2 lithographs)

Antwerp: Middelheim Park, "First International Exhibition of Sculpture in the Open Air"

London: Battersea Park, "Second International Exhibition of Sculpture in the Open Air"

1951–52 Exhibition organized by the British Council: Haus am Waldsee, Berlin; Albertina, Vienna; Neue Galerie der Stadt Linz (10 sculptures, 67 drawings)

1952 *Capetown:* National Gallery of South Africa, "The Meaning of Sculpture" (23 sculptures, 36 drawings)

Salzburg: Galerie Welz, "Moore, Martini, Wotruba" (3 sculptures)

Venice: "XXVI Biennale" (1 sculpture)

Vienna: Albertina, "Exhibition of Religious Art" (3 sculptures)

Mâcon: Musée Municipal, "Artistes Anglais Contemporains" (2 sculptures, 2 lithographs)

Recklinghausen: "Ruhr Miners Festival" (3 sculptures)

London: Tate Gallery, "Twentieth Century Masterpieces"

Arnhem: Sonsbeek, "Europese Beelhawrkunst in de Open Lucht"

Stockholm: Samlanen Gallery (24 sculptures, 16 drawings)

1952–53 One-man exhibition organized by the British Council: Royal Academy of Art, Stockholm; Akademier, Norrköping; Akademier, Örebro; Kunstmuseum, Göteborg; Kunstforeningen, Copenhagen; Kunstnerns Hus, Oslo; Kunstforeningen, Trondheim; Kunstforeningen, Bergen; Boymans–van Beuningen Museum, Rotterdam (23 sculptures, 30 drawings)

1953 *São Paulo:* Museum of Modern Art, "Second Biennial" (29 sculptures, 40 drawings)

Antwerp: Comitee vaar Artisticke Werking, 1930–1952 (25 sculptures, 25 drawings, 17 bozzetti)

Hamburg: Alsterborland, "Plastik im Freien" (1 sculpture)

Varese: "IInd International Review of Sculpture in the Open Air" (1 sculpture, 3 drawings)

London: Institute of Contemporary Art (106 drawings)

London: Whitechapel Art Gallery, "Twentieth Century Form"

Antwerp: Middelheim Park, "Second International Exhibition of Sculpture in the Open Air"

1953–54 Exhibition organized by the British Council: Kestner Gesellschaft, Hannover; Haus der Kunst, Munich; Stadelsches Kunstinstitut, Frankfurt; Staatsgalerie, Stuttgart; Kunsthalle, Mannheim; Kunsthalle, Bremen; Stadtverwaltung, Göttingen (24 sculptures, 38 drawings)

1954 *London:* Leicester Galleries (33 sculptures)

New York: Curt Valentin Gallery (32 sculptures, 20 drawings)

London: Holland Park, "Third International Exhibition of Sculpture in the Open Air"

"Henry Moore," traveling exhibition: Boulder, University of Colorado; Denver, Art Museum; Laramie, University of Wyoming; Colorado Springs, Fine Art Center (50 drawings)

London: Leicester Galleries (22 sculptures, 17 drawings)

London: Roland, Browse, and Delbanco (27 drawings)

Exhibition organized by the British Council: Kunsthalle, Basel; Tomislav Pavilion, Zagreb; Kalemegdan Pavilion, Belgrade; Moderna Galerija, Lublin; Daud Pash Hamaki, Sofia

(29 sculptures, 55 drawings)

Arnhem: Sonsbeek, "Europese Beelhawrkunst in de Open Lucht" (6 sculptures)

Recklinghausen: "Ruhr Miners' Festival" (5 sculptures, 3 drawings)

Lublin: Moderna Galerija, "International Exhibition of Graphics" (4 lithographs)

Kassel: Fridericianum Museum, "Documenta" (10 sculptures)

San Francisco: San Francisco Museum of Art, "Art in the Twentieth Century" (2 sculptures)

Antwerp: Middelheim Park, "Third International Exhibition of Sculpture in the Open Air"

1955–58 Exhibition organized by the British Council: Musée des Beaux-Arts, Montreal; National Gallery of Canada, Ottawa; Art Gallery, Toronto; Art Gallery Association, Winnipeg; Art Gallery, Vancouver; City Art Gallery, Auckland; Canterbury Society of Arts, Christchurch; Public Art Gallery, Dunedin; National Art Gallery, Wellington; George V Gallery, Port Elizabeth; Rhodes Centenary Art Gallery, Salisbury; National Museum, Bulawayo; Art Gallery, Johannesburg (25 sculptures, 32 drawings)

1956 *Copenhagen:* Kunstforeningen, "British Kunst 1900–1955" (2 sculptures, 3 lithographs)

Oslo: Kunstnerns Hus. "Britisk Natidskunst" (2 sculptures, 3 lithographs)

1957 *Paris:* Galerie Berggruen (30 sculptures, 32 drawings)

London: Roland, Browse and Delbanco, "Moore" (28 drawings)

Paris: Musée Rodin, "Exposition Internationale de la Sculpture Contemporaine" (2 sculptures)

Tokyo: "First International Biennial of Prints" (5 lithographs)

Düsseldorf: "Exhibition of Prints and Drawings" (3 drawings)

London: Holland Park, "Fourth International Exhibition of Sculpture in the Open Air" (1 sculpture)

London: Arts Council, traveling exhibition, "Contemporary British Sculpture" (1 sculpture)

1958 *Newcastle-on-Tyne:* Hatton Gallery (38 sculptures)

Milan: Galleria Blu, "Armitage, Chadwick, Moore, Sutherland" (4 sculptures, 3 drawings)

Arnhem: Sonsbeek, "Europese Beelhawrkunst in de Open Lucht" (19 sculptures)

Los Angeles: Landau Gallery

Pittsburgh: Carnegie Institute, "Bicentennial International Exhibition" (1 sculpture)

Leeds: City Art Gallery, "Modern Sculpture" (1 sculpture)

London: Marlborough Fine Art, "XIXth and XXth Century European Masters" (4 sculptures)

Brussels: Palais International des Arts, "Cinquante Années d'Art Contemporain" (2 sculptures)

Brussels: British Embassy, "Contemporary British Painting, Sculpture, and Drawings" (1 sculpture)

Tübingen: Universitätstadt, "Henry Moore und Englische Zeichner" (7 sculptures, 3 drawings, 3 lithographs)

Duisburg: Städtisches Kunstmuseum, "Zeichnungen des XXsten Jahrhunderts" (7 sculptures, 3 drawings, 3 lithographs)

1959 *Chicago:* Arts Club (38 sculptures, 43 drawings)

Exhibition organized by the British Council in Japan, "Fifth International Art Exhibition": Tokyo; Sogo Department Store, Hiroshima; Daimaru Department Store, Fukuoka; City Hall, Ube; Nakamura Department Store, Saseho (15 sculptures, 30 drawings, 1950 to 1958)

Exhibition organized by the British Council: Palacio Fox, Lisbon; Escola de Bellas Artes, Oporto; Sala de Exposiciones, Direccion General de Bellas Artes, Madrid; Recinto del Antiguo Hospital de la Santa Cruz, Barcelona (30 sculptures, 28 drawings)

Paris: Musée Rodin, "Jeunesse des Maîtres de la Sculpture au XXe Siècle" (6 sculptures)

Otterlo: Rijksmuseum Kröller-Müller, "International Exhibition of Sculptor's Drawings" (7 drawings)

New York: Fine Arts Associates Gallery

Carrara: "Second International Biennial of Sculpture"

Antwerp: Middelheim Park, "Fifth International Exhibition of Sculpture in the Open Air" (16 sculptures)

Kassel: Fridericianum Museum, "Documenta II" (7 sculptures)

Exhibition organized by the British Council in Poland: Zachenta Gallery, Warsaw; Society for Fine Arts, Krakow; National Museum, Poznan; Central Board of Exhibitions, Wroclaw; Museum of Pomerania, Stettin (30 sculptures, 30 drawings)

1960 *London:* Whitechapel Art Gallery (73 sculptures)

Rotterdam: Boymans–van Beuningen Museum, "International Sculpture Exhibition" (9 sculptures)

London: Battersea Park, "Fifth International Exhibition of Sculpture in the Open Air" (1 sculpture)

1961 *London:* Marlborough Fine Art (45 sculptures)

Edinburgh: Scottish National Gallery of Modern Art, "Henry Moore, 1928–1961" (19 sculptures, 29 drawings)

Paris: Musée Rodin, "Deuxième Exposition Internationale de la Sculpture" (1 sculpture)

Antwerp: Middelheim Park, "Sixth International Exhibition of Sculpture in the Open Air" (4 sculptures)

Cardiff, Swansea, Aberystwyth, Bangor: "Sculpture 1961" (15 sculptures)

London: Marlborough Fine Art, "Some Aspects of 20th Century Art" (54 sculptures)

1961–62 Exhibition organized by the British Council, "Recent British Sculpture": Musée des Beaux-Arts, Montreal; Art Gallery, Winnipeg; Art Gallery, Regina; Art Gallery, Toronto; Public Library and Art Museum, Ontario; Art Gallery, Vancouver; City Art Gallery, Auckland; Otago Museum; Canterbury Museum, Christchurch (5 sculptures)

1962 Exhibition organized by the Art Council: Cambridge Arts Gallery, Cambridge, York, Nottingham, Aldeburgh (53 sculptures, 23 drawings)

New York: Knoedler Gallery (59 sculptures)

London: Marlborough Fine Art, "1927–1962" (49 watercolors and drawings)

London: Marlborough Fine Art, "1928–1933" (10 sculptures, 16 drawings)

Oxford: Ashmolean Museum (35 sculptures, 13 drawings)

Seattle: World's Fair, "Art since 1950" (1 sculpture)

Venice: Galleria Internazionale d'Arte Moderna, "First Prizes from the Biennale, 1948–1960" (1 sculpture)

Exhibition organized by the C. Gulbenkian Foundation, "Arte Britanica no seculo XX": Sociedade Nacional de Belas Artes, Lisbon; University of Coimbra; Museo Nacional de Soares dos Reis, Oporto (2 sculptures)

Carrara: "Third Biennial of Sculpture" (3 sculptures)

Spoleto: "Fifth Festival of Two Worlds: International Exhibition of Sculpture" (2 sculptures)

Vienna: Museum des XXten Jahrhunderts, "Kunst von 1900 bis Heute" (2 sculptures)

Cardiff: National Museum of Wales, "British Art and the Modern Movement, 1930–1940" (15 sculptures)

1962–63 *Geneva:* Galerie Gerald Cramer (24 sculptures, 18 drawings, 21 etchings)

1963 *Wakefield:* City Art Gallery (59 sculptures, 53 drawings)

London: Marlborough Fine Art, "1960–1963" (19 sculptures)

Santa Barbara, Los Angeles, La Jolla: "Henry Moore" (60 sculptures, 41 drawings)

Reineckendorf, Berlin–Tempelhof, Munich, Düsseldorf, Castrop–Rauxel: "Henry Moore, 1929–1962" (55 drawings)

London: Battersea Park, "Sixth International Exhibition of Sculpture in the Open Air" (1 sculpture)

London: Brook Street Gallery, "Modern Sculpture" (6 sculptures)

Washington: Gallery of Modern Art, "Sculptors of Our Time" (2 sculptures)

1963–64 Exhibition of contemporary English sculpture organized by the British Council: Western Australia Gallery, Perth; National Gallery of South Australia, Adelaide; Tasmanian Museum and Art Gallery, Hobart; Queen Victoria Museum and Art Gallery, Launceston; National Gallery of Victoria, Melbourne; Art Gallery of New South Wales, Sydney; Queensland Art Gallery, Brisbane; Newcastle War Memorial Culture Centre, Newcastle; Albert Hall, Canberra; Bridgestone Gallery, Tokyo; National Museum of Modern Art, Kyoto; City Hall, Hong Kong (5 sculptures)

1964 *London:* Marlborough Fine Art, "1924–1961" (25 drawings)

New York: Knoedler Gallery

King's Lynn, Norfolk: "Festival Exhibition" (33 sculptures, 23 drawings)

London: Tate Gallery, "Painting and Sculpture of a Decade, 1954–1964" (3 sculptures)

Paris: Galerie Charpentier, "Exposition Surréaliste" (2 sculptures)

London: Marlborough Fine Art, "Aspects of Twentieth Century Art" (13 sculptures)

London: Brook Street Gallery, "Four Sculptors" (7 sculptures, 4 drawings)

Kassel: Fridericianum Museum, "Documenta III" (9 sculptures)

Darmstadt: "First International Exhibition of Drawings" (5 drawings)

1964–65 Exhibition organized by the British Council: Palacio de Bellas Artes, Mexico City; Museo de Bellas Artes, Caracas; Museo de Arte Moderna, Rio de Janeiro; Museo de Bellas Artes, Buenos Aires (27 sculptures, 39 drawings)

1965 *London:* Marlborough Fine Art (25 sculptures, 10 drawings)

New Orleans: Orleans Gallery (47 sculptures, 10 drawings)

Rome: Marlborough Galleria d'Arte (44 sculptures, 10 drawings)

Tucson: University of Arizona Art Gallery, "Henry Moore" (56 sculptures)

London: Marlborough Fine Art, "Art in Britain, 1930–1940" (11 sculptures, 4 drawings)

Jerusalem: Bezalel Museum, "Sculpture in the Open Air"

Little Rock: Arkansas Art Center (58 sculptures, 22 drawings)

Vienna: Museum des XXten Jahrhunderts, "Kunst in Freiheit: Dubuffet, Moore, Tobey."

Bologna: Museo civico, "Arte e Resistenza in Europa"; Turin, Galleria civica d'arte moderna (6 drawings)

London: Marlborough Gallery, "Henry Moore, Francis Bacon" (25 sculptures, 35 drawings)

Krakow: Palace of Fine Arts, "First International Biennial of Graphics"

1965–66 Exhibition organized by the British Council, "Nine Living British Sculptors": Lalit Akademie, New Delhi; Lalit Kala Akademie, Calcutta; Rajah Hall, Madras; Jahangir Art Gallery, Bombay (24 sculptures)

1966 *London:* Marlborough Fine Art (24 sculptures)

Folkestone: New Metropolitan Art Gallery (51 sculptures, 21 drawings)

Plymouth, England: City Museum and Art Gallery (51 sculptures, 46 drawings)

Philadelphia: Philadelphia College of Art, "Art and Idea: Henry Moore"

London: Arts Council Exhibition (1 sculpture)

Exhibition organized by the British Council: Slovak National Gallery, Bratislava; National Gallery, Prague (33 sculptures, 41 drawings)

Exhibition organized by the British Council: Israel Museum, Jerusalem; Helena Rubinstein Pavilion, Tel Aviv (33 sculptures, 34 drawings)

London: Battersea Park, "International Exhibition of Sculpture in the Open Air" (3 sculptures)

1967 *Lincoln, Mass.:* De Cordova Museum

London: Marlborough Fine Art (29 sculptures)

Sheffield: City Art Gallery and Museum (30 sculptures, 30 drawings)

Montreal: Terre des Hommes, "International Exhibition of Sculpture"

New York: Guggenheim Museum, "Guggenheim International Exhibition 1967" (1 sculpture)

Paris: Galerie Lucie Weill, "Hommage à Rodin" (3 etchings, 1 lithograph)

Pittsburgh: Carnegie Institute (1 sculpture)

Budapest: Mücsarnok, "1927–1964" (43 sculptures, 39 drawings)

Dublin: Trinity College Library (18 sculptures, 23 drawings)

Arnhem: Sonsbeek, "Europese Beehawrkunst in de Open Lucht" (5 sculptures)

1966–68 Exhibition organized by the Smithsonian Institution: Washington, D.C., Lincoln, Mass., Brooklyn, Atlanta, Denver, Memphis, Philadelphia, Kansas City, Minneapolis, Winnipeg, Detroit, Utica

1967–68 Exhibition organized by the British Council in Canada: Art Gallery of Ontario, Toronto; Prince Edward Island Confederation Centre, Charlottetown; Arts and Cultural Centre, St. John's, Newfoundland; Musée des Beaux-Arts, Montreal (42 sculptures and drawings)

1968 *London:* Tate Gallery (142 sculptures, 90 drawings)

Exhibition organized by the British Council: Rijksmuseum Kröller-Müller, Otterlo; Kunsthalle, Düsseldorf; Boymans-van Beuningen Museum, Rotterdam; Kunsthalle, Baden-Baden (51 sculptures, 73 drawings)

1969 Exhibition organized by the British Council in Japan: Tokyo, Osaka, Nagoya, Hong Kong (65 sculptures, 32 drawings)

York: University (42 sculptures)

Norwich: Castle Museum

1970 *New York:* Knoedler Gallery (16 sculptures)

New York: Marlborough Gallery, "Exhibition of Recent Bronzes" (42 sculptures)

1971 Exhibition of sculpture and drawings organized by the British Council in Persia: Teheran, Estahan, Abadan

1972 *Florence:* Forte di Belvedere (289 sculptures, drawings, and prints)

Bibliography

Writings by Henry Moore

"A View of Sculpture," *Architectural Association Journal*. London (May, 1930).

"The Sculptor's Aims," *Unit One*. London: no. 1 (1934).

"Mesopotamian Art," *The Listener*. London (June 5, 1935).

"Notes," *Circle*. London: no. 1 (1937).

"The Sculptor Speaks," *The Listener*. London (August 18, 1937).

"Primitive Art," *The Listener*. London (August 24, 1941).

"Note on *Madonna and Child*," *Transformation*. London: 1946.

"Was der Bildhauer anstrebt," *Thema*. Munich: no. 5 (1949).

"Message de la sculpture," *XXe Siècle*. Paris: no. 1 (1951).

"Family Group," Letter to Dorothy Miller, January 31, 1951. In Philip James, *Henry Moore on Sculpture*. London: Macdonald, 1966.

"Tribal Sculpture," *Man*. London: vol. 51, no. 165 (1951).

"Notes on Sculpture," in Tate Gallery catalogue. London: 1951.

"Témoignage," *XXe Siècle*. Paris: no. 2 (1952).

"Interview," *Ark*. London: no. 6 (1952).

"The Sculptor in Modern Society," *Art News*. New York: vol. 5, no. 6 (1952).

"Form from the Inside Outwards," in F. Man, ed. *Eight European Artists*. London: Heinemann, 1954.

"Sculptor's Drawings," in F. Man, ed. *Eight European Artists*. London: Heinemann, 1954.

"Draped Torso," Letter to S. D. Cleveland, March 12, 1954. In Philip James, *Henry Moore on Sculpture*. London: Macdonald, 1966.

"Time/Life Reclining Figure," in the catalogue of the Third International Exhibition of Sculpture in the Open Air. London: 1954.

"Notes on the Draped Reclining Figure," in the catalogue of the Third International Exhibition of Sculpture in the Open Air. London: 1954.

"Three Standing Figures," in the catalogue of the traveling exhibition organized by the British Council, 1955.

"Sculpture in the Open Air," edited by Robert Melville. London: British Council, 1955.

"Warrior with Shield," Letter of January 15, 1955. In Philip James, *Henry Moore on Sculpture*. London: Macdonald, 1966.

"Upright Internal and External Forms, 1953–54," Letter to Gordon Smith, October 31, 1955. In Philip James, *Henry Moore on Sculpture*. London: Macdonald, 1966.

"King and Queen," Letter to E. Mundt, in *Art and Artist*. Berkeley and Los Angeles: University of California Press, 1956.

"The Hidden Struggle," *The Observer*. London: November 29, 1957.

"Jacob Epstein," *The Sunday Times*. London: August 23, 1959.

"Note on *Glenkiln Cross*," in the catalogue of the Fifth International Exhibition of Sculpture in the Open Air. London: 1960.

"Two-Piece Reclining Figure, 1959 and 1960," Statement to the Tate Gallery. In Philip James, *Henry Moore on Sculpture*. London: Macdonald, 1966.

"The Michelangelo Vision," *Sunday Times Colour Magazine*. London: February 16, 1964.

"Standing Figure," in Philip James, *Henry Moore on Sculpture*. London: Macdonald, 1966.

"Renoir, *La danseuse au tambourin* and *La danse aux castagnettes*," in Philip James, *Henry Moore on Sculpture*. London: Macdonald, 1966.

"Biographical Notes," *The Times*. London: November 2, 1967.

Writings on Henry Moore

Alloway, L. "Sutherland and Moore," *Art News and Review*. London: no. 9 (1953).

———. Review of *The Archetypal World of Henry Moore* by E. Neumann," *Apollo*. London: vol. 70 (October, 1959).

Argan, G. C. *Henry Moore*. Turin: de Silva, 1948.

Argan, G. C. *Studi e note, XXV, Arte moderna in Inghilterra: H. Moore*. Rome: Bocca, 1955.

Arnheim, R. "The Holes of Henry Moore," *Journal of Aesthetics and Art Criticism*. Baltimore: vol. 7, no. 1 (1948).

Ashton, L. *Sculpture, the New Outline of Modern Knowledge*. London: A. Pryce-Jones, 1956.

Auerbach, A. *Sculpture, a History in Brief*. London: Elek, 1952.

Baro, G. "Bond Street and Battersea," *Arts*. New York: vol. 38 (October, 1963).

Barr, A. H., Jr. *Masters of Modern Art*. New York: Museum of Modern Art, 1954.

Bell, C. "Festina lente," *The Arts*. London: no. 2 (1947).

Bell, G. "Henry Moore," *New Statesman and Nation*. London: November 7, 1936.

Berger, J. "Abandon Hope," *New Statesman*. London: November 5, 1955.

———. "Pre-Naturalism," *New Statesman*. London: May 30, 1959.

———. *Permanent Red*. London: Methuen, 1960.

Boks, J. W. C. "Relief in Brick at the Bouwcentrum in Rotterdam," *Architectural Review*. London: vol. 120 (September, 1956).

Bowness, A. *Moore, Sutherland, Chadwick, Armitage*. Milan: Collezione di Presenze, 1958.

———. "Sculpture in the Ascendant in London Exhibitions," *Arts*. New York: vol. 34 (November, 1959).

———. "The Sculpture of Henry Moore," *Arts*. New York: vol. 34 (February, 1960).

———. "Decade of Moore's Work at Whitechapel," *Arts*. New York: vol. 35 (February, 1961).

———. *Modern Sculpture*. London: Studio Vista, 1965.

Brehm, B. *Das Ebenbild*. Munich: Piper, 1954.

Brion, M. *L'Art abstrait*. Paris: Albin Michel, 1956.

Busch, N. "British Sculptor," *Life*. New York: January 20, 1947.

Campbell, R. "A Sculptor's Themes," *New Statesman*. London: August 20, 1960.

Caro, A. "The Master Sculptor," *The Observer*. London: November 27, 1960.

Cassou, J. *Panorama des arts plastiques contemporains*. Paris: Gallimard, 1960.

Clark, K. "A Madonna by Henry Moore," *Magazine of Art*. Washington: vol. 37 (November, 1944).

———. "Henry Moore's Family Group," in exhibition catalogue. New York: Buchholz Gallery, 1951.

———. "Henry Moore's Metal Sculpture," *Magazine of Art*. Washington, D.C.: vol. 44 (May, 1951).

———. *The Nude*. London: John Murray, 1956; New York, Pantheon, 1956.

Conil-Lacoste, M. "Henry Moore," *Le Monde*. Paris: September 18, 1968.

Cooper, D. "Review of Sculptures and Drawings," *Horizon*. London: no. 60 (1944).

Danz, L. *Dynamic Dissonance*. New York: Farrar, Strauss, and Young, 1952.

Degand, L. "Henry Moore," *Art d'Aujourd'hui*. Paris: no. 4 (1949).

Delevoy, R. *Dimensions of the 20th Century*. Geneva: Skira, 1965.

Devree, H. "Moore's Sculpture," *The New York Times*. November 7, 1954.

Digby, G. W. *Meaning and Symbol in Three Modern Artists*. London: Faber, 1955.

Evans, M. *The Painter's Object*. London: Howe, 1937.

Falkenstein, C. "Work of Henry Moore," *Art and Architecture*. Los Angeles: vol. 67 (October, 1950).

Farr, D. "Review of *The Archetypal World of Henry Moore* by E. Neumann," *Burlington Magazine*. London: vol. 103 (January, 1961).

Flemming, H. T. *Henry Moore, Katakomben*. Munich: Piper, 1956.

Forma, W. *Five British Sculptors*. New York: Grossman, 1964.

Gaunt, W. *The Observer's Book on Sculpture*. London: F. Warne, 1966.

Gertz, U. *Plastik der Gegenwart*. Berlin: Rembrandt, 1953.

Ghiselin, B. *The Creative Process*. Los Angeles: University of California Press, 1952.

Giedion-Welcker, C. *Contemporary Sculpture*. New York: Wittenborn, 1955.

Goldwater, R. "Review of G. Grigson: *Henry Moore*; Herbert Read: *Henry Moore*," *College Art Journal*. New York: vol. VI, no. 1 (1946).

Greenberg, C. "Henry Moore," *The Nation*. New York: February 8, 1947.

Grigson, G. *Henry Moore*. Harmondsworth: Penguin, 1943.

Grigson, G., and Newton, E. "Henry Moore's *Madonna and Child*," *Architectural Review*. London: vol. 95 (1944).

Grigson, G. "Authentic and False in the New Romanticism," *Horizon*. London: no. 99 (1948).

———. *Comment to Henry Moore: Heads, Figures, and Ideas—A Sculptor's Notebook*, 64 facs. London: G. Rainbird, 1958.

Grohmann, W. *The Art of Henry Moore*. London: Thames and Hudson, 1960; New York: Abrams, 1960.

———. *The Art of Our Time*. London: Thames and Hudson, 1967.

Hall, D. "An Interview with Henry Moore," *Horizon*. New York: no. 2 (1960).

———. *The Life and Work of a Great Sculptor: Henry Moore*. New York: Harper and Row, 1965.

Hamilton, G. H. *Painting and Sculpture in Europe, 1880–1940*. Harmondsworth: Penguin, 1967.

Hammacher, A. *Modern English Sculpture*. London: Thames and Hudson, 1967.

———. *Barbara Hepworth*. London: Thames and Hudson, 1968.

———. Catalogue introduction to an exhibition of Moore. Otterlo: Rijksmuseum Kröller-Müller, 1968.

Haskell, A. L. *Black and White*. London: Barker, 1933.

Hedgecoe, J. *Henry Moore*. New York: Simon and Schuster, 1968.

Hendy, P. "Henry Moore," *Horizon*. London: no. 21 (1941).

———. "Henry Moore," *Britain Today*. London: no. 106 (1945).

———. "Henry Moore," *Art d'Aujourd'hui*. Paris: no. 4 (1949).

———. "Humanism and Wild Ones," *New Statesman*. London: December 13, 1958.

Hodin, J. P. *The Dilemma of Being Modern*. London: Routledge, 1956.

———. *Henry Moore*. London: Zwemmer, 1958.

———. "The Avant-Garde of English Sculpture and the Liberation from the Liberators," *Quadrum*. Brussels: no. 18 (1965).

Hofmann, W. *Die Plastik des XXten Jahrhunderts*. Frankfurt am Main: Fischer, 1958.

———. *Henry Moore, Schriften und Skulpturen*. Frankfurt am Main: Fischer, 1959.

Hoffmann, E. "Sculpture at Battersea Park," *Burlington Magazine*. London: vol. X (July, 1948).

Hogarth, W. "Henry Moore," *Architectural Review*. London: vol. 108 (August, 1950).

James, P., ed. *Henry Moore on Sculpture*. London: Macdonald, 1966.

Jarvis, A. "Henry Moore's Sculpture in Canada," *Canadian Art*: vol. 16 (May, 1959).

Jianou, I. *La Sculpture et les sculpteurs*. Paris: F. Nathan, 1967.

———. *Henry Moore*. New York: Tudor, 1968.

Lake, C. "Henry Moore's World," *Atlantic Monthly*. Boston: vol. 209, no. 1 (1962).

Lambert, R. S. *Art in England*. Harmondsworth: Penguin, 1938.

Langsner, J. "Henry Moore, Sculptor in the English Tradition," *Arts and Architecture*: vol. 85 (August, 1958).

Le May, R. "Henry Moore," *Studio*. London: vol. 142 (December, 1951).

Levy, M. "Henry Moore: Sculpture against the Sky," *Studio International*. London: vol. 167 (May, 1964).

Lewis, D. "Moore and Hepworth," *College Art Journal*. New York: vol. 14 (Summer, 1955).

Licht, F. *Sculpture, 19th and 20th Centuries*. London: Michael Joseph, 1967.

Limbour, G. "Deux Sculpteurs—Henry Moore, Adam," *Les Temps Modernes*. Paris: no. 51 (1950).

Man, F. *Eight European Artists*. London: Heinemann, 1954.

Mathews, D. "Sculptures and Drawings by Henry Moore," *Art News and Review*. London: no. 7 (1951).

Melville, R. "Henry Moore and the Siting of Public Sculpture," *Architectural Review*. London: vol. 15 (February, 1954).

———. "New Pieces on View at Hanover," *Architectural Review*. London: vol. 124 (October, 1958).

———. "Henry Moore: the Recent Sketchbook," *Graphis*. Zurich: vol. 15 (September–October, 1959).

———. "Exhibition at Marlborough Fine Art," *Architectural Review*. London: vol. 126 (August, 1959).

———. "Moore's *Glenkiln Cross*," *Architectural Review*. London: vol. 128 (September, 1960).

———. "Two Divided Reclining Figures in Bronze at Whitechapel Art Gallery," *Architectural Review*. London: vol. 129 (March, 1961).

———. "Moore at Lynn," *Architectural Review*. London: vol. 136 (November, 1964).

———. *Henry Moore, Sculpture and Drawings, 1921–1969*. New York: Abrams, 1970.

Middleton, M. "Henry Moore," *L'Oeil*. Paris: March 3, 1955.

Morse, J. D. "Moore Comes to America," *Magazine of Art*. Washington, D.C.: vol. 40 (March, 1947).

Motherwell, R. "Henry Moore," *New Republic*. New York: October 22, 1945.

Muller, J. E. *L'Art au XXe siècle*. Paris: Larousse, 1967.

Mullins, E. "The Open-Air Vision: A Survey of Sculpture in London since 1945," *Apollo*. London: vol. 77 (August, 1962).

Mundt, E. "King and Queen," in *Art and Artist*. Berkeley and Los Angeles: University of California Press, 1956.

Negri, M. "Henry Moore," *Domus*. Milan: no. 310 (September, 1955).

Neumann, E. *The Archetypal World of Henry Moore*, Bollingen Series 68. New York: Pantheon, 1959; London: Routledge, 1959.

Newton, E. "Henry Moore's *Madonna and Child* for St. Matthew's, Northampton," *Architectural Review*. London: vol. 95 (May, 1944).

————. *In My View*. London: Longmans Green, 1954.

————. "Henry Moore, Ex-revolutionary," *The New York Times Magazine*: no. 6, 1956.

Onslow-Ford, G. "The Wooden Giantess of Henry Moore," *London Bulletin*: nos. 18–20 (1940).

Oxenaar, R. W. D. *Sculptures of the Rijksmuseum Kröller-Müller*. Otterlo: 1966.

Penrose, R. "Henry Moore: Reclining Figures," *Quadrum*. Brussels: no. 6 (1959).

————. Catalogue introduction to an exhibition of Moore organized by the British Council. Paris: 1961.

Pevsner, N. "Thoughts on Henry Moore," *Burlington Magazine*. London: vol. 86 (February, 1945).

————. *The Englishness of English Art*. London: Architectural Press, 1950.

Piper, M. "Back in the Thirties," *Art and Literature*. London: no. 7 (1965).

Ramsden, E. H. *Twentieth Century Sculpture*. London: Pleiades, 1949.

————. *Theme and Variations Towards a Contemporary Aesthetic*. London: Lund and Humphries, 1953.

Read, H. *Henry Moore, Sculptor*. London: Zwemmer, 1934.

————. *Henry Moore, Sculpture and Drawings*, 3 vols. London: Lund and Humphries, 1944–65.

————. Catalogue introduction to the exhibition of Henry Moore organized by the British Council. Paris: 1949; Amsterdam and Bern: 1950.

————. *The Philosophy of Modern Art*. London: Faber, 1952; New York: Horizon Press, 1953.

————. "A Sculptor's Landscape," *The Painter and the Sculptor*: vol. 1, no. 2 (1958).

————. "Trois Sculpteurs anglais," *XXe Siècle*. Paris: no. 21 (1959).

————. *The Forms of Things Unknown*. London: Faber, 1960.

————. *The Art of Sculpture*, Bollingen Series 35. New York: Pantheon, 1961.

————. *A Concise History of Modern Sculpture*. London: Thames and Hudson, 1964; New York: Praeger, 1968.

————. *Contemporary British Art*. Harmondsworth: Penguin, 1964.

————. "Art and Idea," Catalogue introduction to Henry Moore exhibition. Philadelphia College of Art, 1965.

————. *Henry Moore: A Study of His Life and Work*. New York: Praeger, 1965.

————. *The Origin of Forms*. London: Thames and Hudson, 1965.

————. "The Art of Henry Moore," *Sculpture International*: no. 1 (1966).

Reichardt, J. "Henry Moore at the New London Gallery," *Apollo*. London: vol. 75 (August, 1961).

Richter, G. "Introduction to Henry Moore," *Art in America*. New York: vol. 35 (January, 1947).

Ritchie, A. C. *Sculpture of the Twentieth Century*. New York: Museum of Modern Art, 1953.

Robertson, B. Catalogue introduction to an exhibition of Henry Moore. London: Whitechapel Art Gallery, 1960.

Rothenstein, J. *Modern English Painters: Lewis to Moore*. London: Eyre and Spottiswood, 1956.

Rothenstein, W. *Since Fifty: Men and Memories, 1922–1938*. London: Faber, 1939.

Russell, J. *From Sickert to 1948*. London: Lund and Humphries, 1948.

————. "Sculpture Renaissance," *Art in America*. New York: vol. 48 (Summer, 1960).

————. "Mooresday," *Art News*. New York: vol. 59 (January, 1961).

————. Foreword for *Henry Moore, Wood and Stone Carvings at Marlborough Fine Art*. London: 1961.

————. Catalogue introduction for Moore exhibition. New York: Knoedler Gallery, 1962.

————. *Henry Moore*. Harmondsworth: Penguin, 1968; New York: Putnam, 1968.

Sackville-West, E. "A Sculptor's Workshop, Notes on a New Figure by Henry Moore," *The Arts*. London: no. 1, 1946.

Savage, S. A. "Art for Investment," *Studio*. London: vol. 162 (July, 1961).

Seldis, H. J. "Henry Moore," *Art in America*. New York: vol. 51 (October, 1963).

Selz, J. *Modern Sculpture*. New York: Braziller, 1963.

Seuphor, M. *The Sculpture of this Century*. New York: Braziller, 1960.

Shaeffer-Simmern, H. *Sculpture in Europe Today*. London: Berkeley, 1956.

Strachan, W. J. "Henry Moore's UNESCO Statue," *The

Studio. London: vol. 156 (December, 1958).

Strauss, M. "Sculpture at the Whitechapel Gallery," *Burlington Magazine.* London: vol. 103 (January, 1961).

Sutton, D. "Henry Moore and the English Tradition," *Kingdom Come.* Oxford: vol. 2, no. 2 (1940–41).

———. "Henry Moore, a Sculptor's Vision," *The New York Times*: March 23, 1959.

Sweeney, J. J. *Henry Moore.* New York: Museum of Modern Art, 1946.

Sweeney, J. J. "Interview with Henry Moore," *Partisan Review.* New York: vol. XIV, no. 2 (1947).

Sylvester, D. "The Evolution of Henry Moore's Sculpture," *Burlington Magazine.* London: vol. 90 (July, 1948).

———. "Sculptures and Drawings by Henry Moore," Catalogue introduction. London: Tate Gallery, 1951.

———. "Henry Moore's Sculptures," *Britain Today.* London: no. 215, 1954.

———. *Henry Moore*, catalogue. London: Tate Gallery, 1968; New York: Praeger, 1968.

Thompson, D. "Recent British Sculpture," in catalogue of exhibition organized by the British Council for Canada, Australia, and New Zealand, 1961.

Thwaites, J. A. "Notes on Some English Sculptors," *Art Quarterly.* Detroit: vol. 15, no. 1 (1952).

Tillim, S. "Exhibition at Knoedler," *Arts.* New York: vol. 36 (May, 1962).

Trier, E. *Form and Space: Sculpture of the Twentieth Century.* New York: Praeger, 1968.

Valier, D. *L'Art abstrait.* Paris: Librairie Générale Française, 1967.

Valentiner, W. R. *Origins of Modern Sculpture.* New York: Wittenborn, 1946.

Volboudt, P. "Moore," *XXe Siècle.* Paris: June, 1957.

Walter, S. *Henry Moore.* Kenlen: Walter, 1955.

Wheldon, H. *Monitor, An Anthology.* London: Macdonald, 1962.

Whittet, G. B. "Three Works in Masters of Modern Art Exhibition," *Studio.* London: vol. 160 (September, 1960).

Whittick, A. "Epstein and Moore," *Building.* London: April, 1942.

———. "British Sculpture Today," *Commemorative Art*: April, 1965.

Wight, F. "Henry Moore: The Reclining Figure," *Journal of Aesthetics and Criticism.* Baltimore: vol. 6, no. 2 (1947).

Wilenski, R. H. "Ruminations on Sculpture and the Work of Henry Moore," *Apollo.* London: vol. 12 (December, 1930).

Illustrations

27. *Figure* 1933—Corshill stone, 29½ in.—Collection Carlo Ponti and Sophia Loren

28. *Two Forms* 1934—oak, 20¾ in.—New York, The Museum of Modern Art

29. *Two Forms* 1934—oak, 20¾ in.—New York, The Museum of Modern Art

30. *Two Forms* 1934—oak, 20¾ in. New York, The Museum of Modern Art

31. *Two Forms* 1934—oak, 20¾ in.—New York, The Museum of Modern Art

32. *Studies for Composition in Two Pieces* 1934—pastel and watercolor, 15 × 22 in.—Otterlo, Rijksmuseum Kröller-Müller

33. *Notebook Page* (sketches of reclining figures) 1935—pencil and pastel, 5⅜ × 8⅜ in.—Much Hadham, Collection the artist

34. *Four-Piece Composition: Reclining Figure* 1934—Cumberland alabaster, 20 in.—New York, Collection Martha Jackson

35. *Sculpture* 1935—21⅝ in.—Art Institute of Chicago

36. *Reclining Figure* 1936—elm, 42 in.—Wakefield, England, City Art Gallery and Museum

37. *Reclining Figure* 1936—elm, 21⅝ in.—Wakefield, England, City Art Gallery and Museum

38. *Mother and Child* 1936—Lancaster stone, 20 in.—London, British Council

39. *Four Forms* 1936—African wonder stone, 22 in.—Bloomington, Indiana, Collection Henry R. Hope

40. *Square Form* 1936—green Hornton stone, 15¾ in.—London, Collection Sir Robert and Lady Sainsbury

41. *Landscape with Stones* 1936—pen and wash, 22 × 15 in.—Private collection

42. *Figures in a Cave* 1936—pastel and wash, 14⅞ × 21⅝ in.—Much Hadham, Collection the artist

43. *Reclining Figure* 1937—Hopton-wood stone, 20 in.—Pomfret, Connecticut, Collection Lois Orswell

44. *Figure* 1937—Bird's eye marble, 20 in.—St. Louis, City Art Museum

45. *Stringed Relief* 1937—beech and string, 19 in.—Sweden, Collection Bo Boustedt

46. *Head* 1938—elm and string, 8 in.—London, Collection Erno Goldfinger Esq.

47. *Stringed Figure* 1938—bronze (edition of 10 in 1960), 13⅛ × 10⅞ in.—Private collection

48. *Reclining Figure* 1938—lead, 13 in.—New York, The Museum of Modern Art

49. *Recumbent Figure* 1938—green Hornton stone, 55 in.—London, Tate Gallery

50. *Study for Plate 48*—1938—pen and watercolor, 15 × 22 in.—London, Miss Isabel Walker

51. *Drawing for Sculpture* 1938—pastel and watercolor, 15 × 22 in.—Private collection

52. *Reclining Figure* 1939—elm, 81 in.—Detroit Institute of Arts

53. *Reclining Figure* 1939—elm, 81 in.—Detroit Institute of Arts

54. *Reclining Figure* 1939—detail, elm, 81 in.—Detroit Institute of Arts

55. *Reclining Figure* 1939—detail, elm, 81 in.—Detroit Institute of Arts

56. *Two Sleepers* 1941—pastel and watercolor, 14⅞ × 21⅝ in.—Chicester (Sussex), Collection Rev. Walter Hussey

57. *Underground Shelter* 1941—pen and watercolor, 14⅞ × 21⅝ in.—London, Tate Gallery

58. *Stringed Figure* 1939—lead and wire, 10 in.—Much Hadham, Collection Irina Moore

59. *Bird Basket* 1939—lignum vitae and string, 16½ in.—Much Hadham, Collection Irina Moore

60. *Bird Basket* 1939—lignum vitae and string, 16½ in.—Much Hadham, Collection Irina Moore

61. *Ideas for Sculpture in Metal* 1939—pen and watercolor, 10 × 16¾ in.—New York, Collection Mrs. Benjamin Watson

62. *Two Women* 1939—watercolor, 17½ × 15 in.—Kent, Collection Lord Clark of Saltwood

63. *Ideas for Metal and Wire Sculpture* 1939—pen and watercolor, 11 × 15 in.—Private collection

100. *Standing Figure* 1950—bronze, 87 in.—Dumfries, Collection W. J. Keswick, Shawhead, Scotland

101. *Animal Head* 1951—bronze (edition of 8), 11¾ in. —Private collection

102. *Upright Internal Form: Flower* 1951—bronze (edition of 6), 22½ in.—Private collection

103. *Reclining Figure: Internal and External Forms* 1951—bronze (edition of 8), 21 in.—Hannover, Niedersächsisches Landesmuseum

104. *Reclining Figure* 1951—bronze (edition of 5), 88⅝ in.—Paris, Musée National d'Art Moderne

105. *Reclining Figure* 1951—model for the bronze (edition of 5), 88⅝ in.—Paris, Musée National d'Art Moderne

106. *Figure No. 3*—1952—bronze (edition of 11), 19 in. —Madrid, Museo Español de Arte Contemporáneo

107. *Figure No. 4*—1952—bronze (edition of 11), 19 in. —Madrid, Museo Español de Arte Contemporáneo

108. *Mother and Child on Ladderback Chair* 1952—bronze (edition of 7), 16 in.—Hull, Ferens Art Gallery

109. *Goat's Head* 1952—bronze (edition of 10), 8 in.—Private collection

110. *Screen—Time-Life*—model, bronze, 39¼ in.—London, Time-Life Building

111. *Reclining Figure* 1952–53—bronze (edition of 3), 68 × 100⅜ in.—London, Time-Life Building

112. *Reclining Figure* 1952–53—bronze (edition of 3), 68 × 100⅜ in.—London, Time-Life Building

113. *King and Queen* 1952–53—detail of the plaster (bronze in edition of 5), 64½ in.—Dumfries, W. J. Keswick, Shawhead, Scotland

114. *King and Queen* 1952–53—bronze, 64½ in.—Dumfries, W. J. Keswick, Shawhead, Scotland

115. *King and Queen* 1952–53—bronze, 64½ in.—Dumfries, W. J. Keswick, Shawhead, Scotland

116. *Three Standing Figures* 1953—bronze (edition of 8), 28 in.—Hamburg, Kunsthalle

117. *Warrior's Head* 1953—bronze (edition of 8), 10 in. —Rio de Janeiro, Museu de Arte Moderna

118. *Draped Torso* 1953—bronze (edition of 4), 35 in.—Hull, Ferens Art Gallery

119. *Reclining Figure: External Form* 1953–54—bronze (edition of 6), 84 in.—Rome, Museo Nazionale d' Arte Moderna

120. *Warrior with Shield* 1953–54—detail, bronze (edition of 5), 60 in.—Arnhem, Holland

121. *Warrior with Shield* 1953–54—detail, bronze, 60 in. —Arnhem, Holland

122. *Family Group* 1954–55—detail, Hadene stone, 64½ in.—Harlow New Town, England, Harlow Art Trust

123. *Family Group* 1954–55—Hadene stone, 64½ in.—Harlow New Town, England, Harlow Art Trust

124. *Wall Relief* 1955—brick, 28½ × 63 ft.—Rotterdam, Bouwcentrum

125. *Wall Relief* 1955—model for bronze (edition of 10), 12⅞ × 18¾ in.—Private collection

126. *Wall Relief* 1955—model for bronze (edition of 12), 9⅞ × 22⅛ in.—Private collection

127. *Wall Relief* 1955—detail, brick, 28½ × 63 ft.—Rotterdam, Bouwcentrum

128. *Upright Motive No. 8*—1955–56—bronze (edition of 7), 78 in.—Cardiff, National Museum of Wales

129. *Reclining Figure* 1956—bronze (edition of 8), 94½ in.—Perth, Western Australian Art Gallery

130. *Animal Head* 1956—bronze (edition of 10), 21⅝ in. —Otterlo, Rijksmuseum Kröller-Müller

131. *Animal Head* 1956—bronze (edition of 10), 21⅝ in. —Otterlo, Rijksmuseum Kröller-Müller

132. *Mother and Child* 1956—detail, bronze (edition of 10), 21⅝ in.—Dorset, Collection Poole College

133. *Mother and Child* 1956—bronze (edition of 10), 21⅝ in.—Dorset, Collection Poole College

134. *Mother and Child* 1956—bronze (edition of 12), 7⅞ in.—Private collection

135. *Falling Warrior* 1956–57—bronze (edition of 10), 58 in.—Liverpool, Walker Art Gallery

136. *Falling Warrior* 1956–57—bronze (edition of 10), 58 in.—Liverpool, Walker Art Gallery

137. *Seated Figure Against Curved Wall* 1956–57—bronze (edition of 10), 31½ in.—London, Arts Council of Great Britain

138. *Seated Woman with Crossed Feet* 1957—bronze (edition of 6), cast 1963, 7½ in.—Private collection

139. *Reclining Figure* 1957—bronze (edition of 12), 27½ in.—Private collection

140. *Reclining Figure* 1957—bronze (edition of 12), 27½ in.—Private collection

141. *Three-Part Object* 1960—bronze (edition of 9), 48½ in.—New York, Collection Mr. and Mrs. Albert List

142. *Sculptural Object* 1960—bronze (edition of 10), 18¼ in.—London, Arts Council of Great Britain

143. *Girl Seated Against Wall* 1957–58—bronze (edition of 12), 40 in.—Private collection

144. *Seated Woman* 1957–58—bronze (edition of 8), 60 in.—Vienna, Museum des XX Jahrhunderts

145. *Seated Woman* 1957—bronze (edition of 6), 57 in. —New York, Collection Joseph H. Hirshhorn

146. *Seated Woman* 1957–58—bronze (edition of 6), 71⅞ in.—Wuppertal, Germany

147. *Seated Woman* 1957–58—detail, bronze, 71⅞ in.— Wuppertal, Germany

148. *Reclining Woman* 1957–58—bronze (edition of 6), 80¾ × 52¼ in.—Stuttgart, Bundestag von Baden

149. *Reclining Woman* 1957–58—detail, bronze, 80¾ × 52¼ in.—Stuttgart, Bundestag von Baden

150. *Reclining Woman* 1957–58—detail, bronze, 80¾ × 52¼ in.—Stuttgart, Bundestag von Baden

151. *Seated Woman* 1959—pastel and gouache, 11¼ × 9¼ in.—Private collection

152. *Relief No. 1*—1959—bronze (edition of 6), 88 in.— Berlin, Private collection

153. *Two-Piece Reclining Figure No. 1*, 1959—bronze (edition of 6), 76 in.—Duisburg, Lehmbruck Museum

154. *Two-Piece Reclining Figure No. 1*, 1959—bronze (edition of 6), 76 in.—Duisburg, Lehmbruck Museum

155. *Three Motives Against Wall No. 1*, 1959—bronze (edition of 12), 42 in.—New York, The Museum of Modern Art

156. *Horse* 1959—bronze (edition of 2), 7½ in.—Much Hadham, Collection Mary Moore

157. *Seated Figures Against a Wall* 1960—bronze (edition of 12), 18¾ in.—Private collection

158. *Square Head* 1960—bronze (edition of 9), 11 in.— Private collection

159. *Square Head* 1960—bronze (edition of 9), 11 in.— Private collection

160. *Two-Piece Reclining Figure No. 2*, 1960—bronze (edition of 7), 100 × 79¾ in.—London, Tate Gallery

161. *Two-Piece Reclining Figure No. 2*, 1960—bronze (edition of 7), 100 × 79¾ in.—London, Tate Gallery

162. *Upright Figure* 1956–60—elm, 9 ft.—New York, The Solomon R. Guggenheim Museum

163. *Reclining Mother and Child* 1960–61—detail, bronze (edition of 7), 86½ in.—Minneapolis, Walker Art Center

164. *Reclining Mother and Child* 1960–61—bronze, 86½ in.—Minneapolis, Walker Art Center

165. *Two Reclining Figures* 1961—pastel, watercolor and gouache, 11½ × 9½ in.—Much Hadham, Collection the artist

166. *Two Figures* 1961—pastel and gouache, 11½ × 9½ in.—Private collection

167. *Two-Piece Reclining Figure No. 3*, 1961—bronze (edition of 7), 94 in.—Gothenburg, Sweden

168. *Two-Piece Reclining Figure No. 3*, 1961—bronze (edition of 7), 94 in.—Gothenburg, Sweden

169. *Two-Piece Reclining Figure No. 3*, 1961—bronze (edition of 7), 94 in.—Gothenburg, Sweden

170. *Two-Piece Reclining Figure No. 4*, 1961—bronze

(edition of 7), 43 in.—Amsterdam, Stedelijk Museum

171. *Seated Woman* 1961—bronze (edition of 7), 64 in. —Newcastle-upon-Tyne, Laing Municipal Art Gallery and Museum

172. *Three-Piece Reclining Figure No. 1*, 1961–62—bronze (edition of 7), 113 in.—Montreal, National Bank of Canada

173. *Three-Piece Reclining Figure No. 1*, 1961–62—bronze (edition of 7), 113 in.—Montreal, National Bank of Canada

174. *Standing Figure: Knife-edged* 1961—bronze (edition of 7), 112 in.—Essen, Germany

175. *Standing Figure: Knife-edged* 1961—bronze (edition of 7), 112 in.—Essen, Germany

176. *The Wall: Background for Sculpture* 1962—bronze (edition of 2), 84 in.—Much Hadham, Collection the artist

177. *Large Torso: Arch* 1962–63—bronze (edition of 6), 78 in.—New York, The Museum of Modern Art·

178. *Three-Piece Reclining Figure No. 2*, 1963—bronze (edition of 6), 99 in.—Leeds, City Art Gallery

179. *Three-Piece Reclining Figure No. 2*, 1963—detail, bronze, 99 in.—Leeds, City Art Gallery

180. *Helmet Head No. 4*—1963—bronze (edition of 6), 18¾ in.—Syracuse, New York, Everson Museum of Art

181. *Divided Head* 1963—bronze (edition of 9), 13¾ in. —Zurich, Kunsthaus

182. *Reclining Figure* 1963 (model for the Lincoln Center Sculpture)—bronze (edition of 2), 168 in.— New York, Collection Mr. and Mrs. Albert List

183. *Two-Piece Reclining Figure No. 5*, 1963–64—bronze (edition of 3), 147 in.—Humlebaek, Louisiana Kunstmuseum

184. *Locking Piece* 1963–64—bronze (edition of 3), 115½ in.—Brussels, Banque Lambert

185. *Reclining Figure* 1959–64—elm, 90 in.—Much Hadham, Collection Irina Moore

186. *Reclining Figure* 1959–64—elm, 90 in.—Much Hadham, Collection Irina Moore

187. *Two Forms* 1964—white marble, 18 in.—Chichester, England, Collection Rev. Walter Hussey

188. *Three-way Piece No. 1 Points*—1964–65—bronze (edition of 3), 76 in.—New York, Columbia University

189. *Locking Piece* 1963–64 (model in the garden at Hoglands), 115½ in.—Much Hadham, Collection the artist

190. *Moon Head* 1964—bronze (edition of 9), 22½ in.— Private collection

191. *Sculpture* 1964—white marble, 17 in.—New York, Collection David Rockefeller

192. *Archer* 1964–65—bronze (edition of 2), 128 in.— Toronto, Nathan Phillip Square

193. *Two-Piece Knife Edge* 1962–65—bronze (edition of 3), 144 in.—Vancouver, Queen Elizabeth Park

194. *Atom Piece* 1964–65—bronze (edition of 6), 47 in.— New York, Collection Governor Nelson A. Rockefeller

195. *Three Rings* 1966—red soraya travertine marble, 106 in.—Maryland, Collection Robert Levi

196. *Family Group* 1966—pencil, pen, watercolor, 11½ × 17⅜ in.—Private collection

197. *Two-Piece No. 7: Pipe*, 1966—bronze (edition of 9), 36 in.—Manchester, Whitworth Art Gallery

198. *Interior Form* 1966—bronze (edition of 6), 13 in.— Private collection

199. *Double Oval* 1966—rosa aurora marble, 24 in.— Texas, Collection James Clark

200. *Two Forms* 1966—red soraya travertine marble, 59 in.—Zurich, Collection Staehelin

201. *Girl: Half Figure* 1967—rosa aurora marble, 35 in.— Collection Annenberg

202. *Sculpture with Hole and Light* 1967—red travertine marble, 50 in.—Otterlo, Rijksmuseum Kröller-Müller

203. *Divided Oval: Butterfly* 1967—white marble, 35 in.

Much Hadham, Collection the artist

204. *Heavy Form* 1962–68–bronze (edition of 9), 29¾ in.–Private collection

205. *Two-Piece Carving: Interlocking* 1968–white marble, 27½ in.–Much Hadham, Collection Mary Moore

206. *Two-Piece Carving: Interlocking* 1968–white marble, 27½ in.–Much Hadham, Collection Mary Moore

207. *Model for a Bronze* 1968–(edition of 9), 6 in.–Much Hadham, Collection the artist

208. *Sheep* 1960–68–bronze (edition of 9), 9¼ in.–Private collection

209. *Model for Three-Piece Sculpture: Vertebrae No. 3,* 1968–bronze (edition of 9), 88⅝ in.–New York, Collection Joseph H. Hirshhorn

210. *Model for Oval with Points* 1968–bronze (edition of 10), 43 in.–Private collection

211. *Two-Piece No. 10: Interlocking*—1968–bronze (edition of 7), 36 in.–Private collection

212. *Two-Piece Reclining Figure No. 9*—1968–bronze (edition of 7), 98 in.–Canberra, Australia

213. *Two-Piece No. 10: Interlocking*—1968–bronze (edition of 7), 36 in.–Oslo, Nasjonalgaleriet

214. *Animal* 1969–travertine marble, 47¼ in.–Much Hadham, Collection the artist

215. *Two Forms* 1969–white marble, 34⅞ in.–City of Manchester Art Galleries, England

216. *Torso* 1969–bronze (edition of 12), 25⅝ in.–Private collection

217. *Reclining Figure* 1961–69–yellow travertine marble, 73⅞ in.–London, Collection Sir Max Rayne

218. *Reclining Figure: Arch Leg* 1969–70–bronze (edition of 9), 7¼ in.–Much Hadham, Collection the artist

219. *Reclining Interior: Oval* 1963–69–red travertine marble, 85 in.–Much Hadham, Collection the artist

220. *Model for Two-Piece Reclining Figure* 1969–70–bronze (edition of 9), 5½ in.–Private collection

221. *Model for Two-Piece Reclining Figure* 1969–70–detail, bronze, 5½ in.–Private collection

222. *Two Interlocking Forms* 1969–70–white marble, 138 in.–Much Hadham, Collection the artist

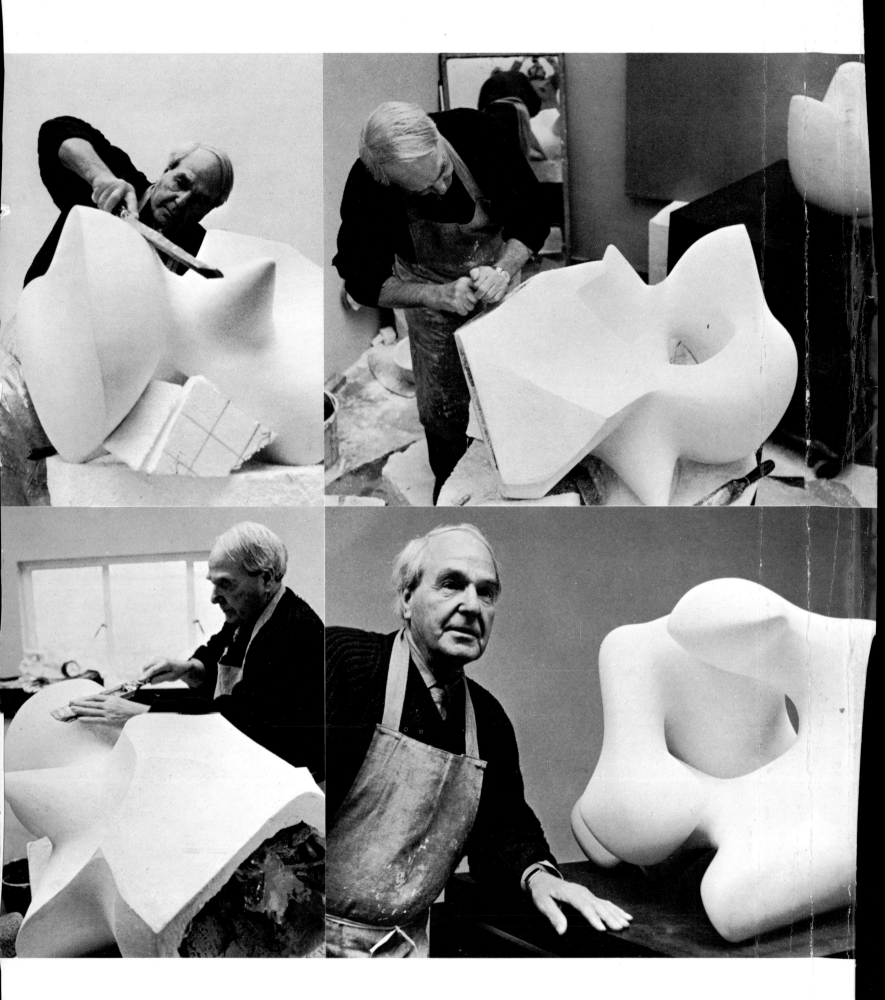

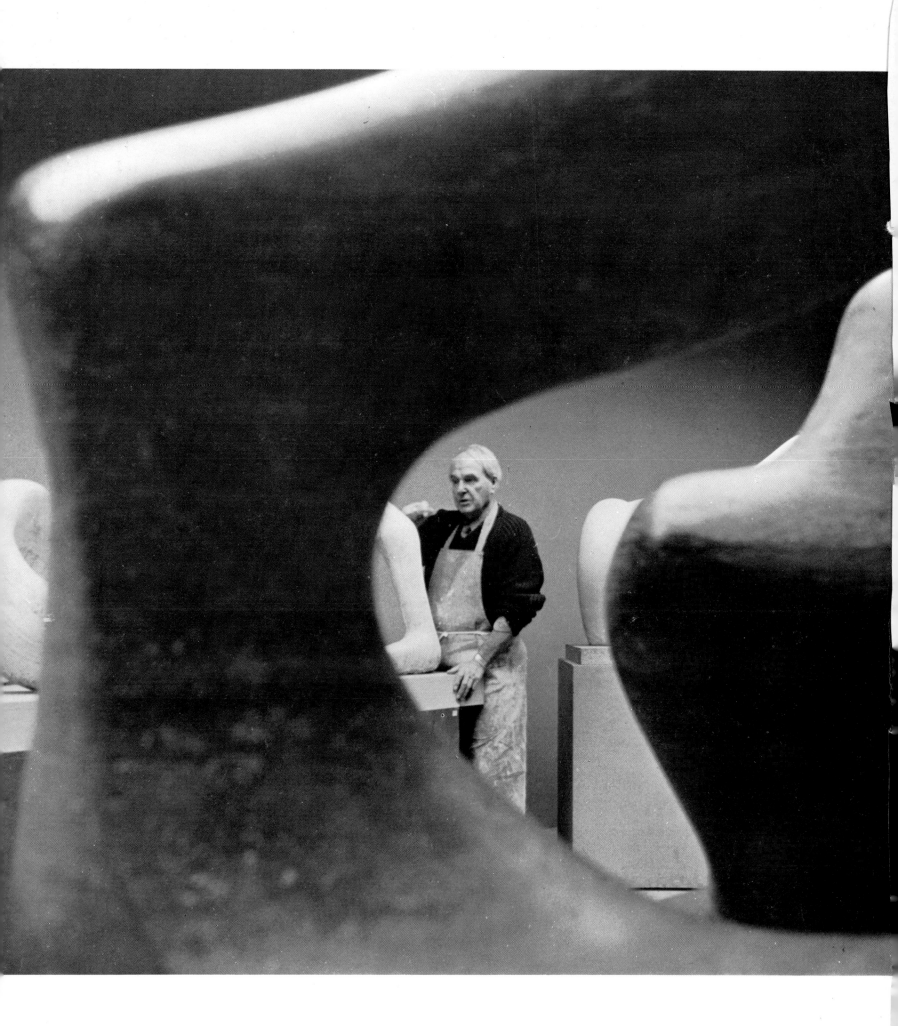

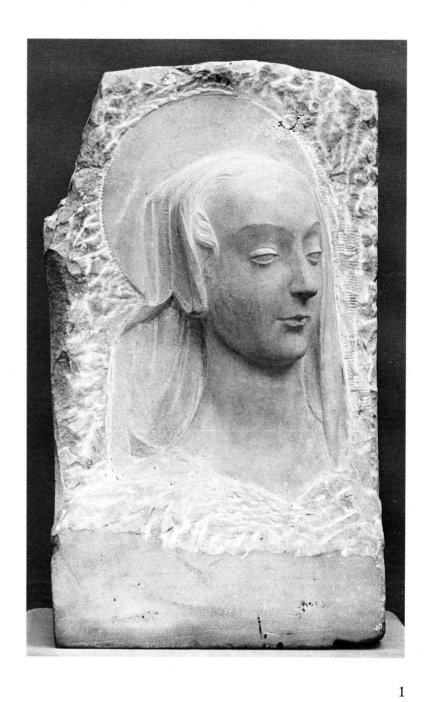

1

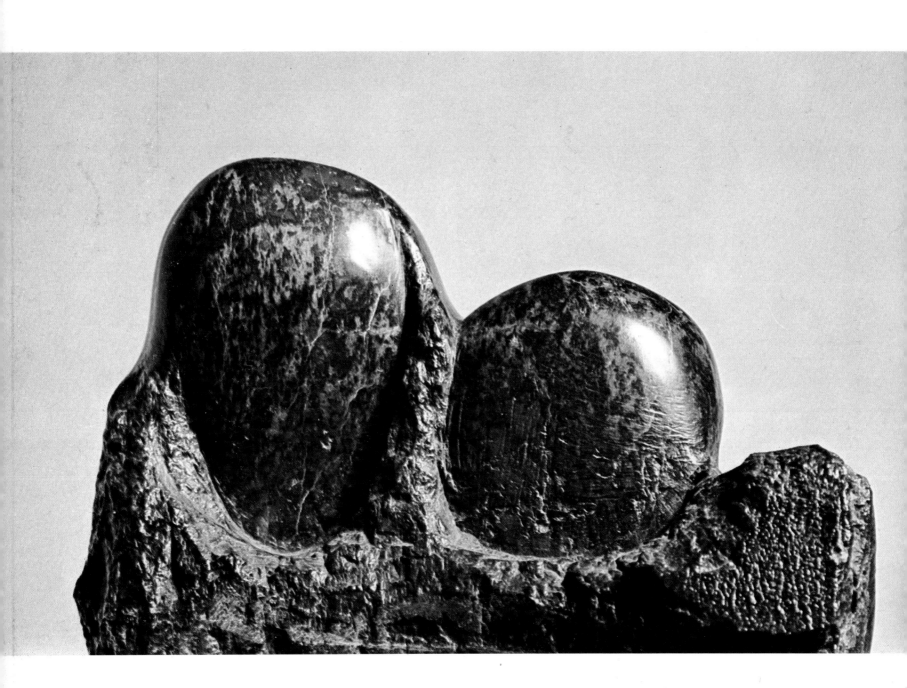

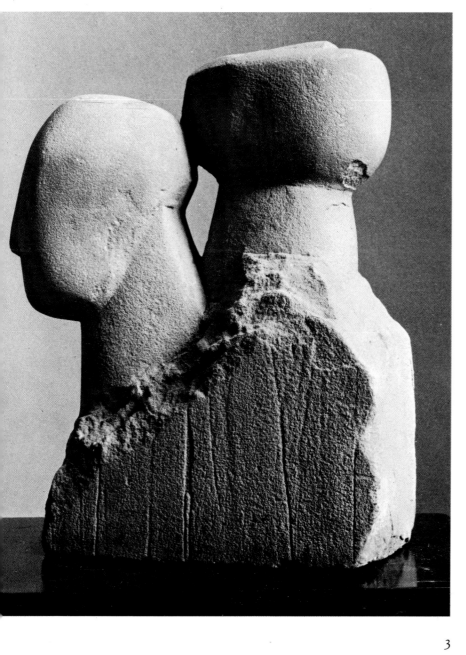

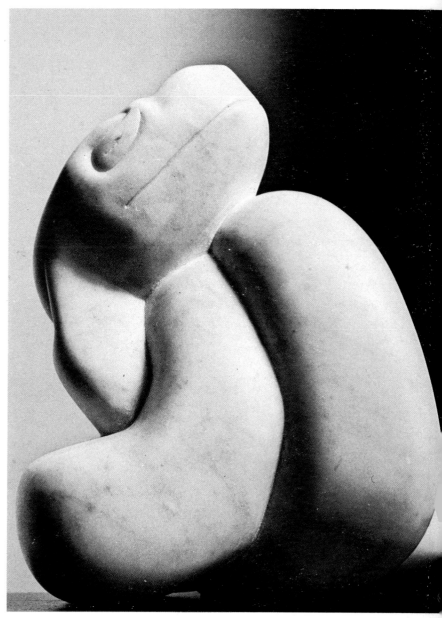

3

4

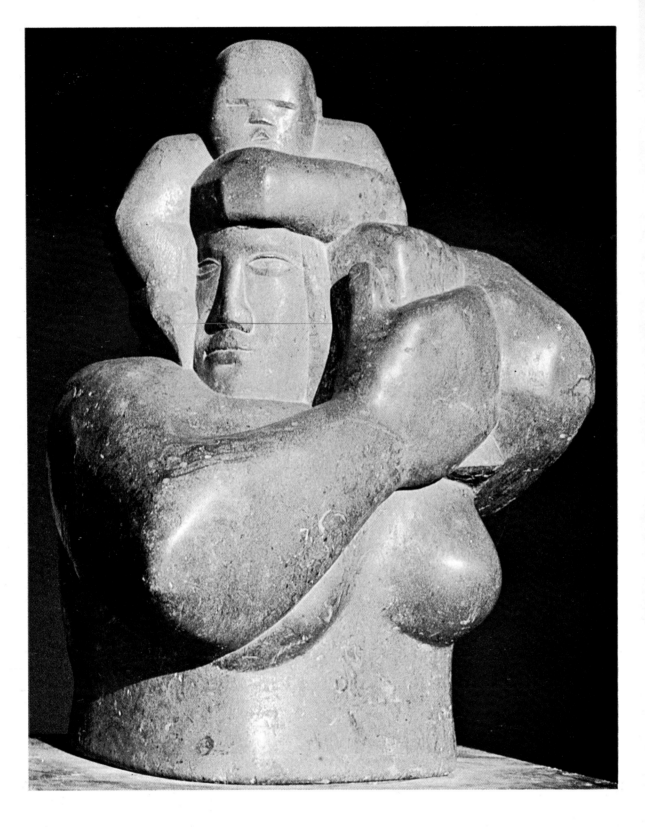

5
6

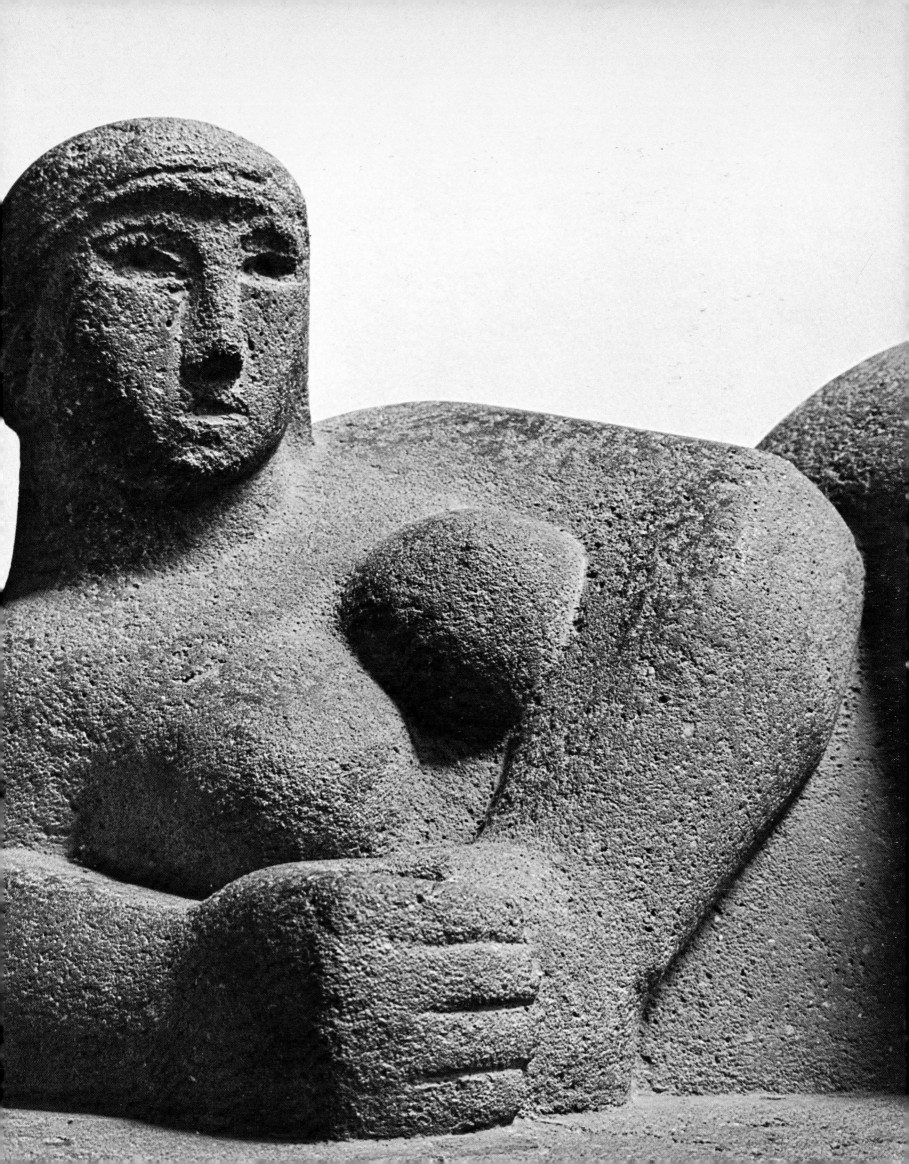

7

8

9

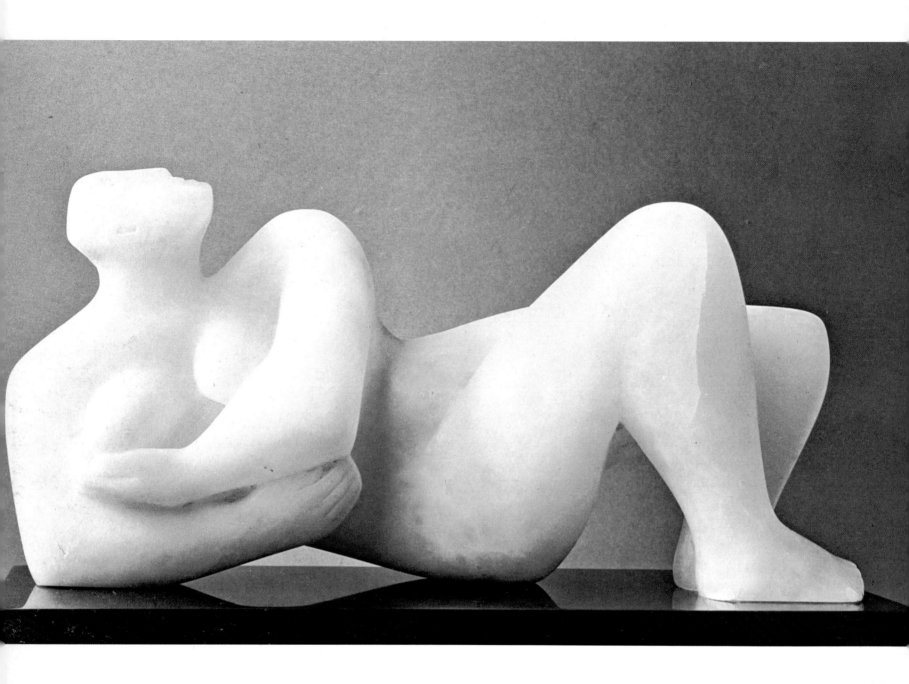

10

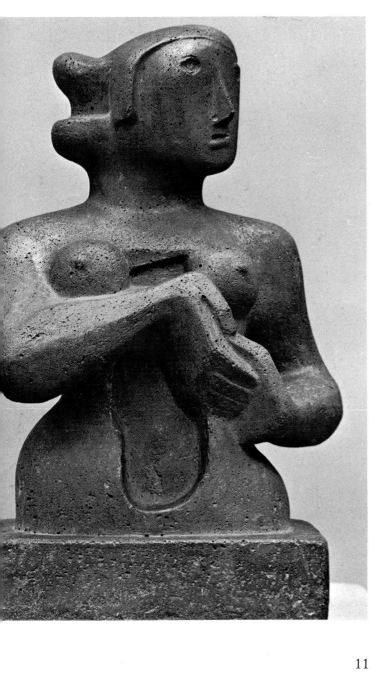

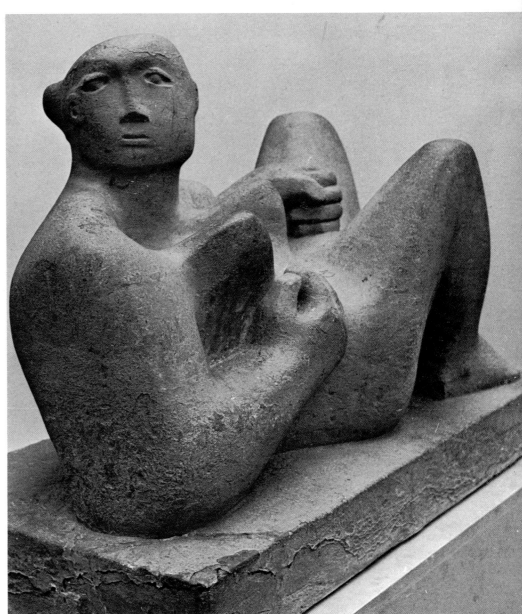

11 12

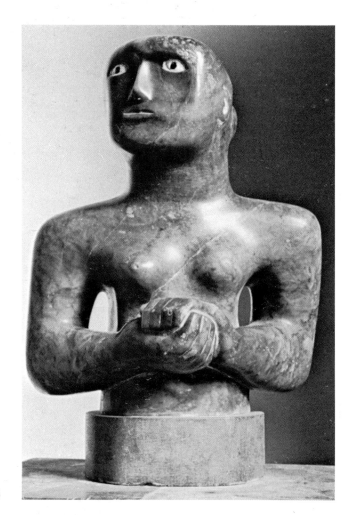

13

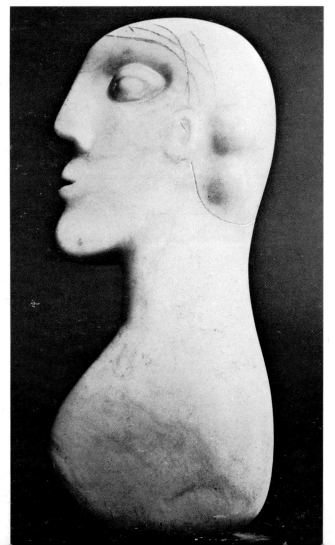

14

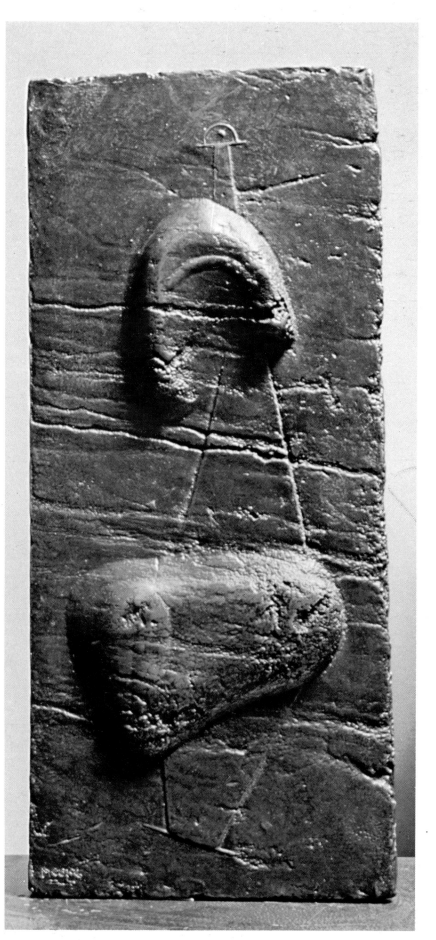

15

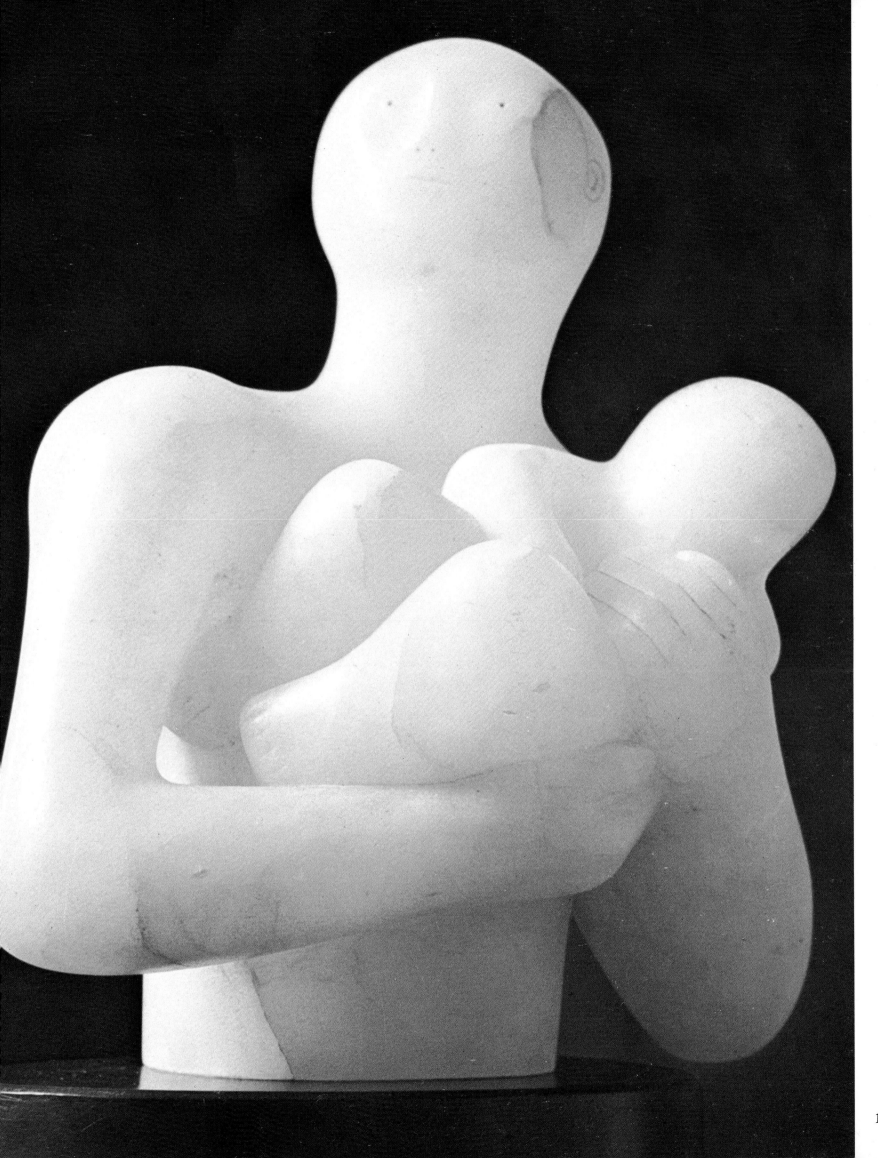

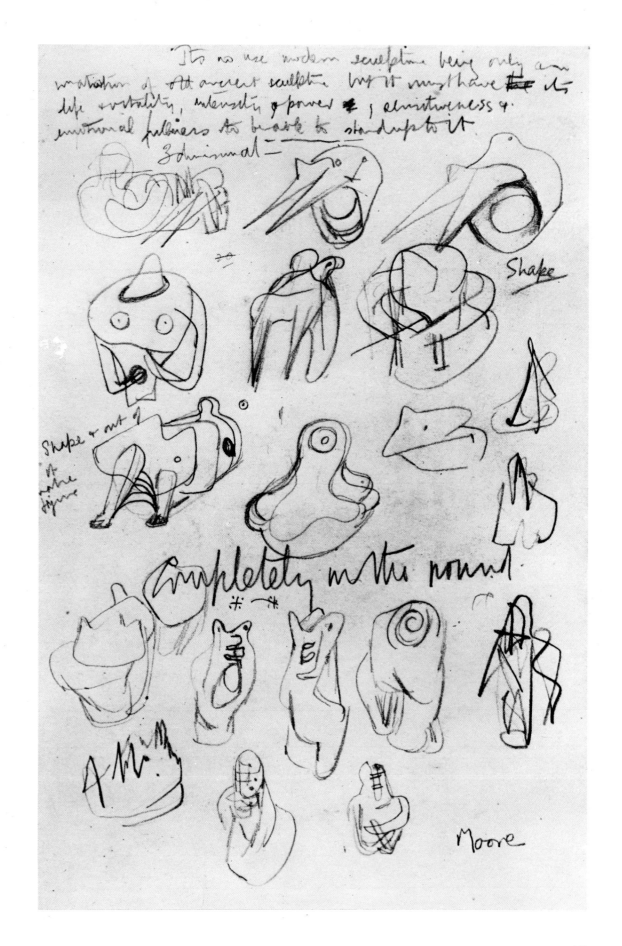

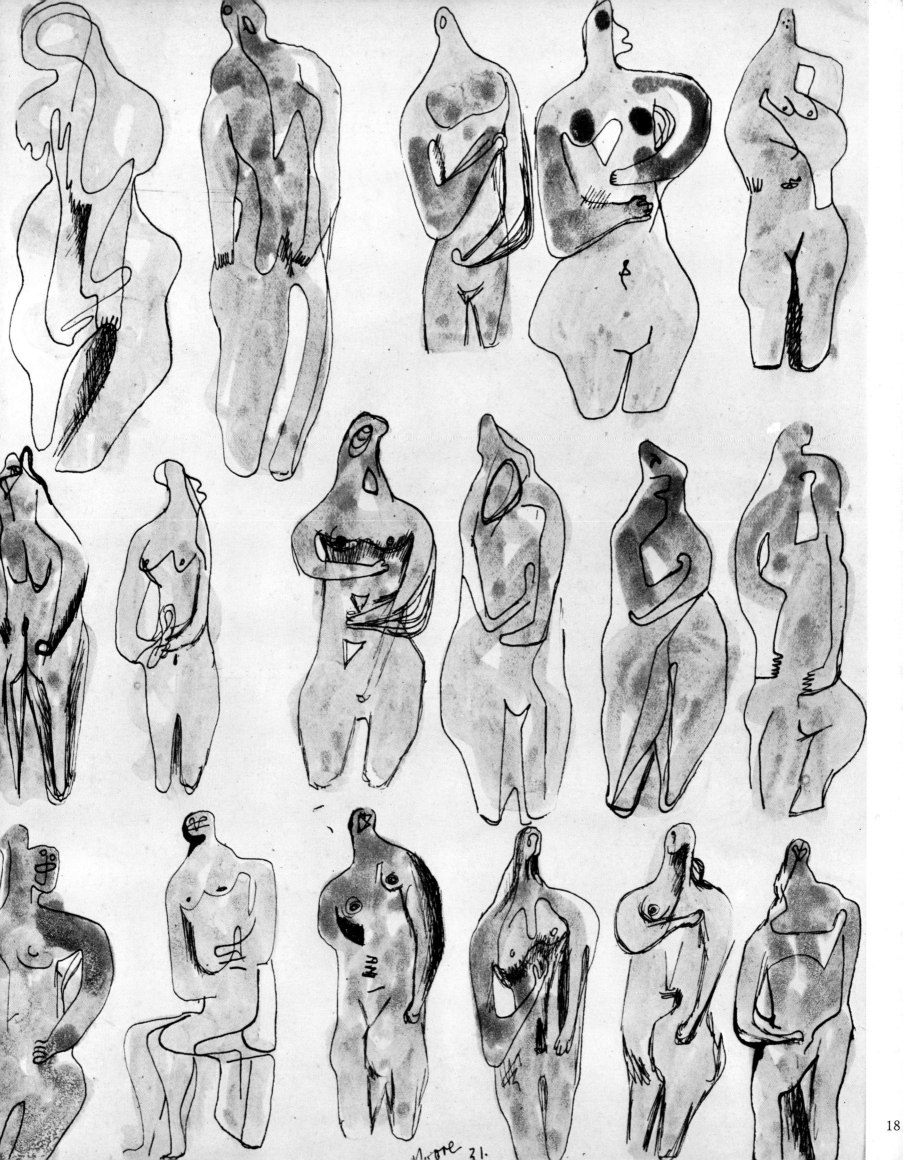

18

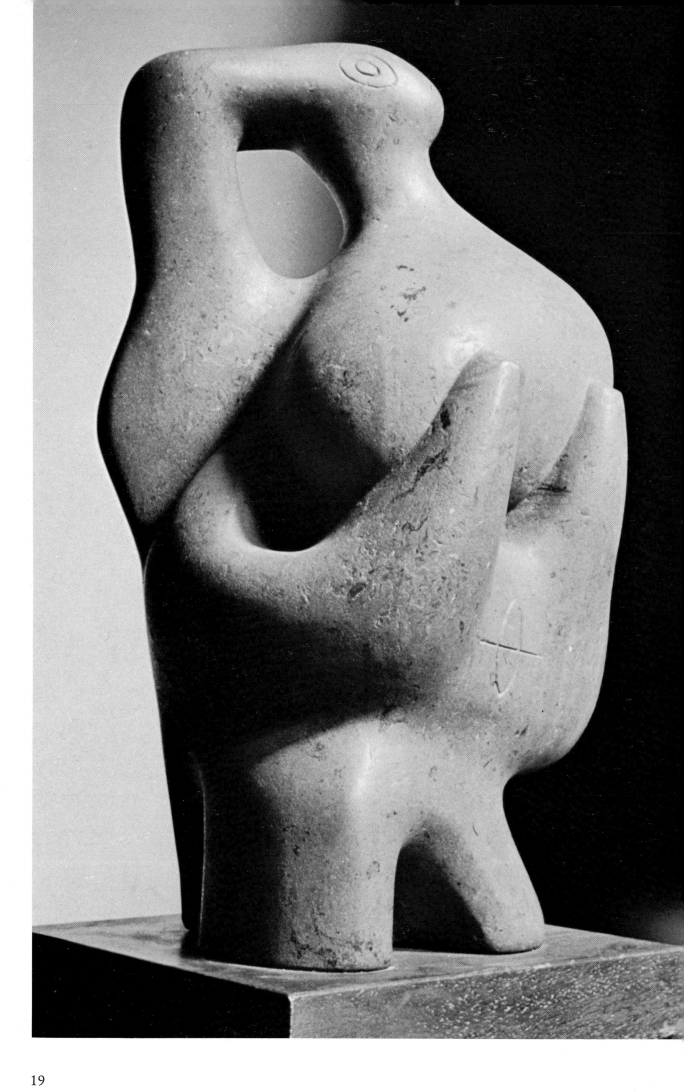

19

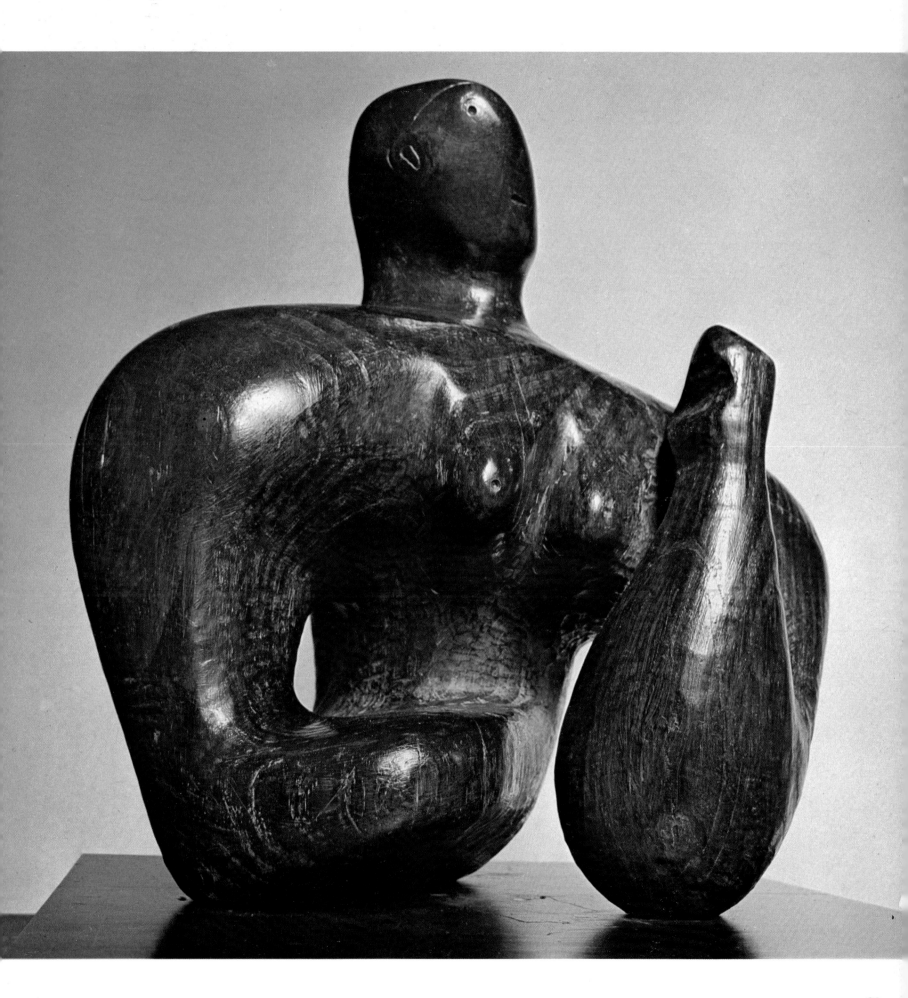

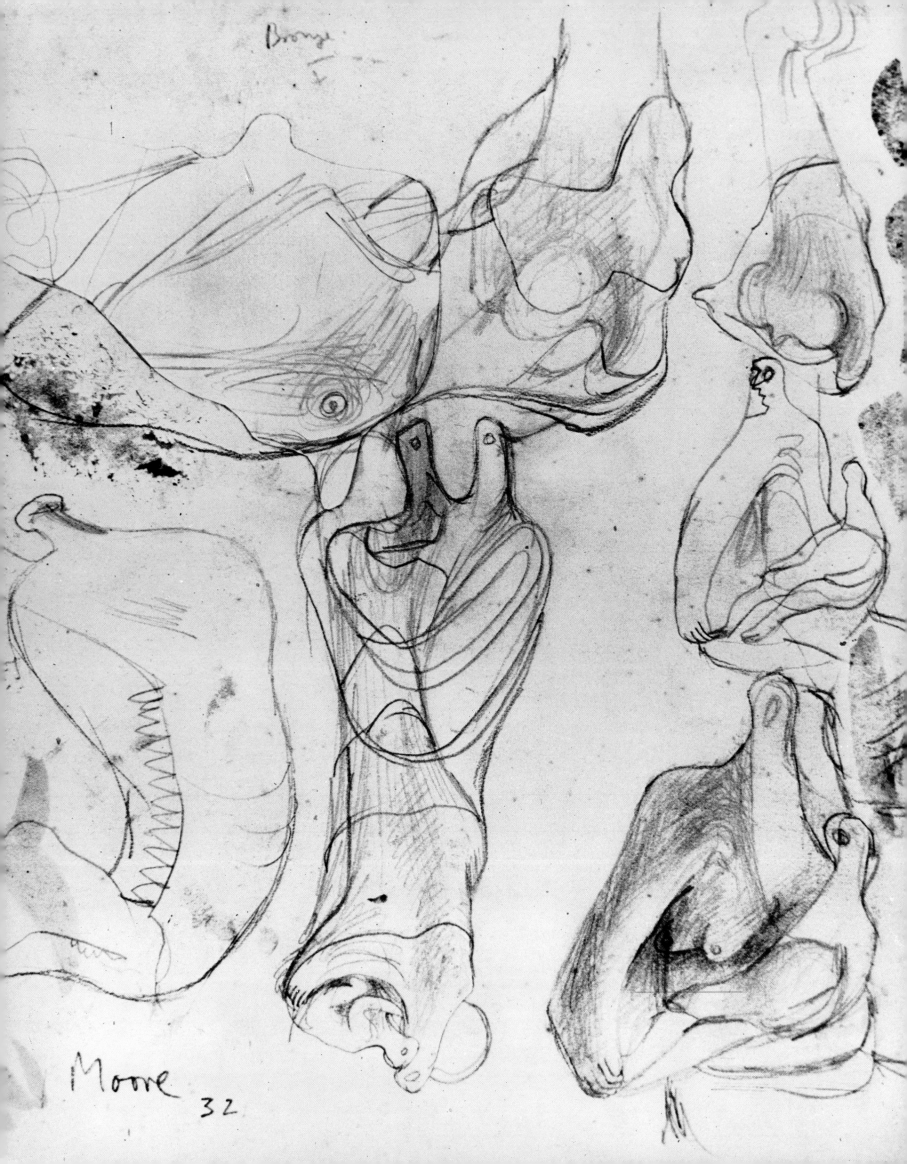

22

23

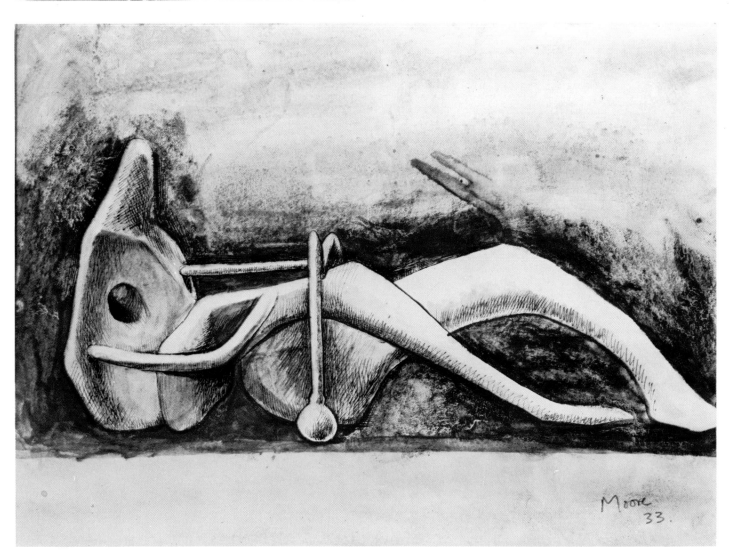

24

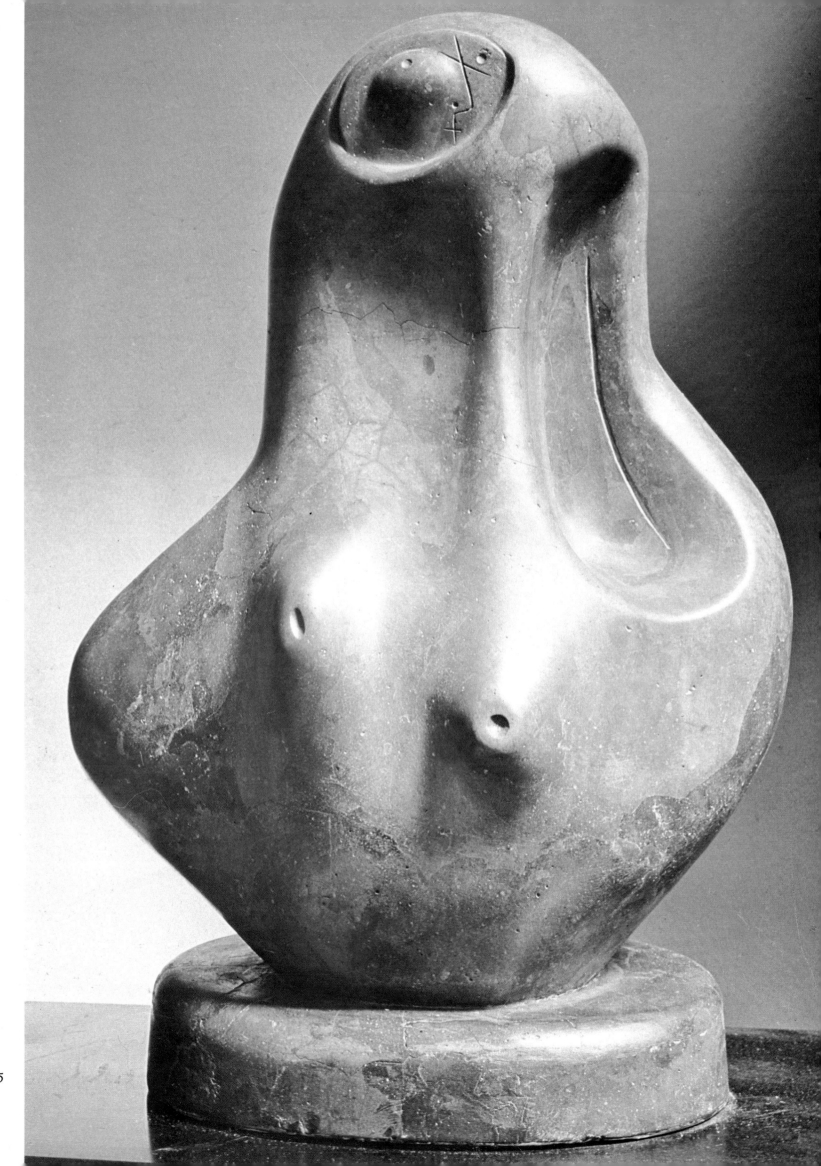

25

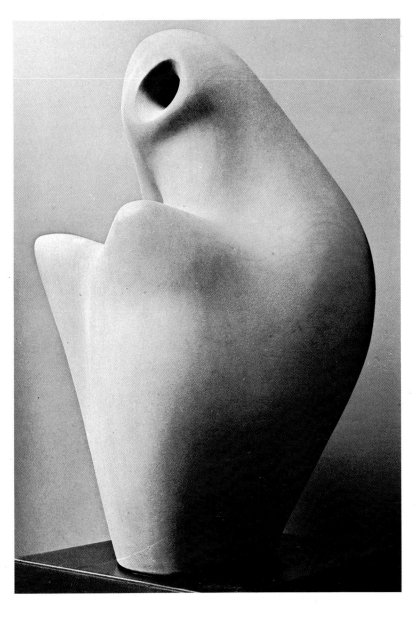

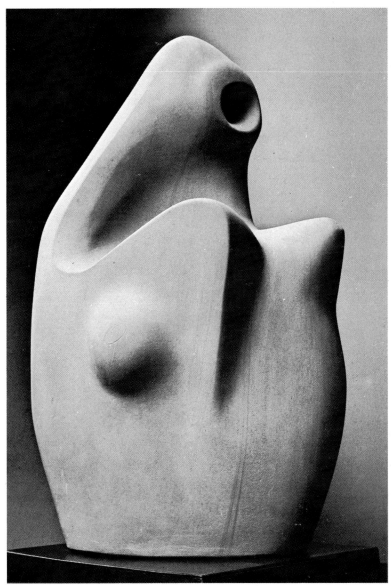

26

27

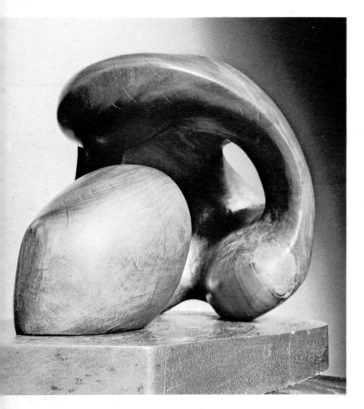

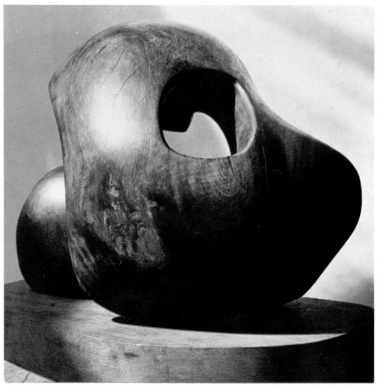

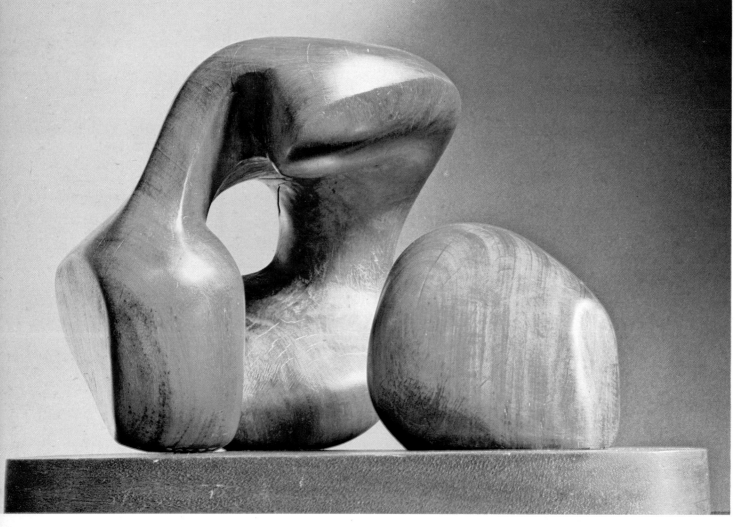

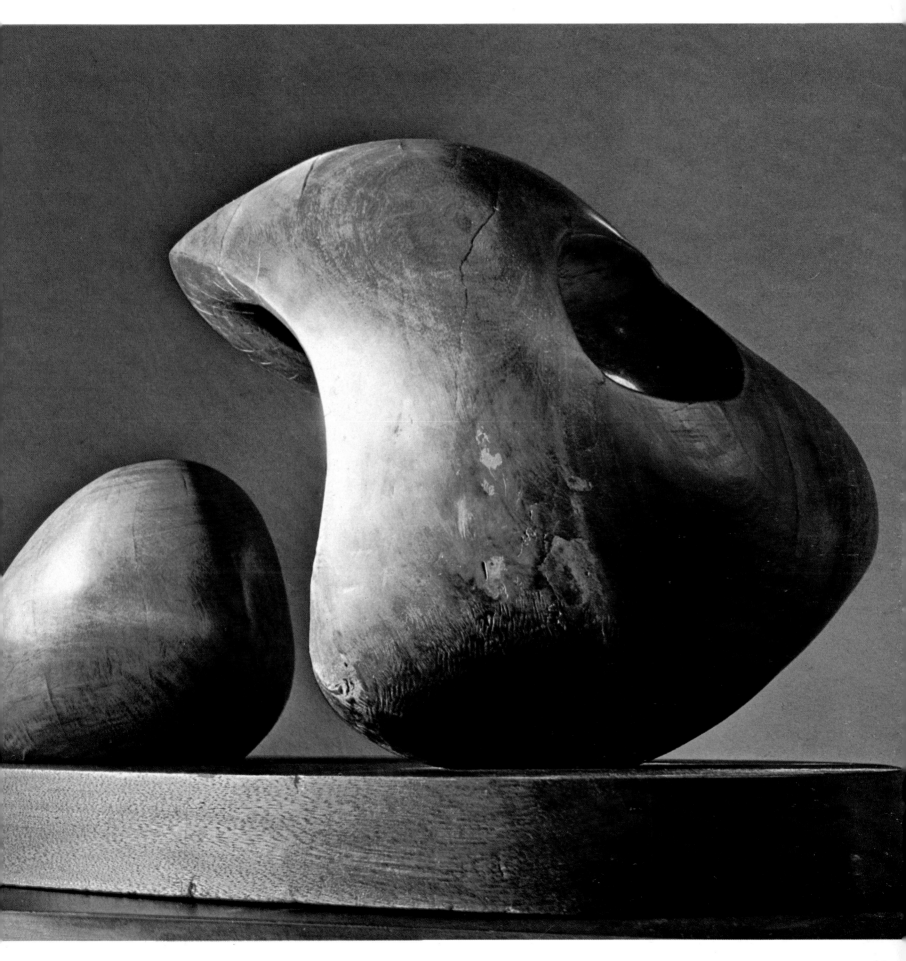

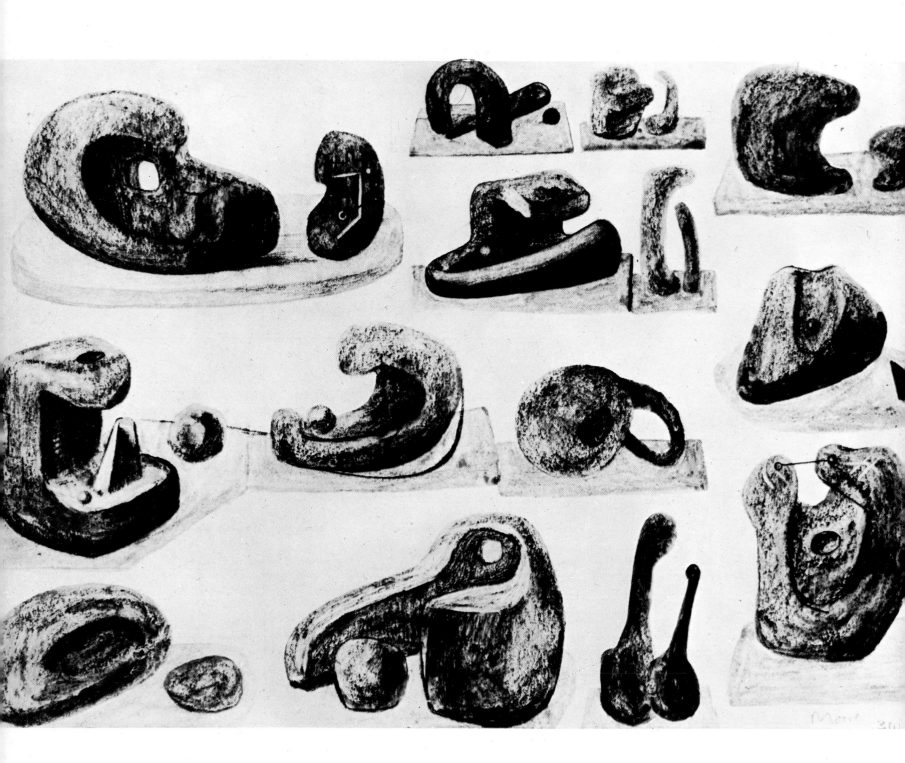

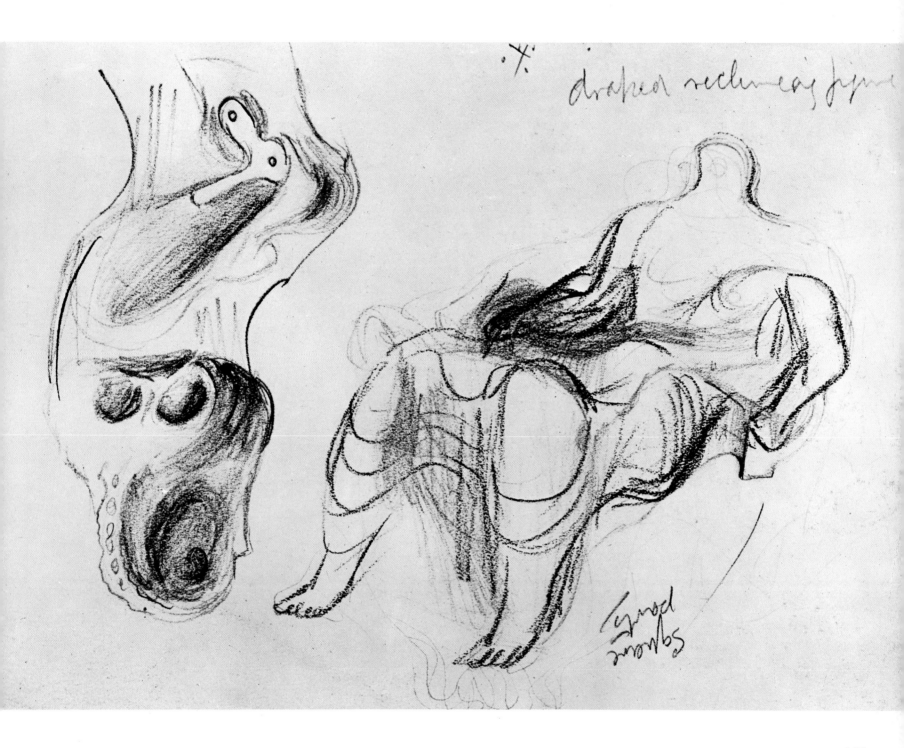

draped reclining figure

33

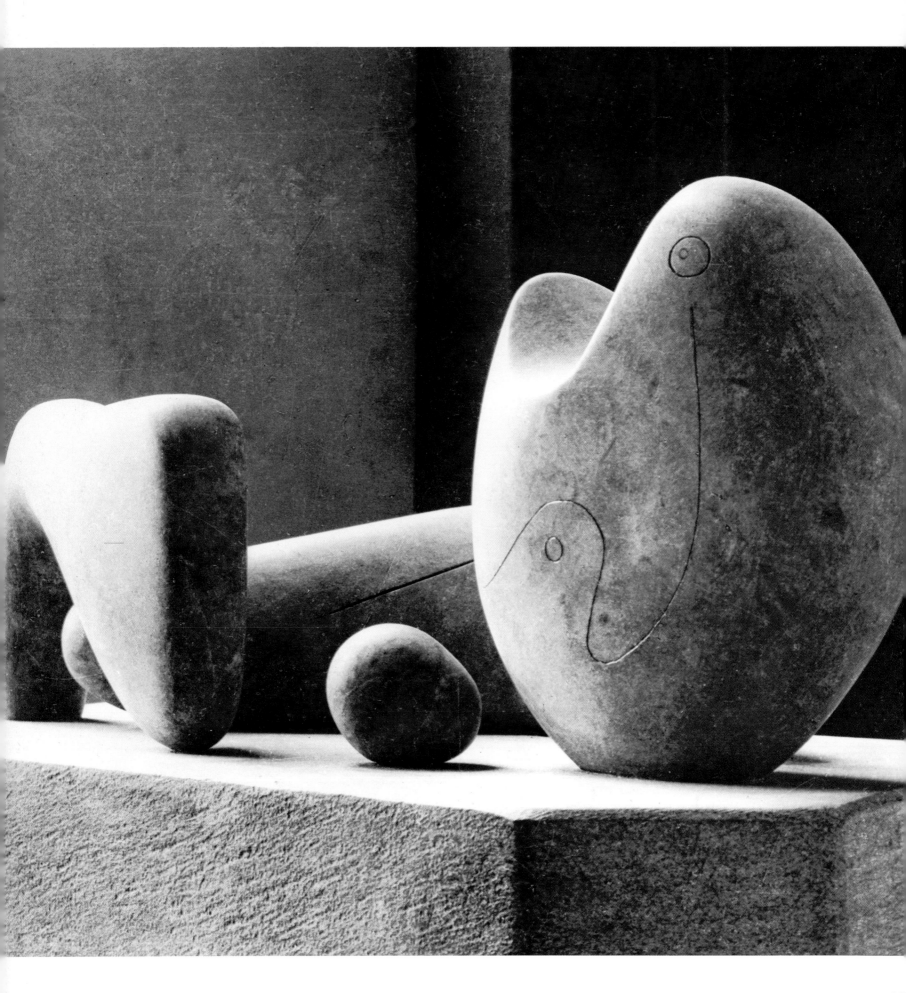

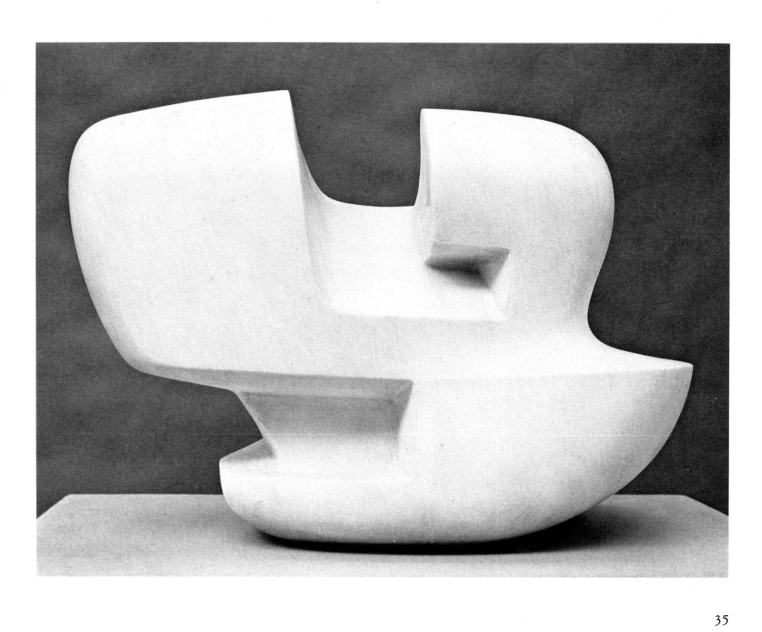

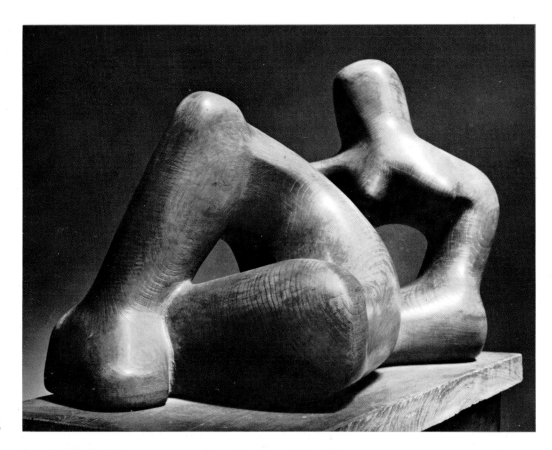

36

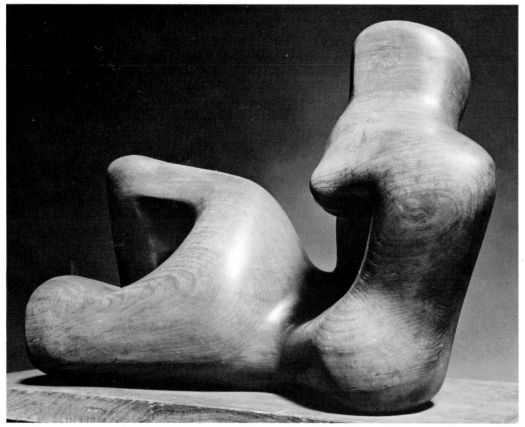

37

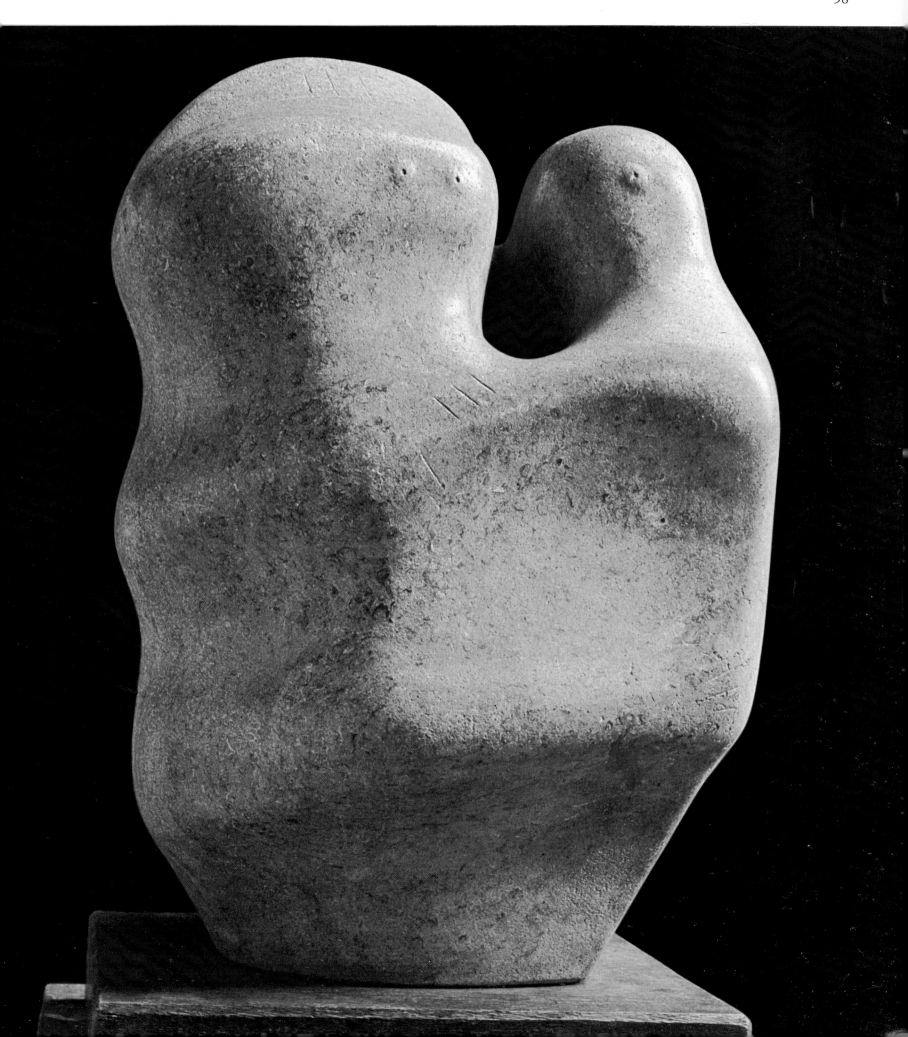

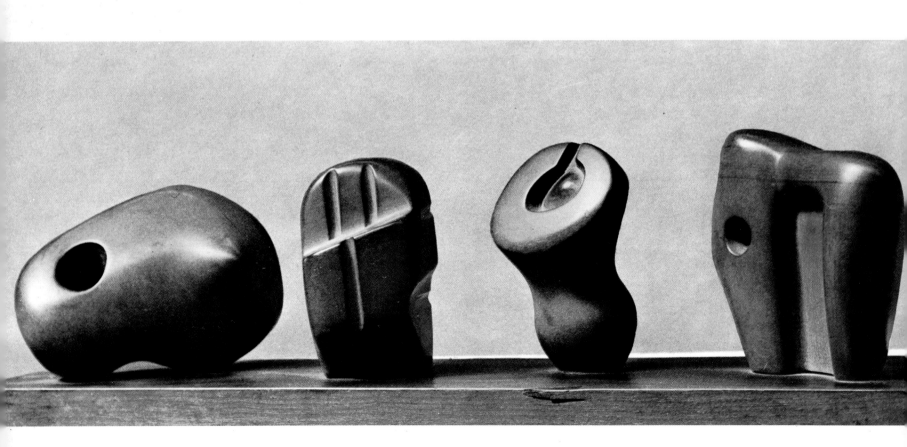

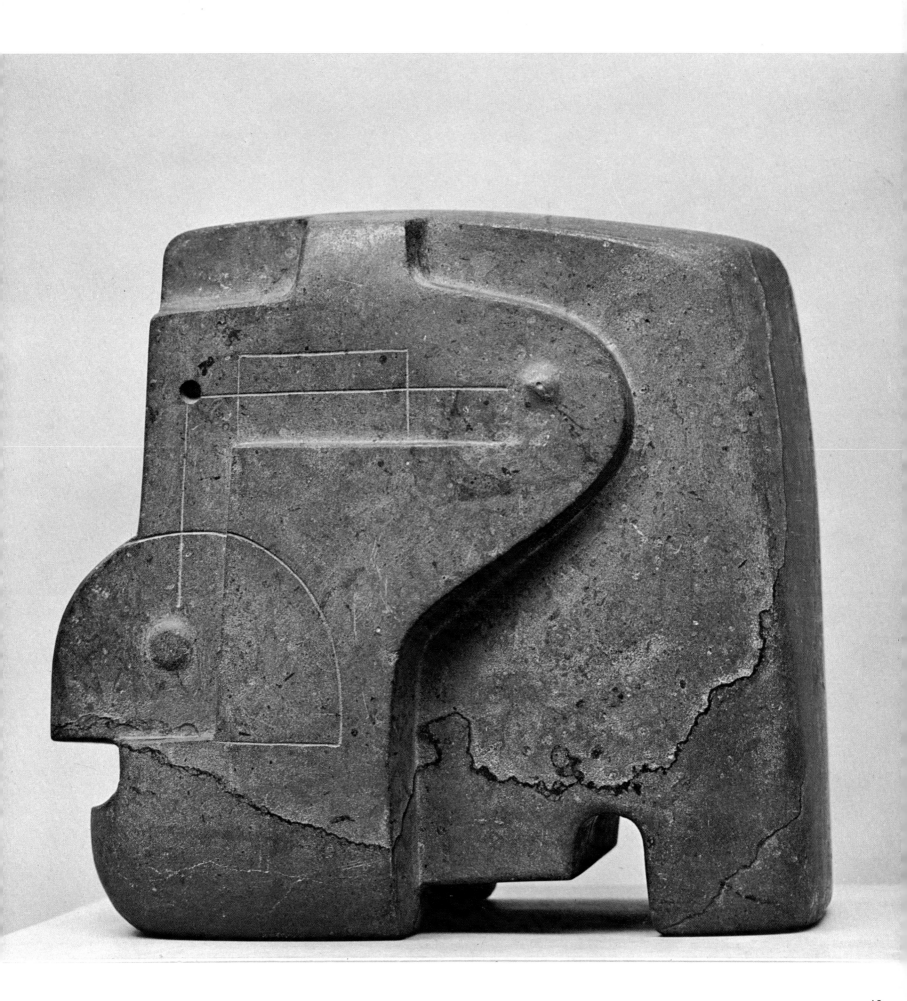

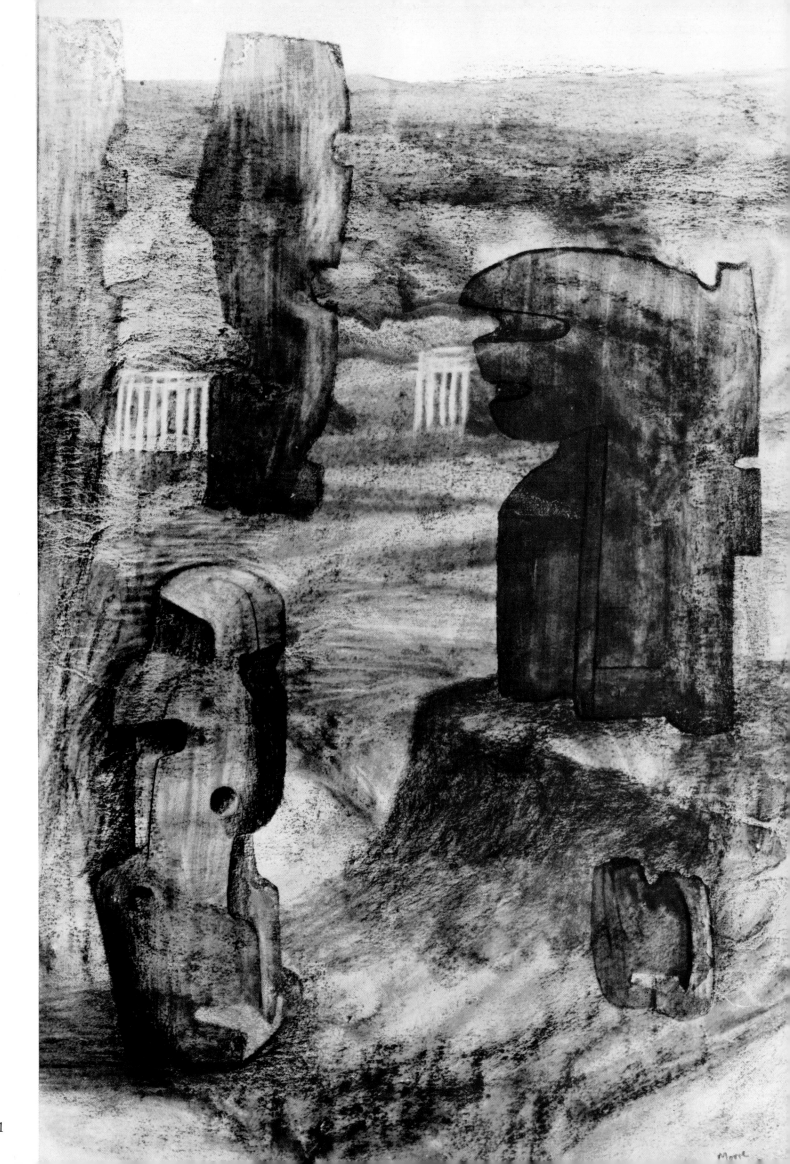

41

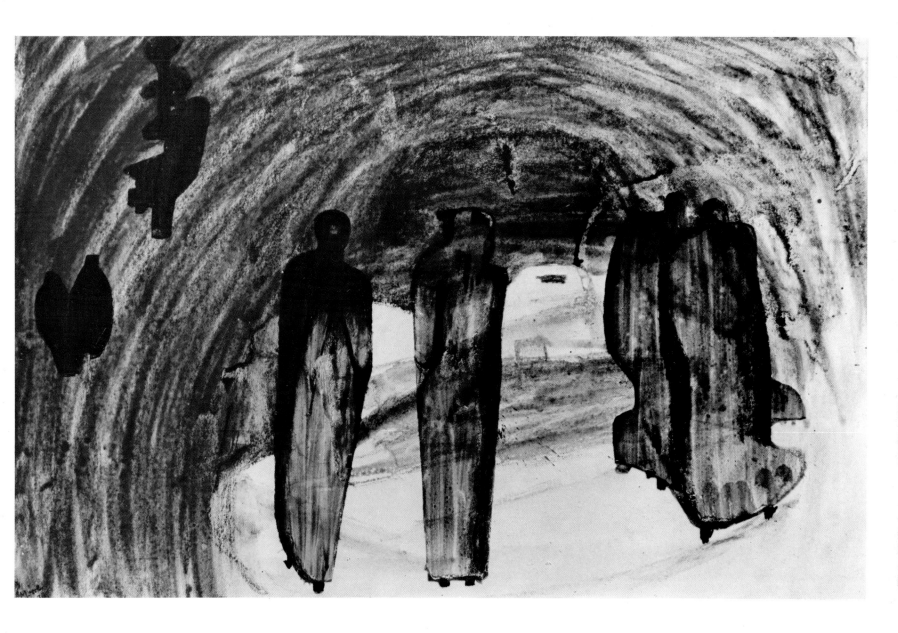

42

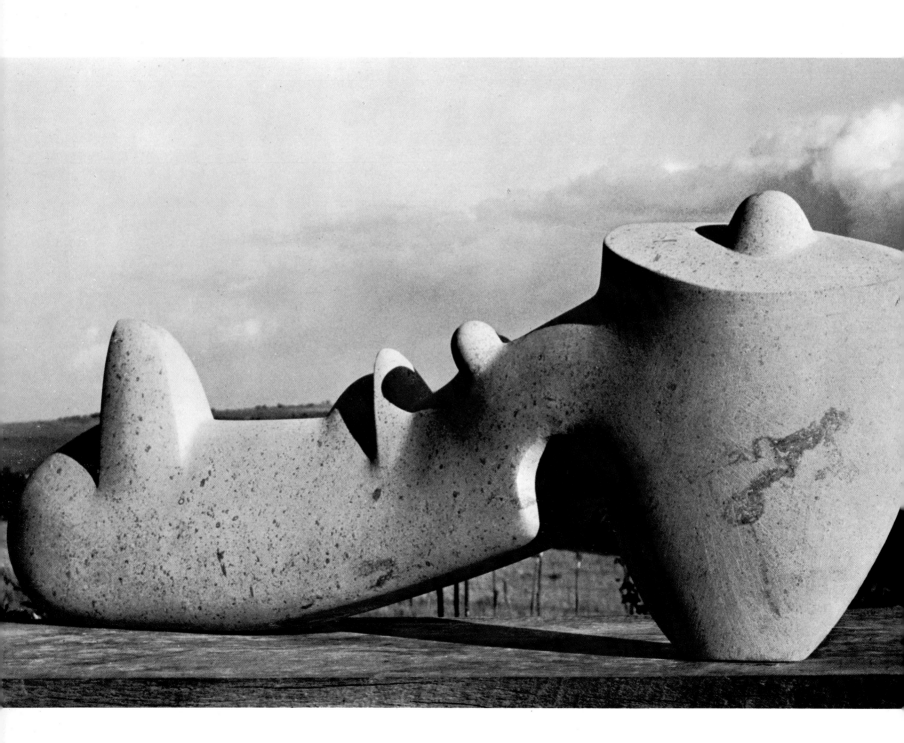

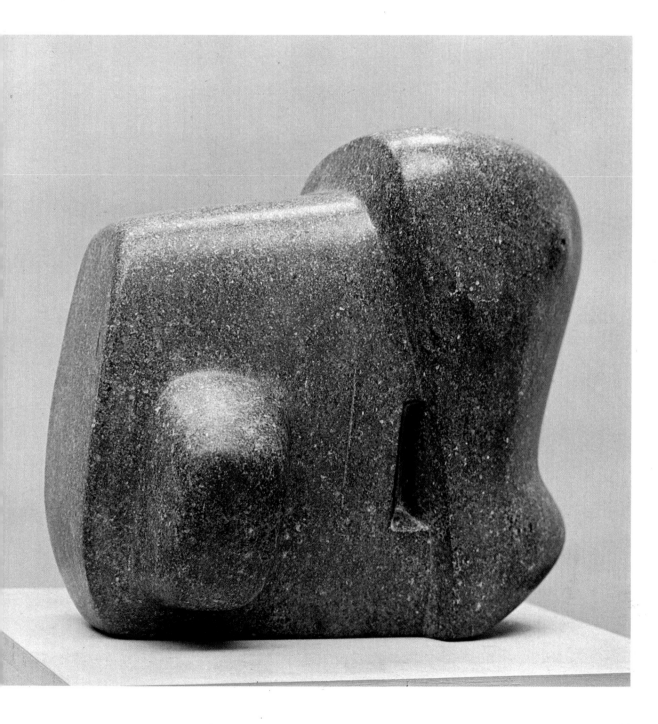

44

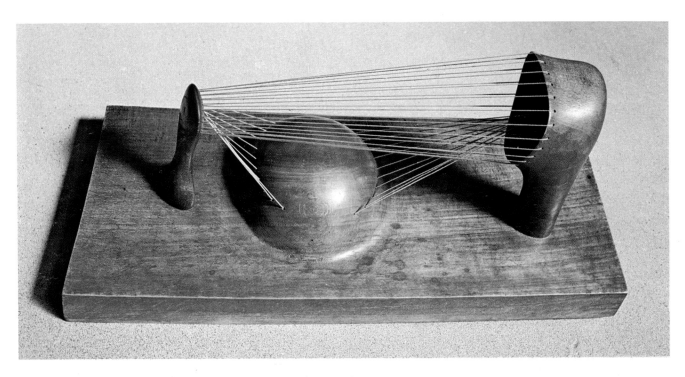

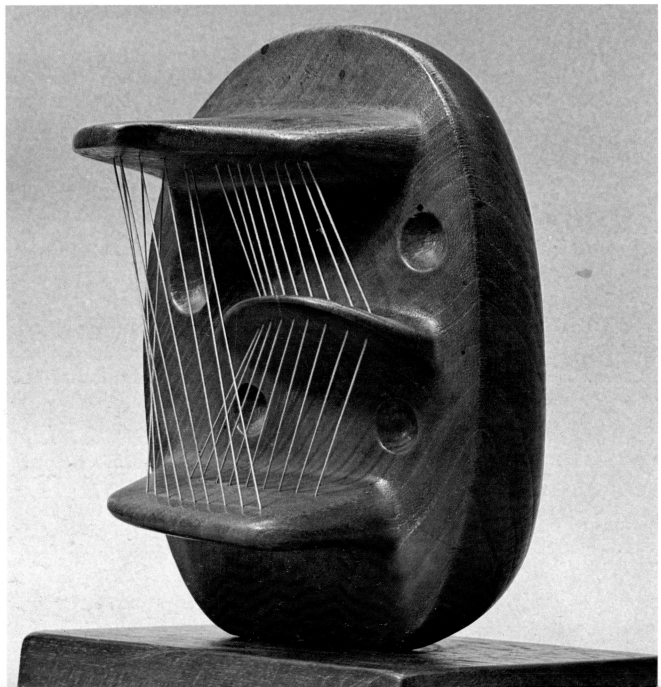

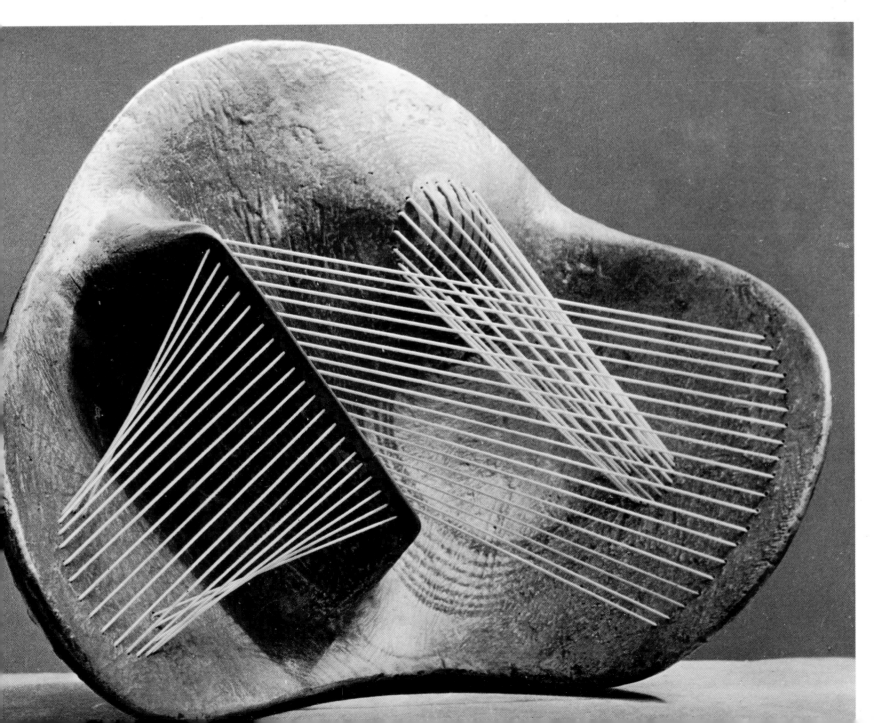

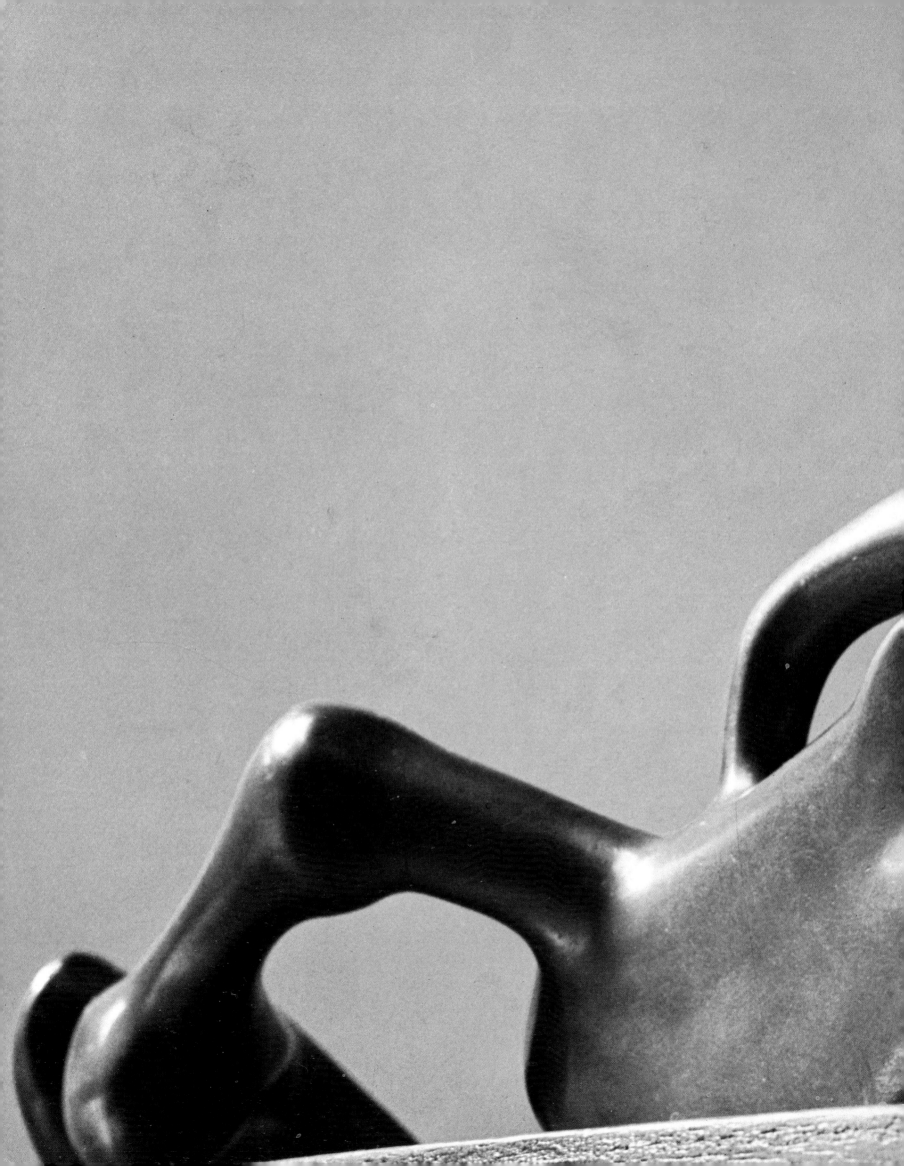

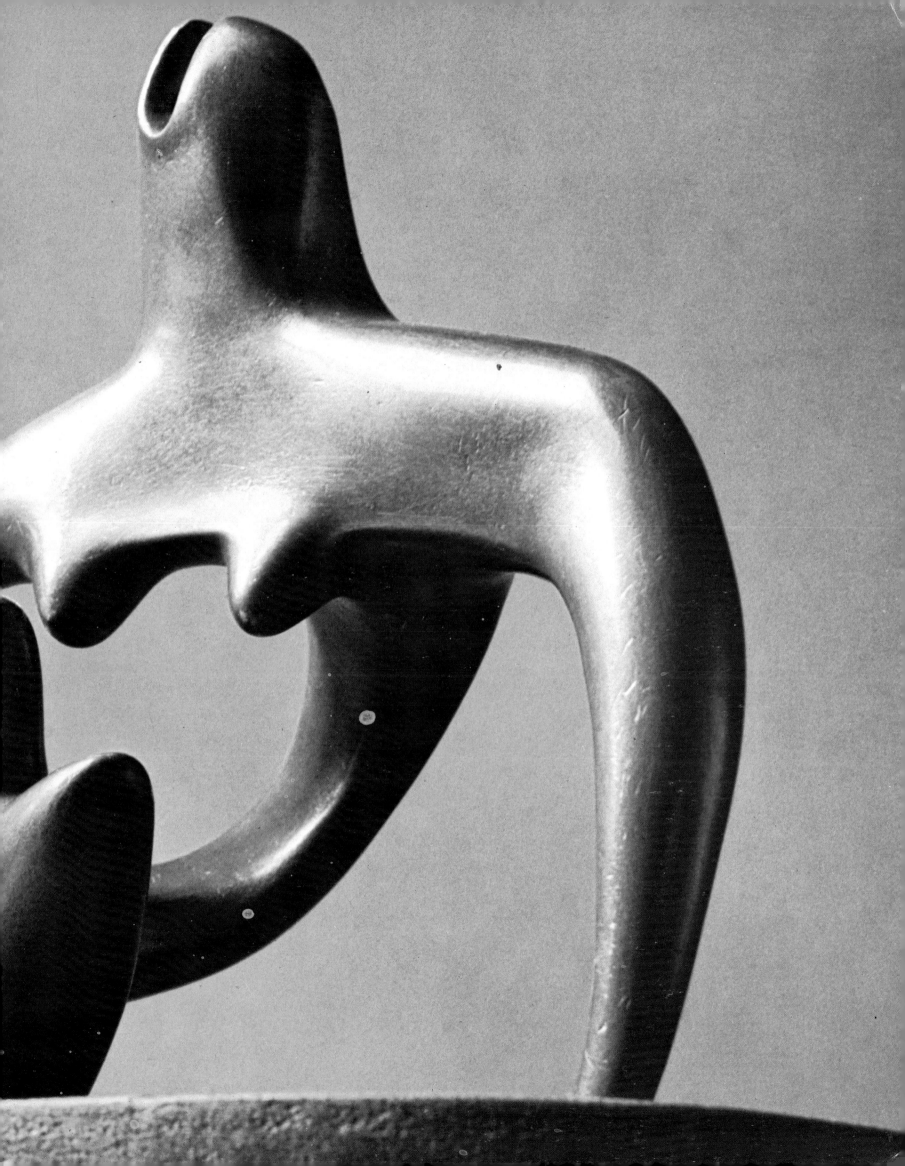

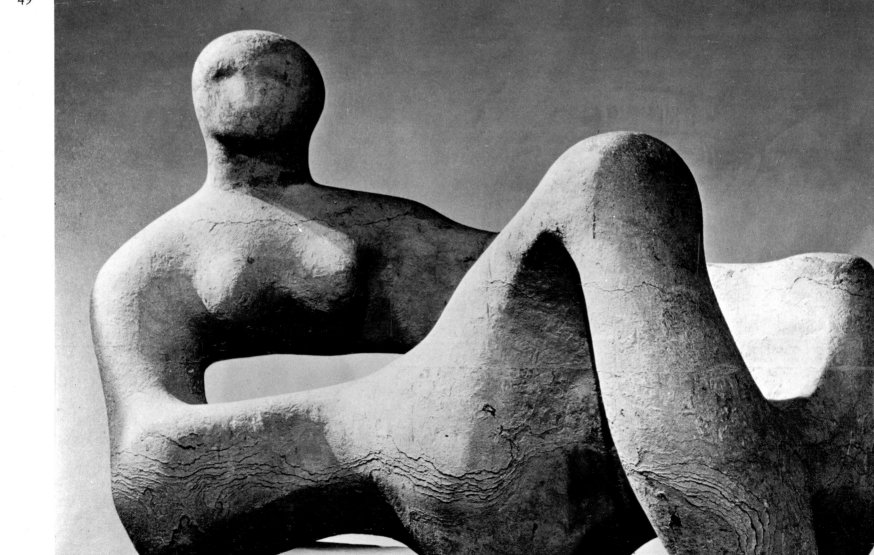

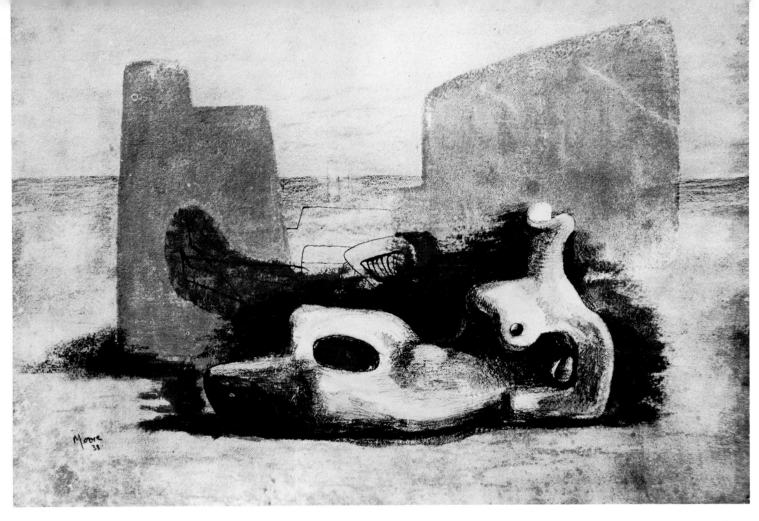

50

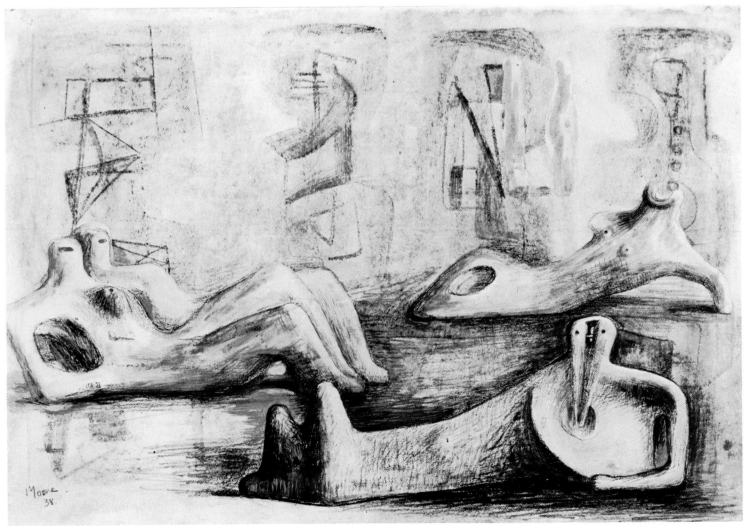

51

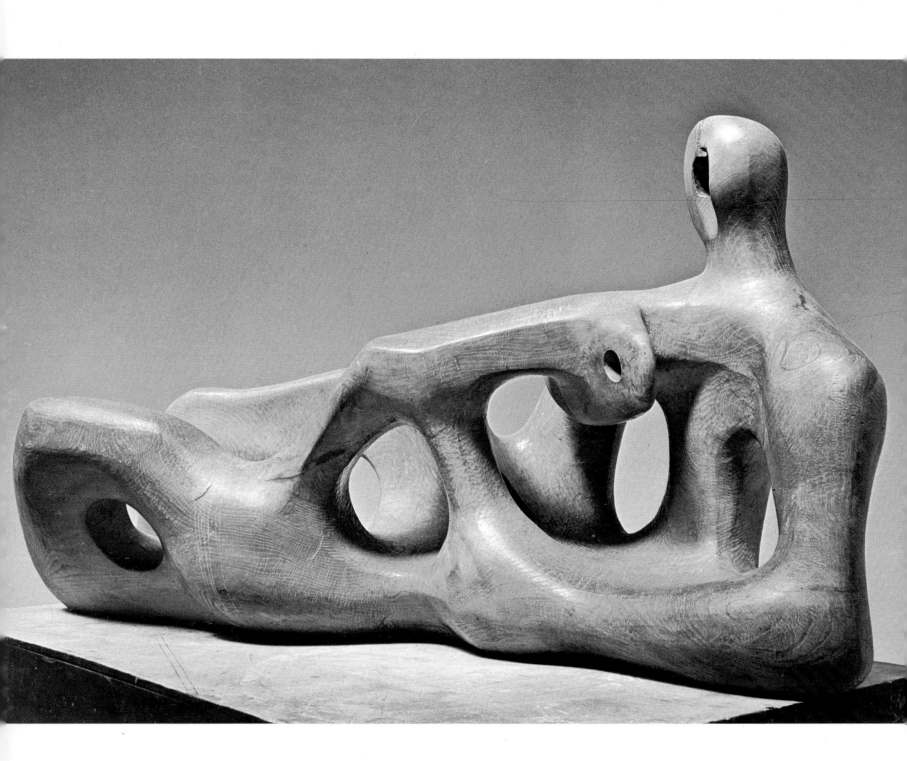

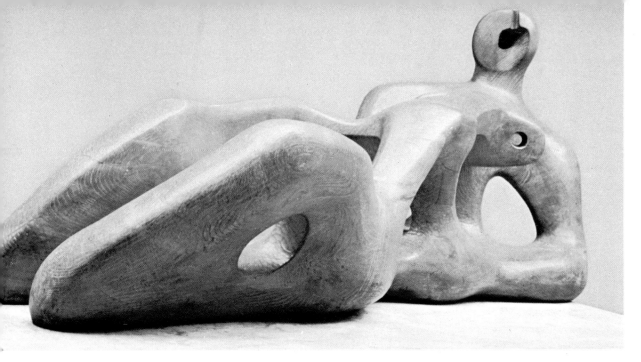

53

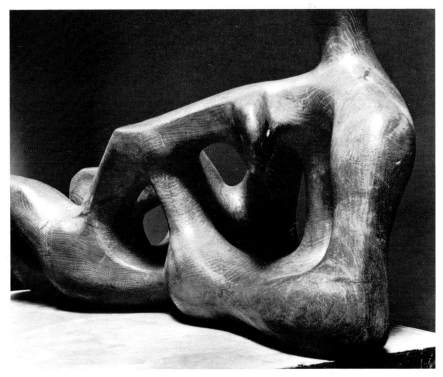

54

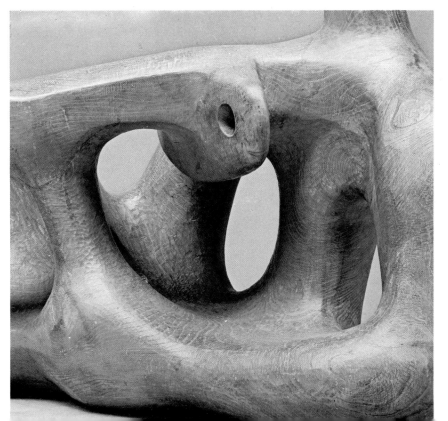

55

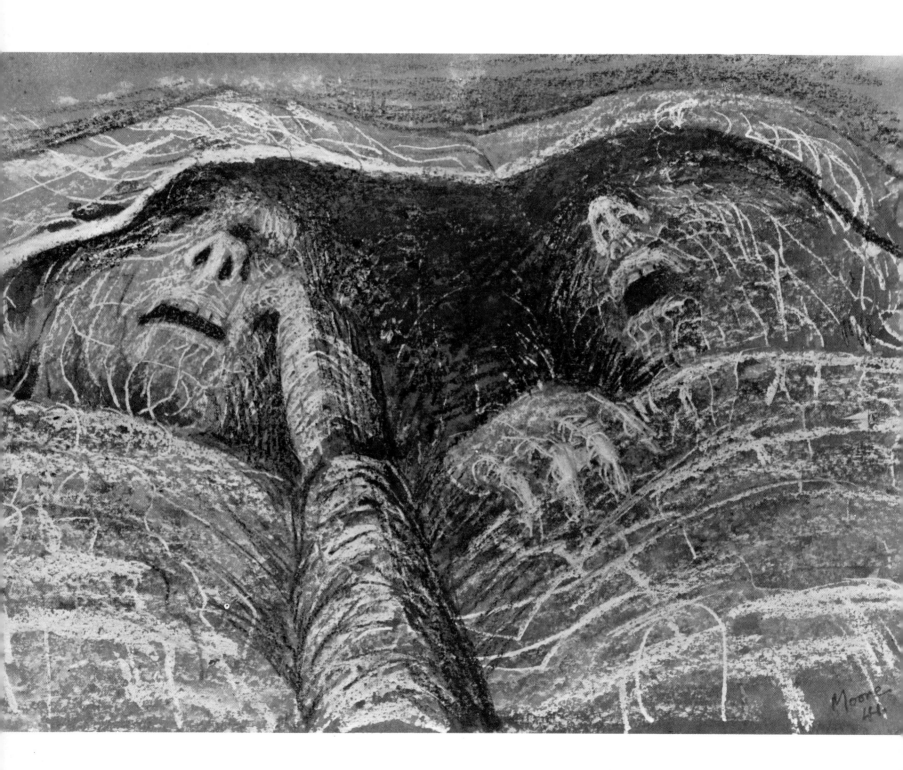

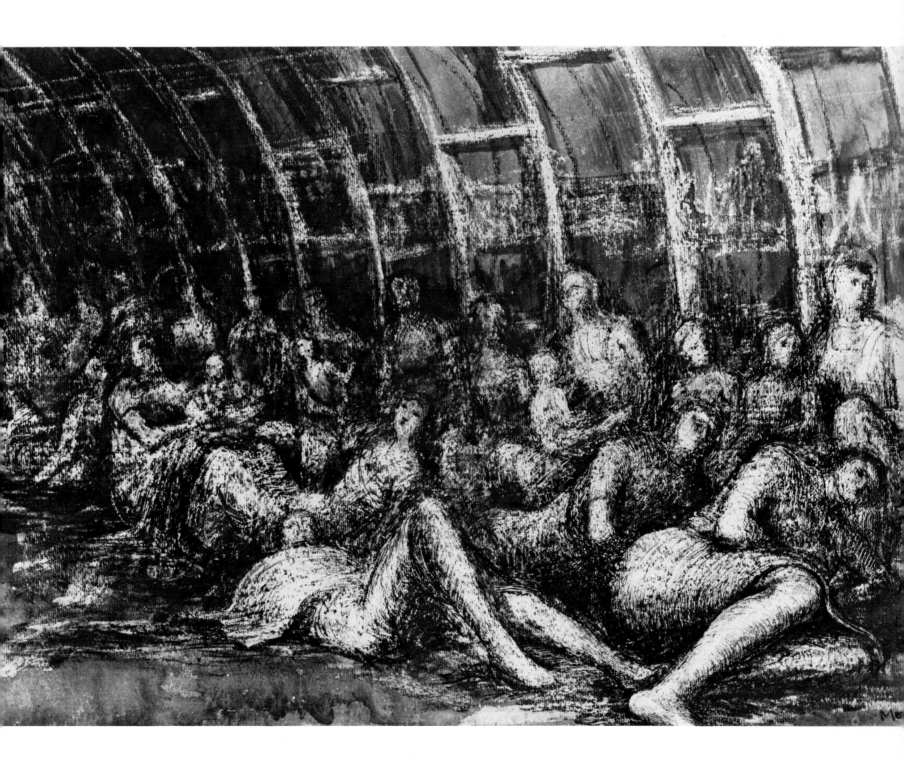

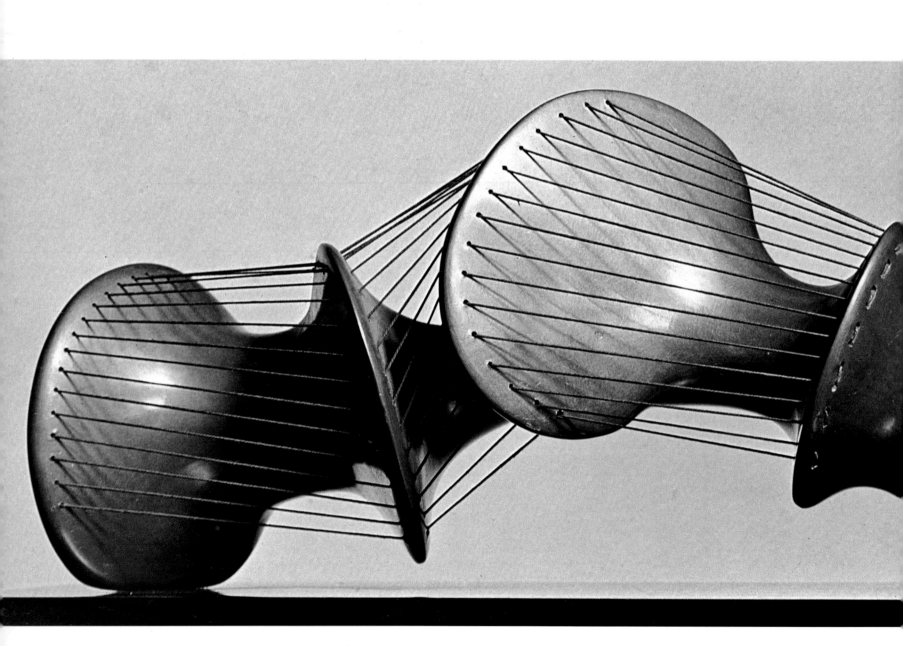

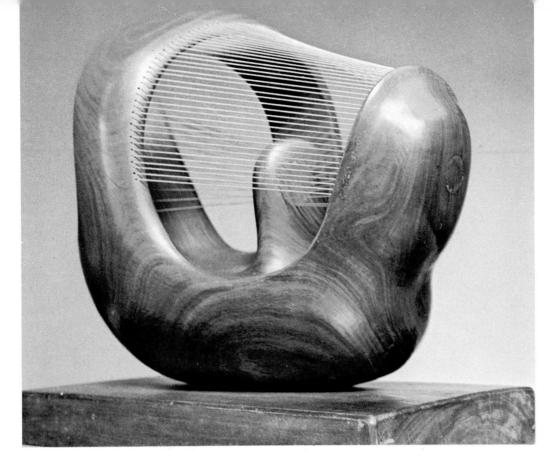

59

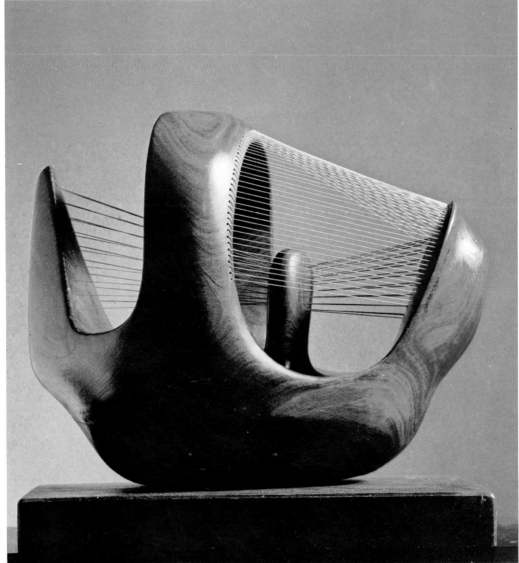

60

58

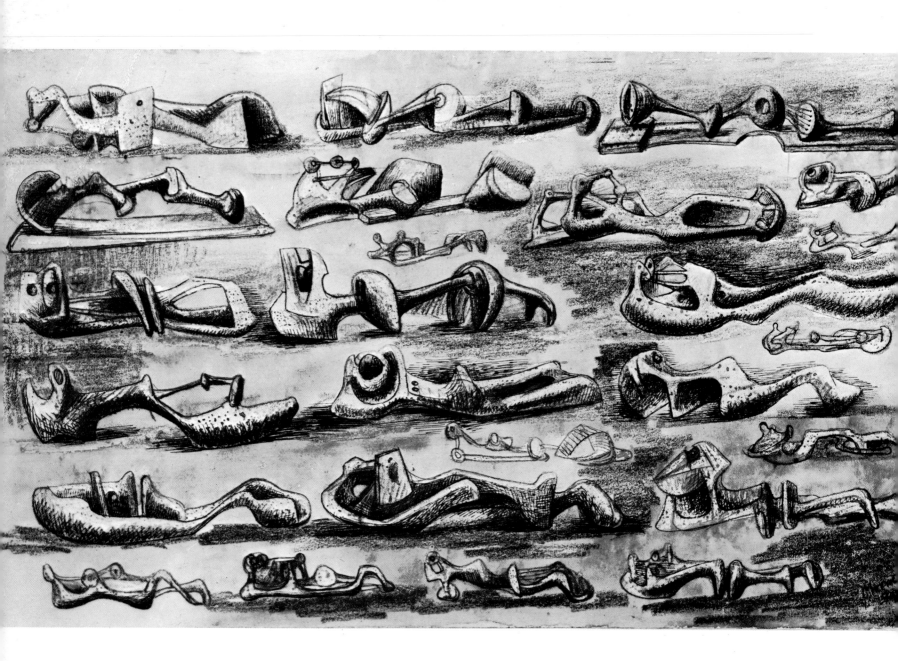

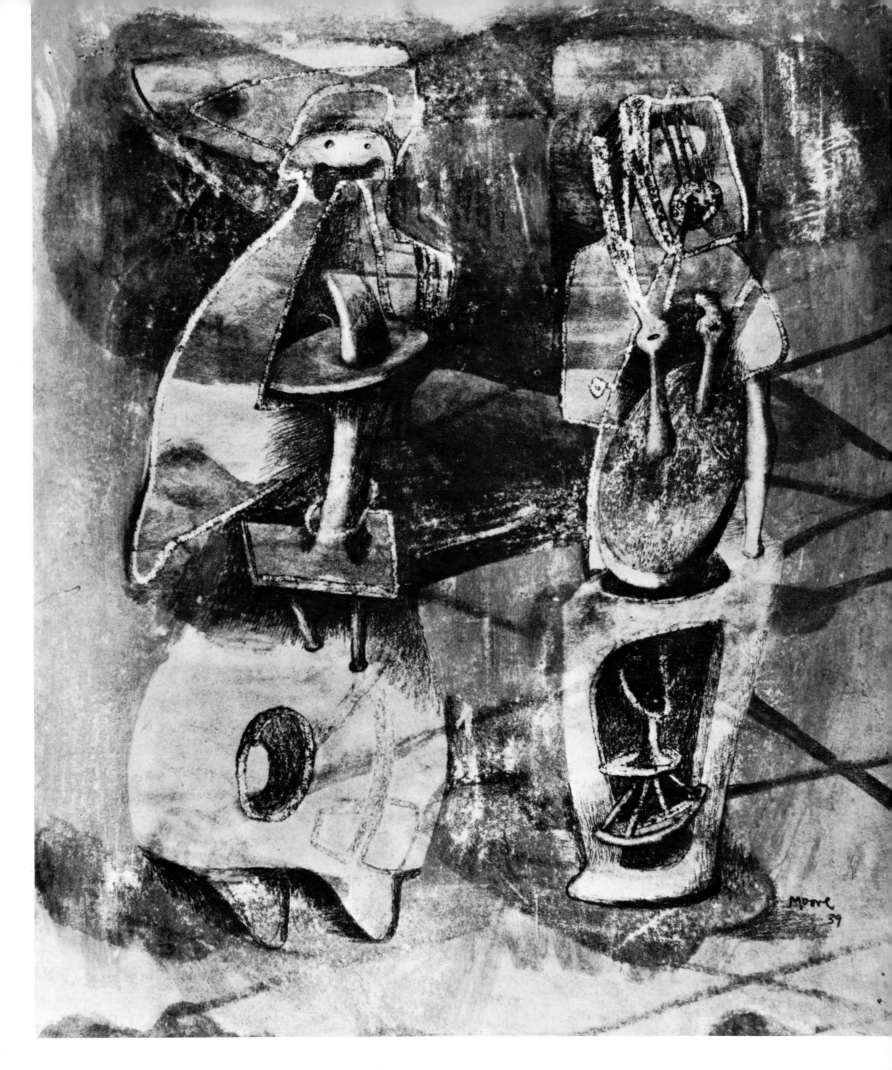

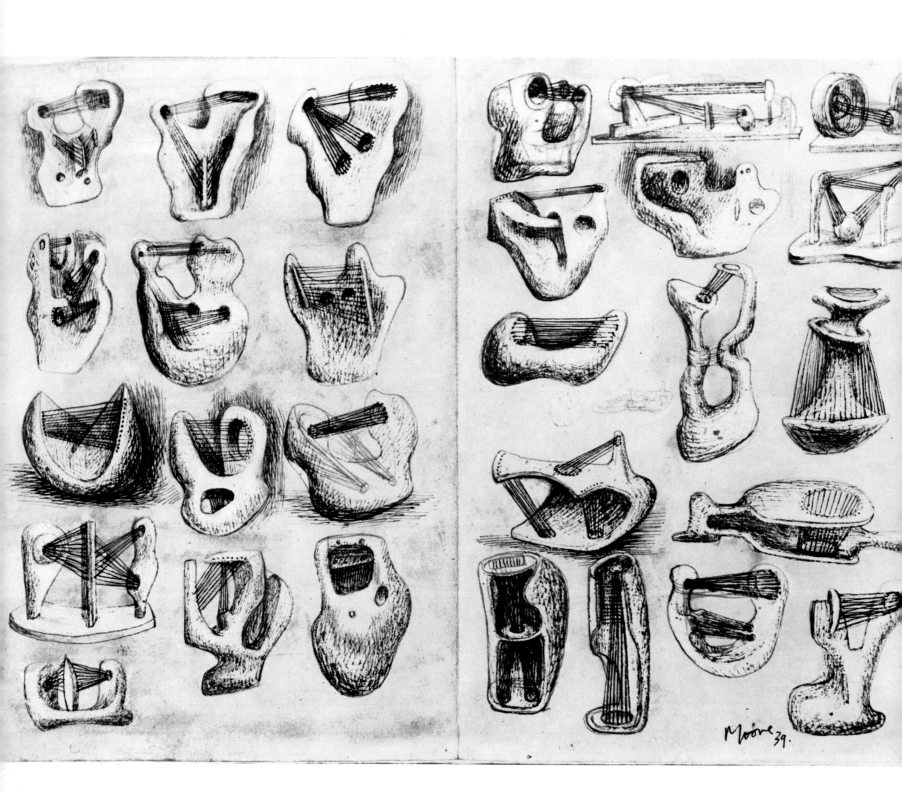

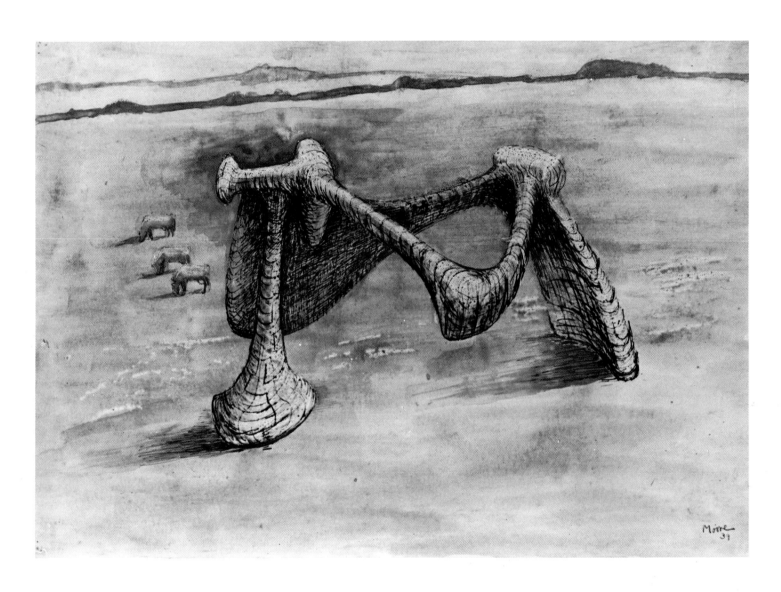

64

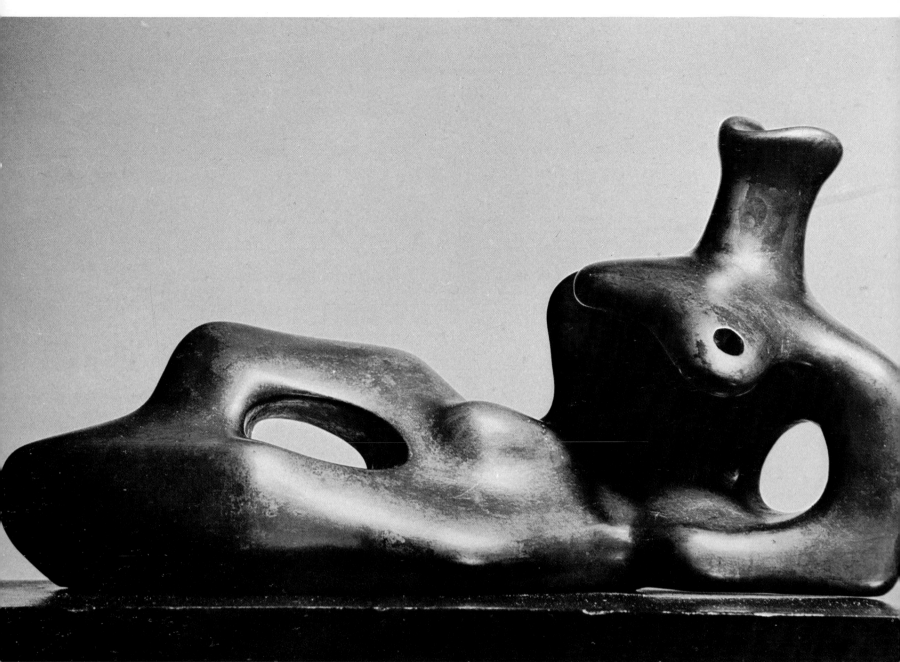

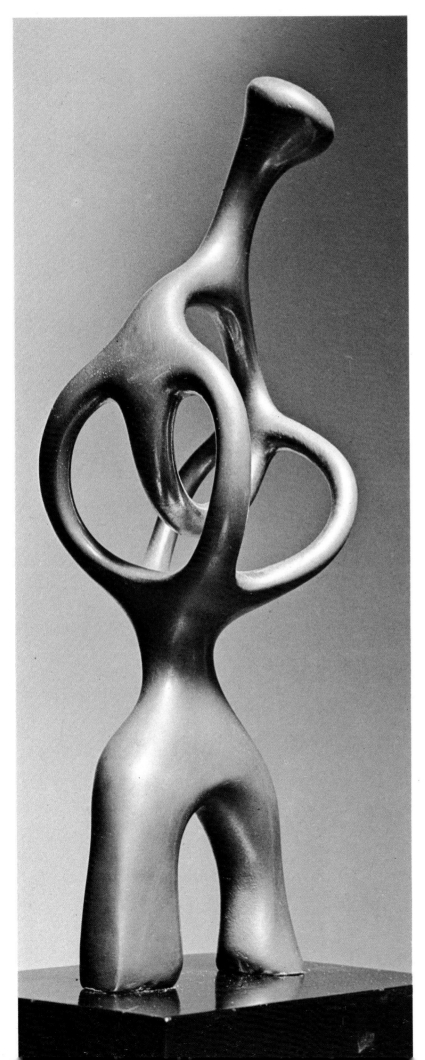

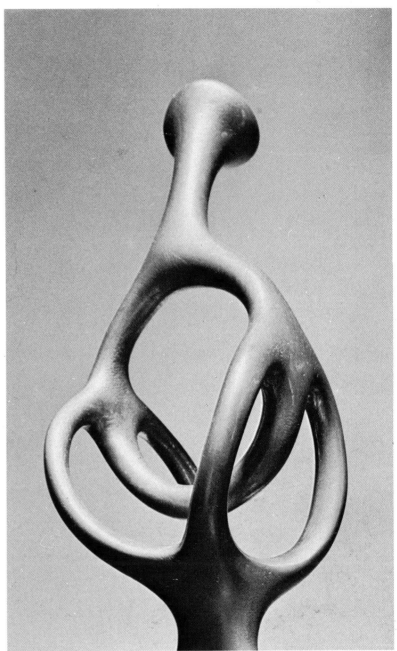

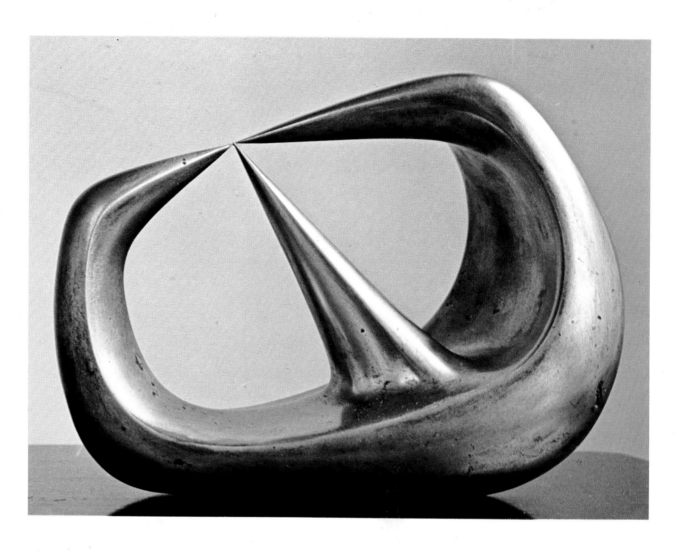

68

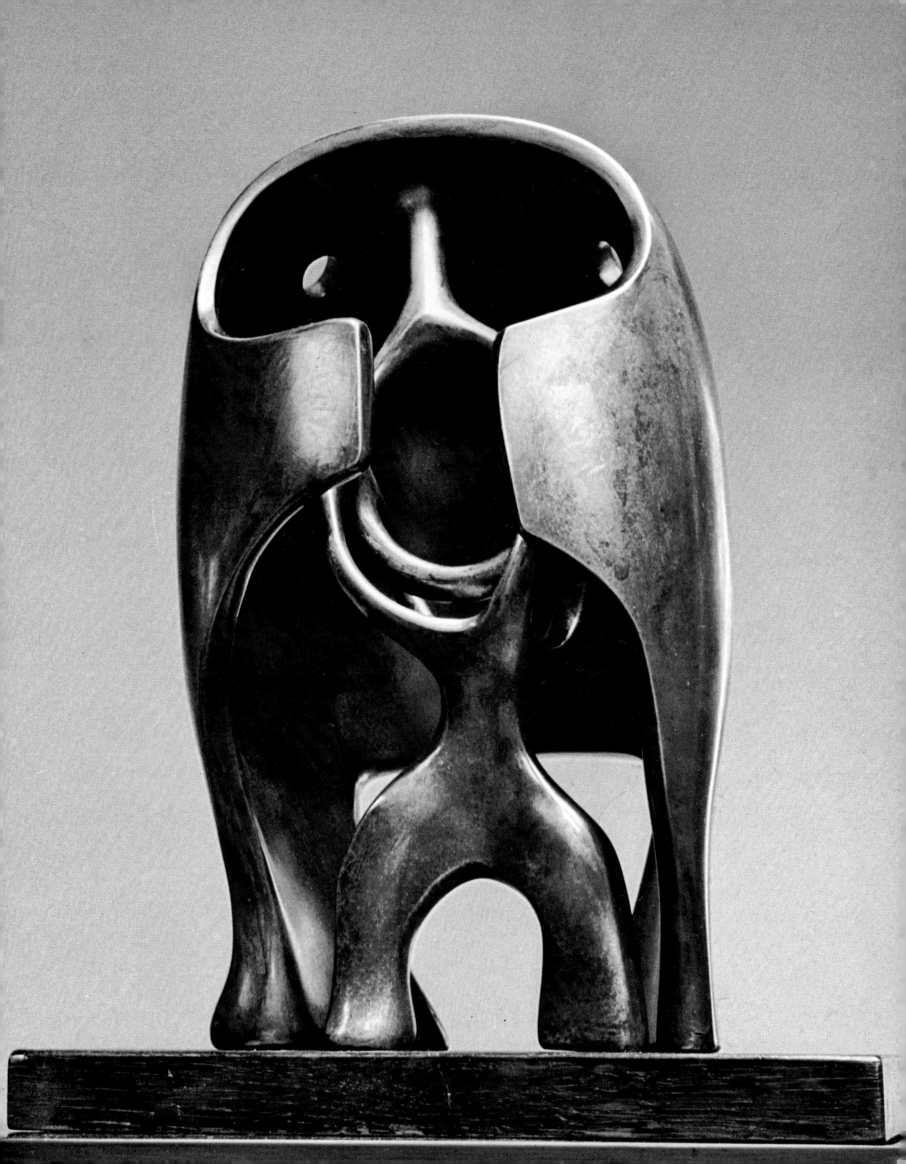

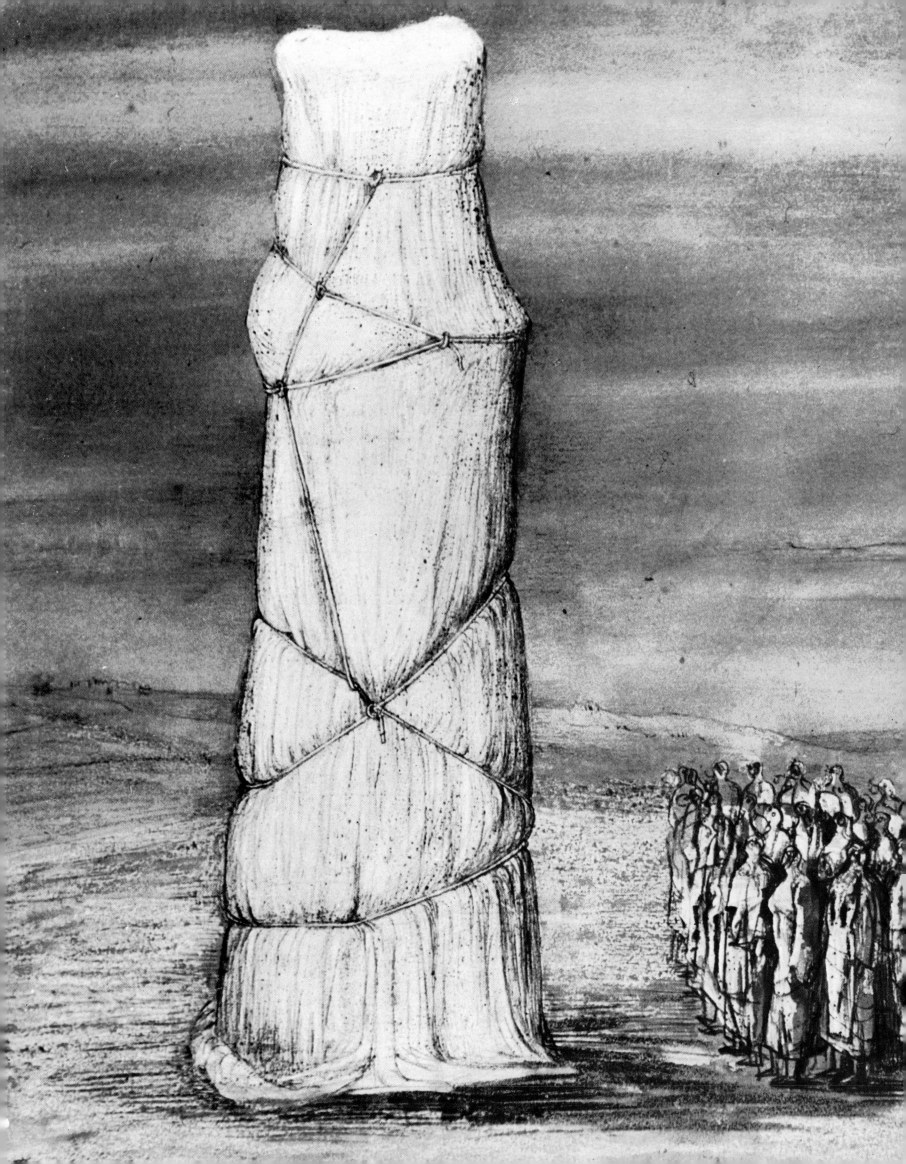

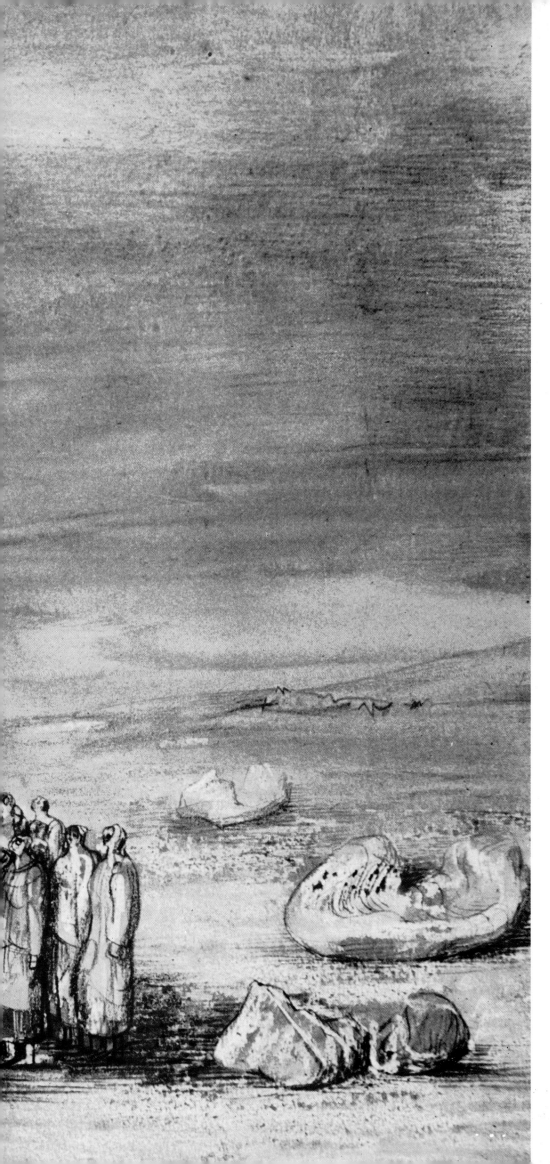

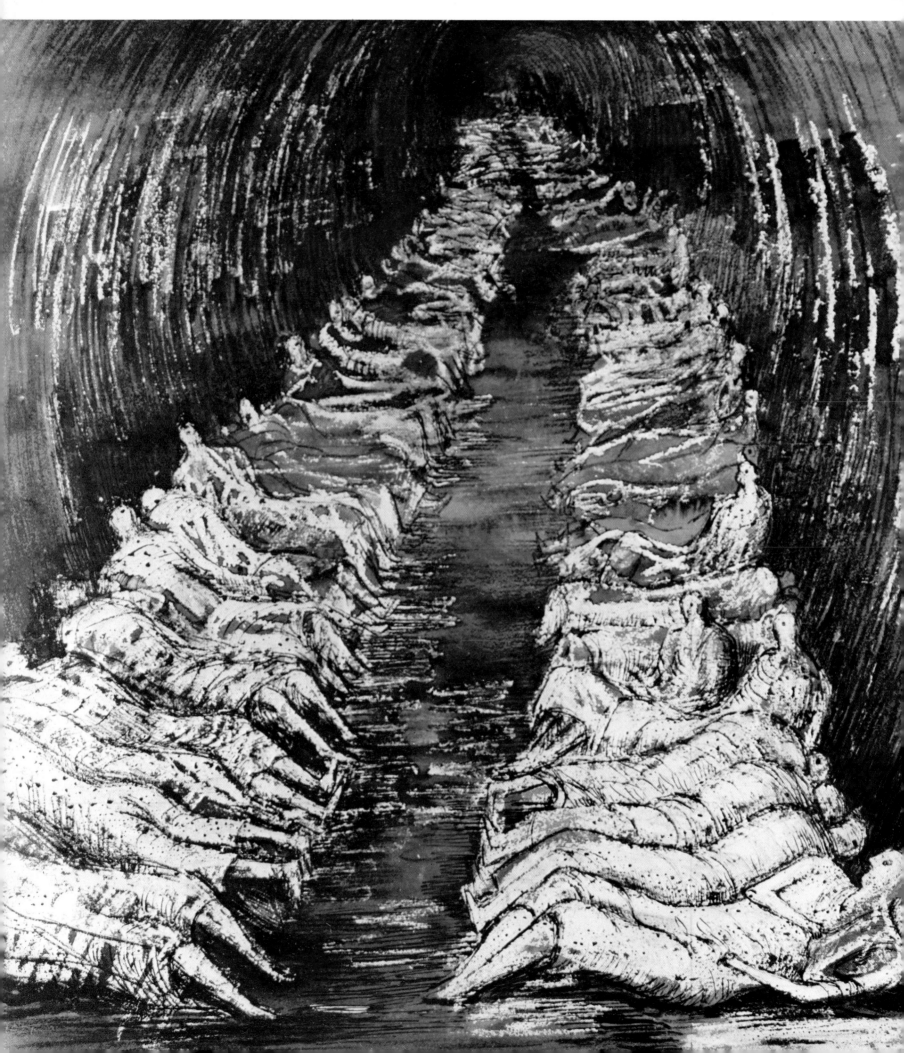

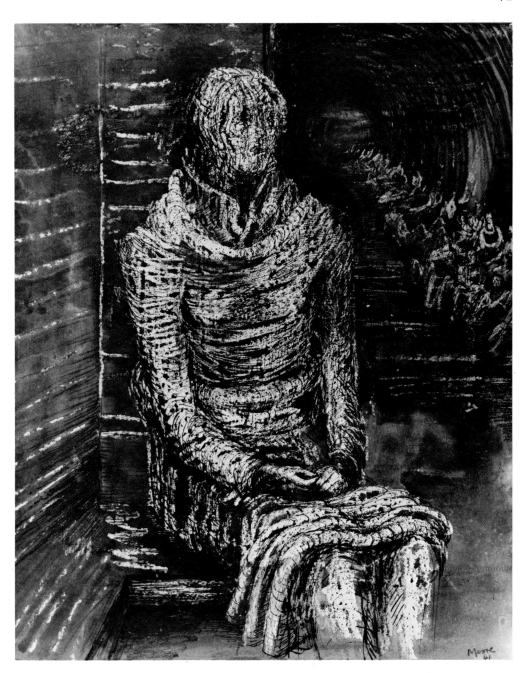

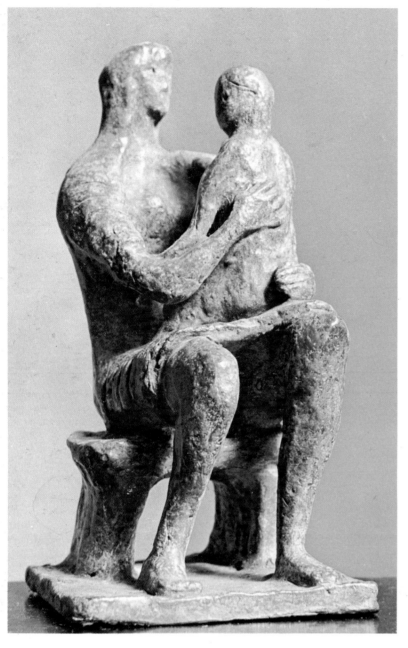

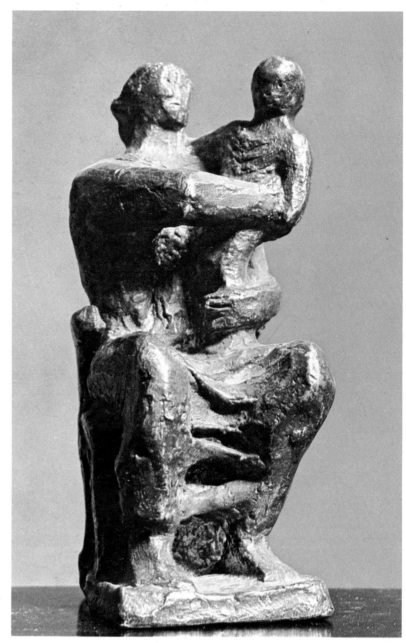

73

74

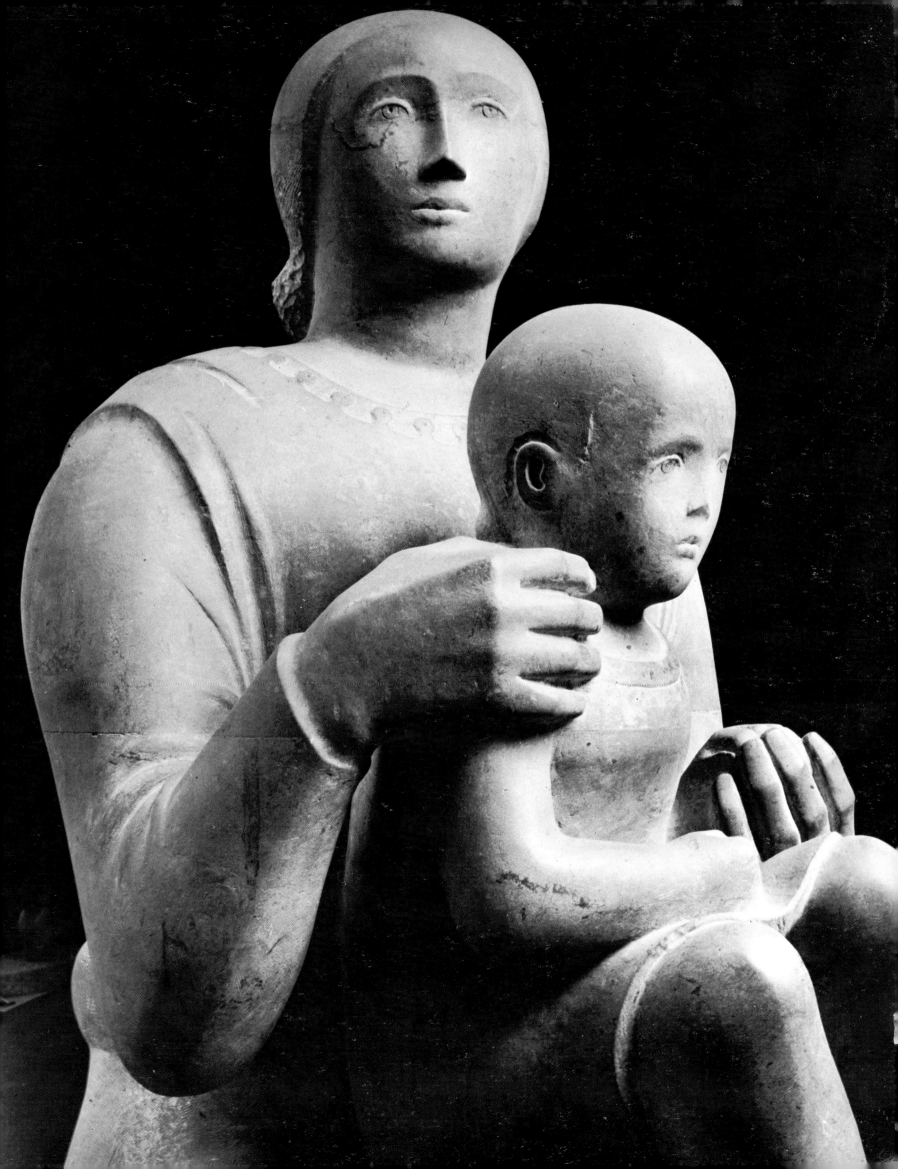

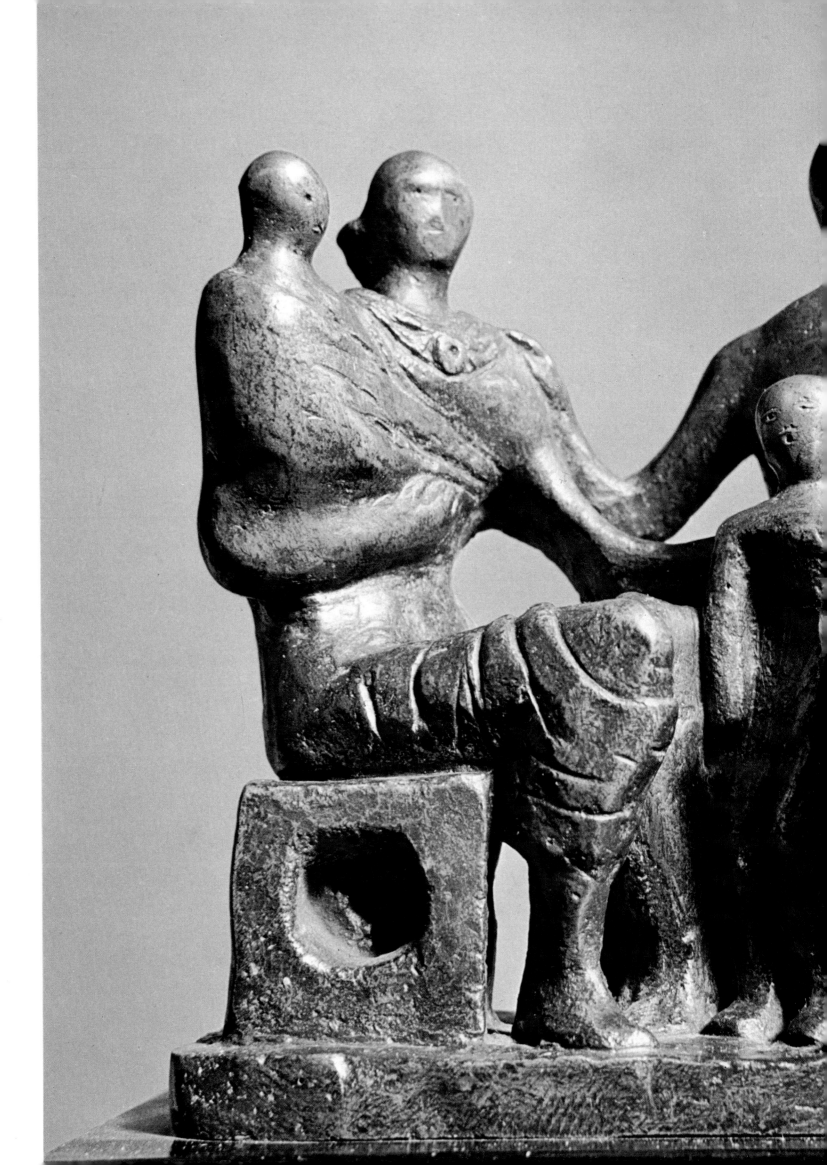

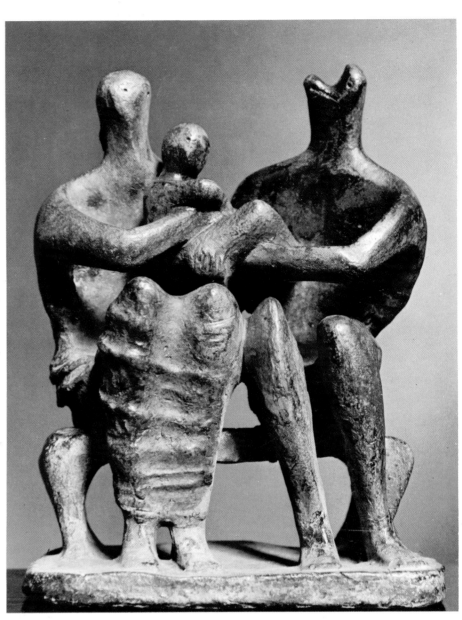

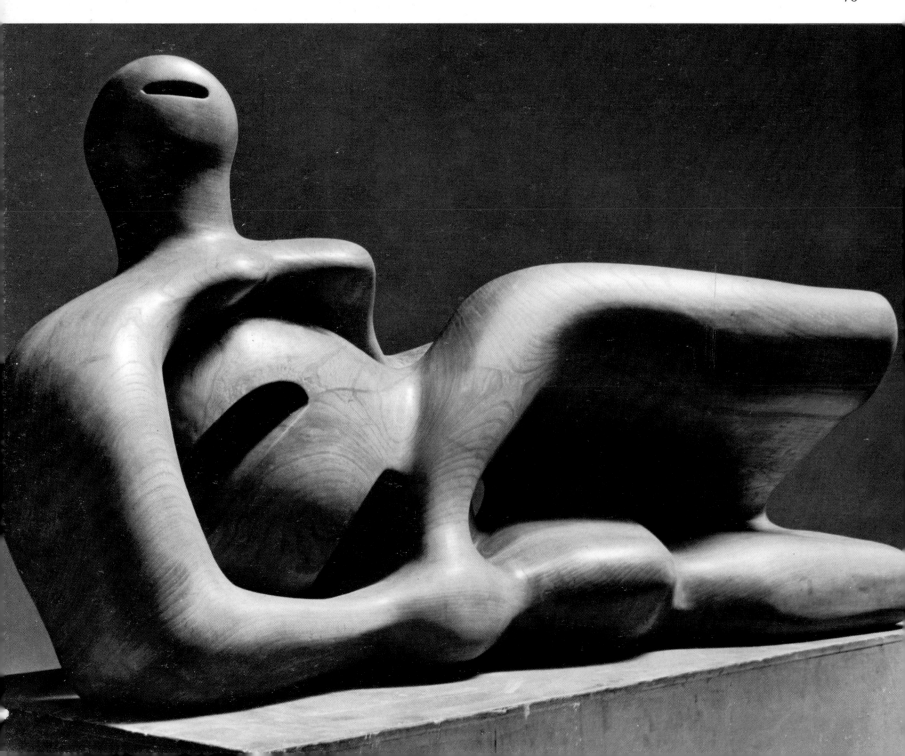

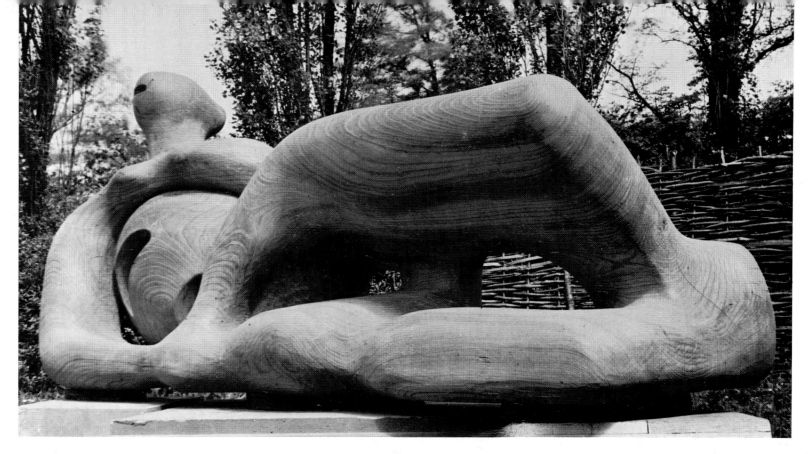

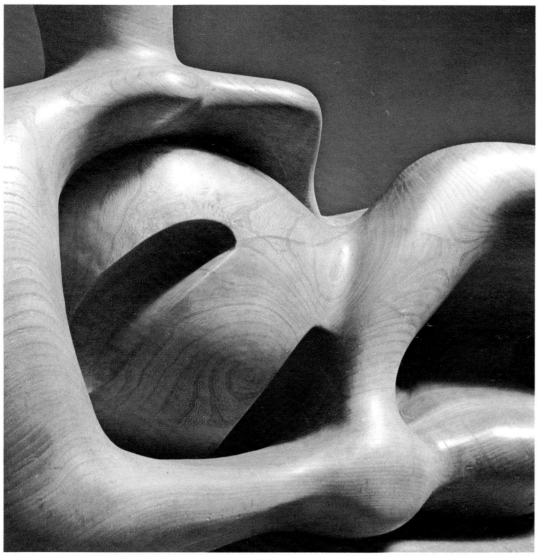

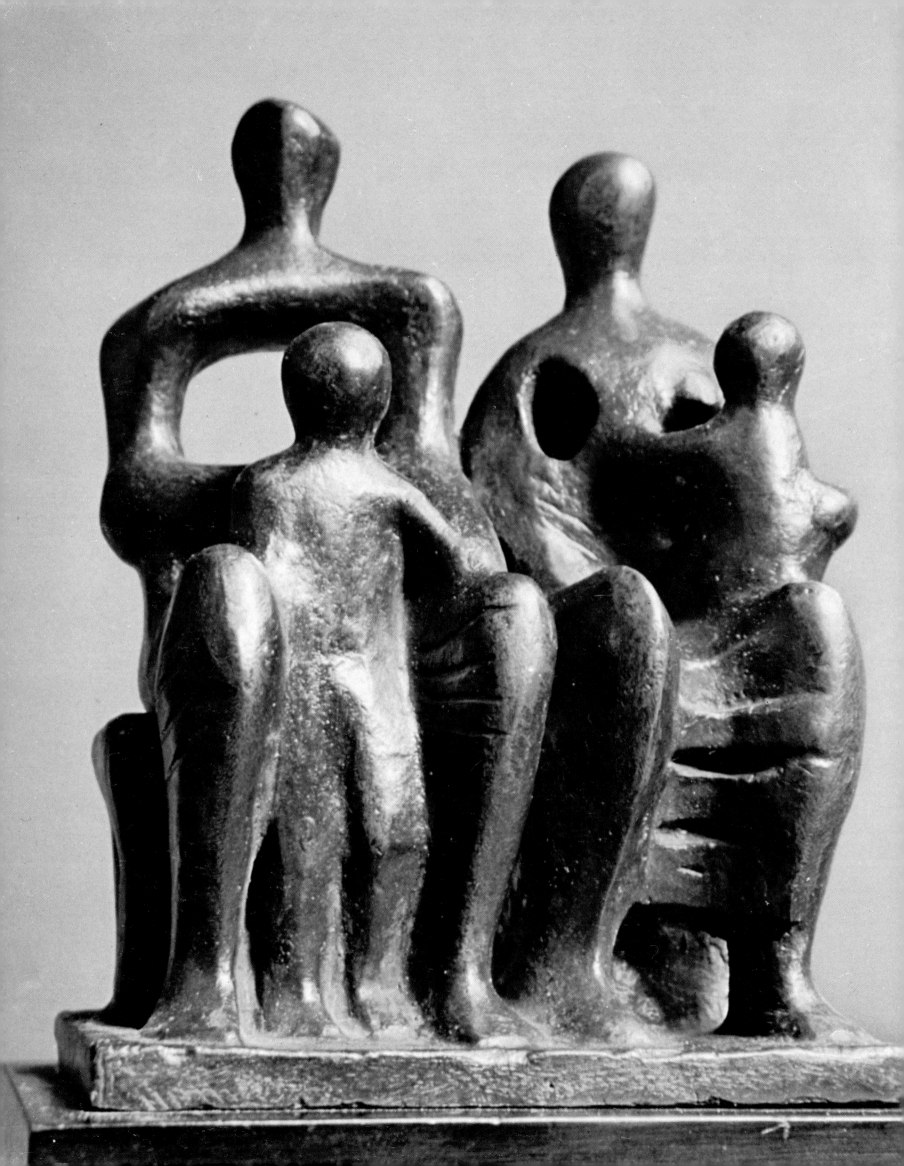

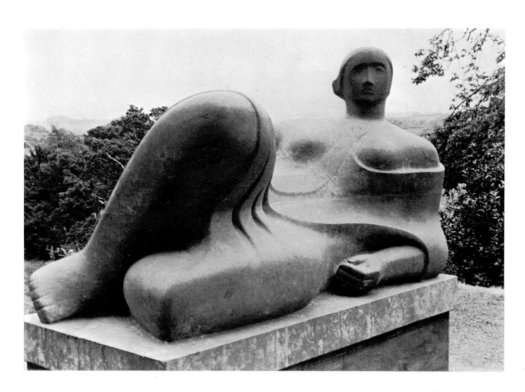

82

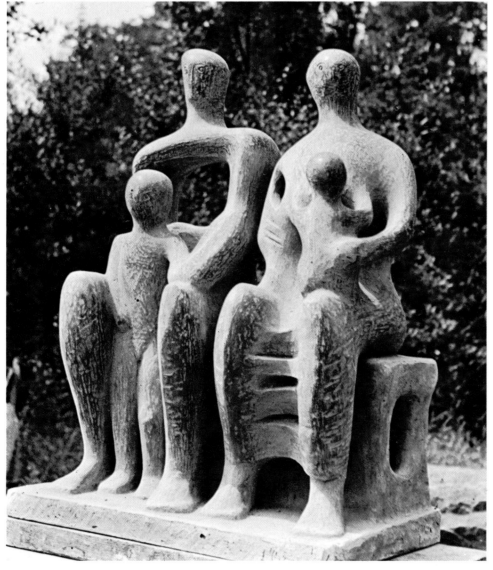

83

81

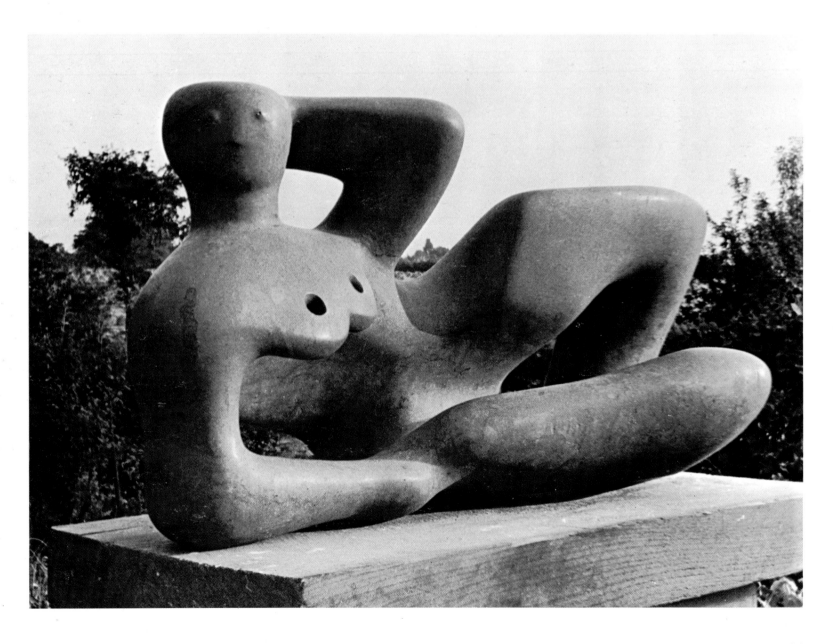

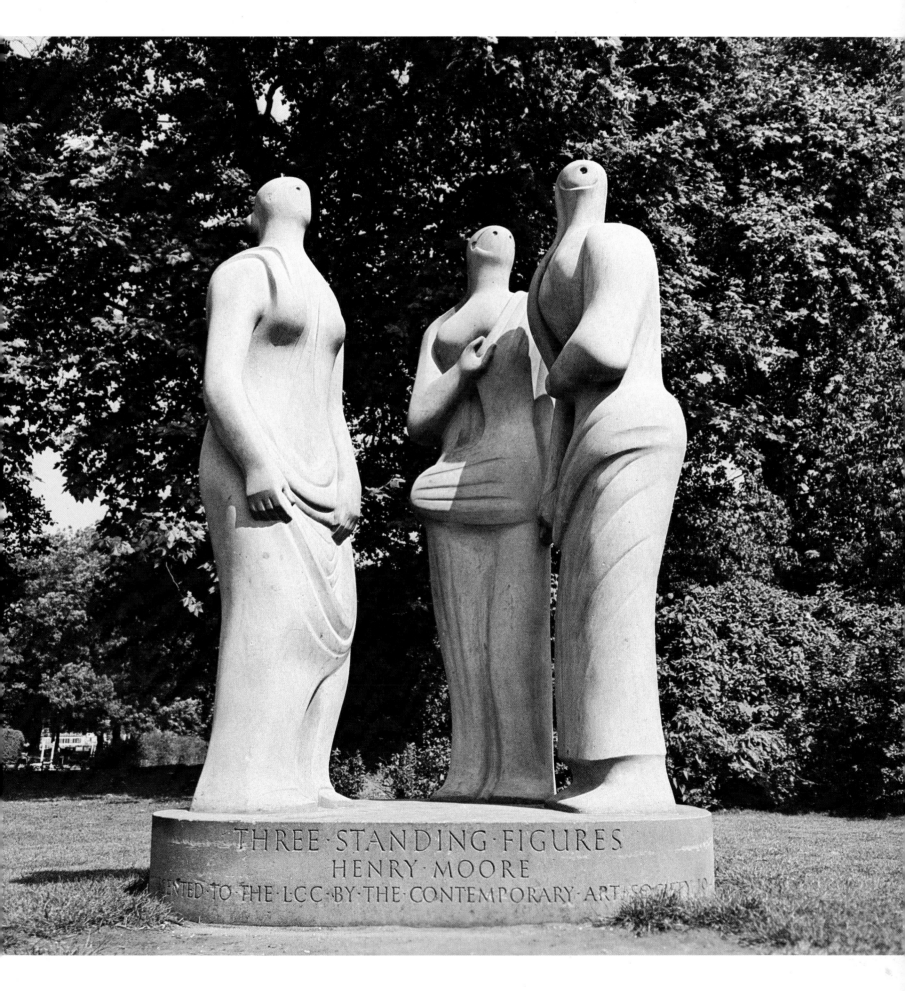

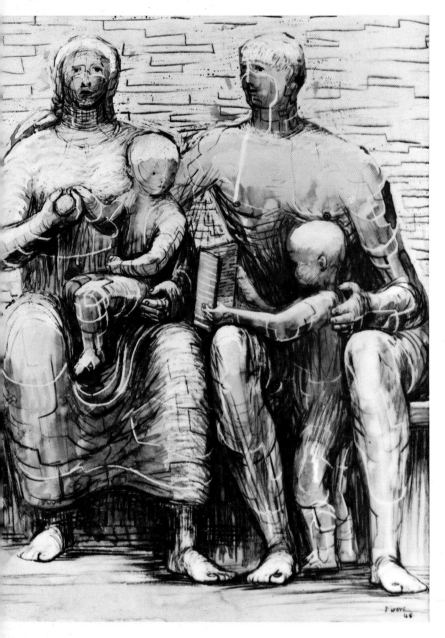 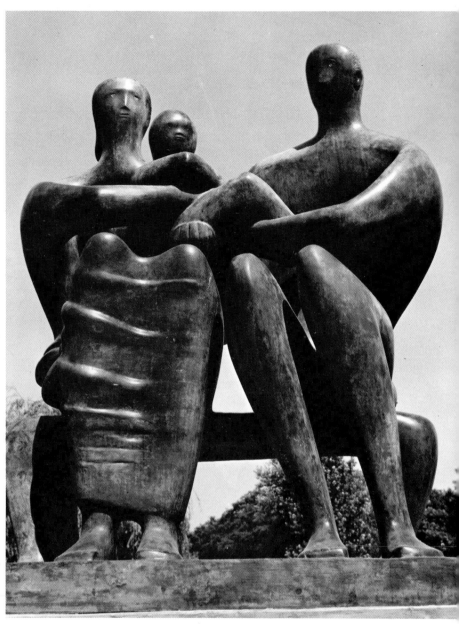

86

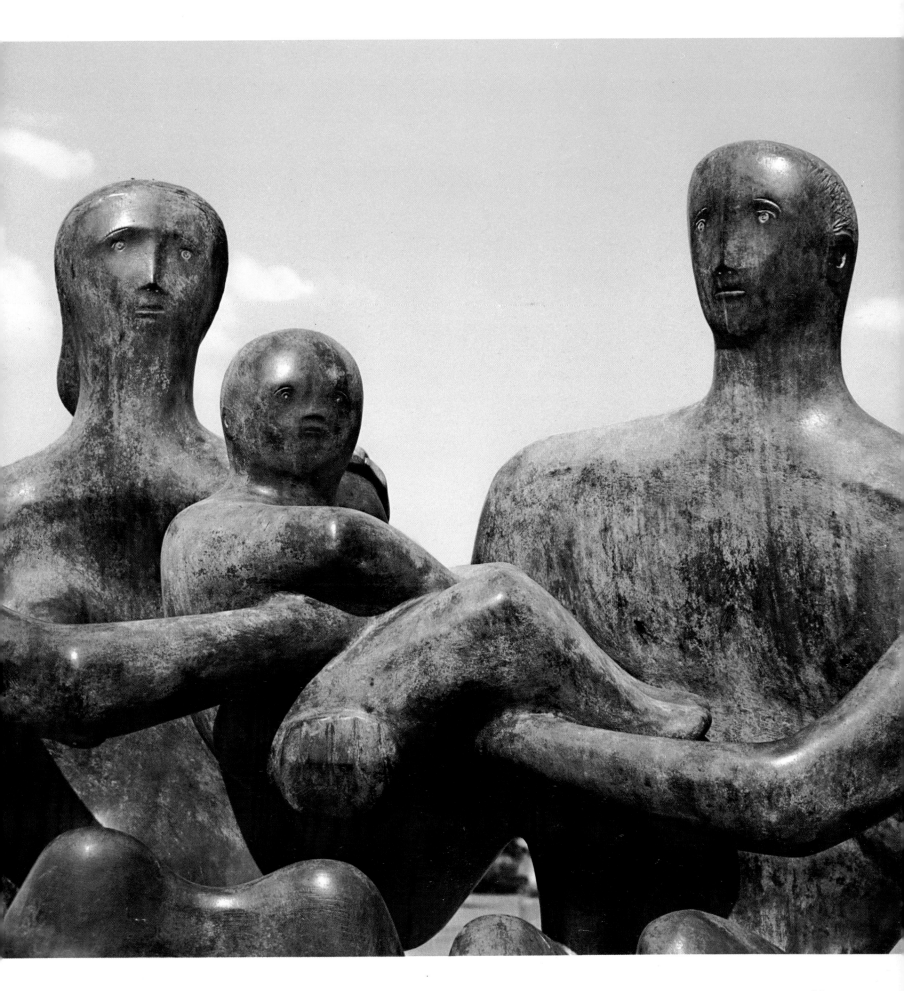

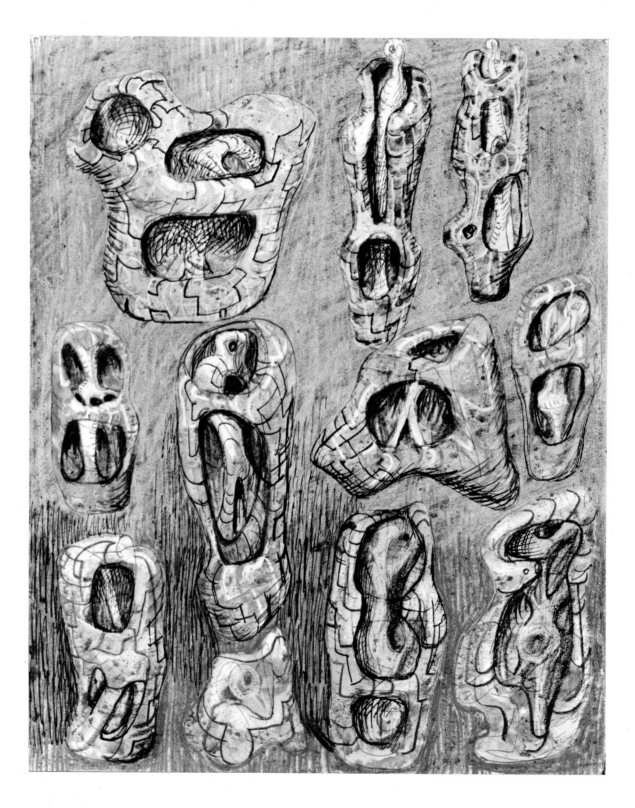

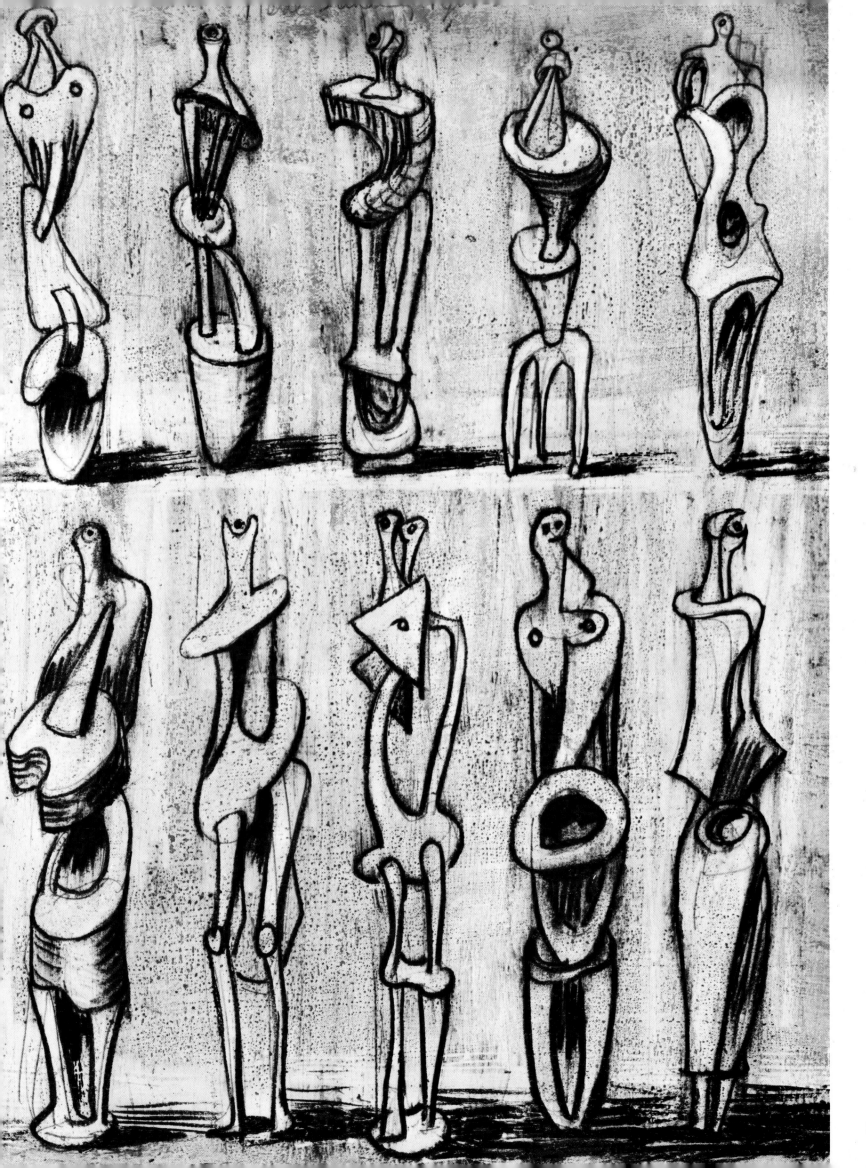

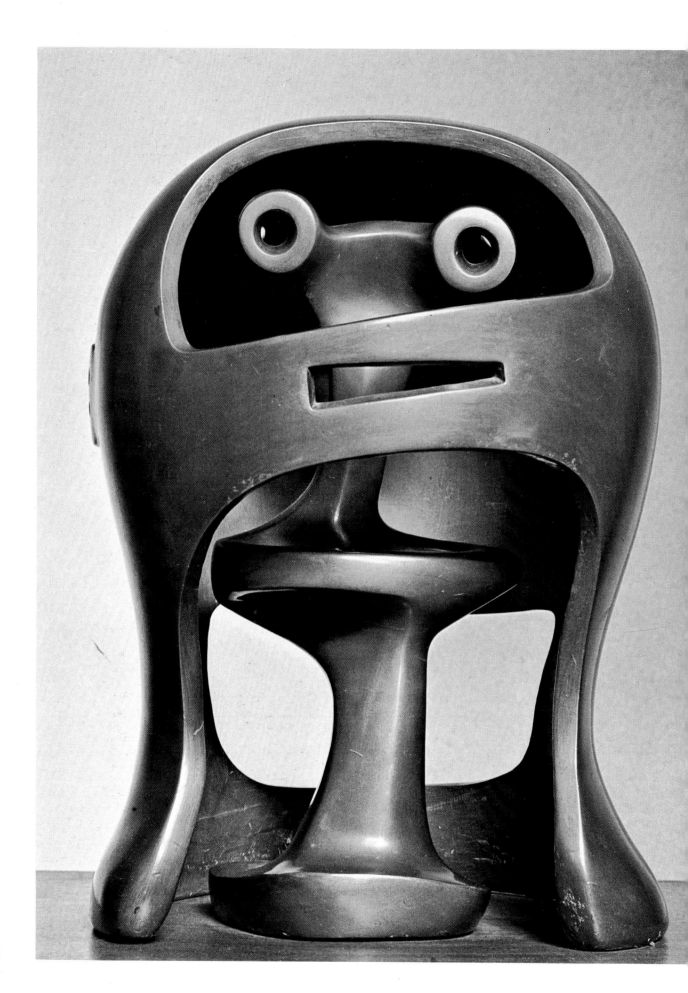

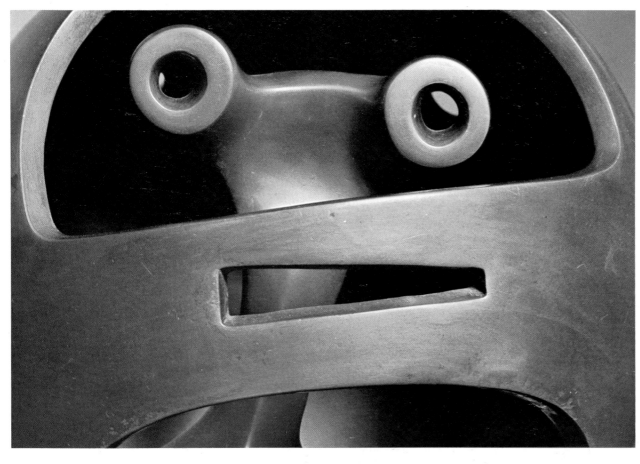

92

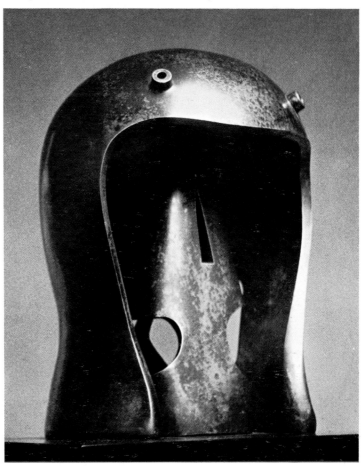

93

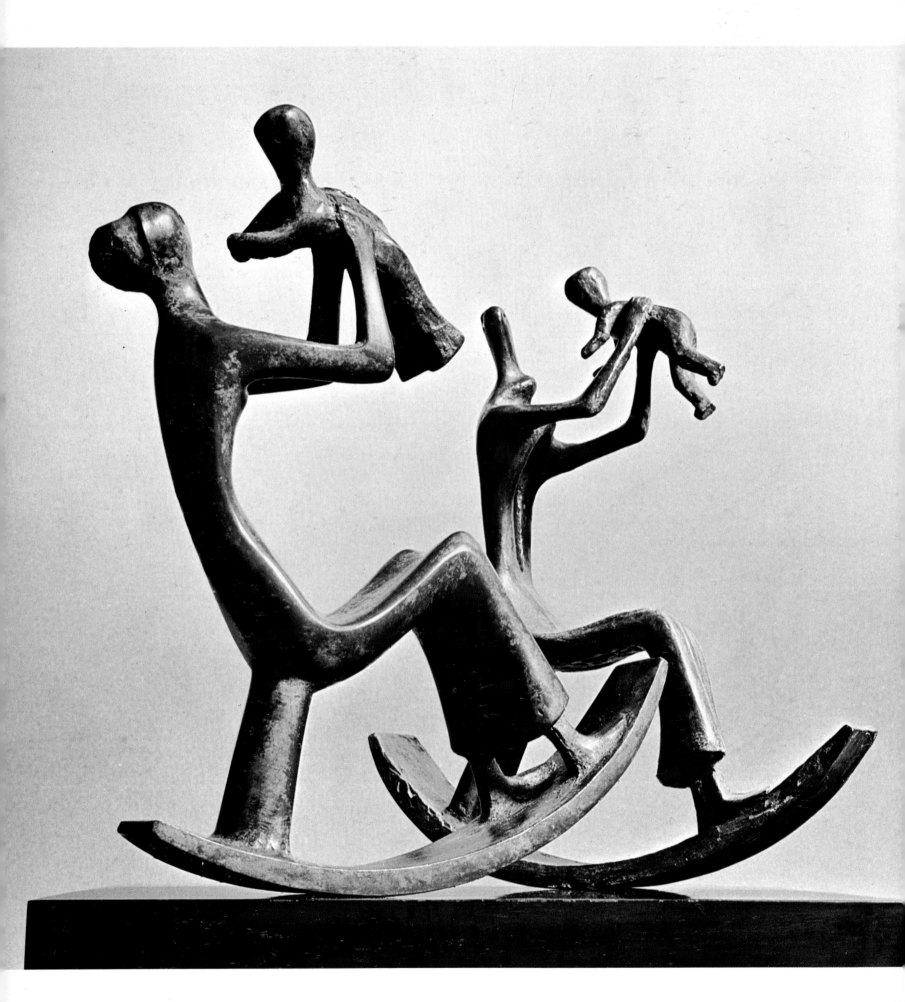

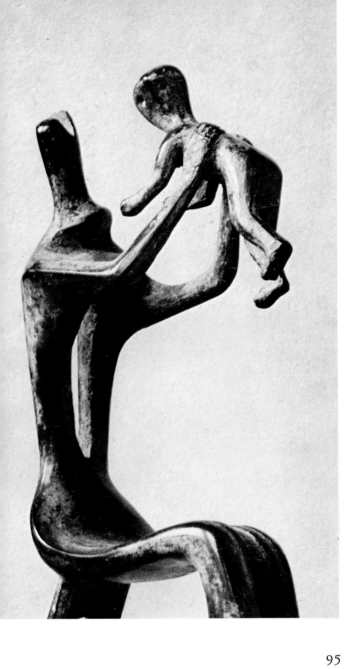

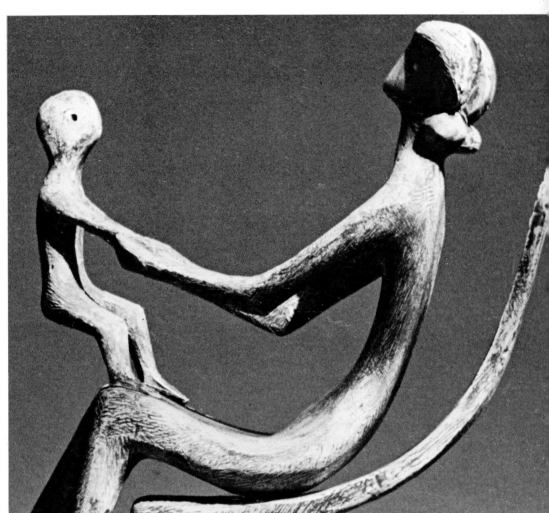

95

96

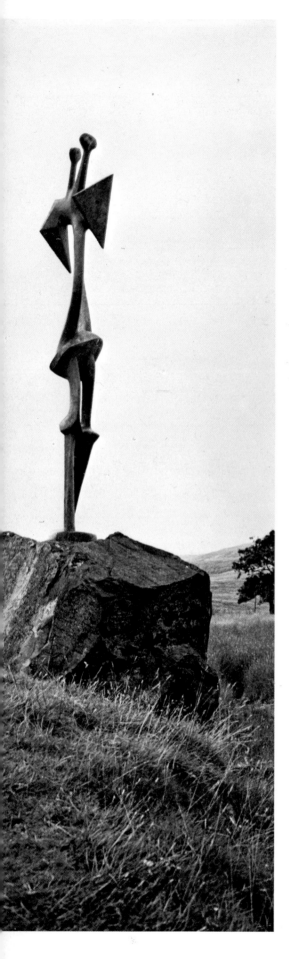

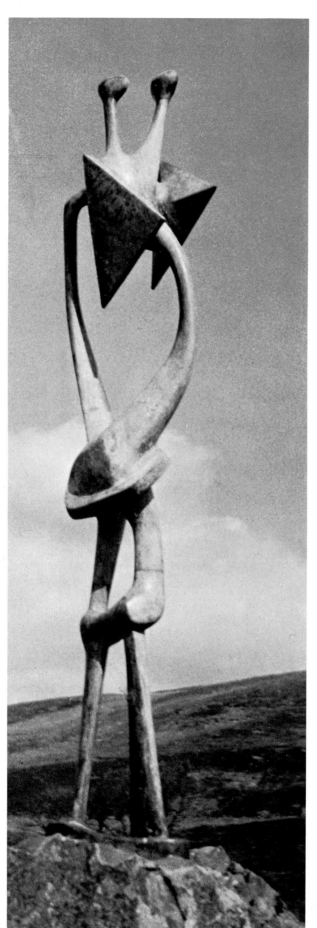

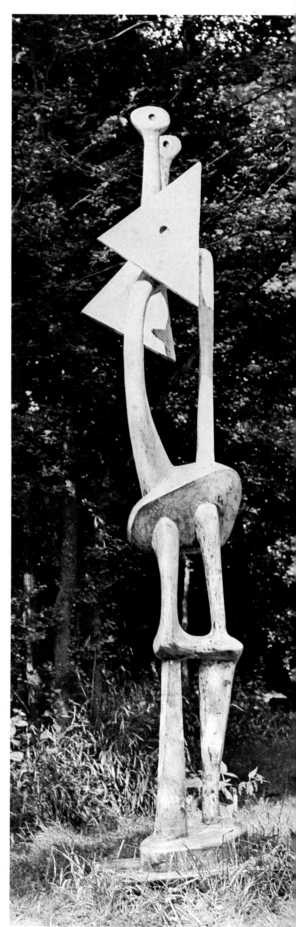

97

98

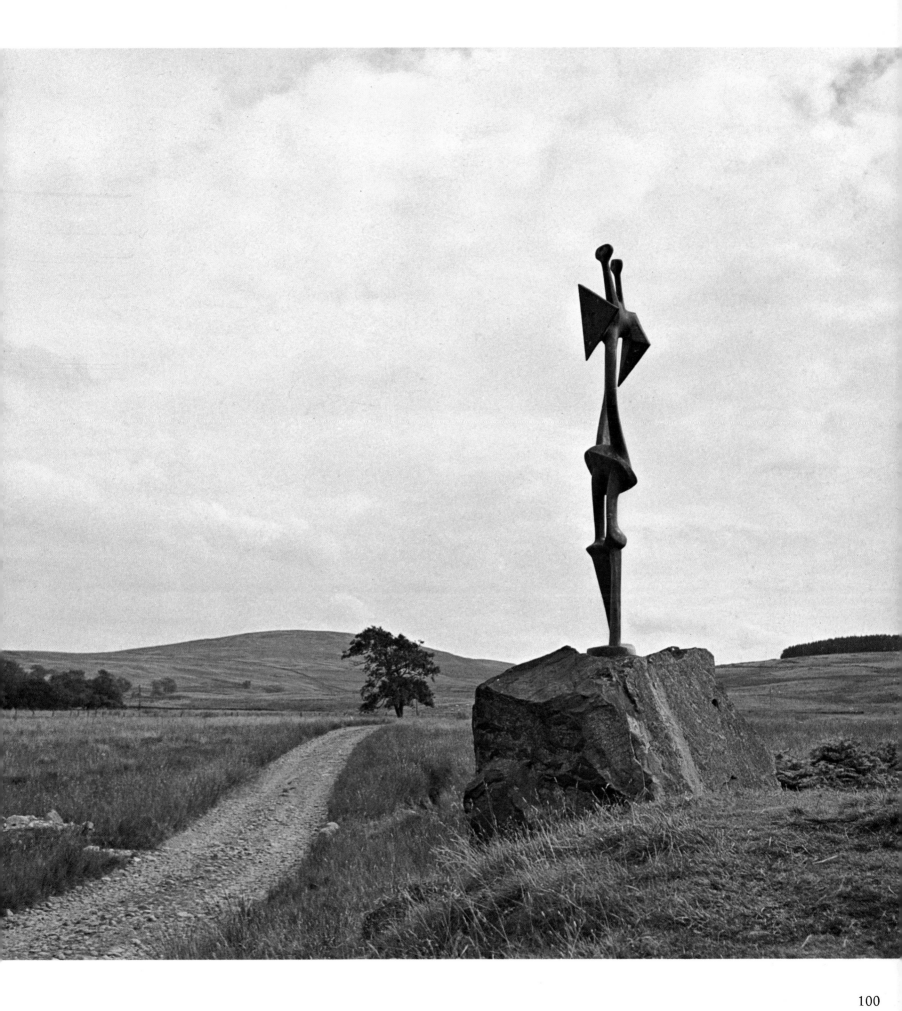

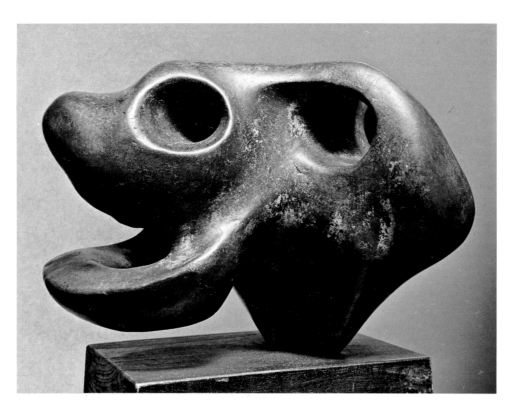

101

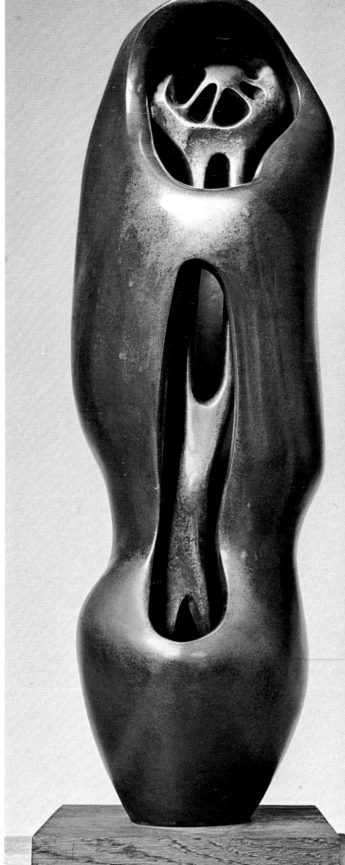

102

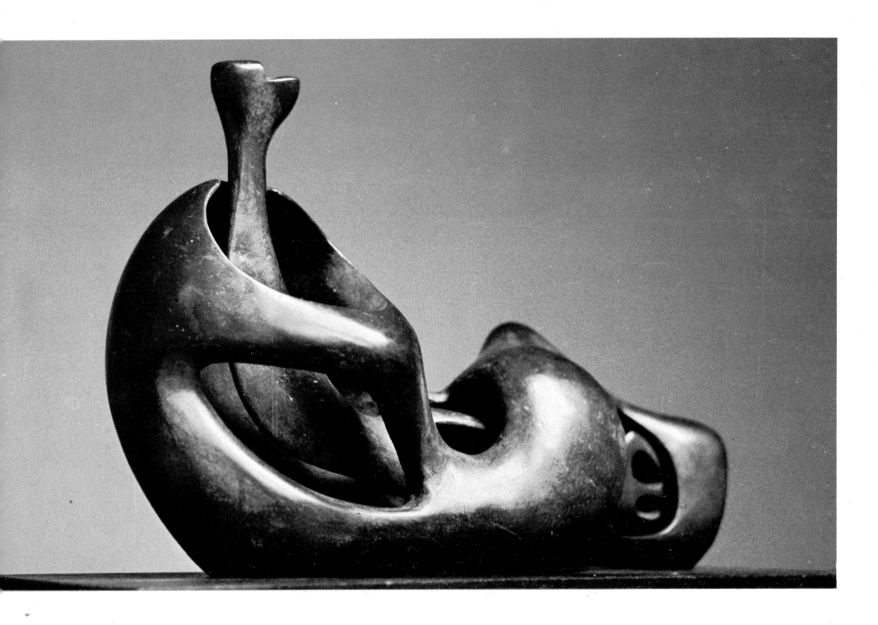

103

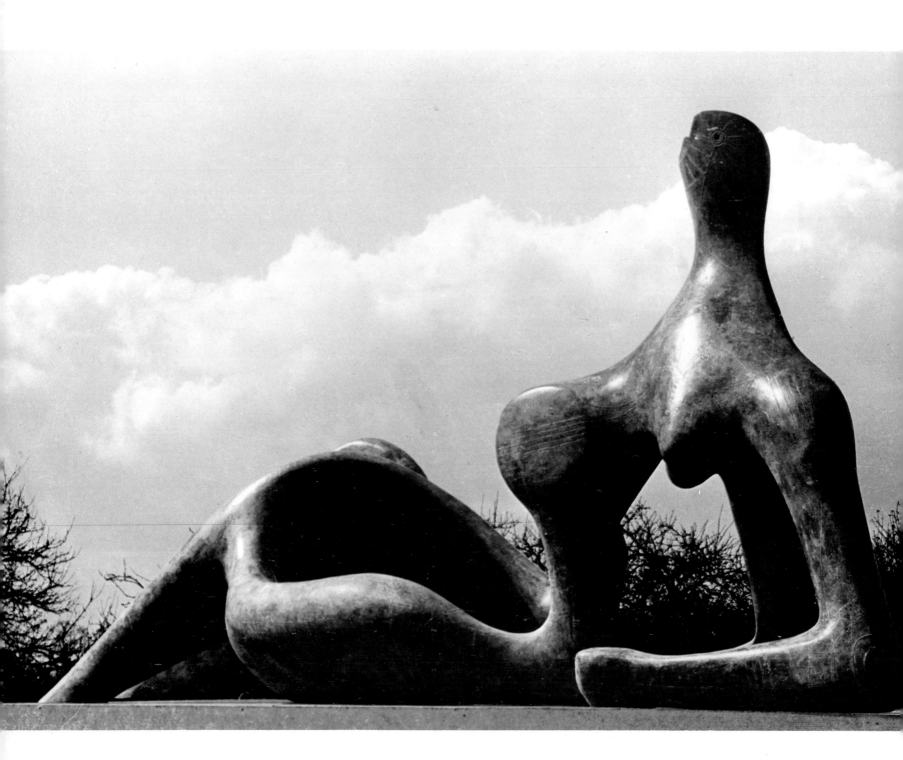

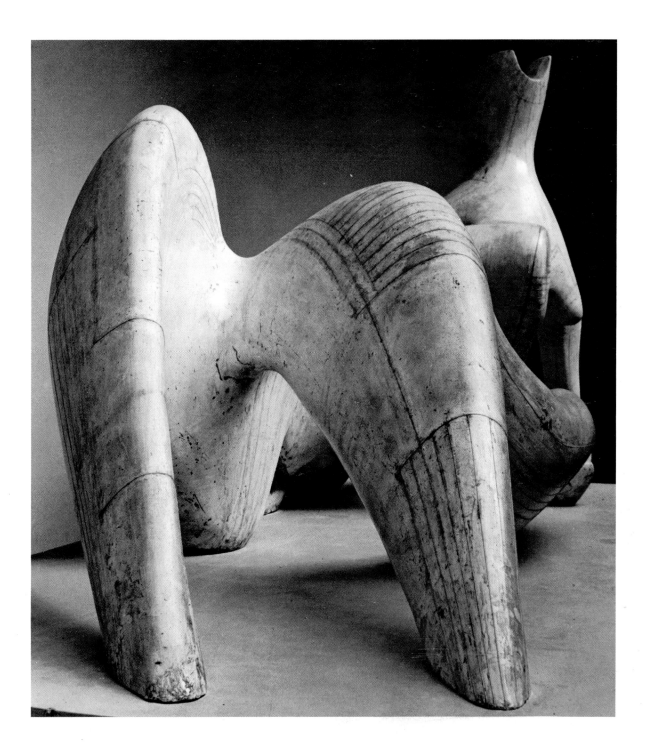

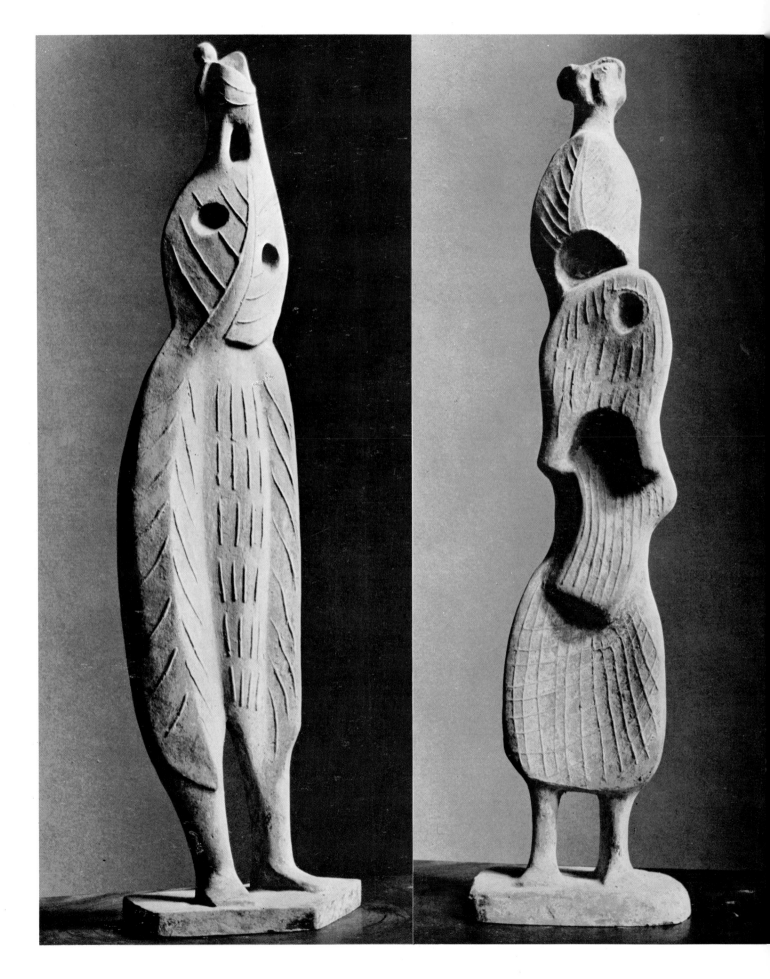

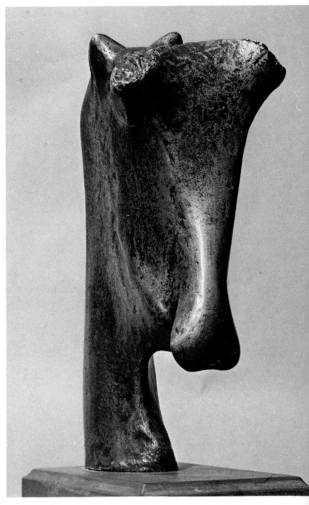

109

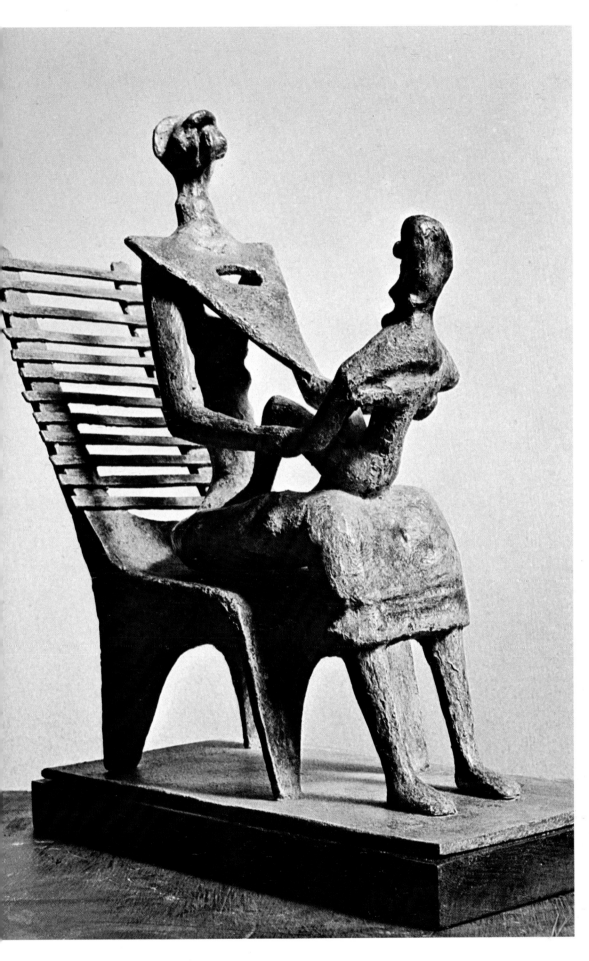

108

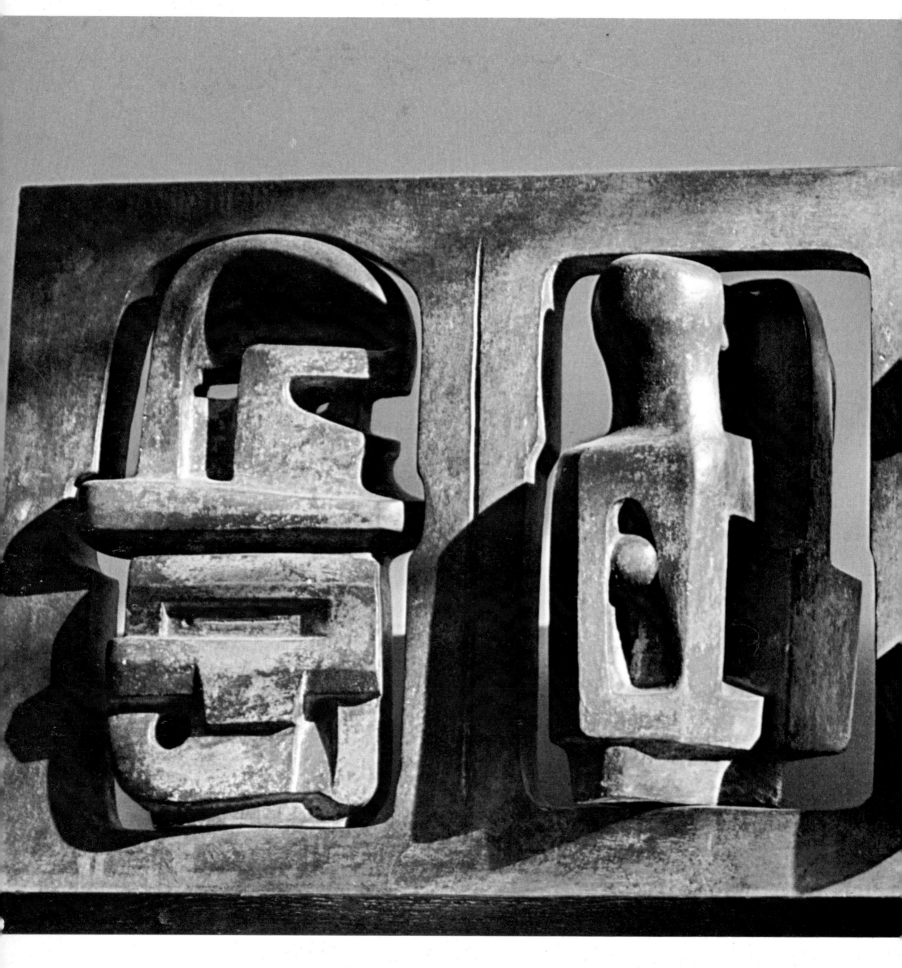

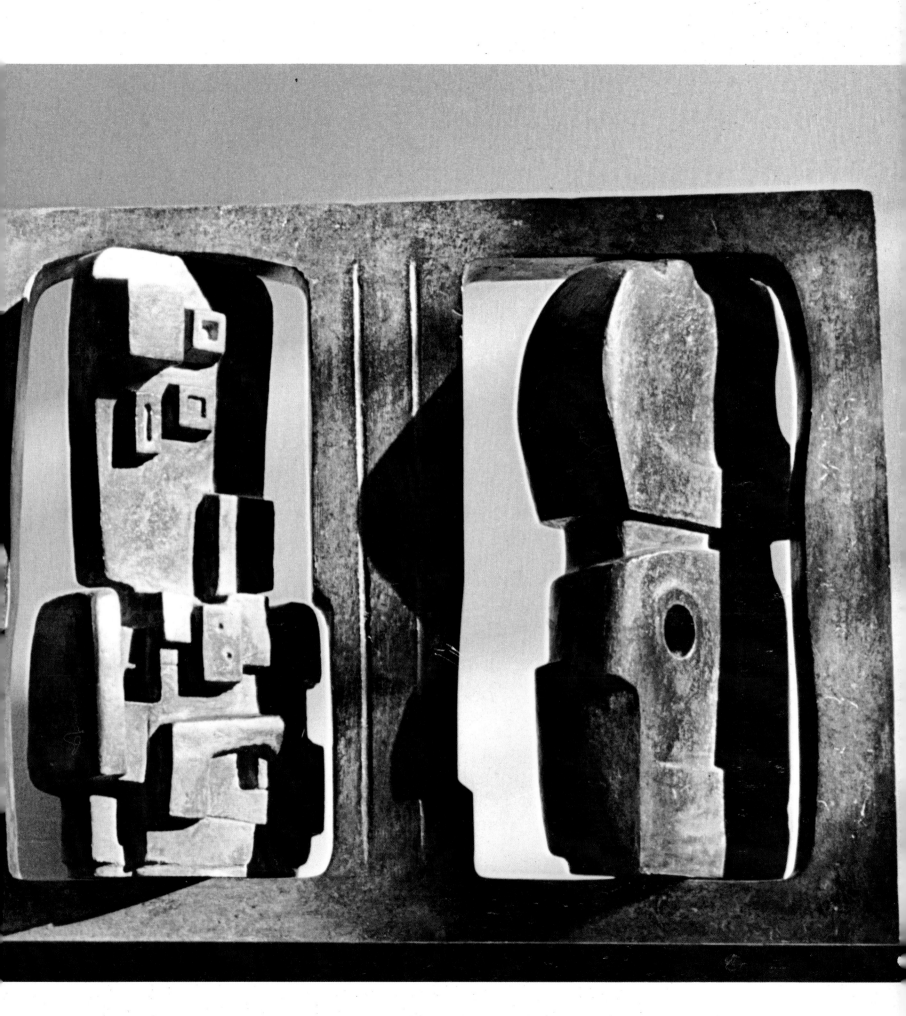

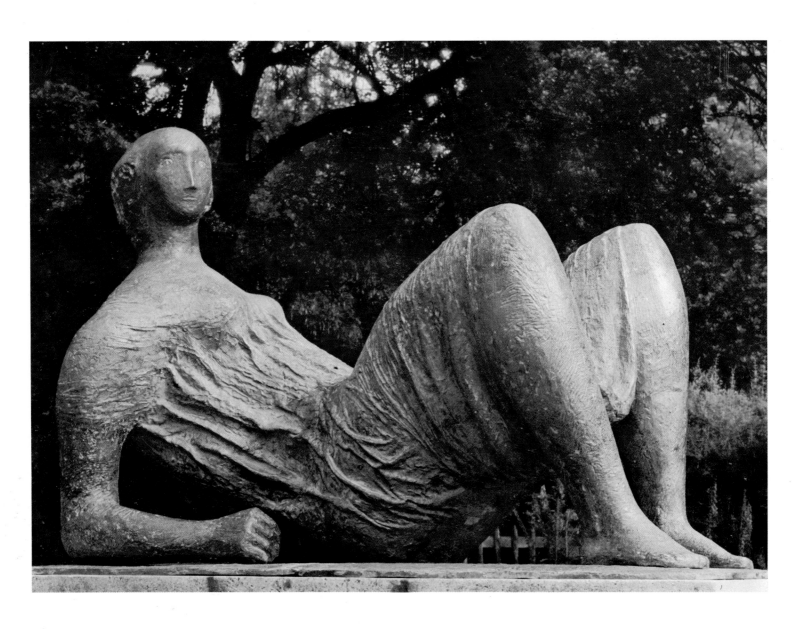

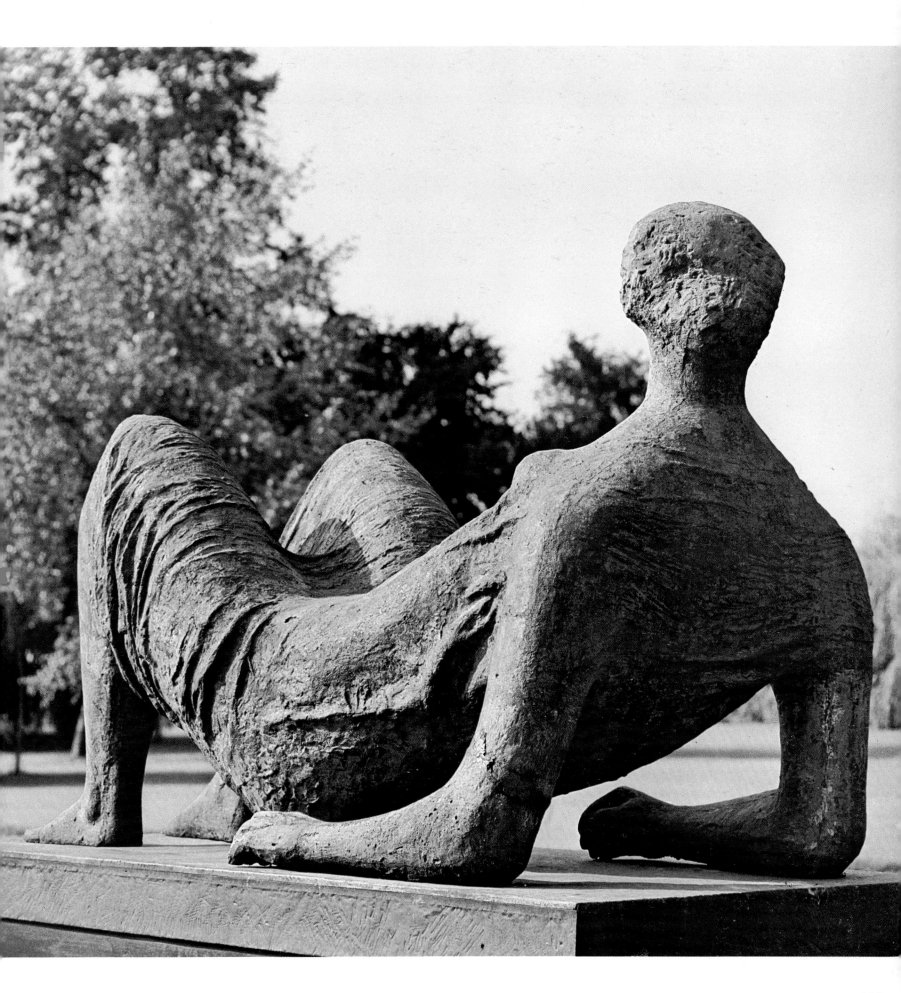

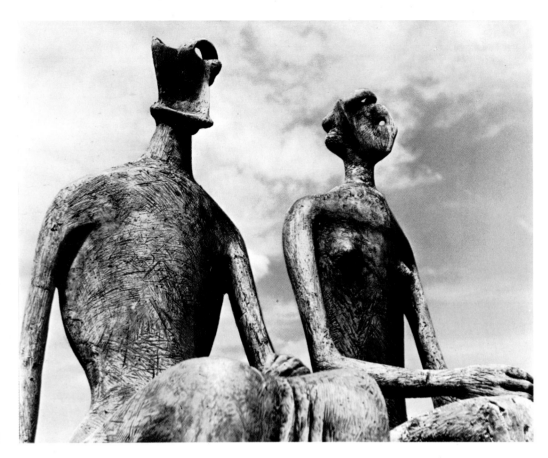

113

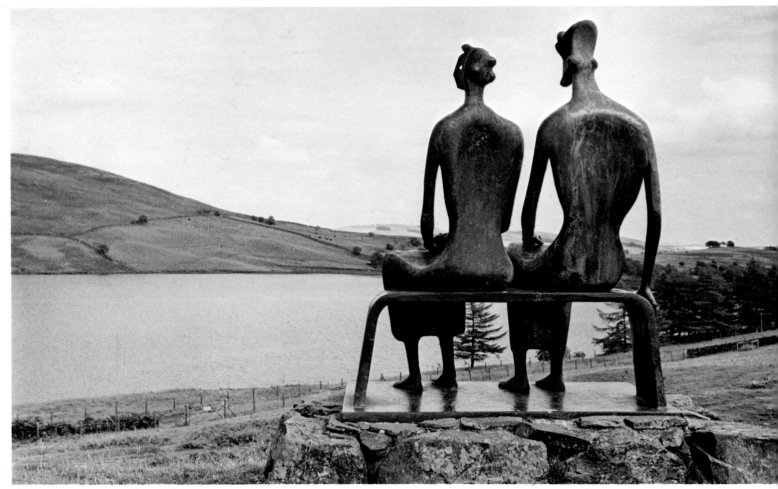

114

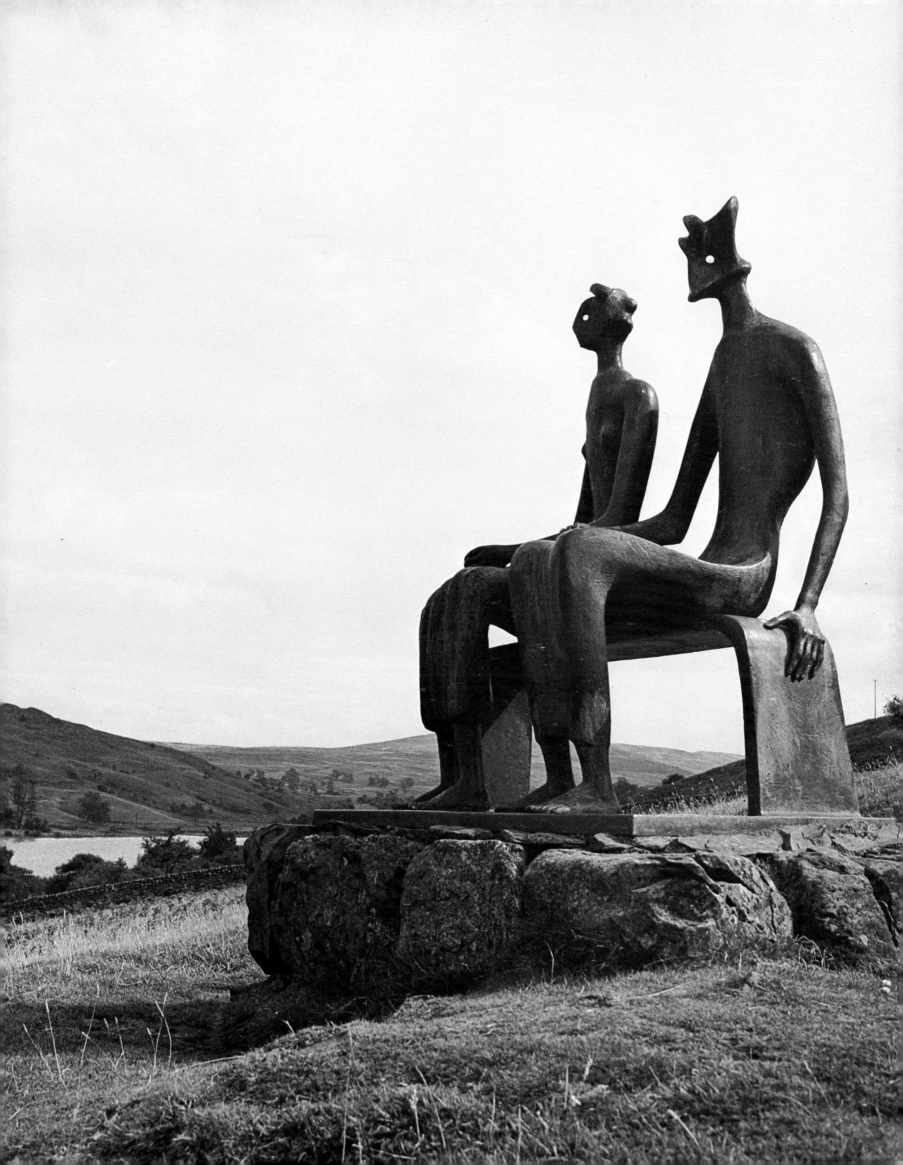

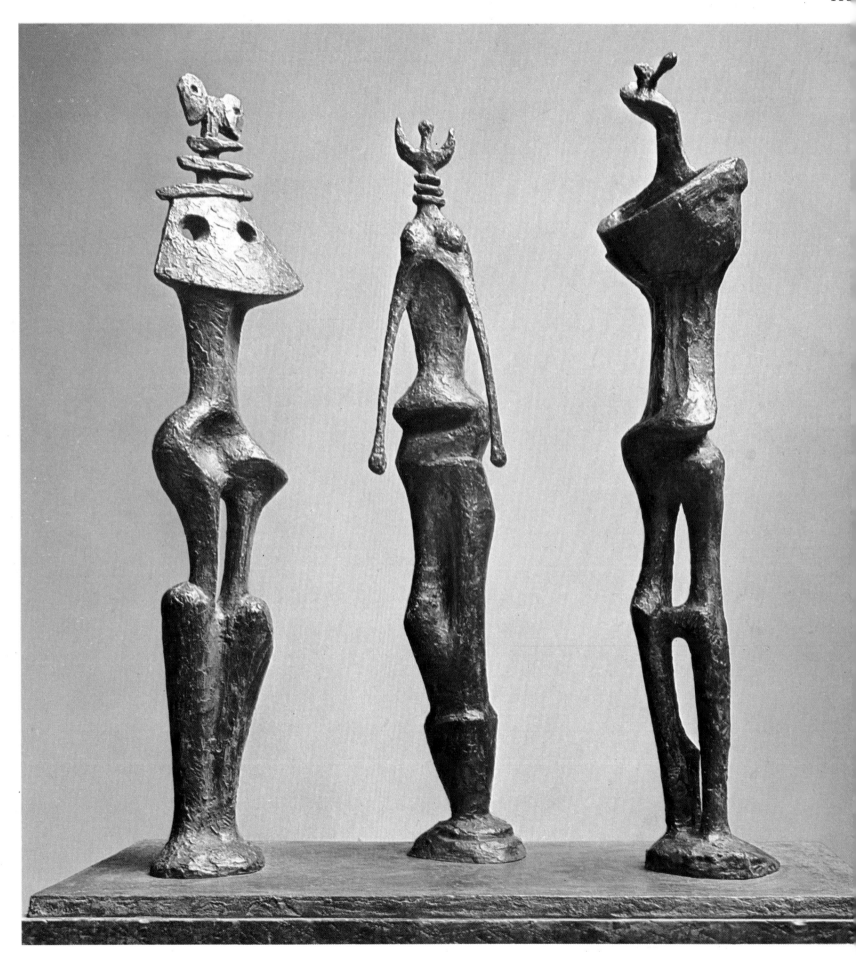

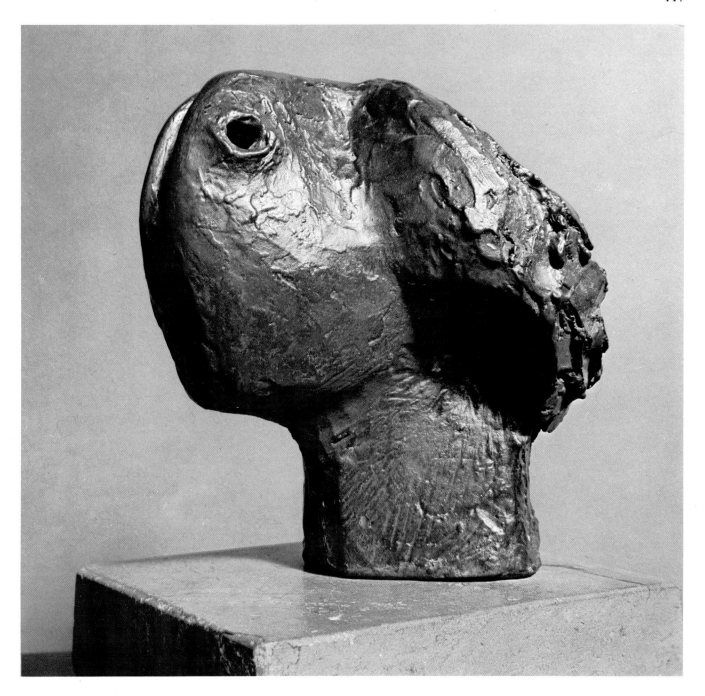

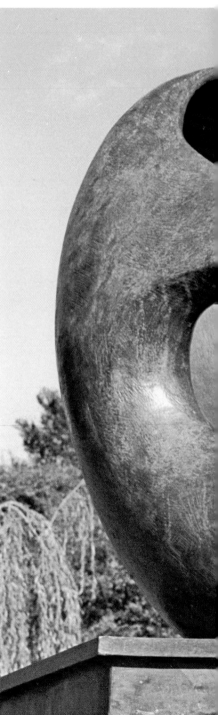

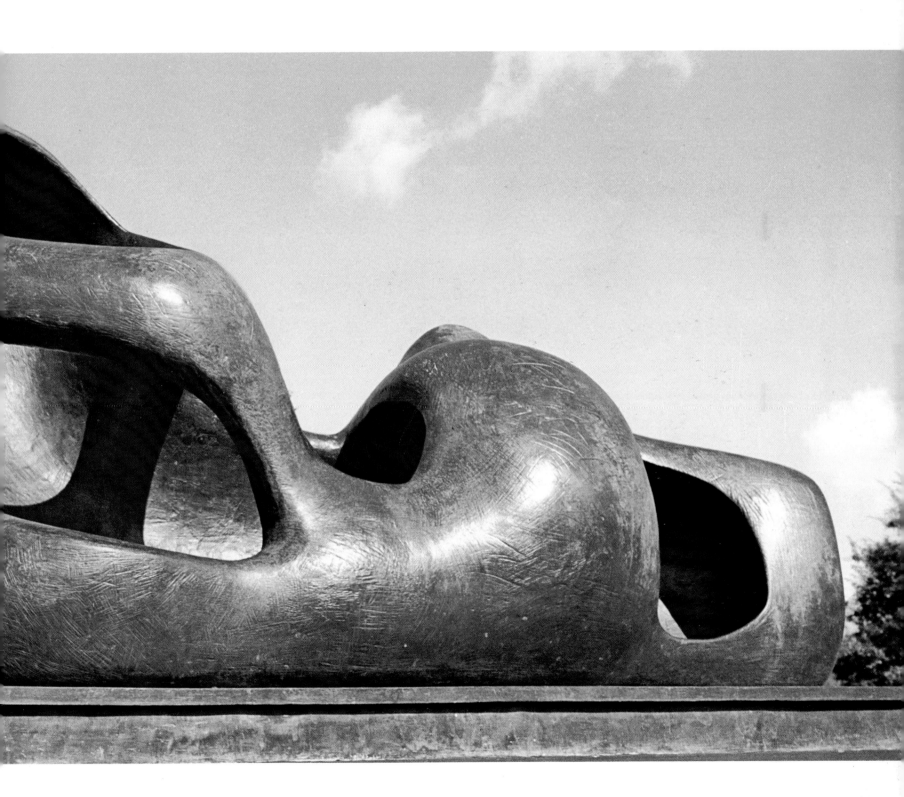

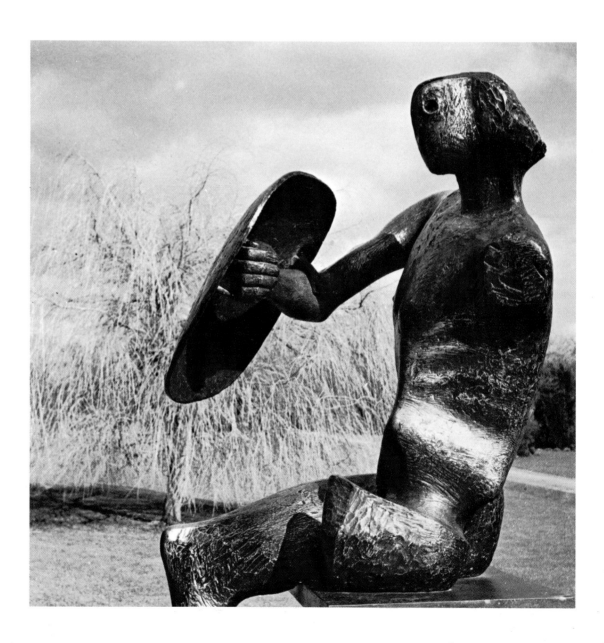

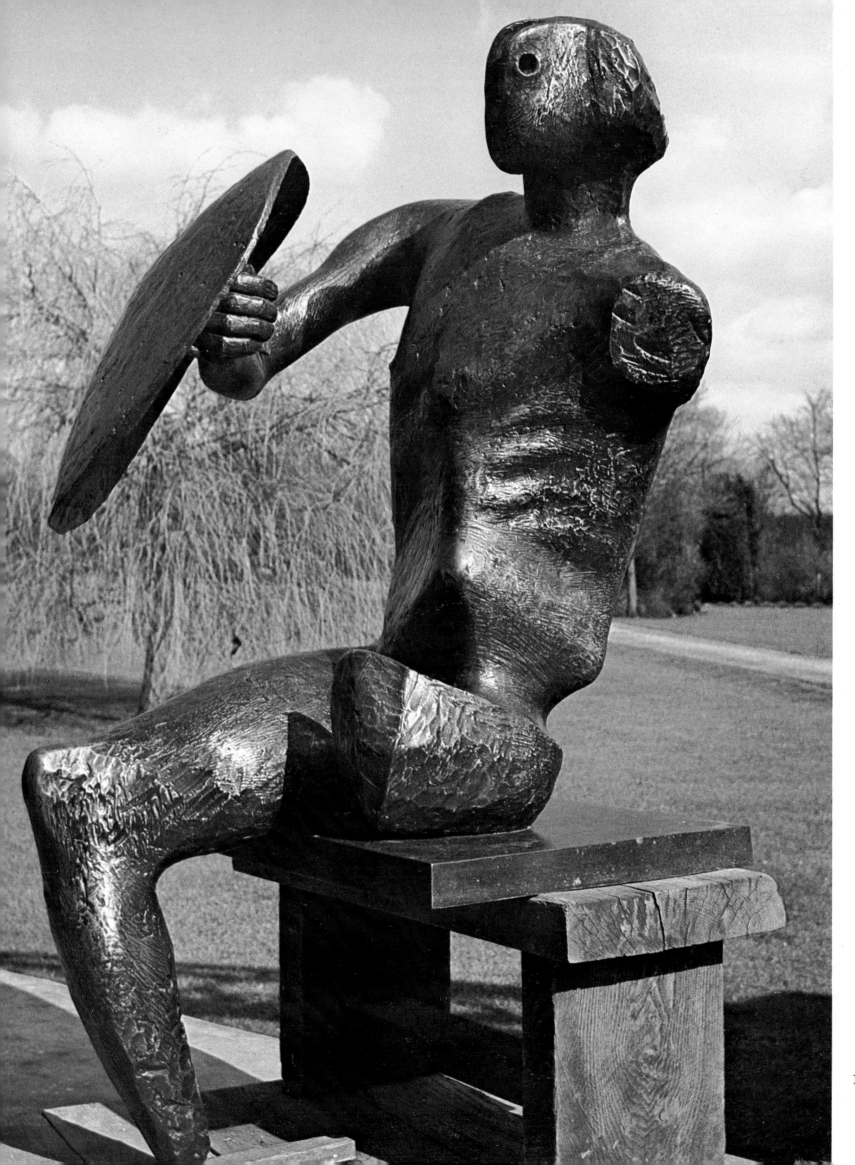

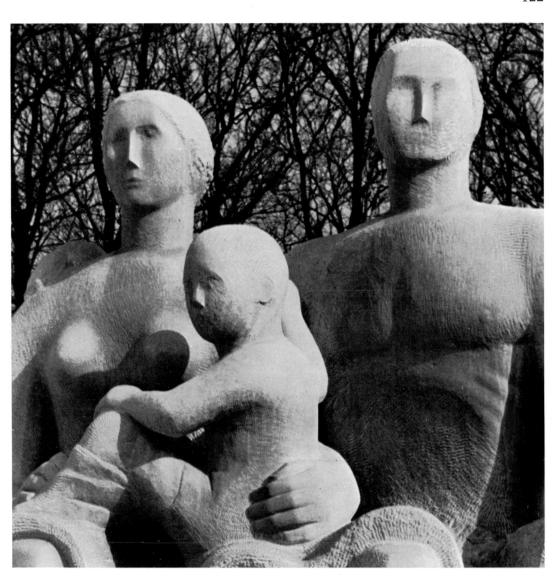

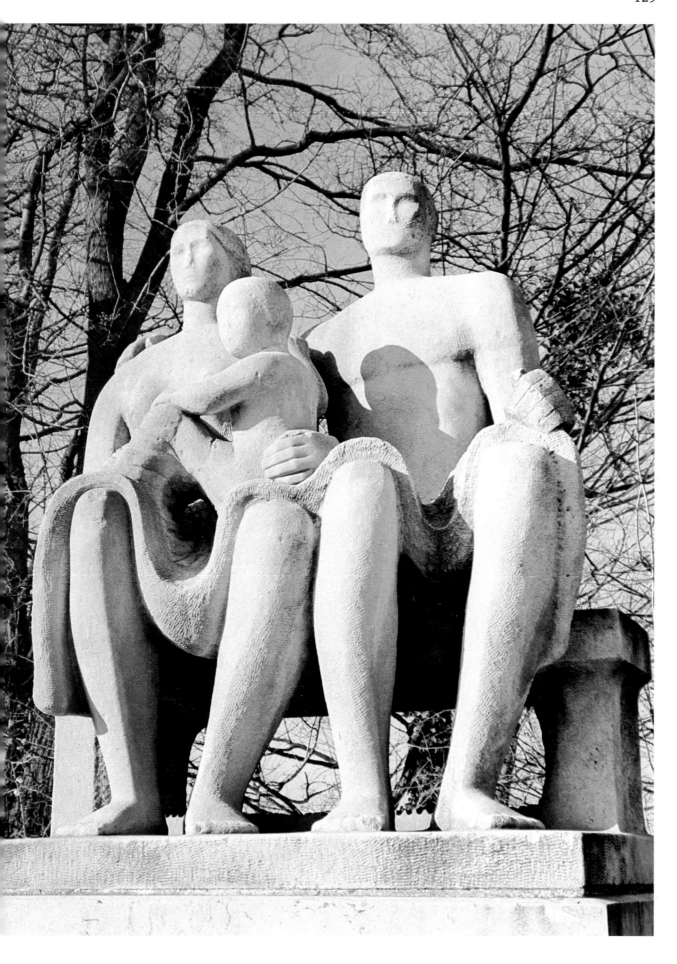

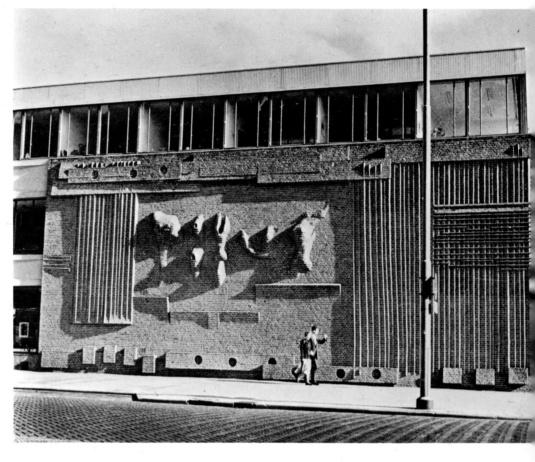

124

125 126

 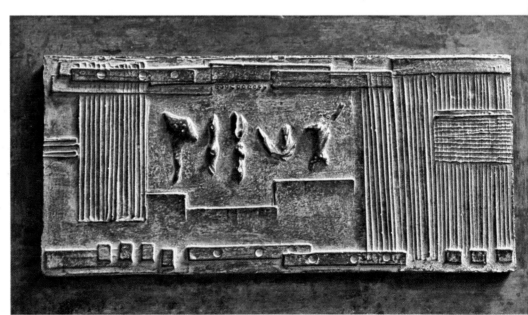

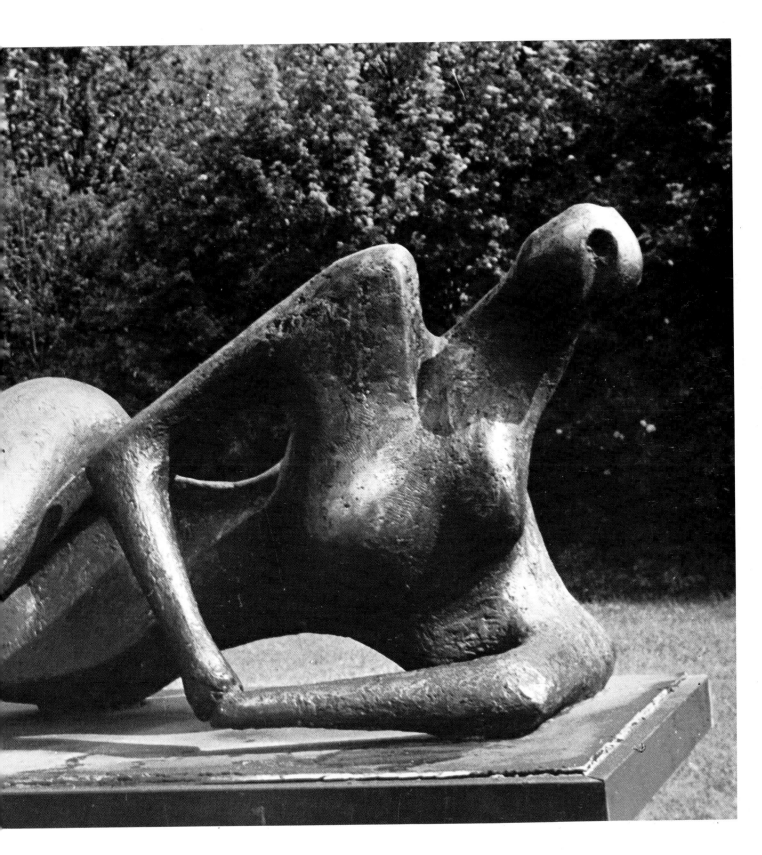

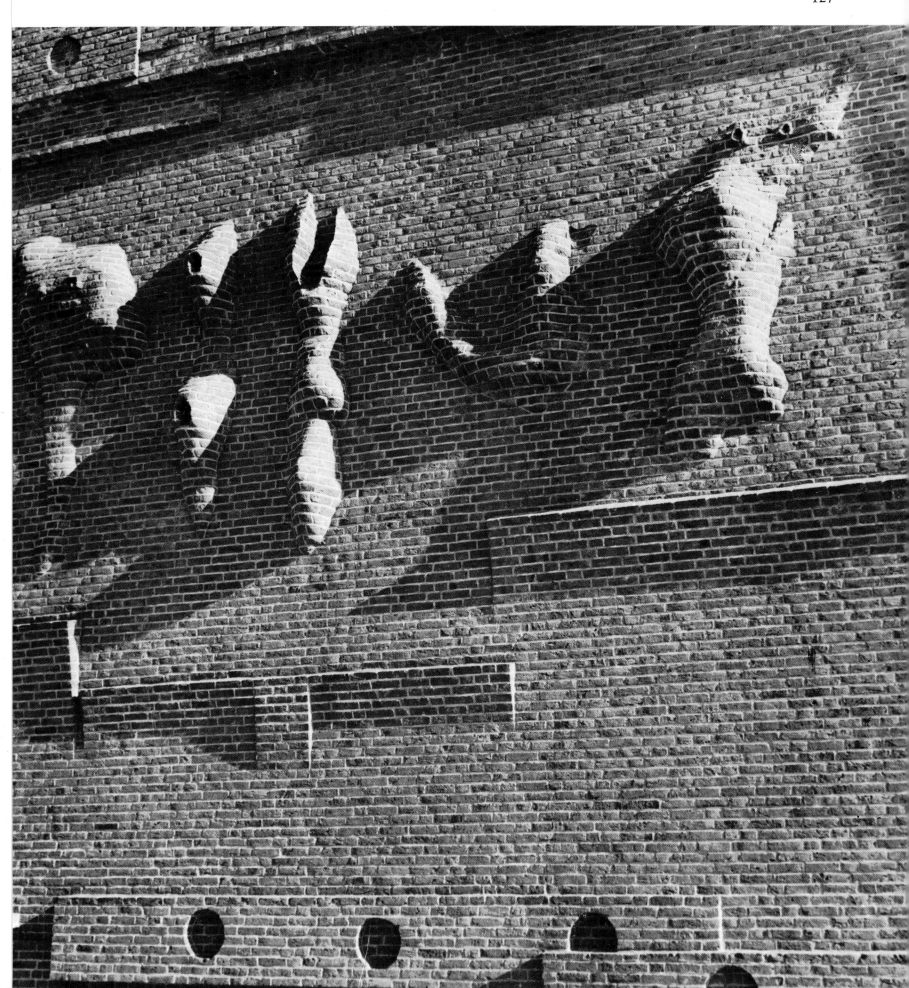

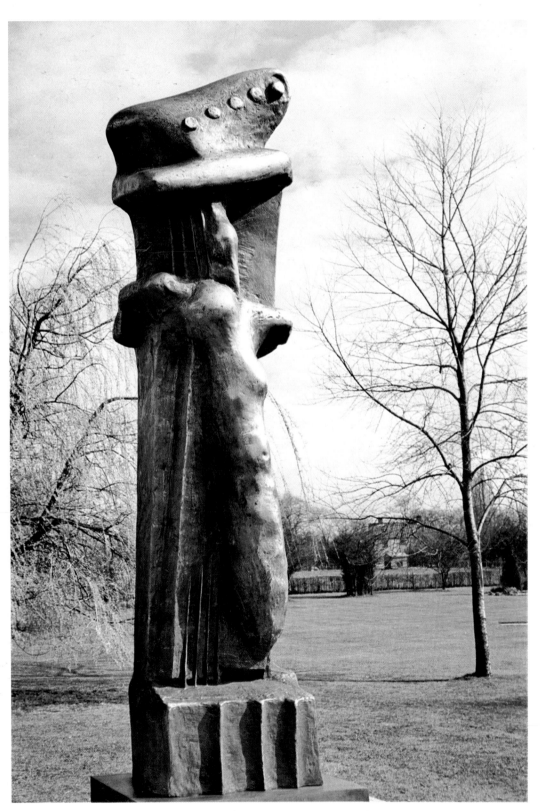

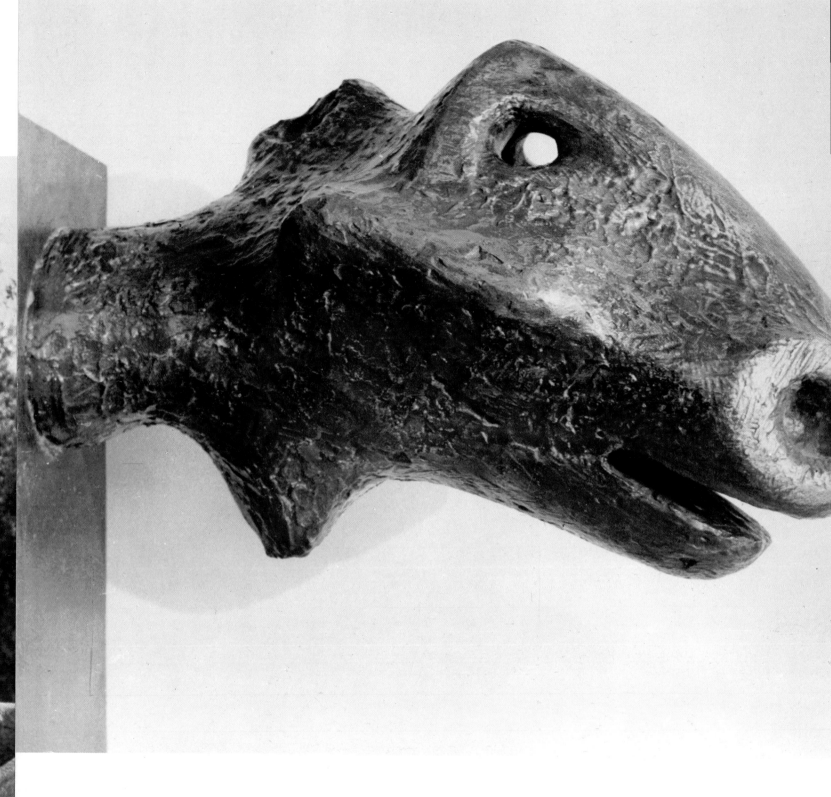

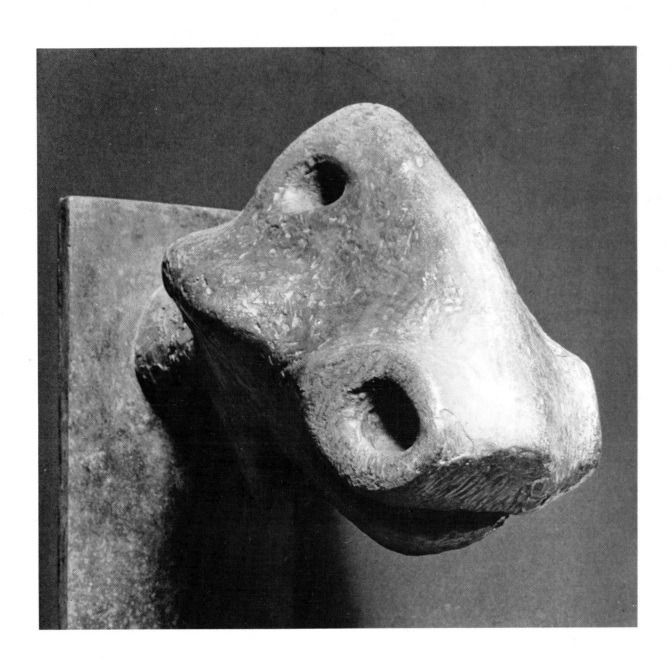

131

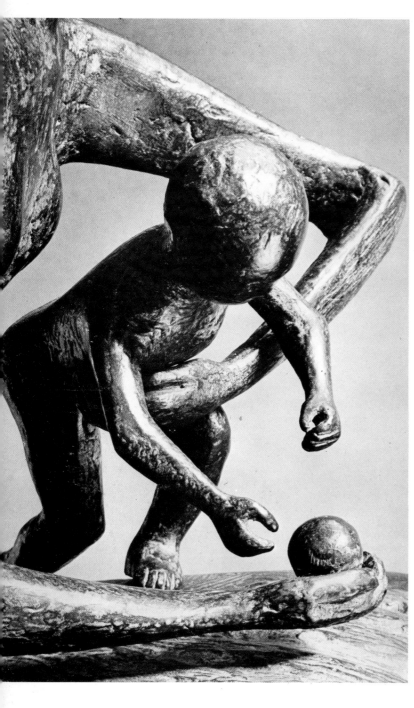

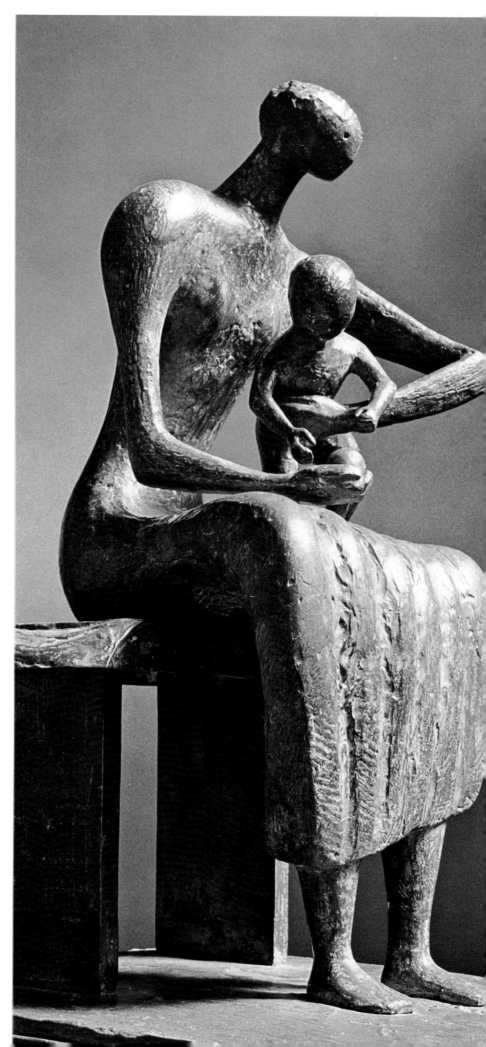

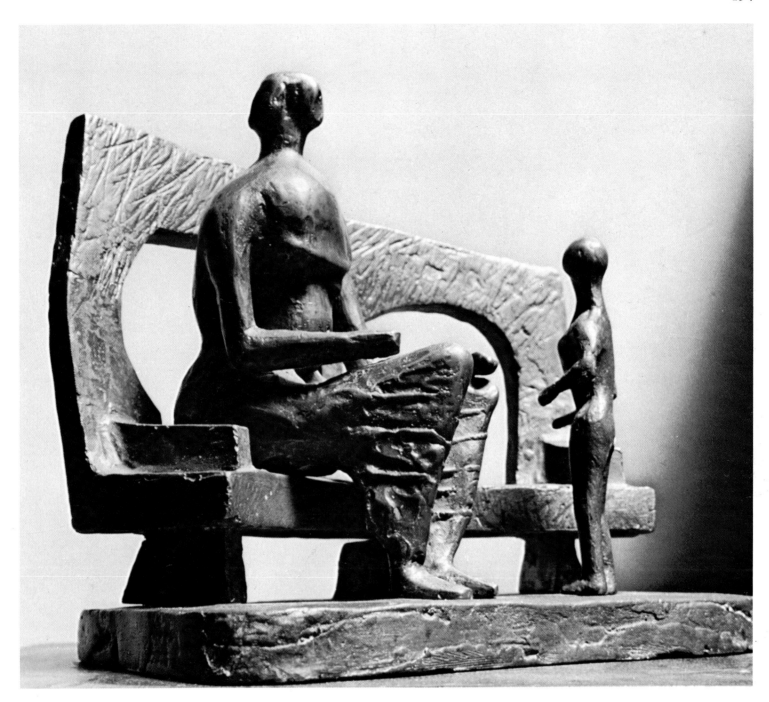

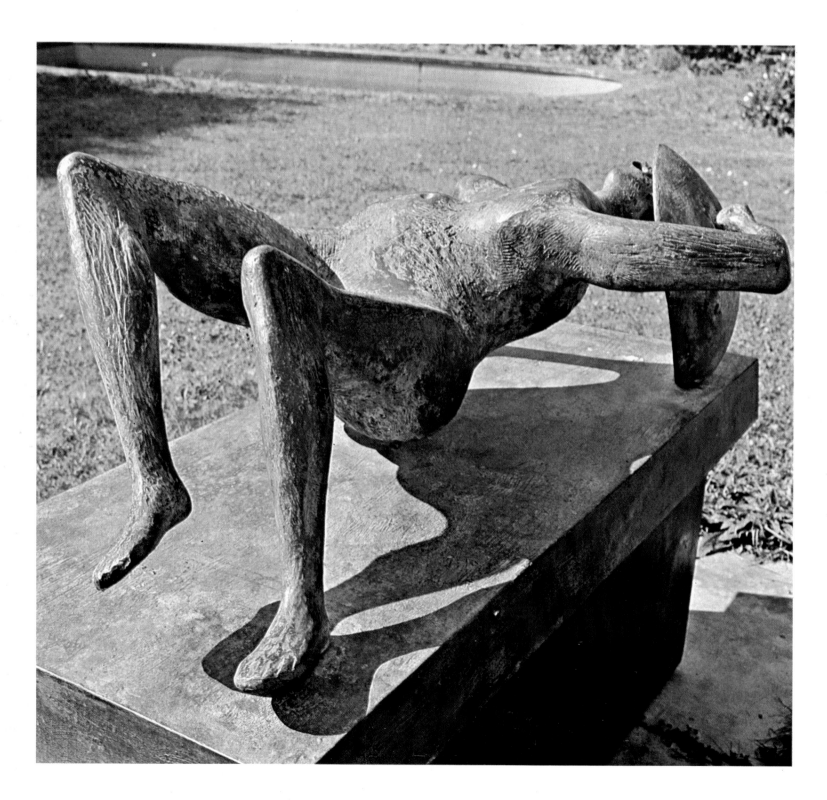

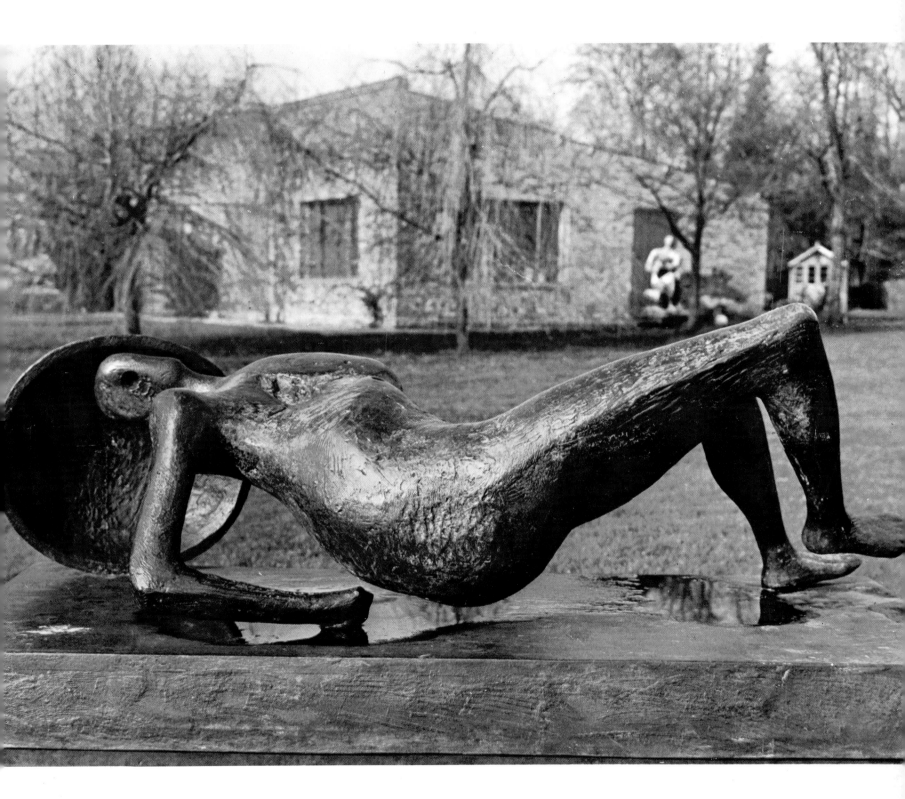

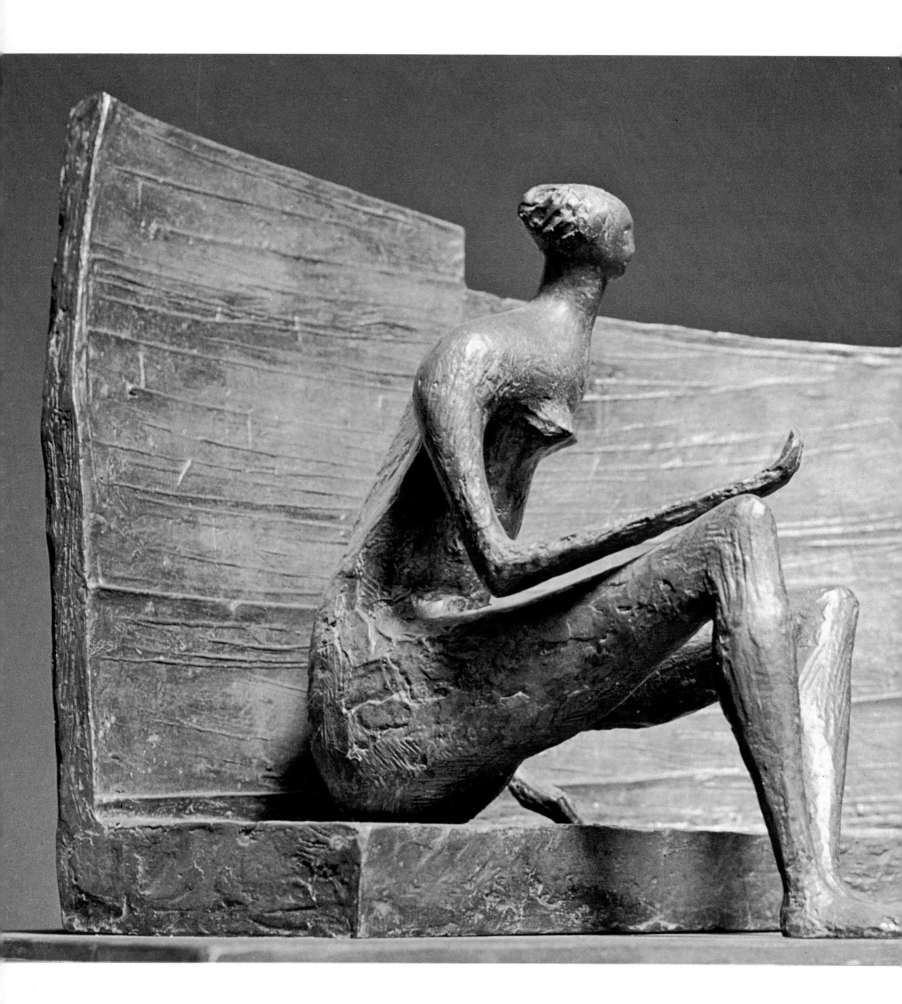

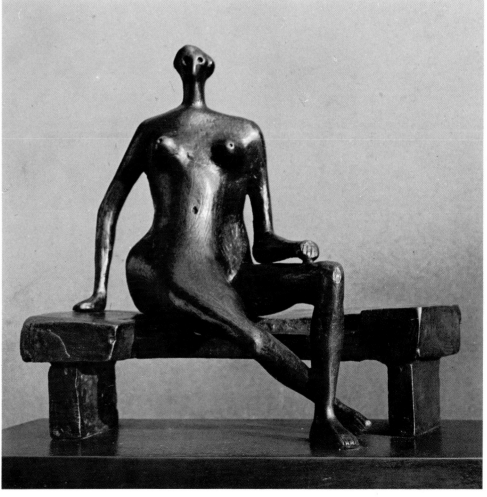

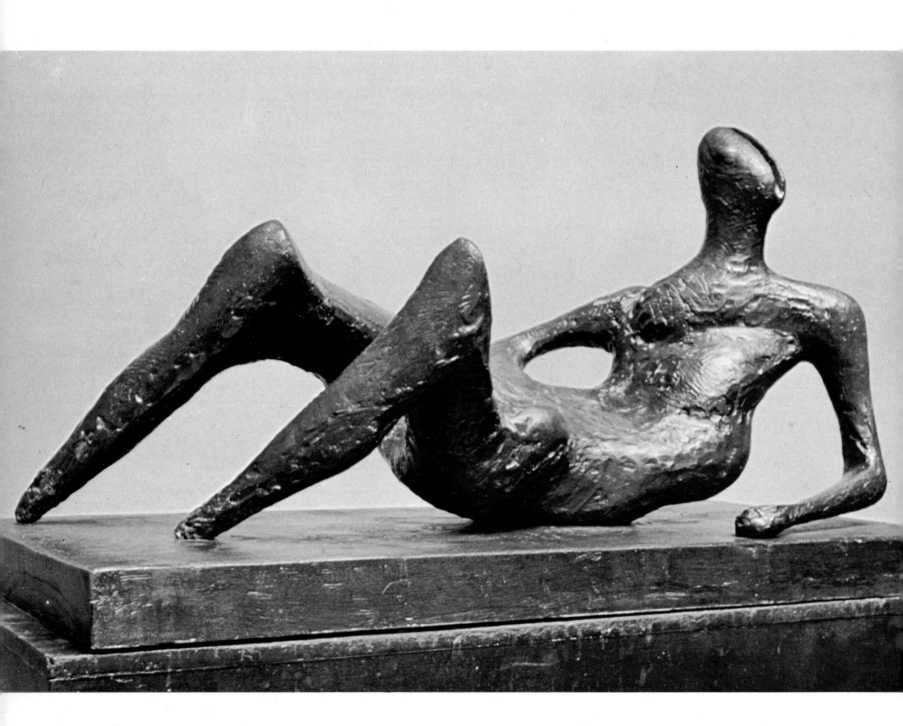

139

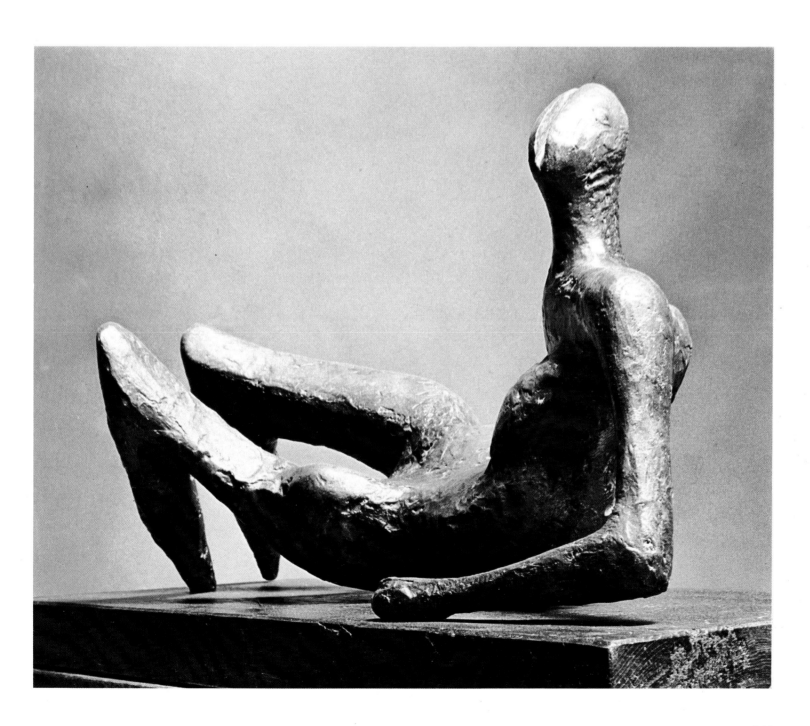

141

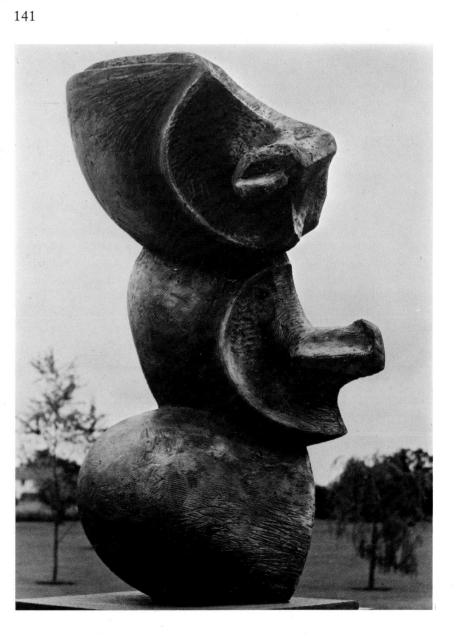

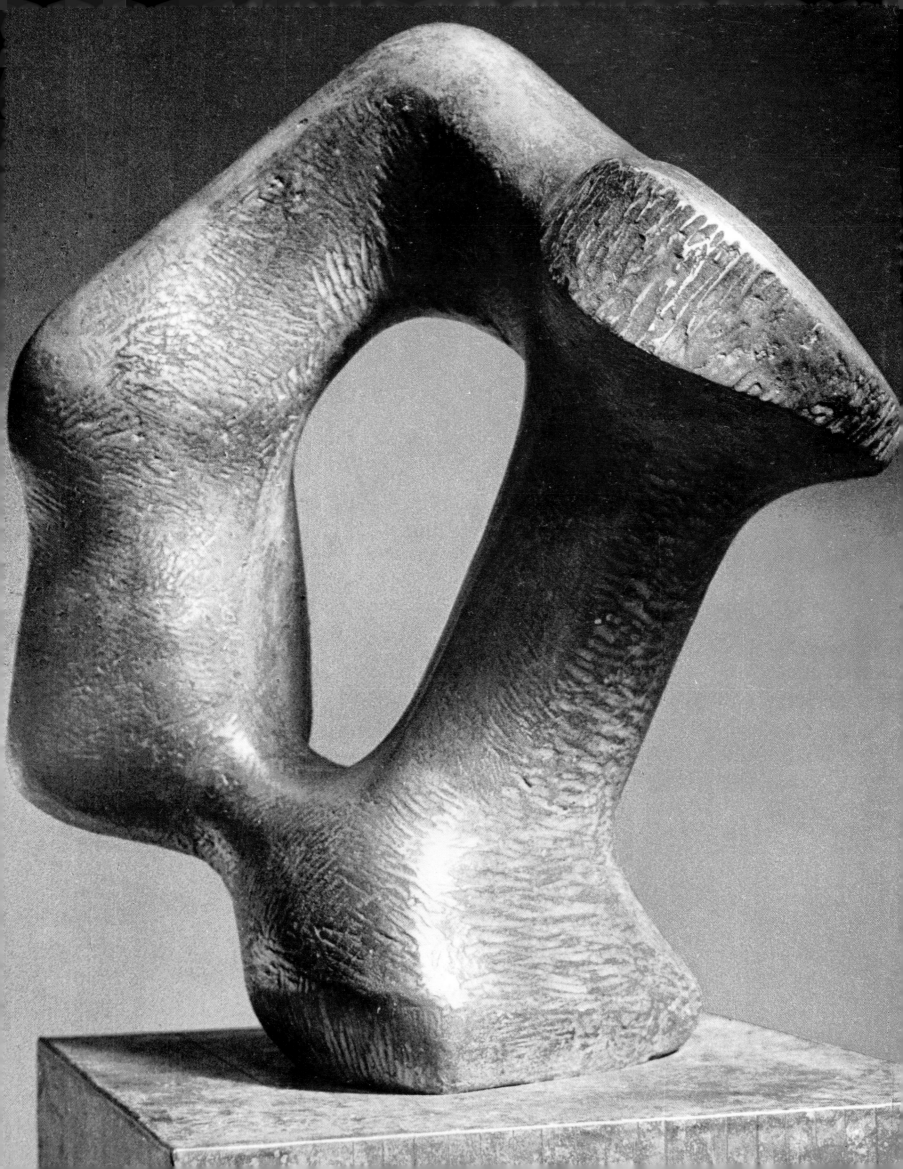

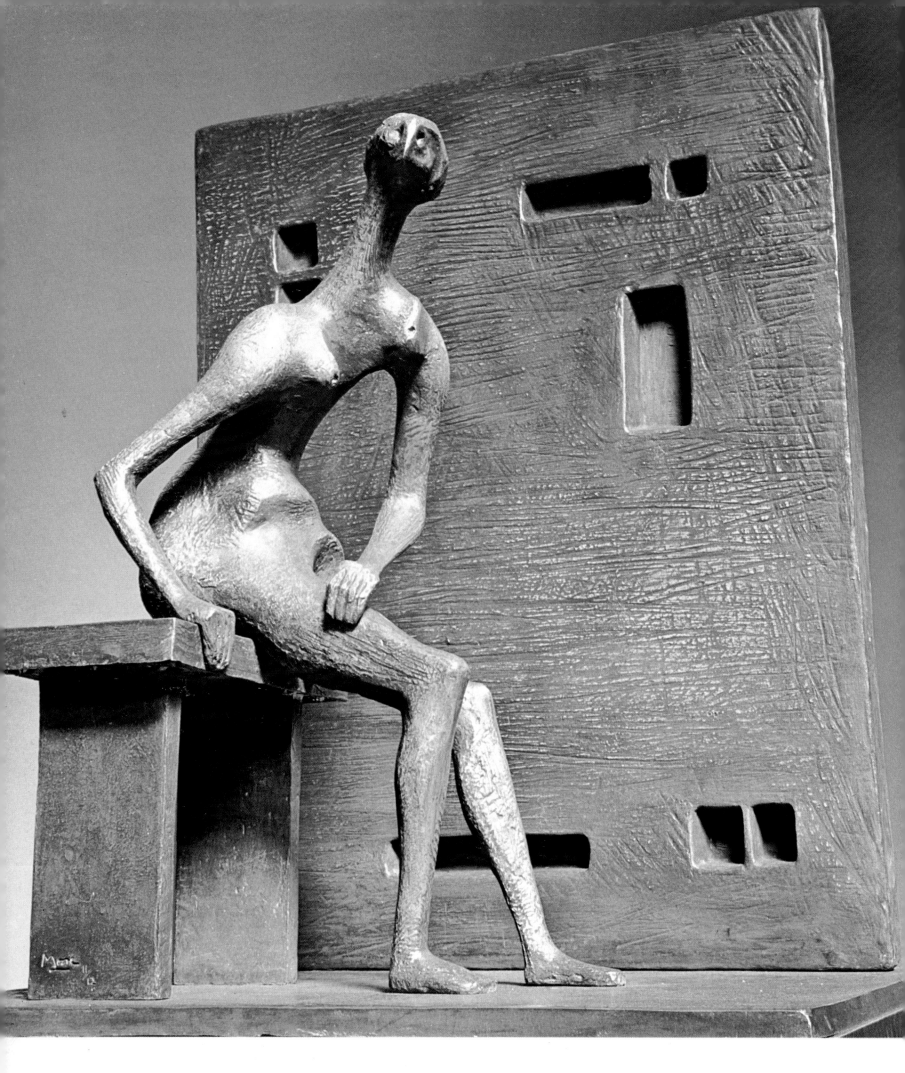

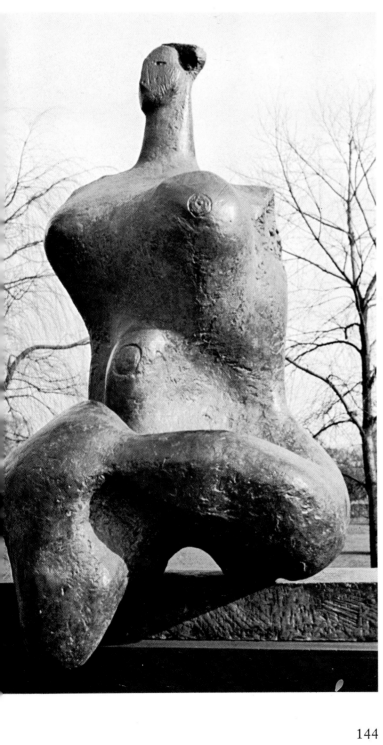

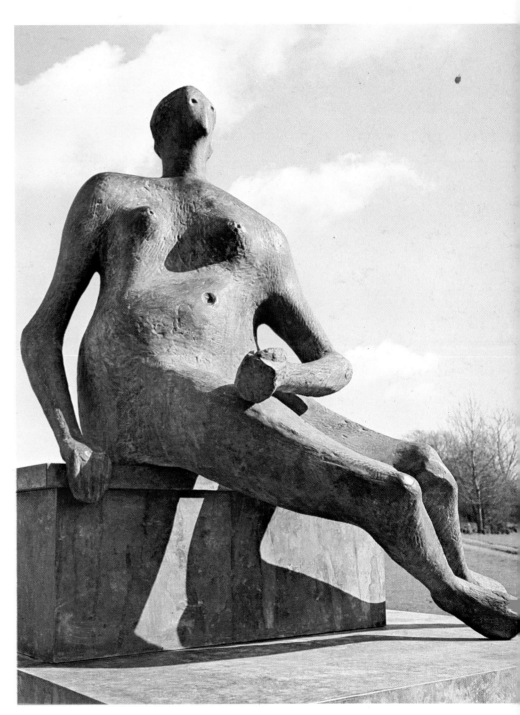

144

145

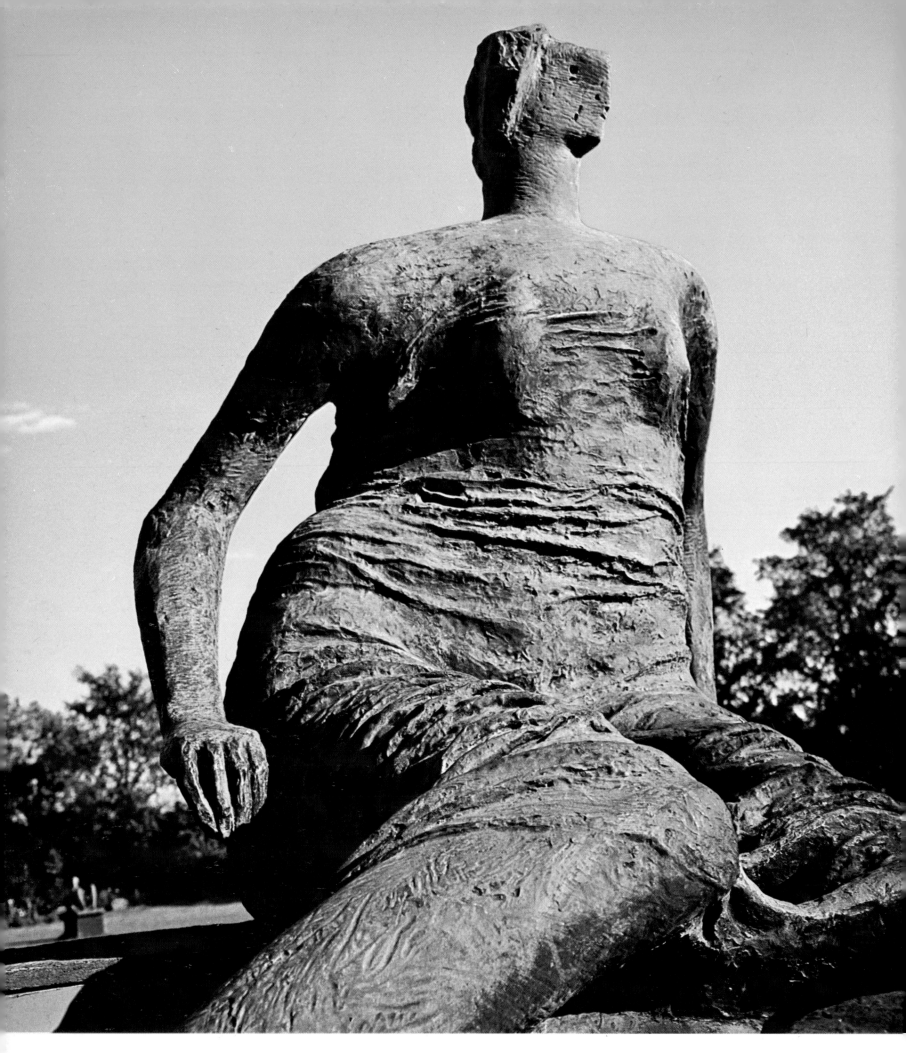

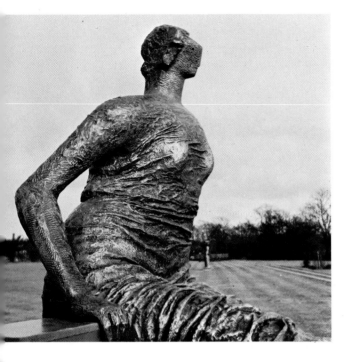

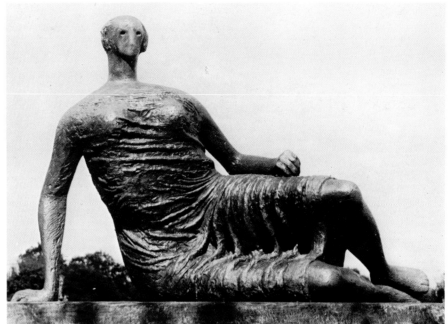

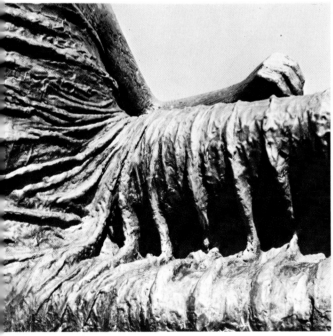

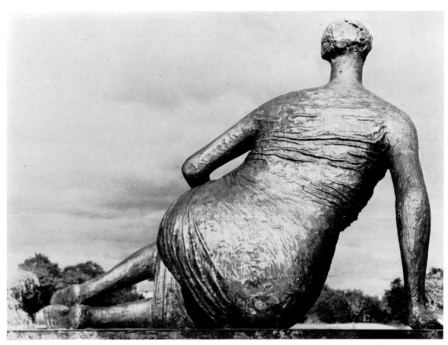

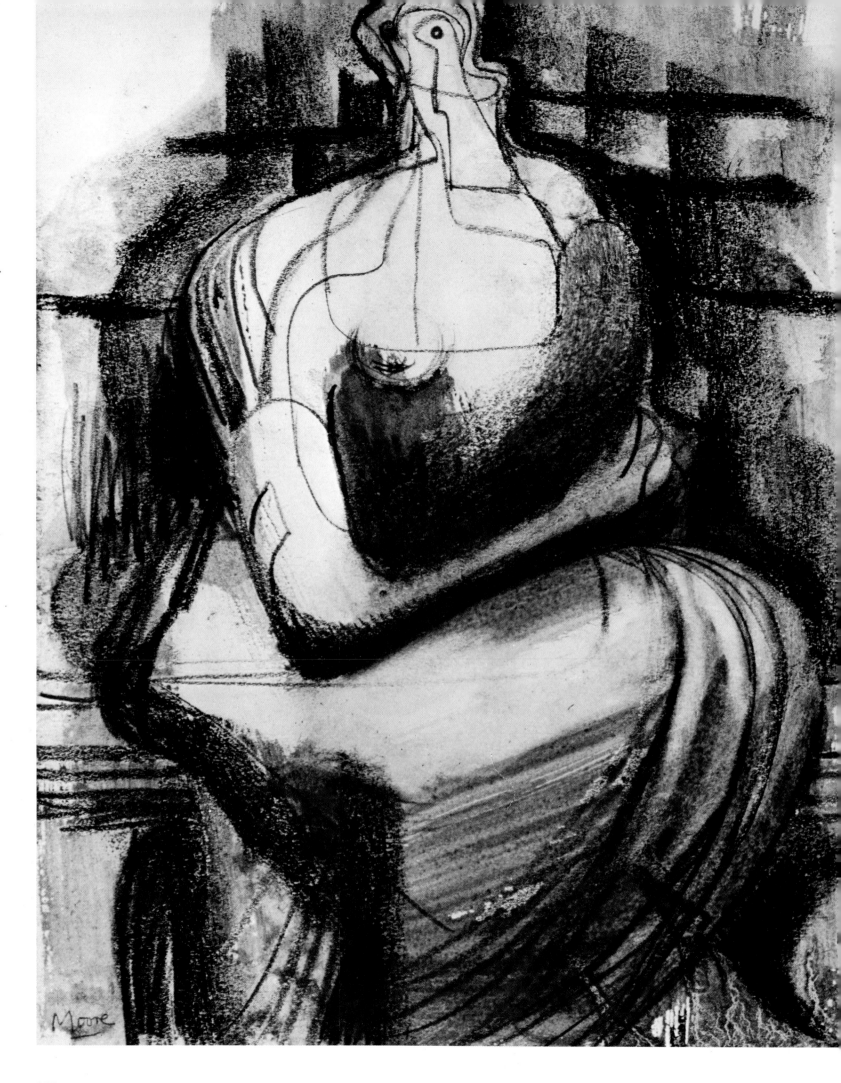

151

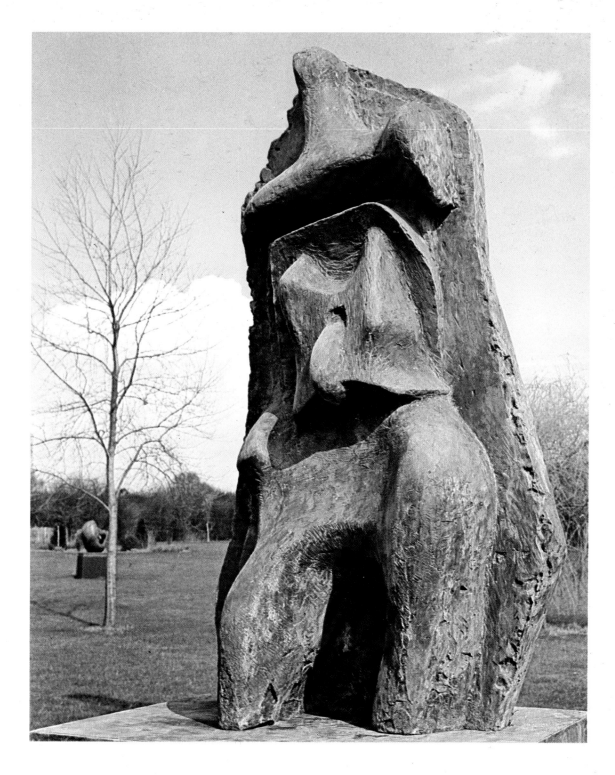

152

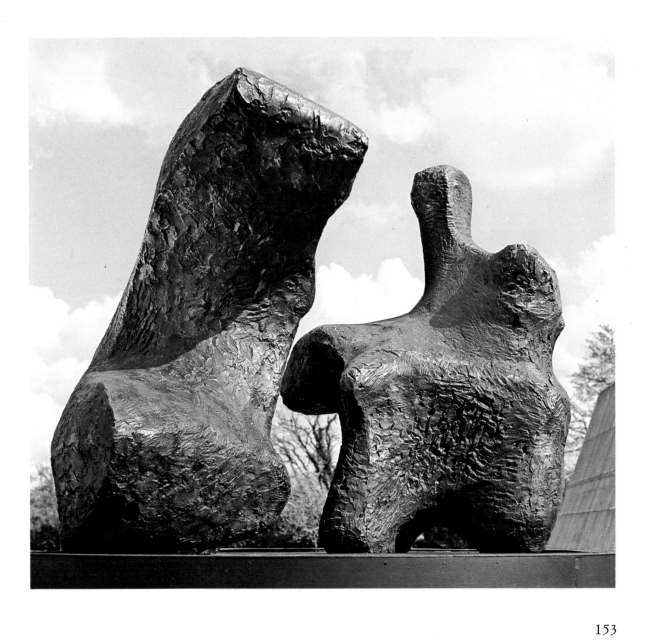

153

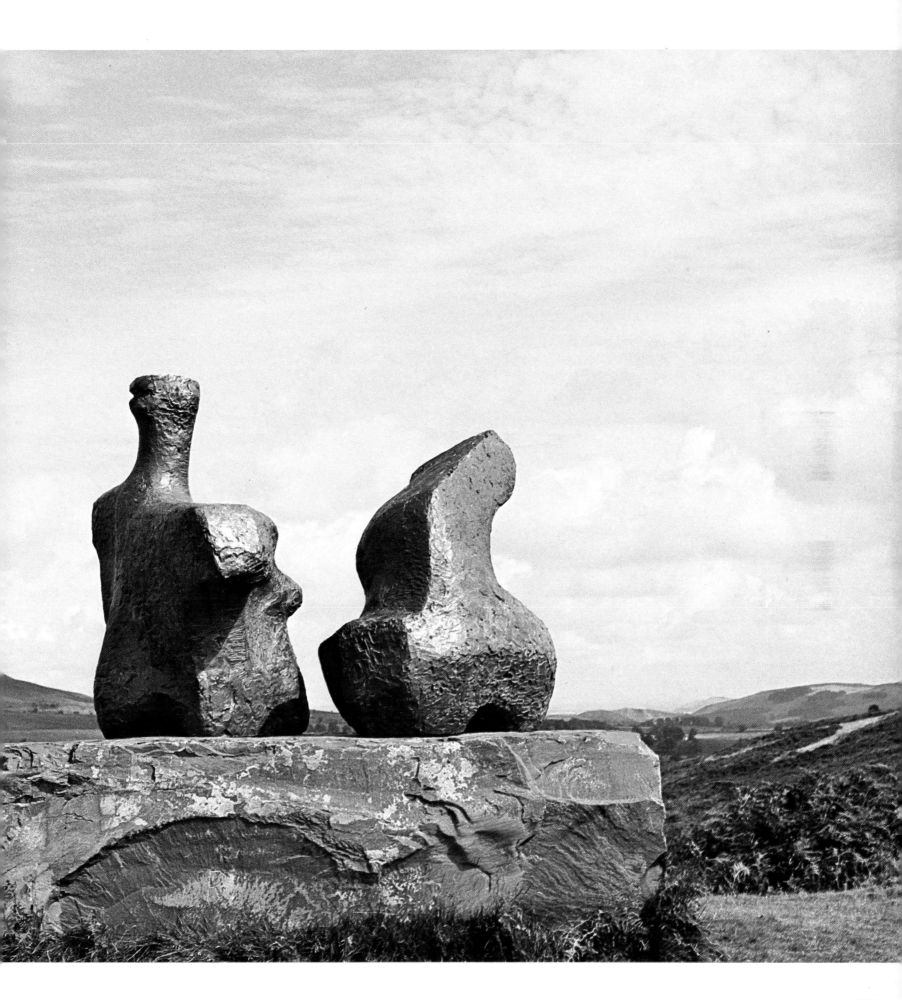

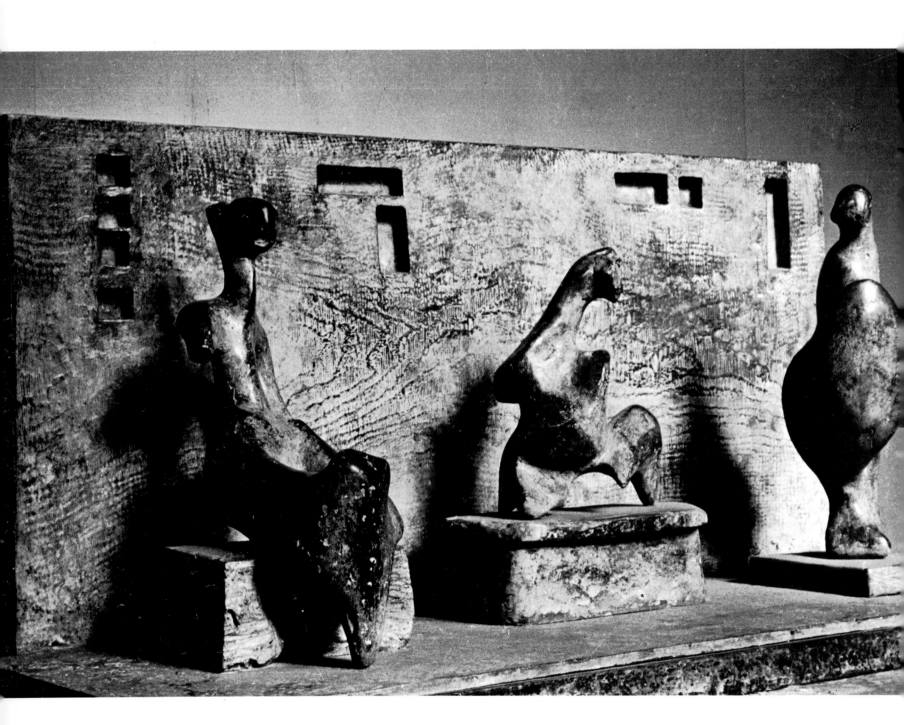

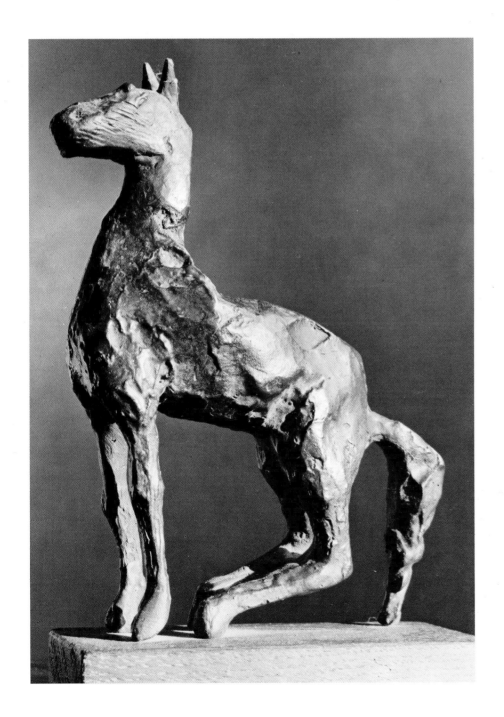

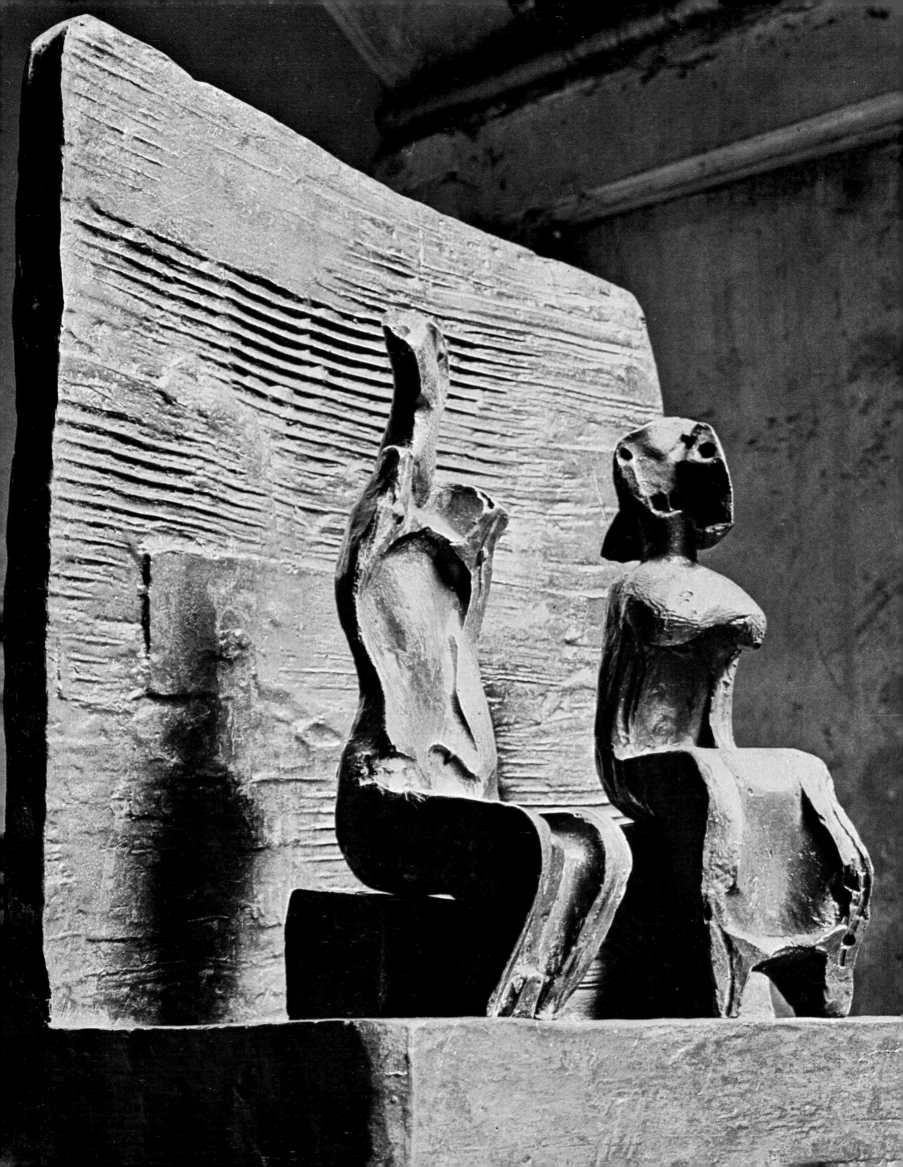

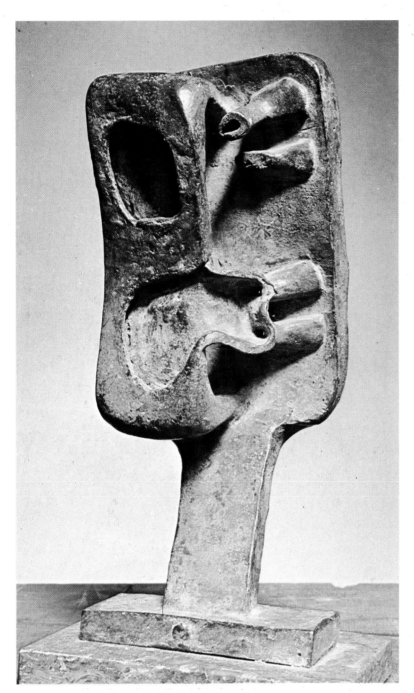

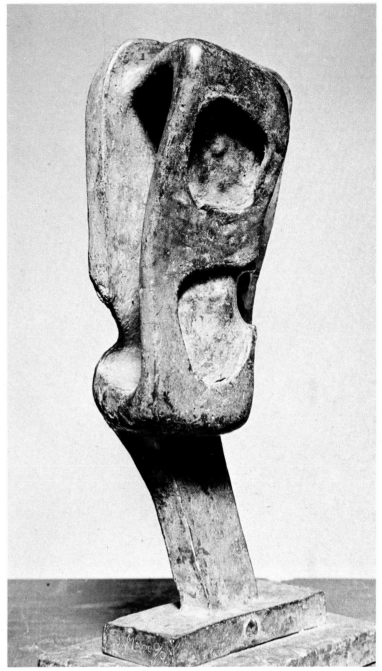

160

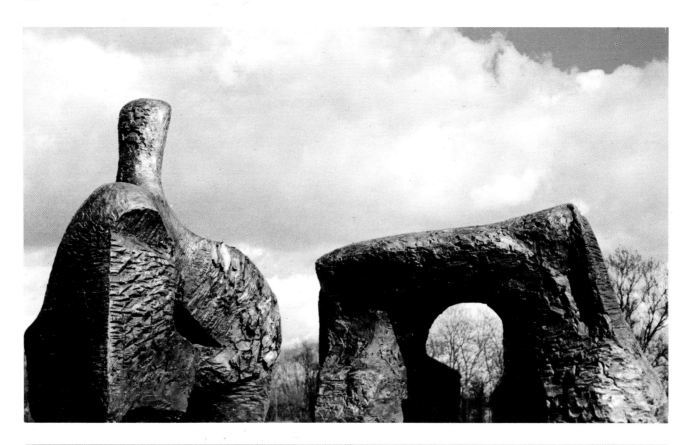

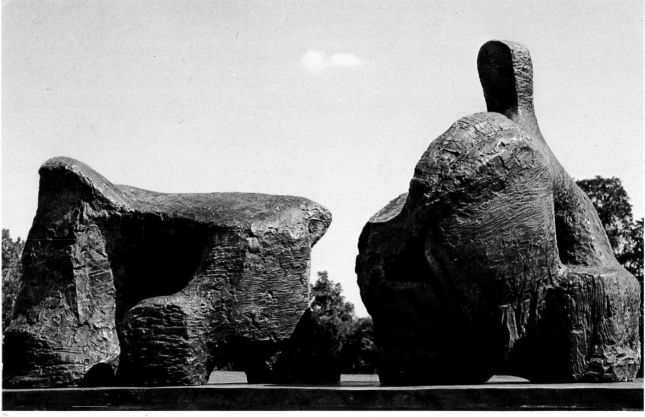

161

162

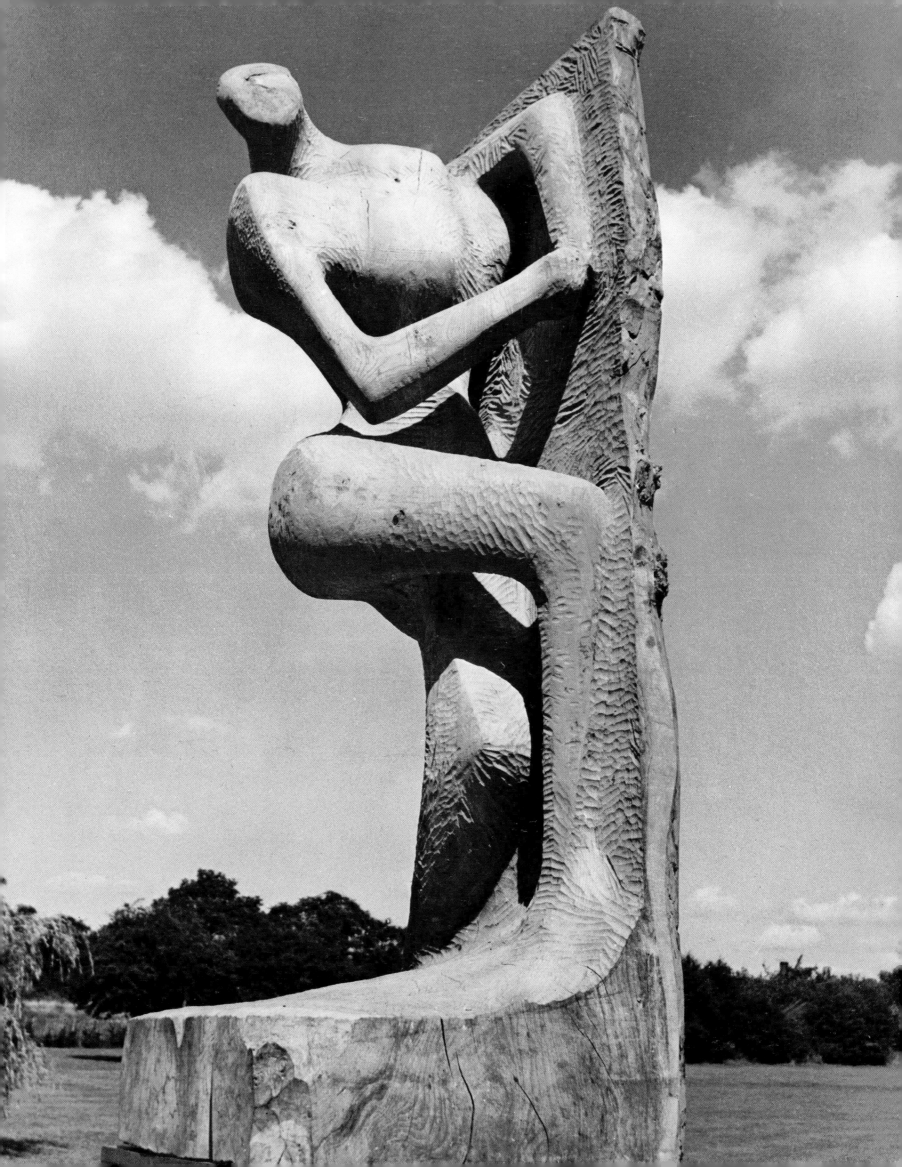

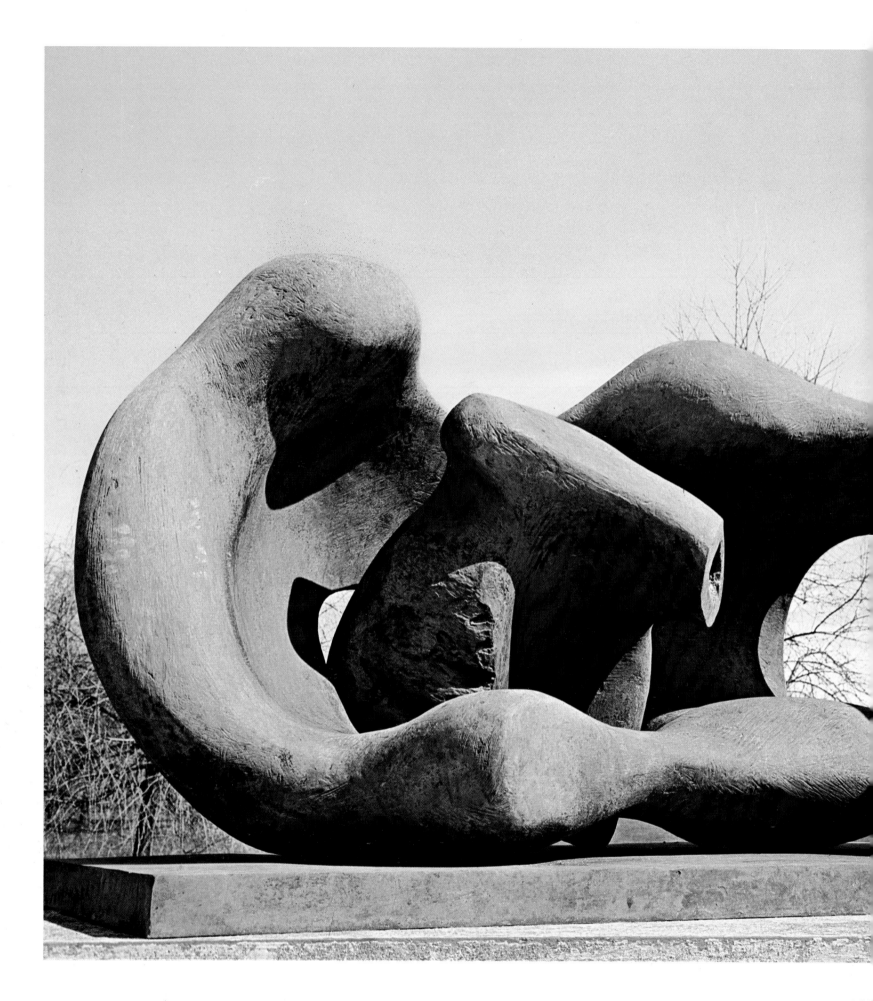

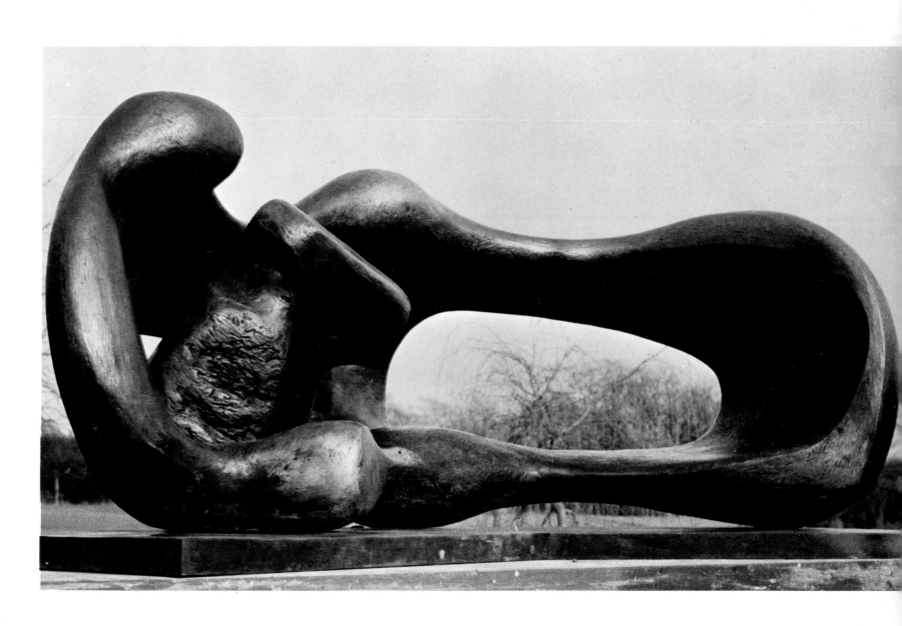

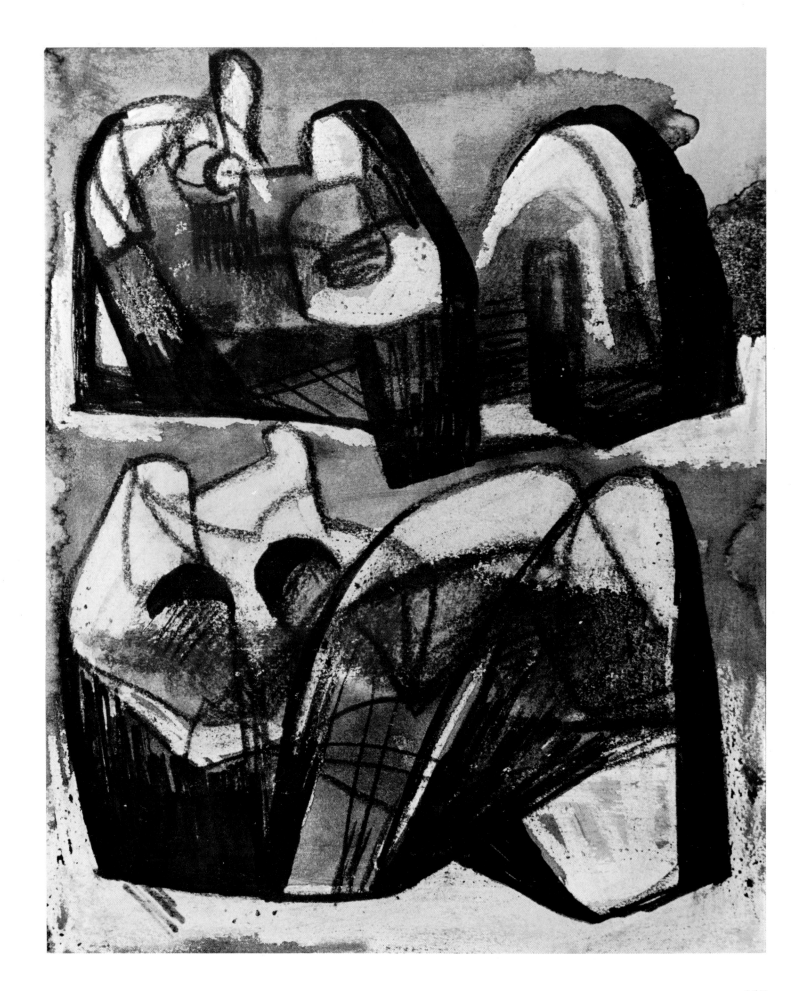

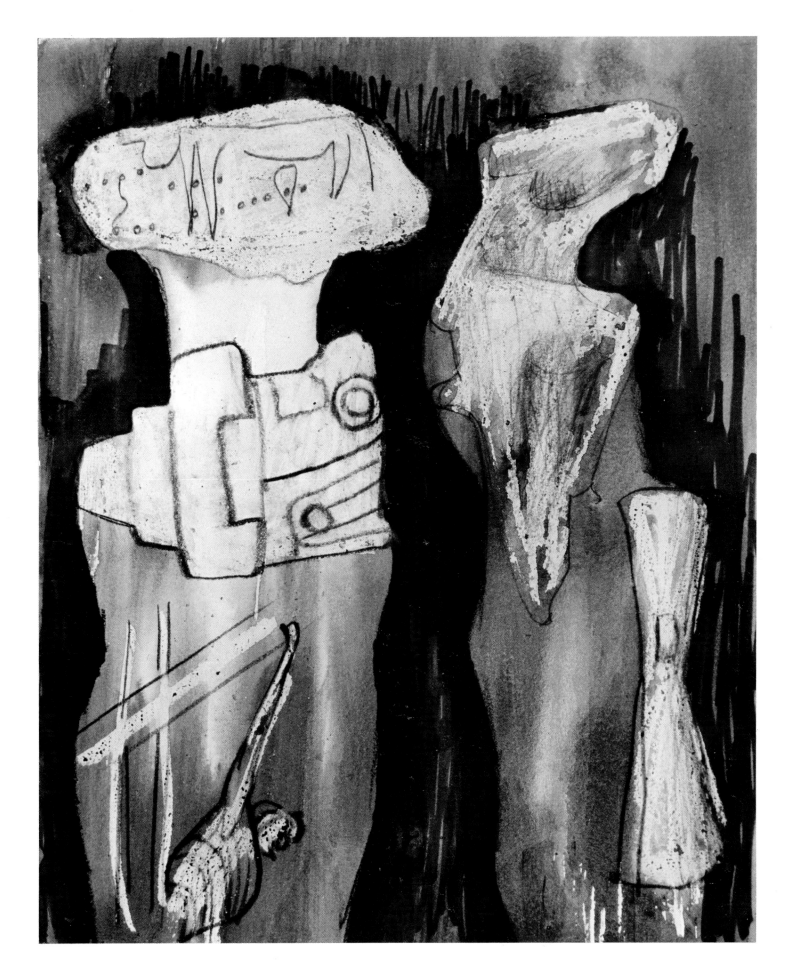

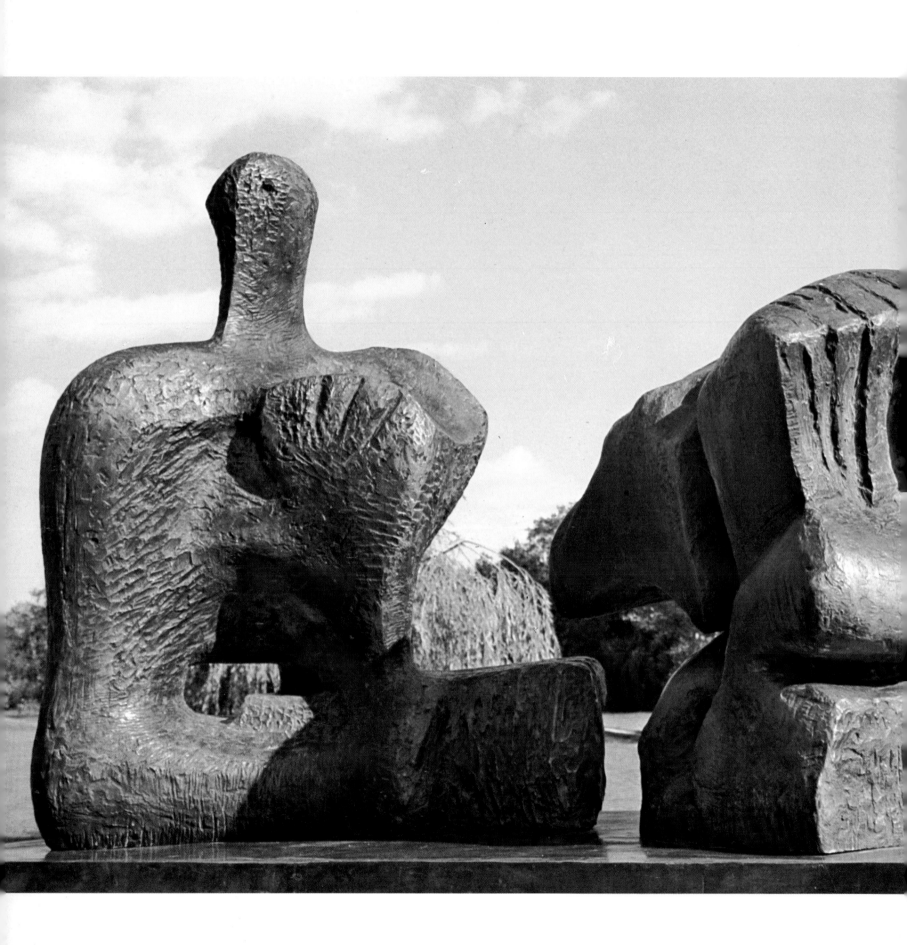

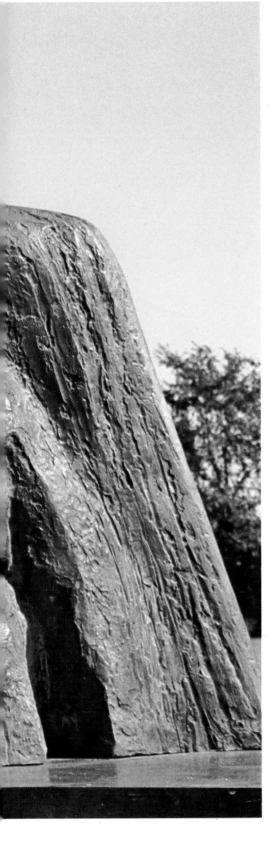

167

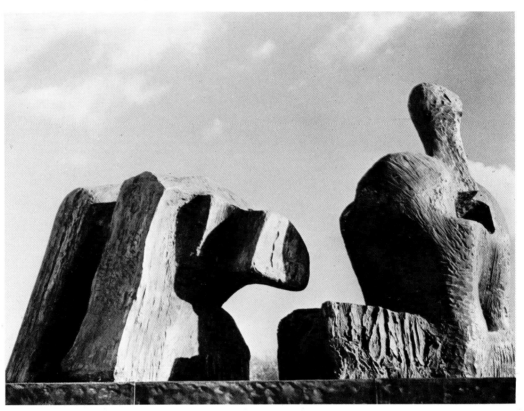

168

169

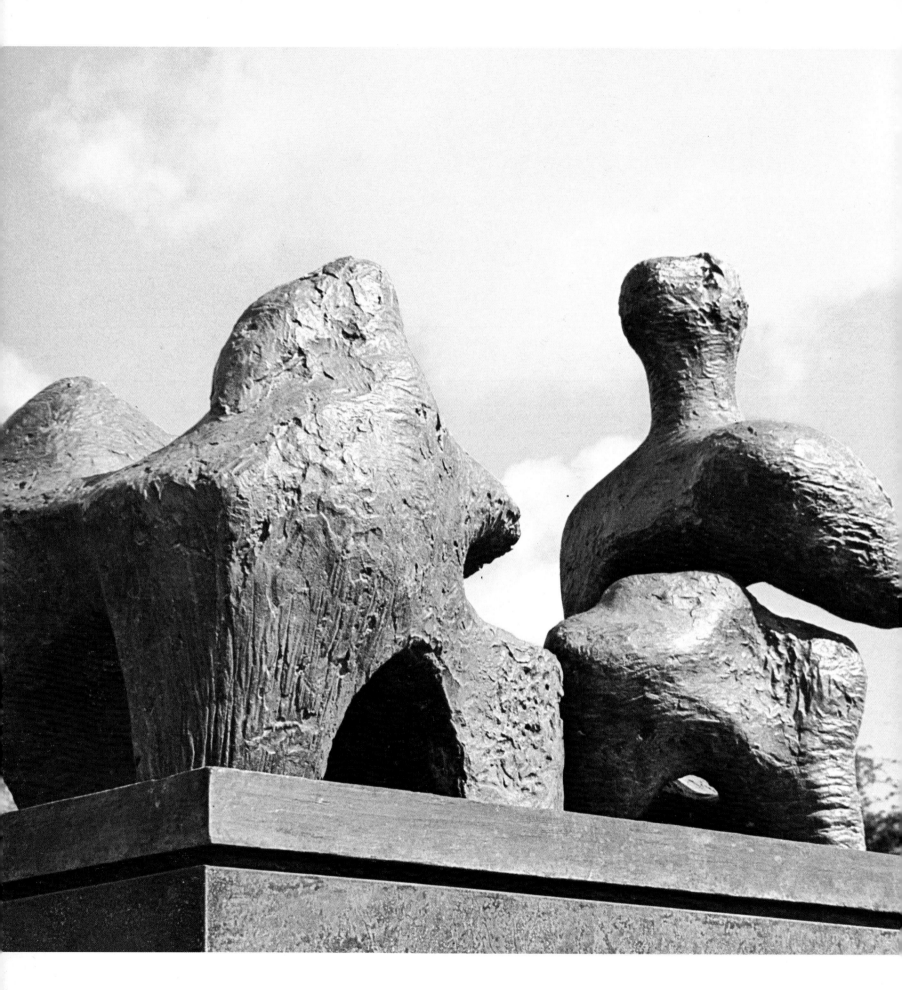

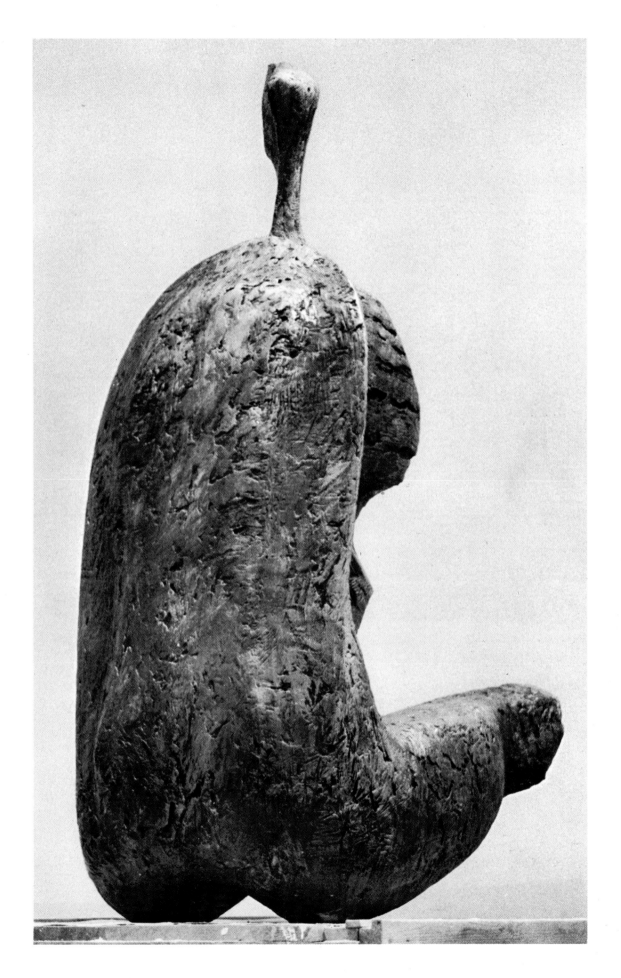

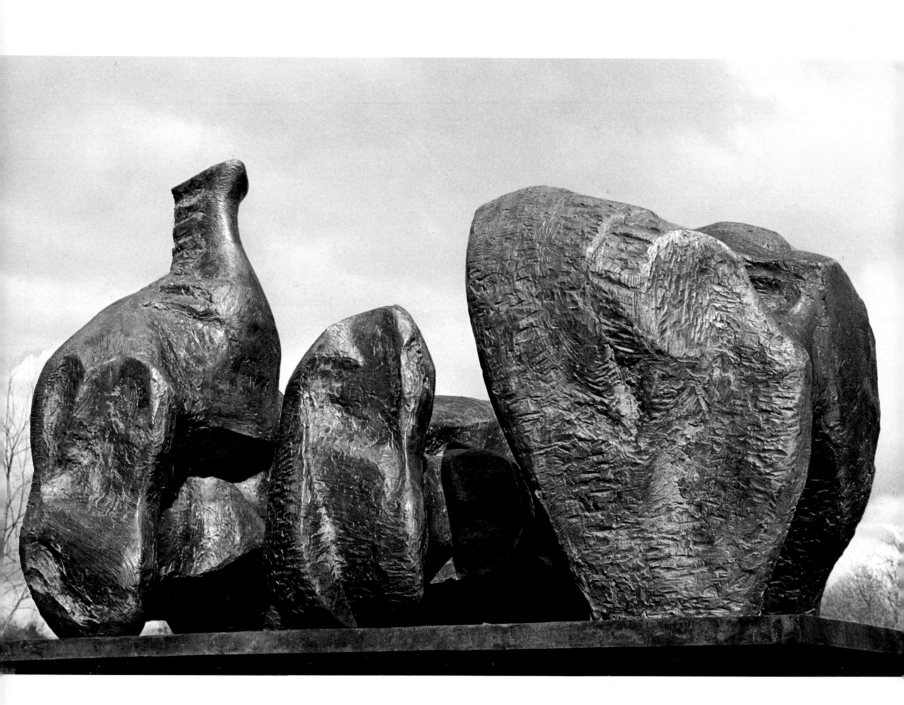

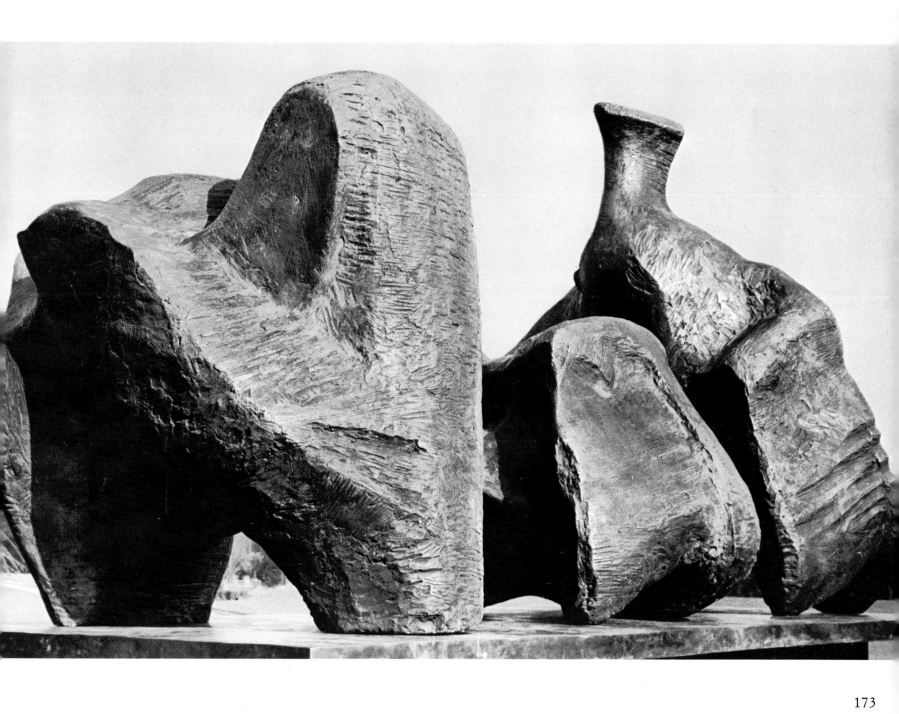

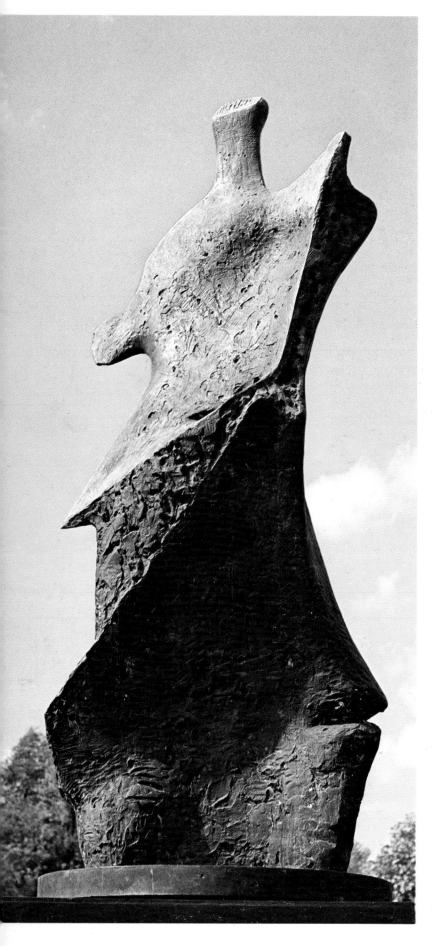

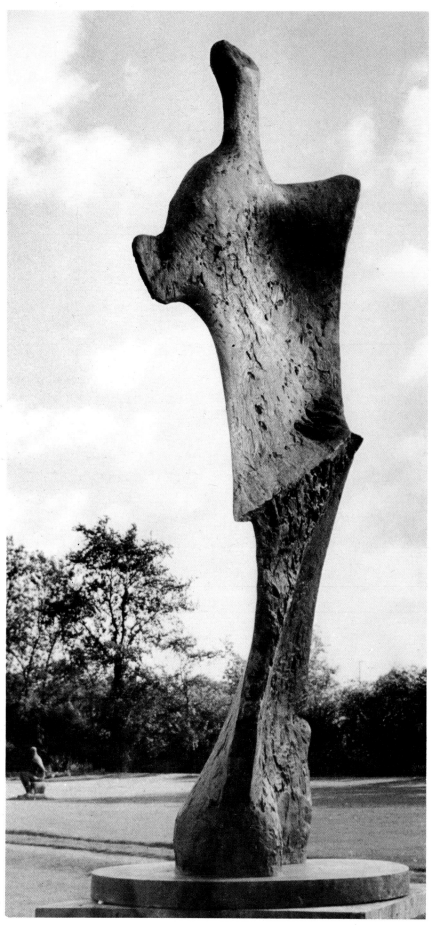

174

175

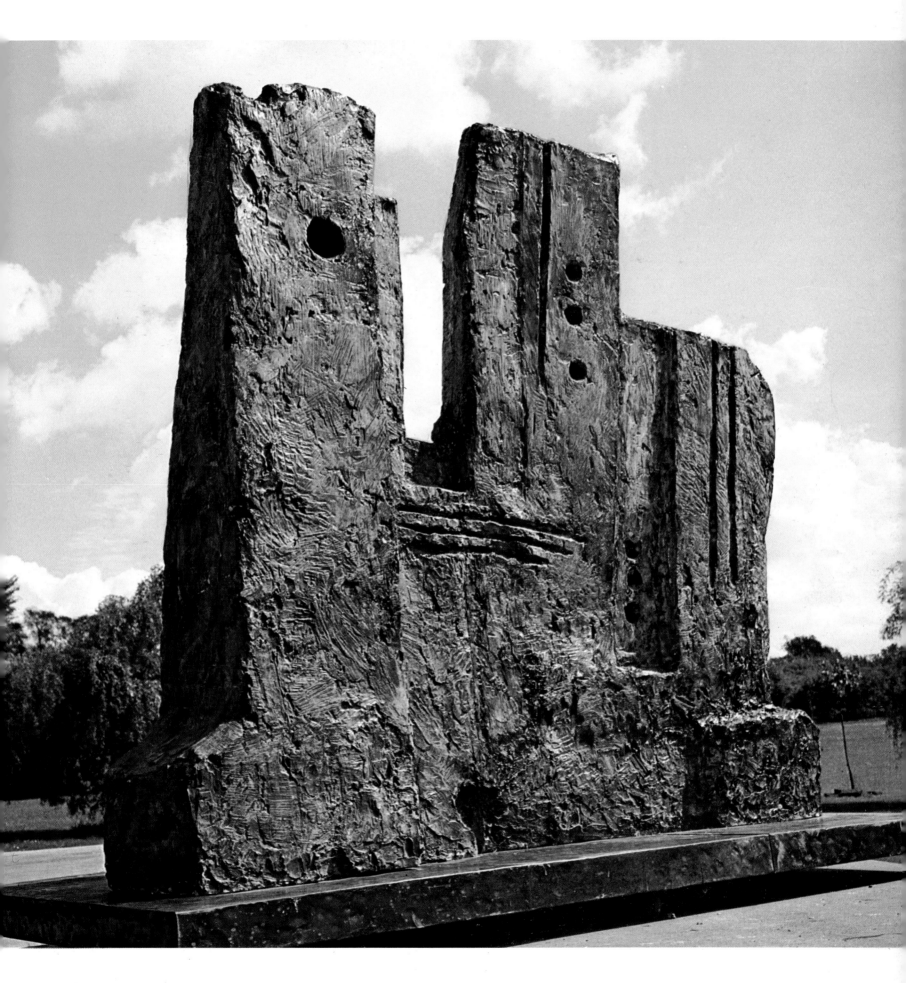

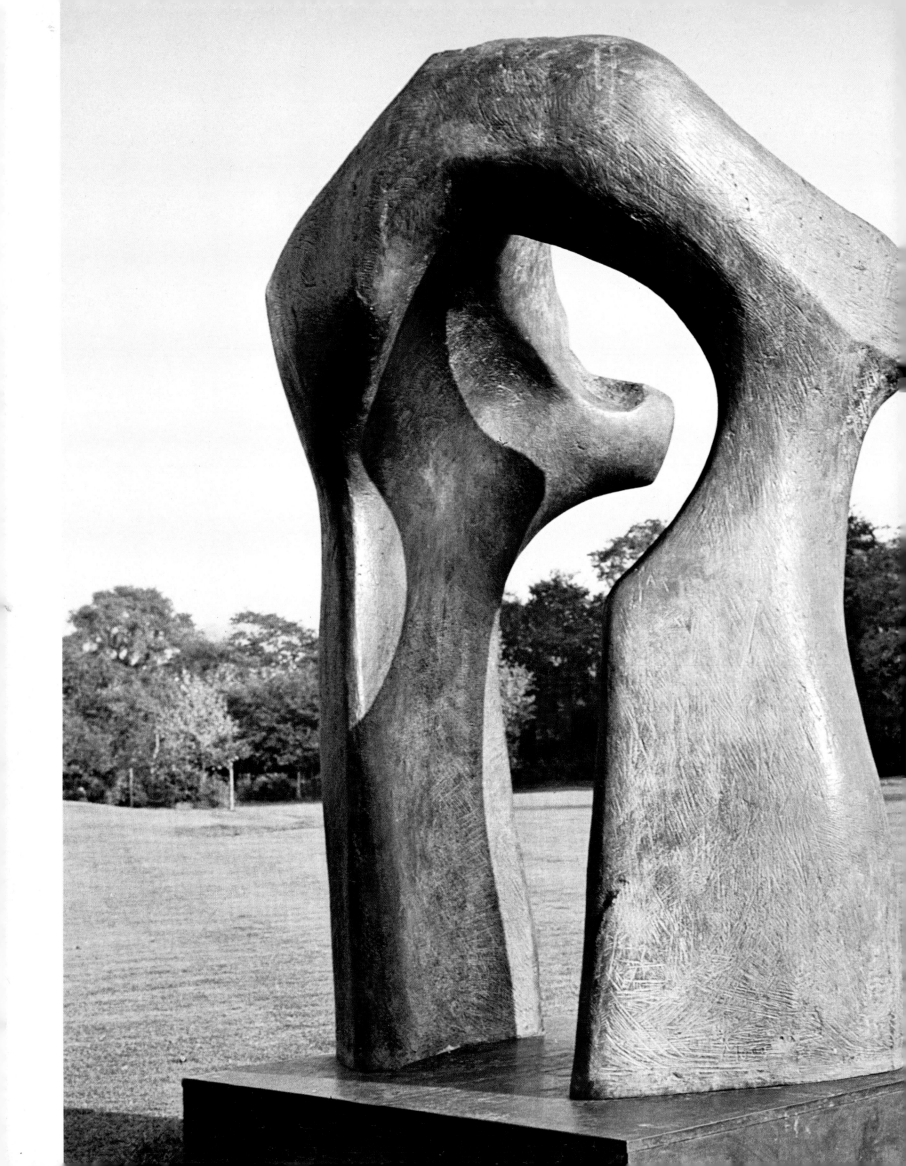

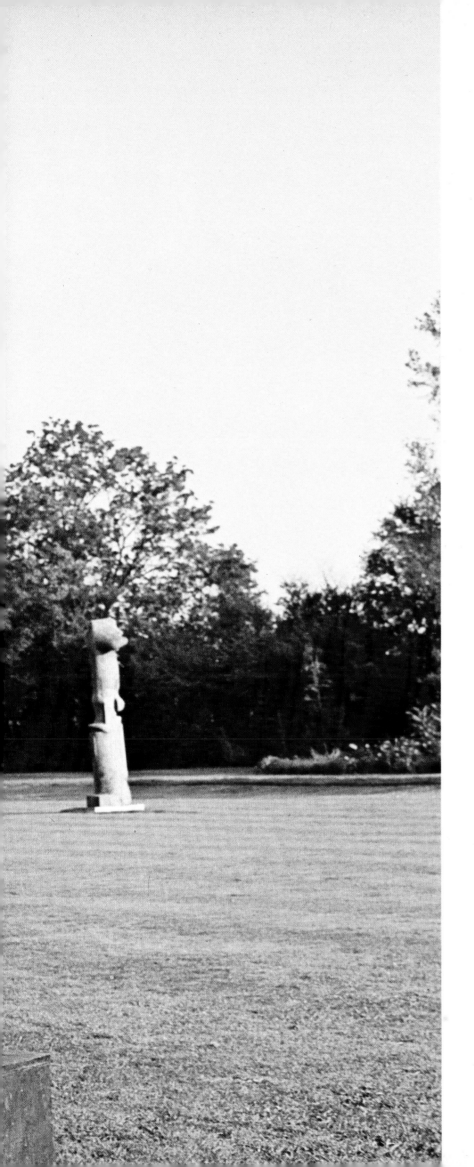

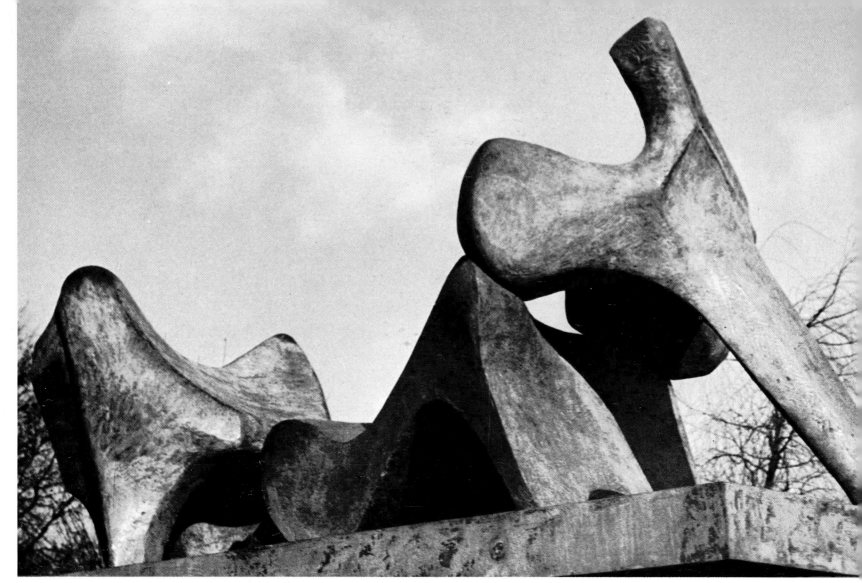

178

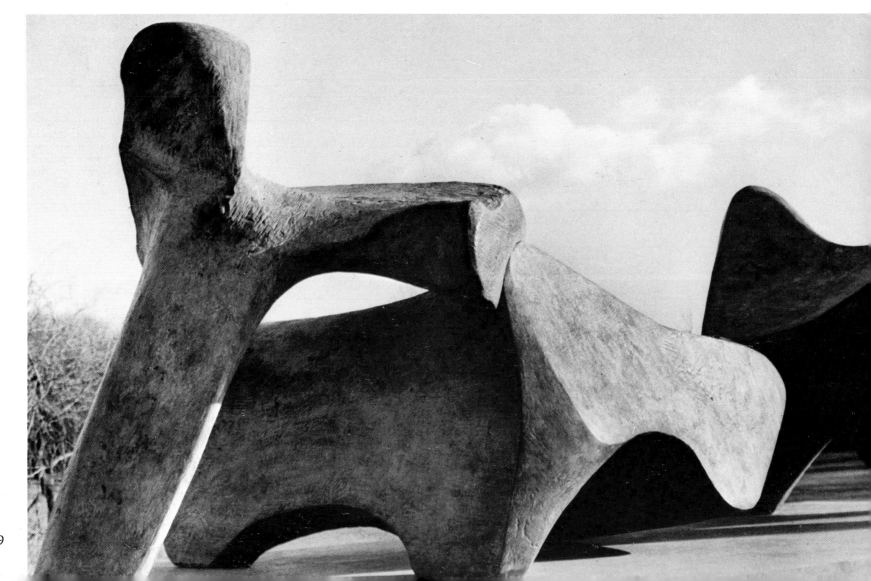

179

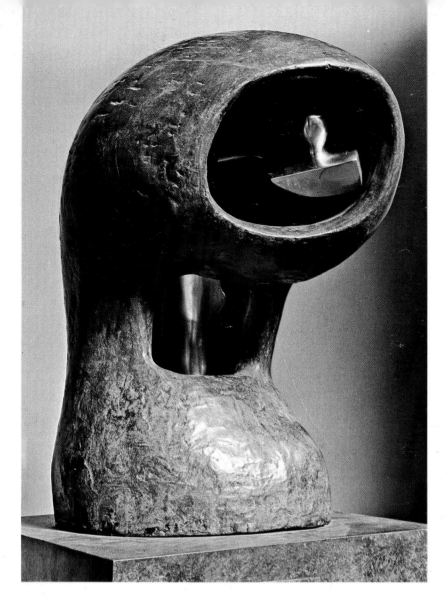

180

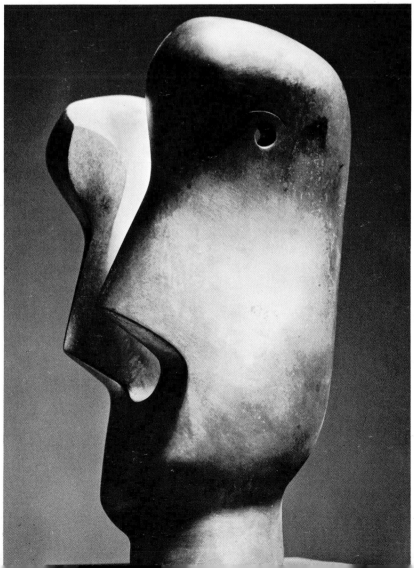

181

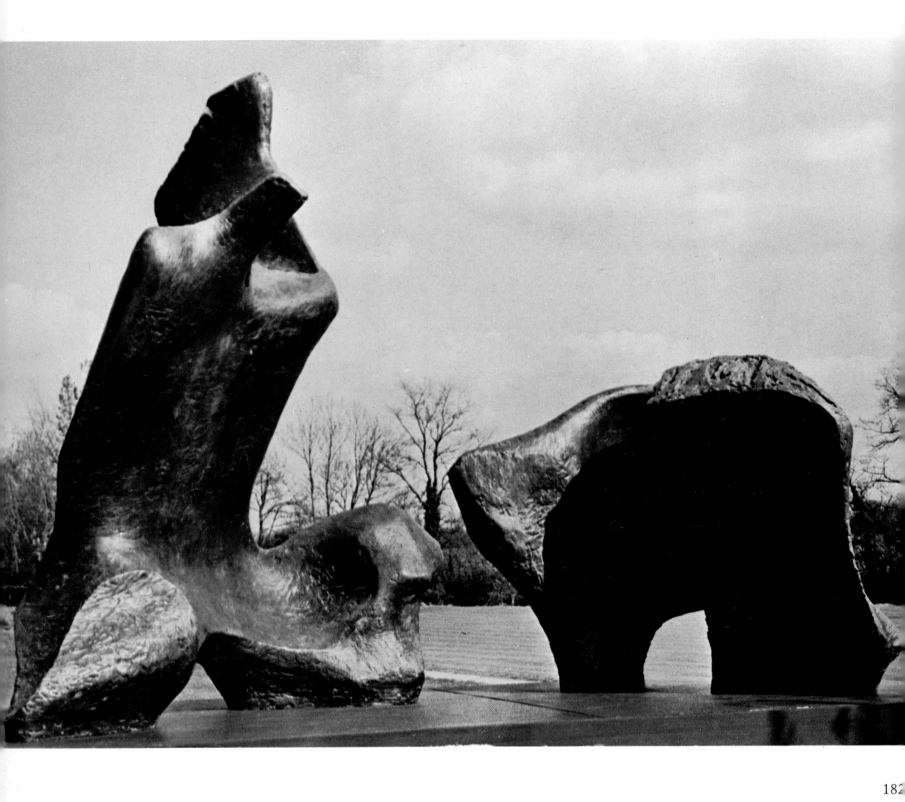

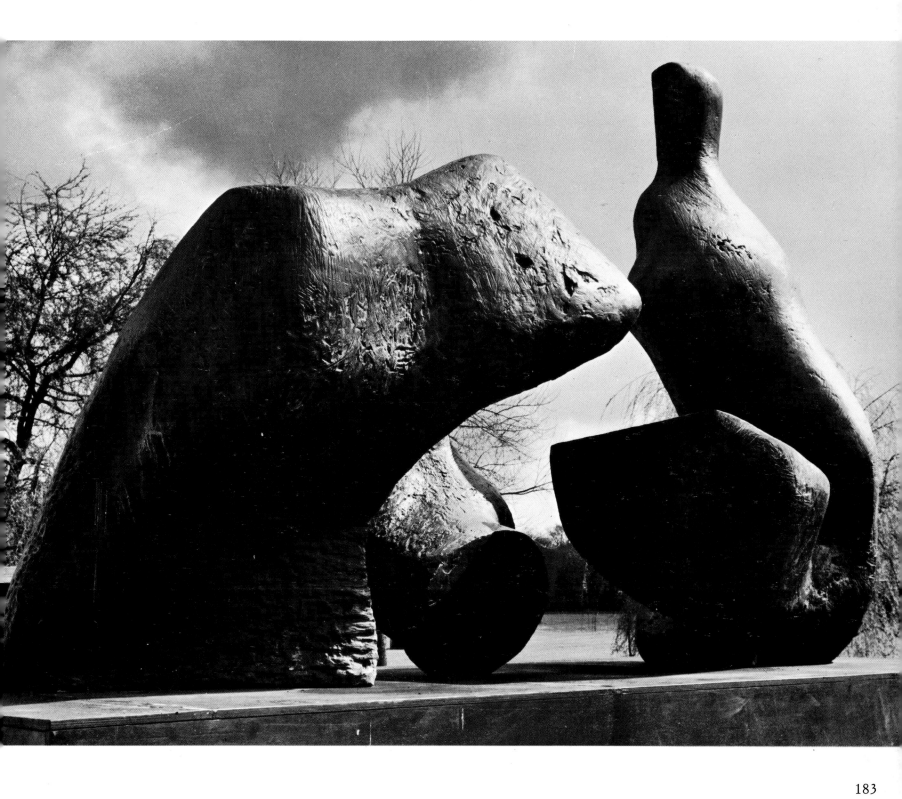

183

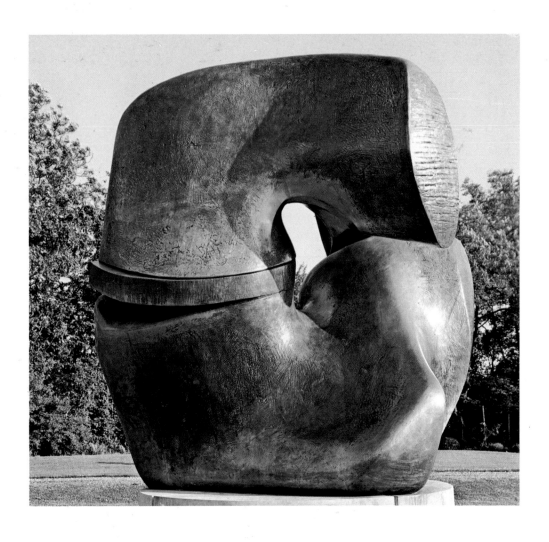

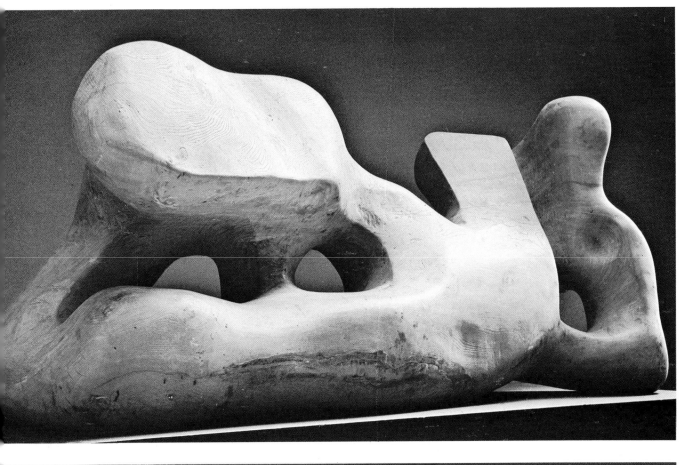

185

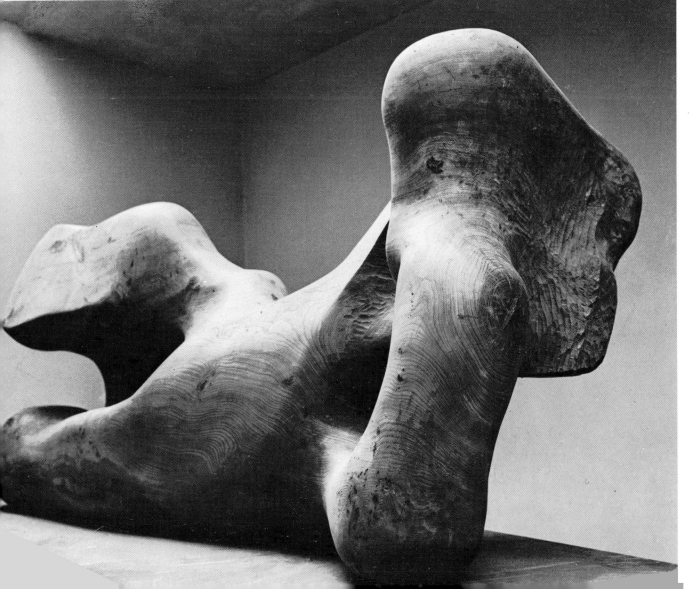

186

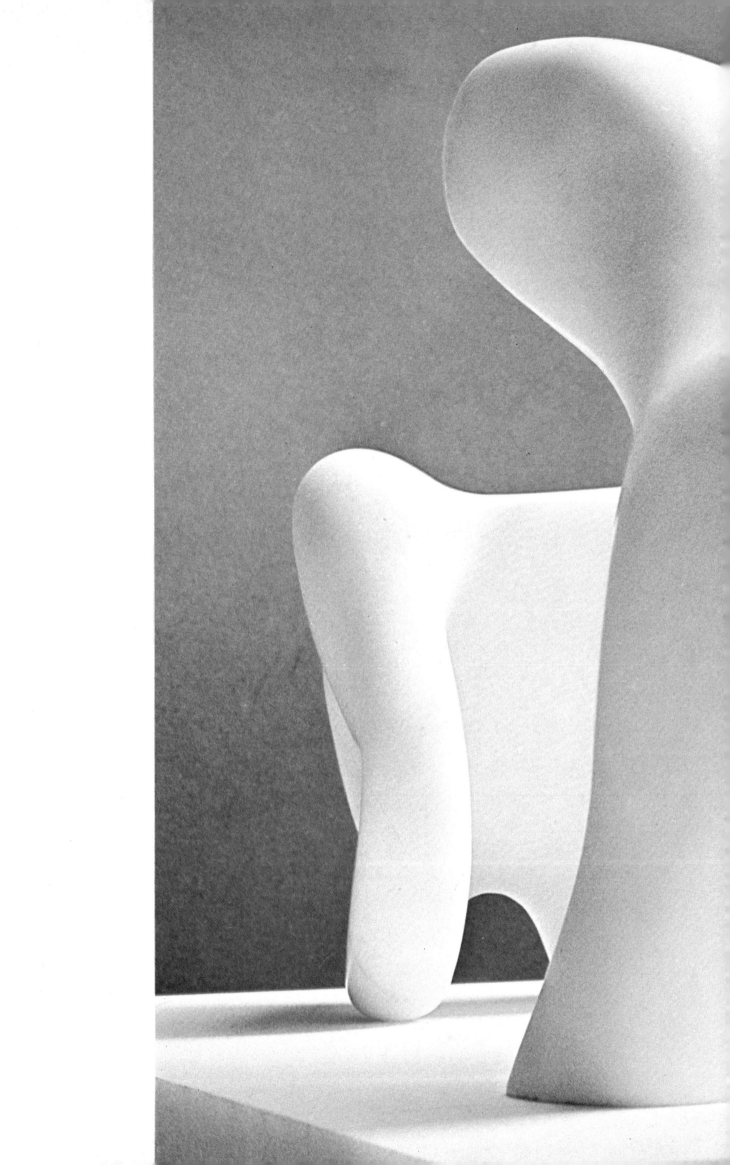

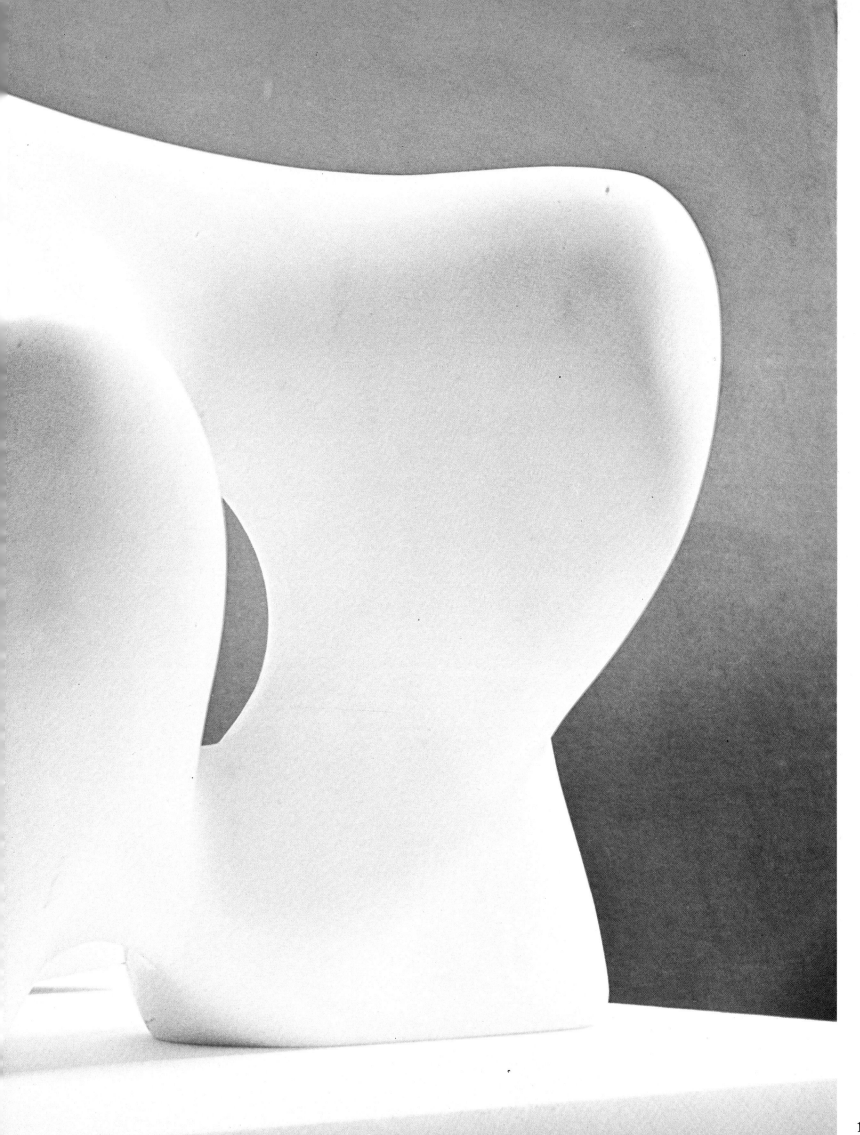

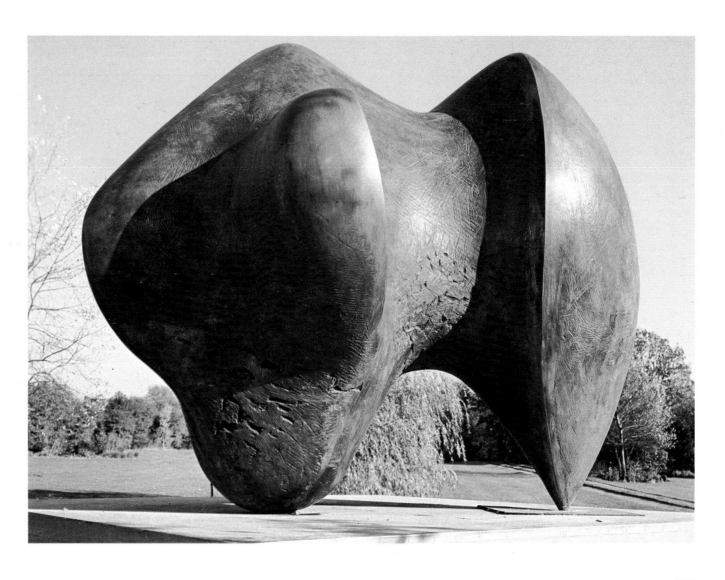

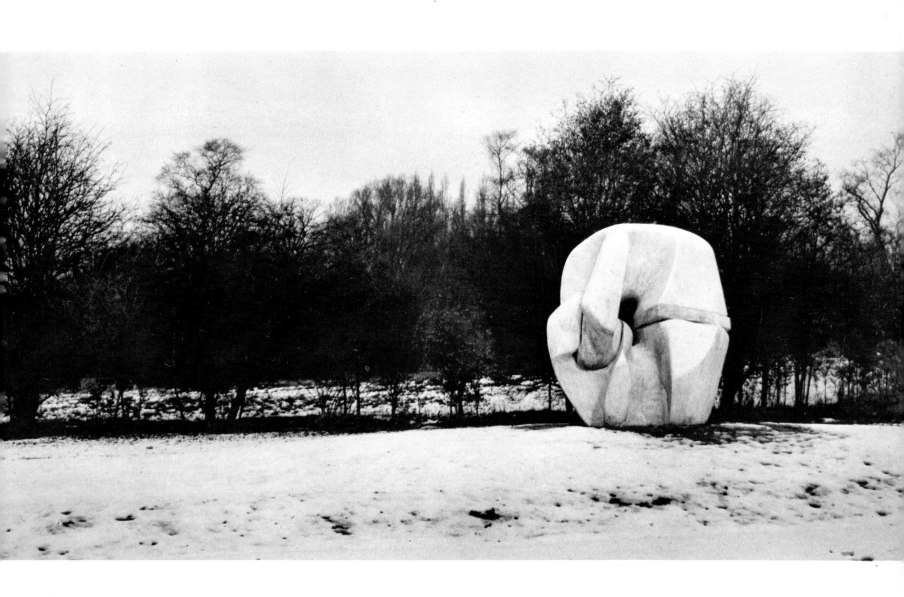

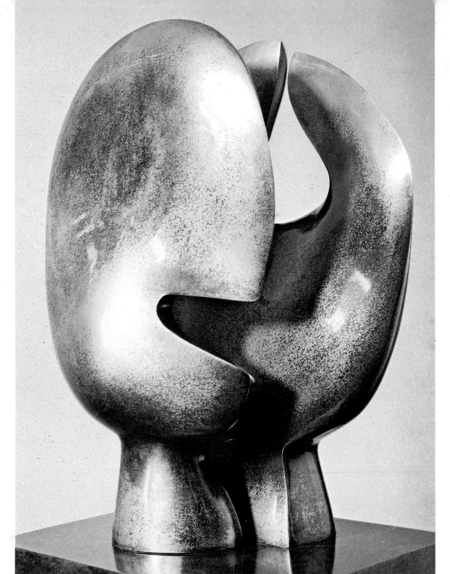

190

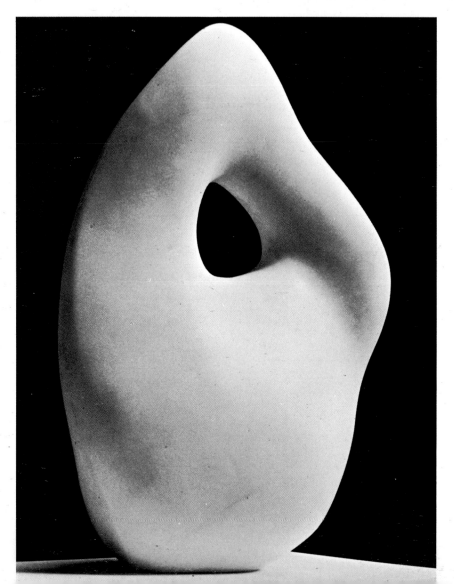

191

192

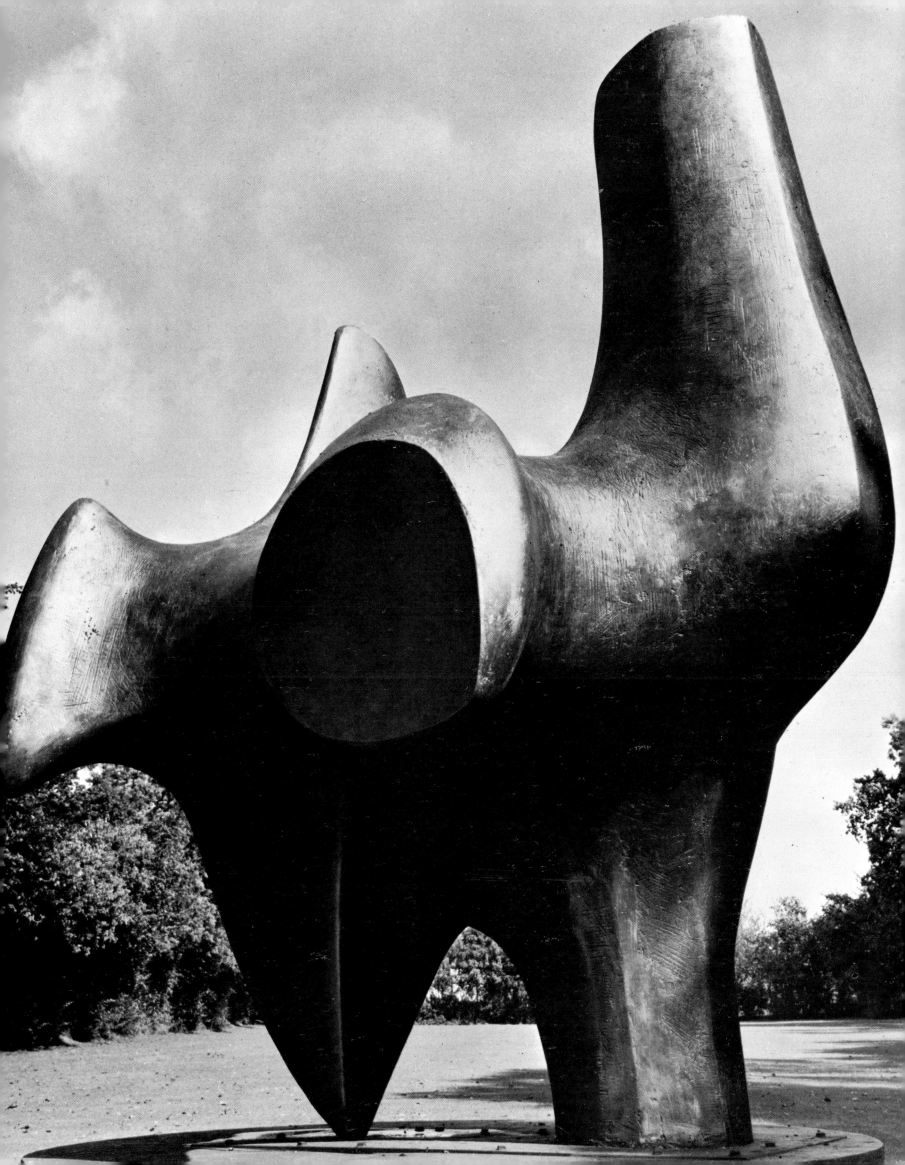

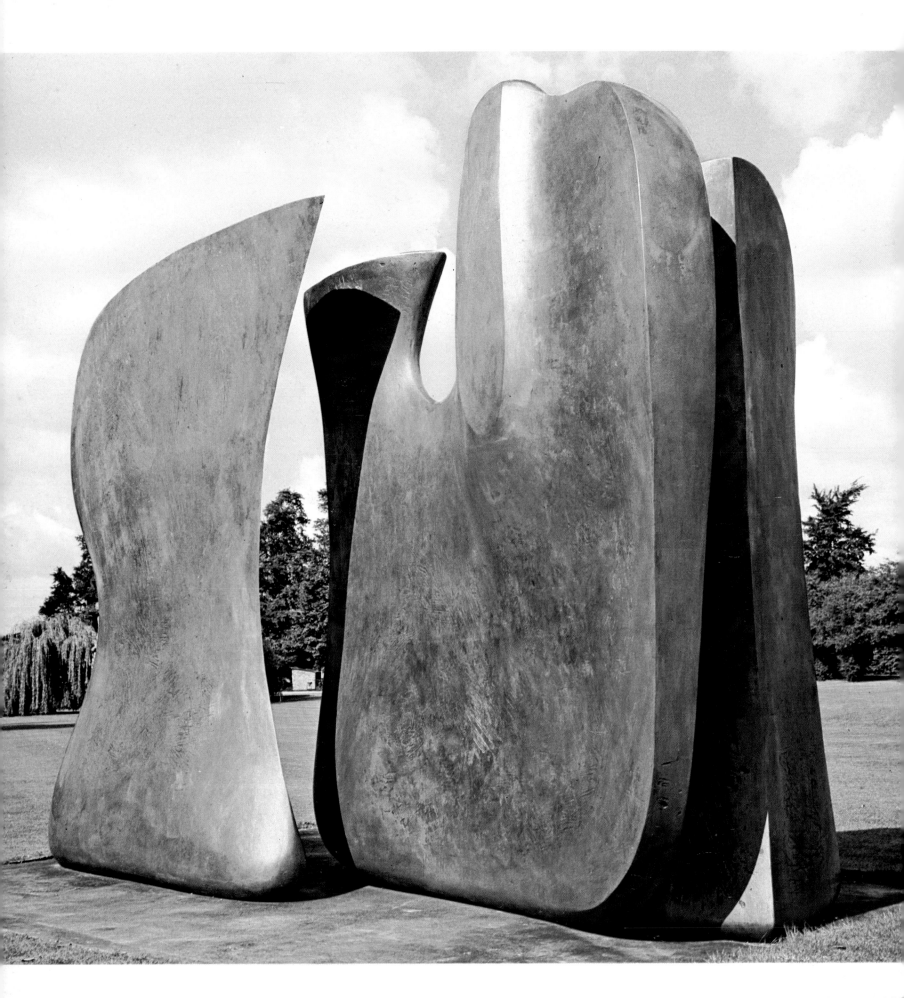

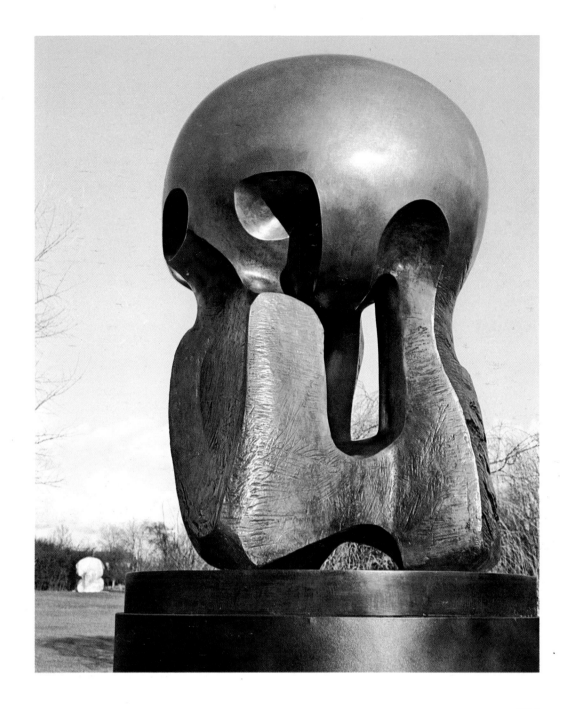

194

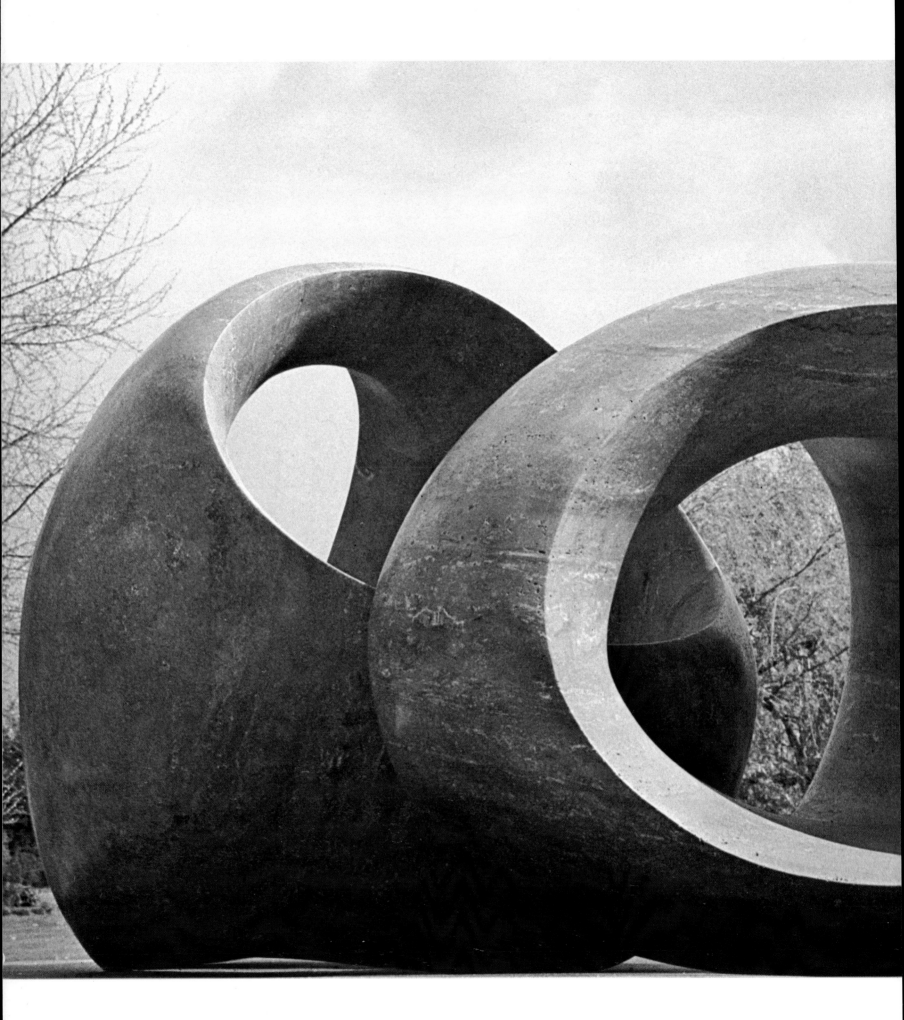

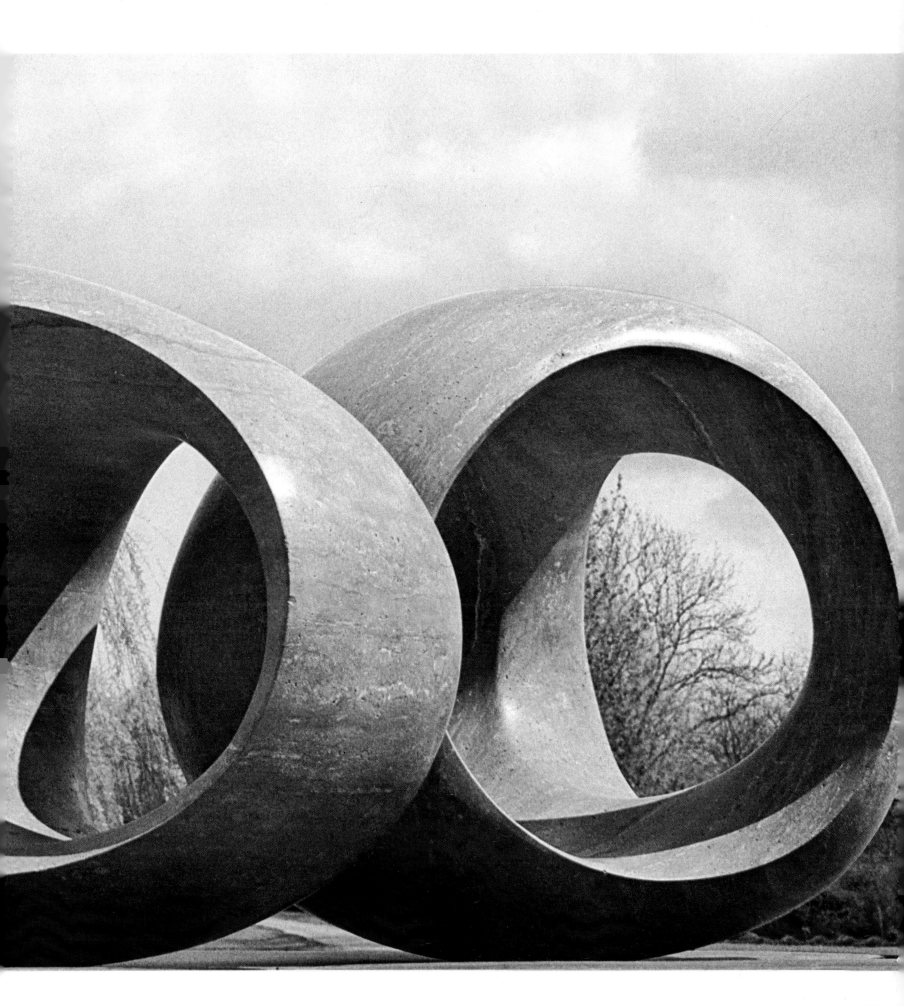

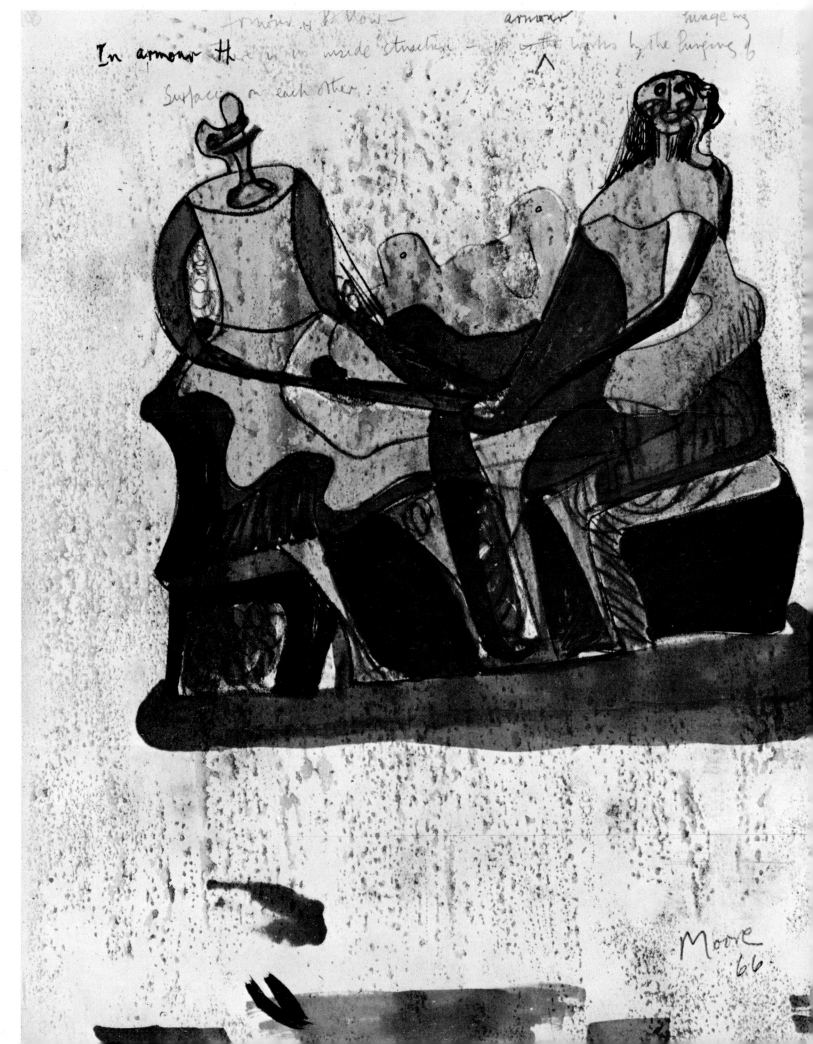

In armour the ... inside structure ... works by the ...
Surface... on each other.

Moore
66

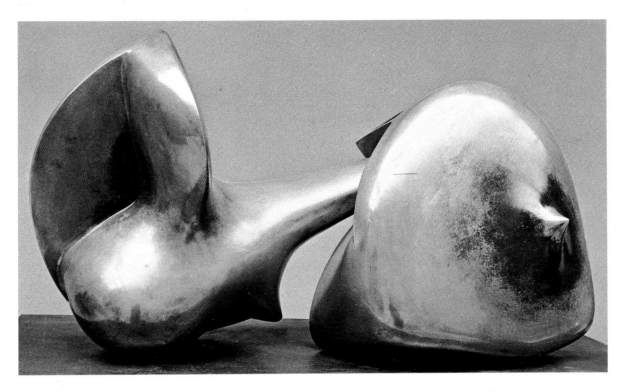

197

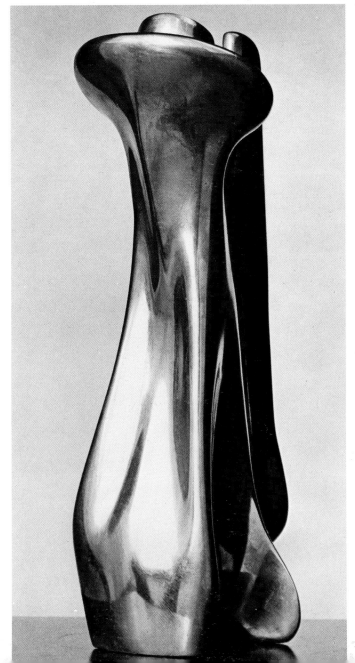

198

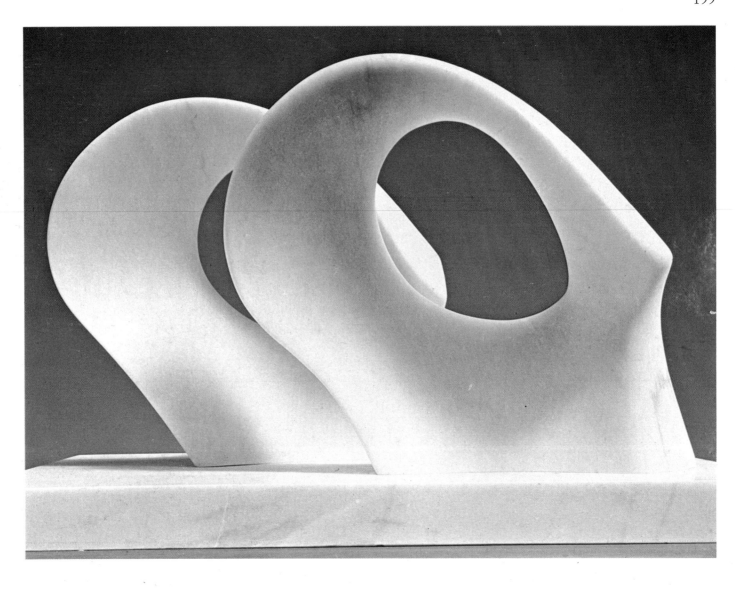

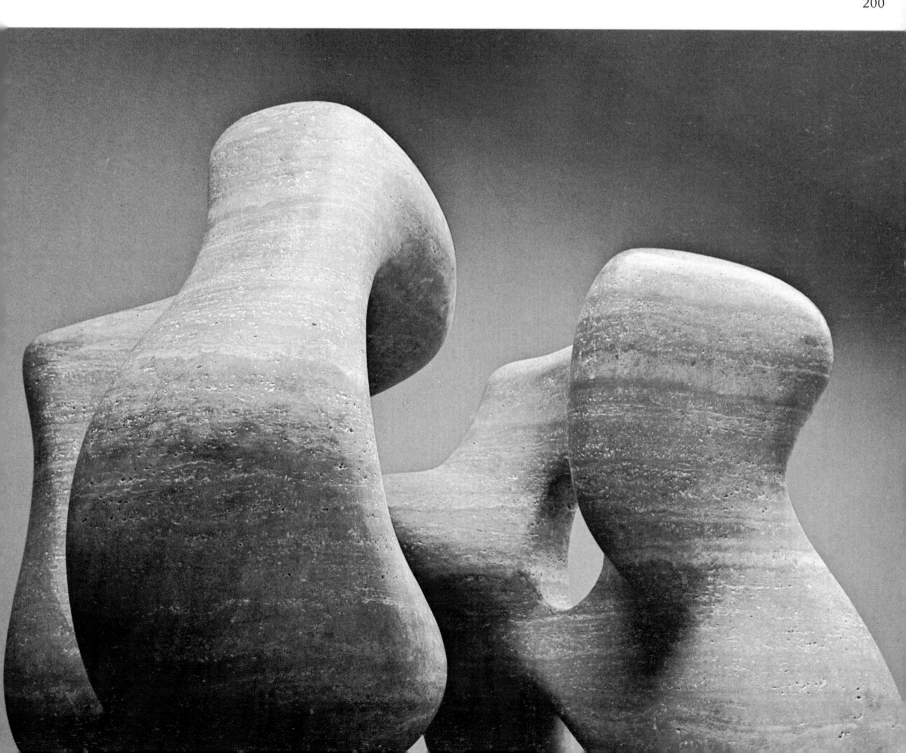

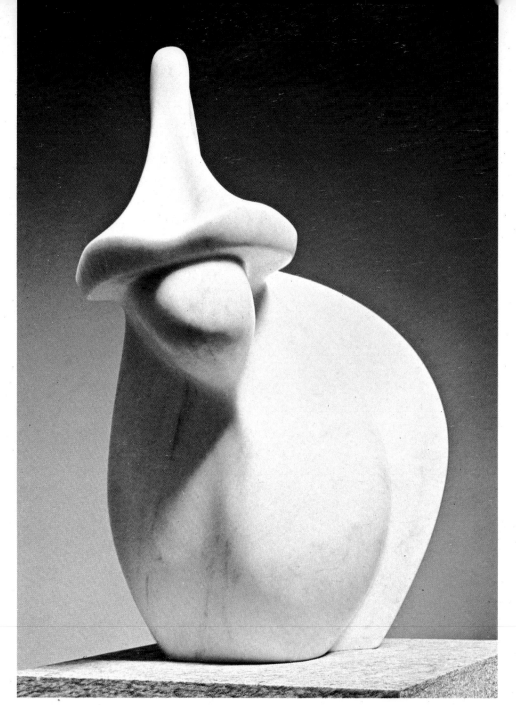

201

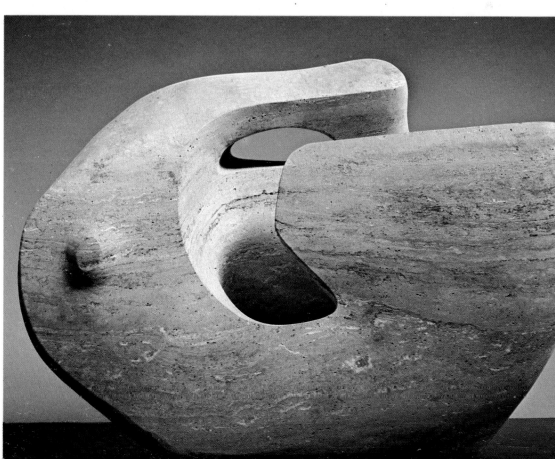

202

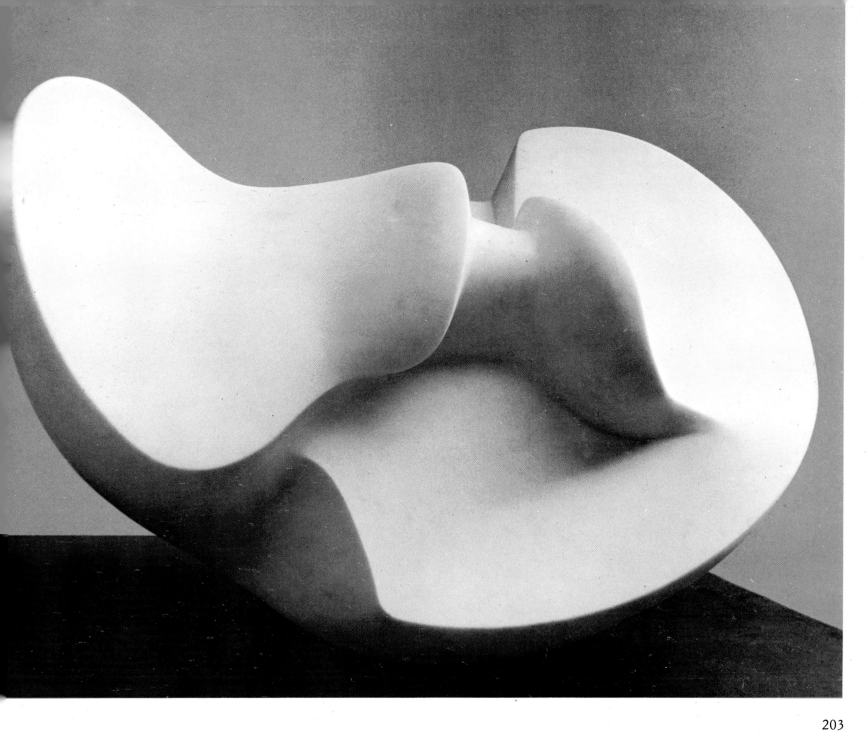

203

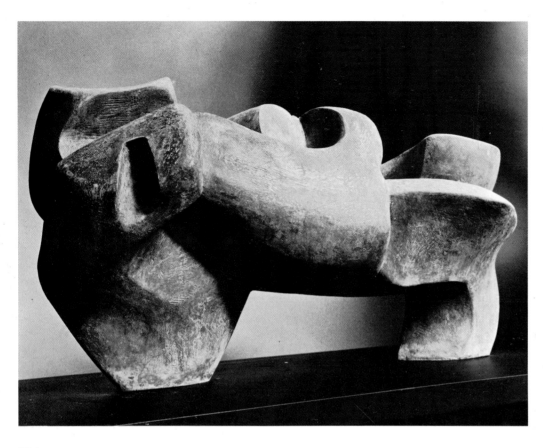

204

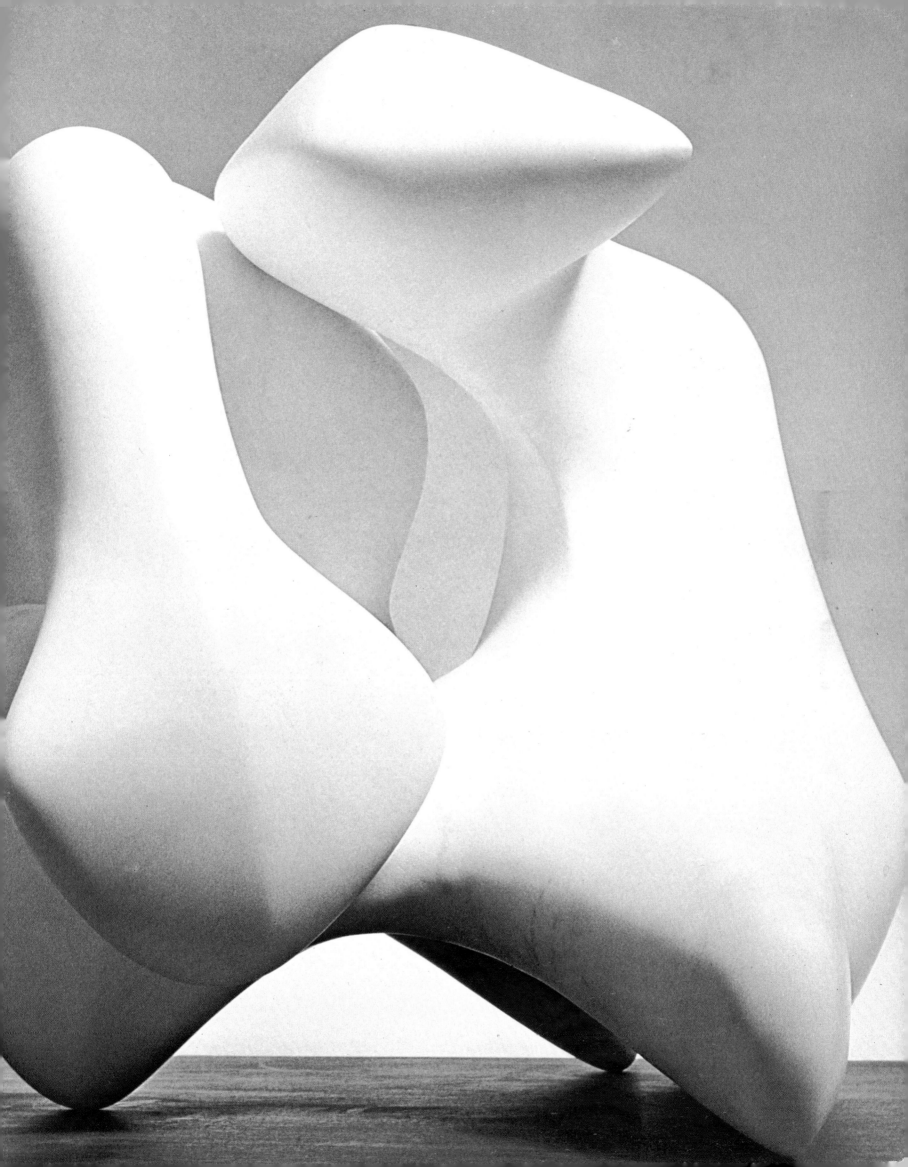

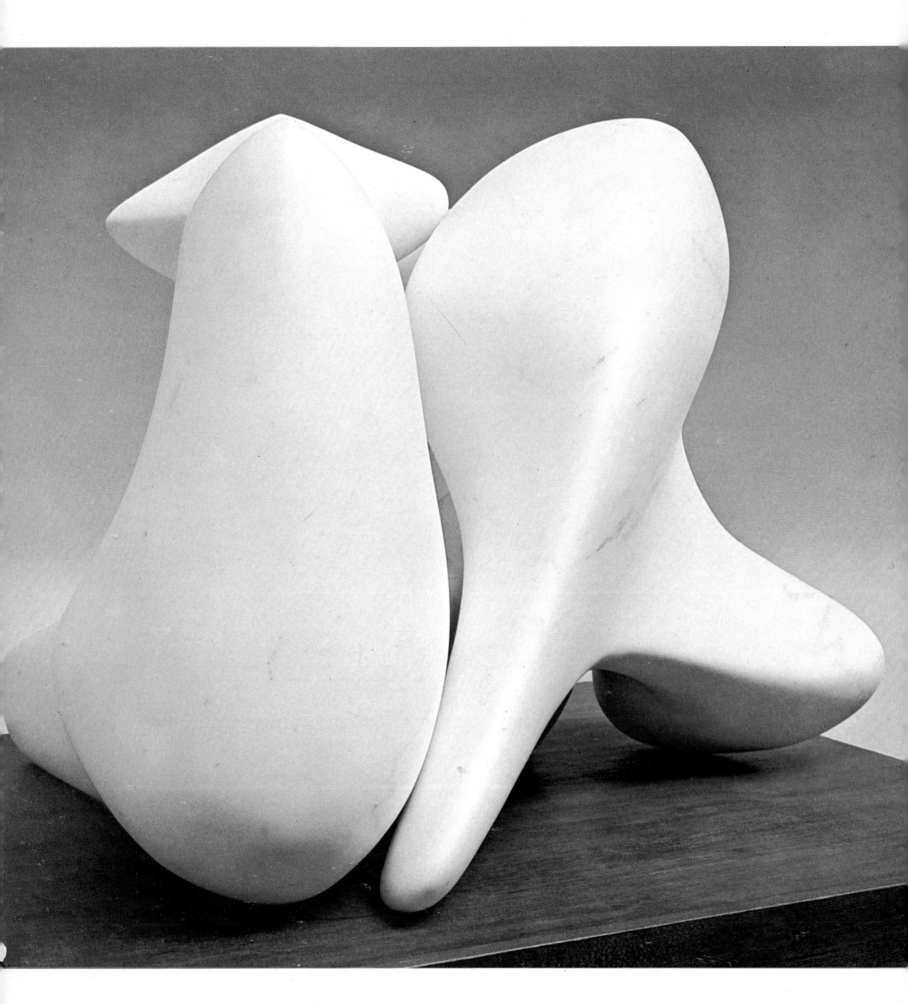

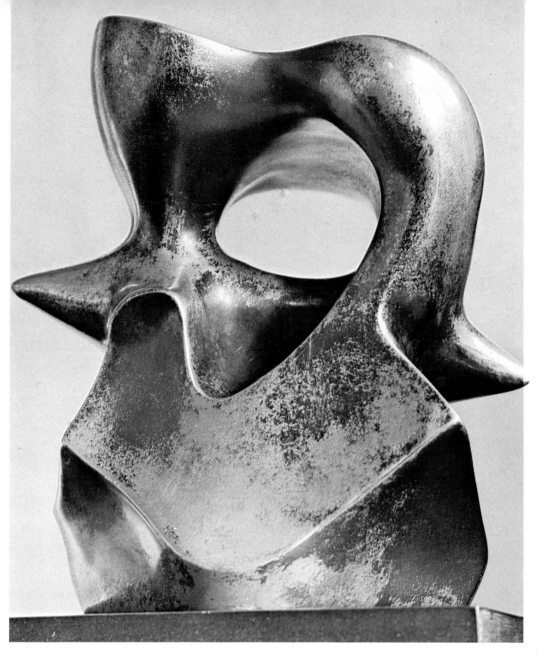

207

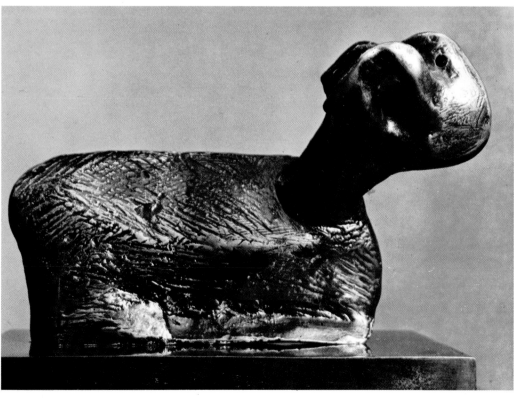

208

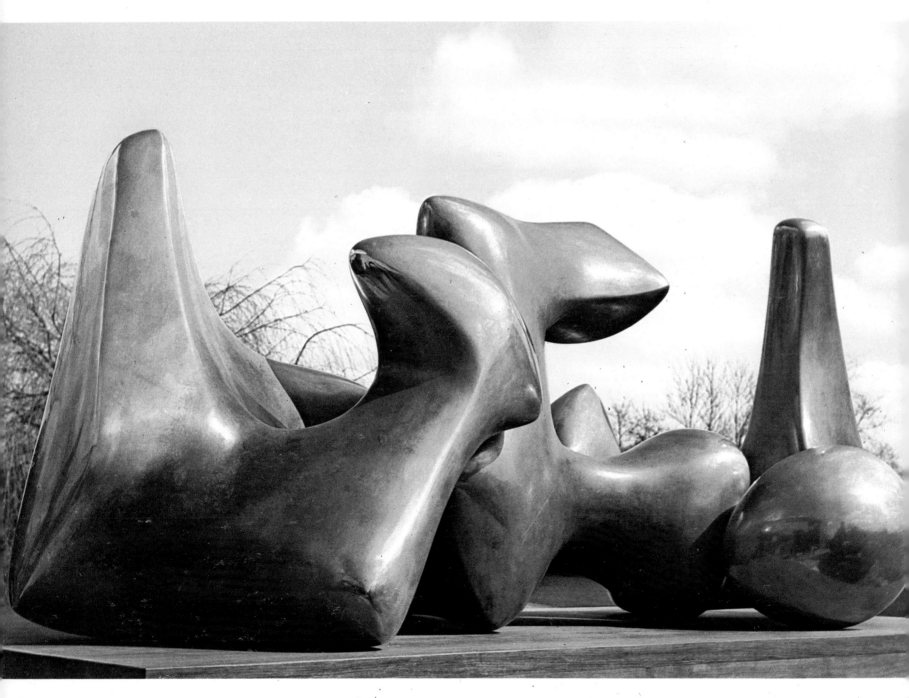

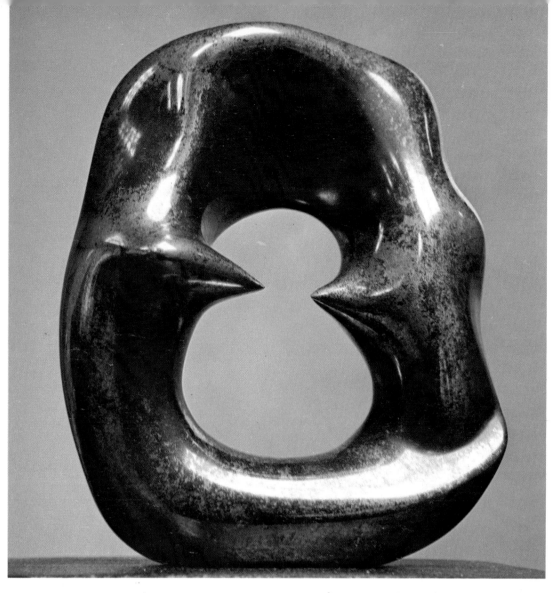

210

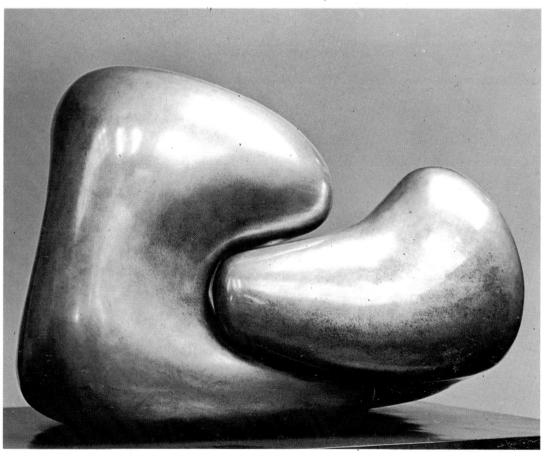

211

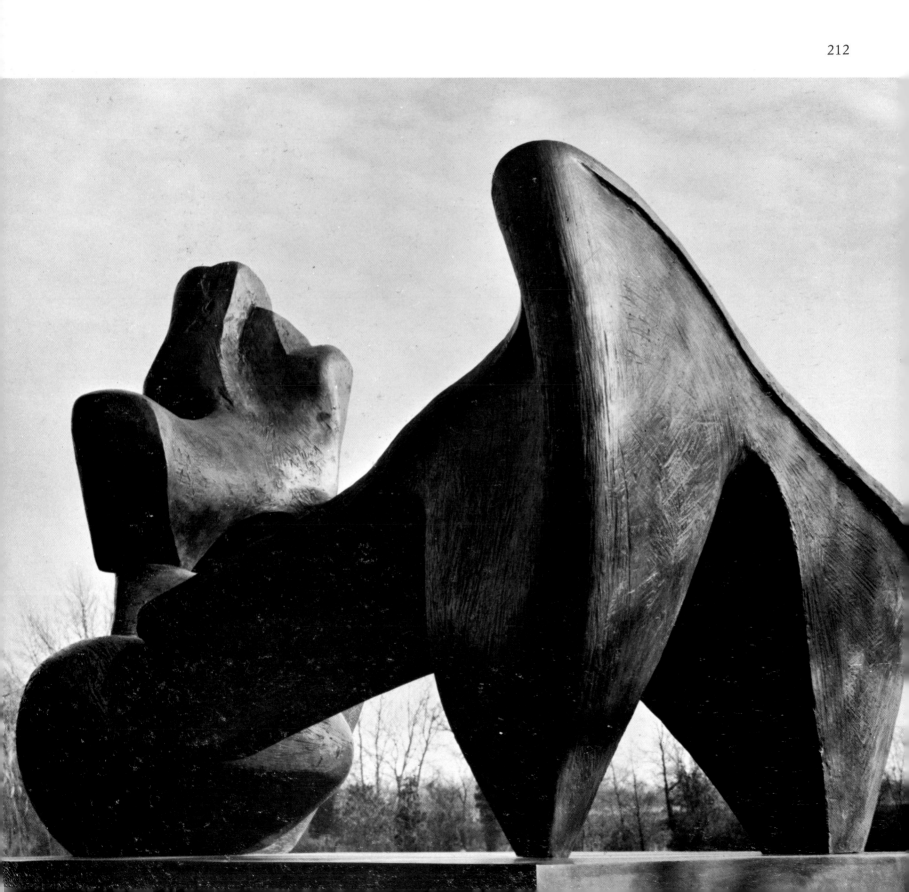

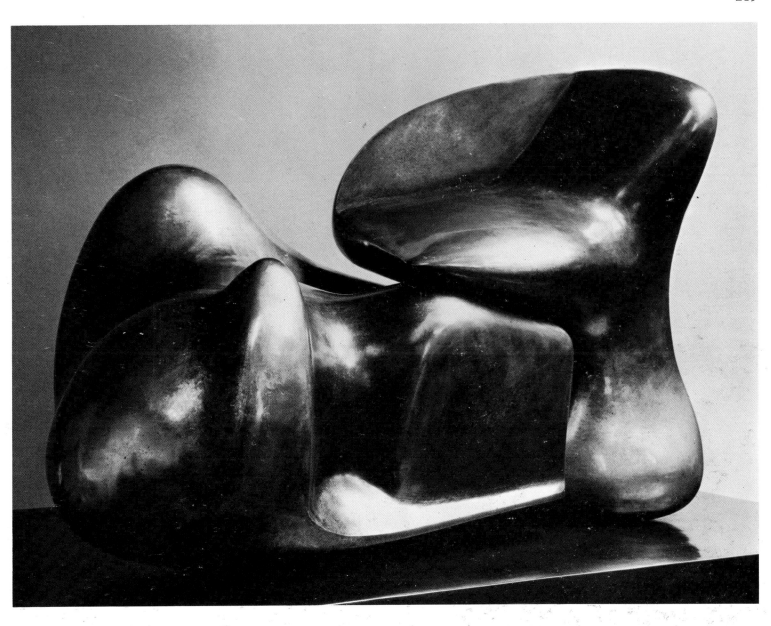

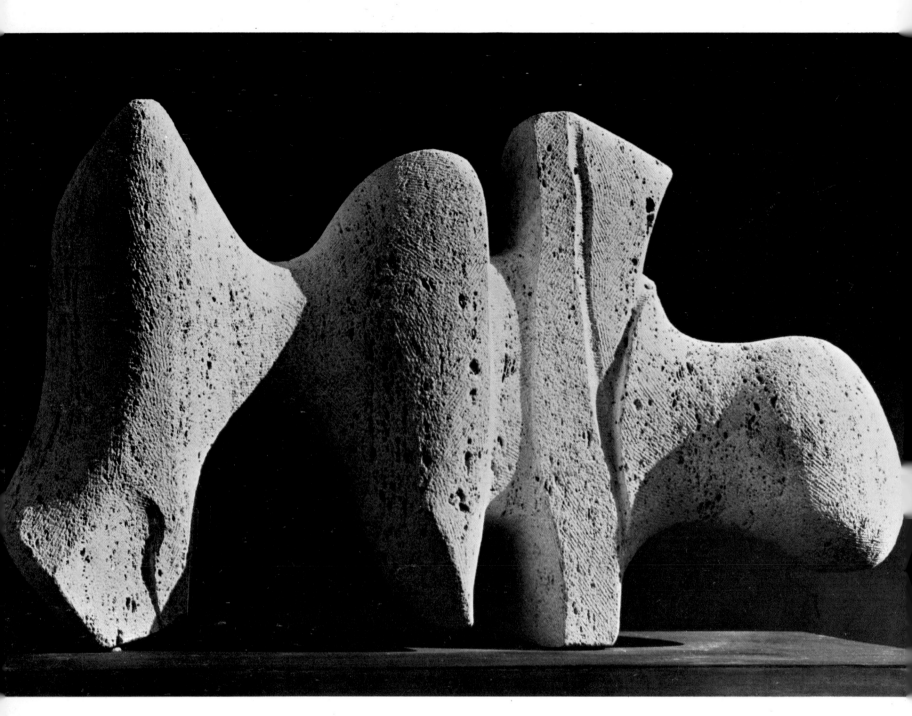

214

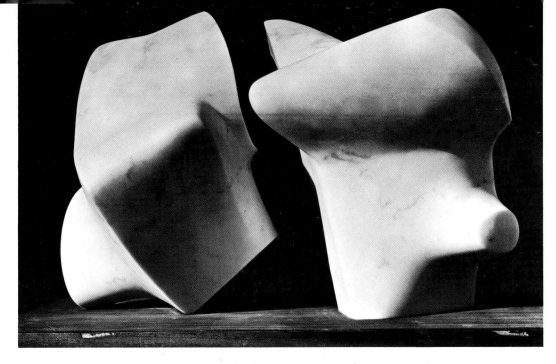

215

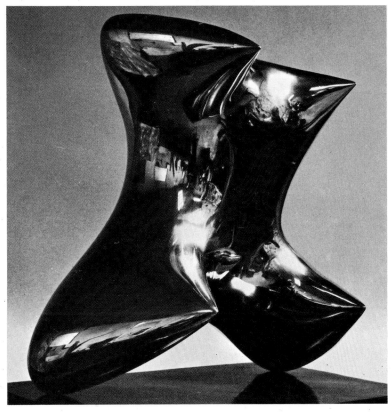

216

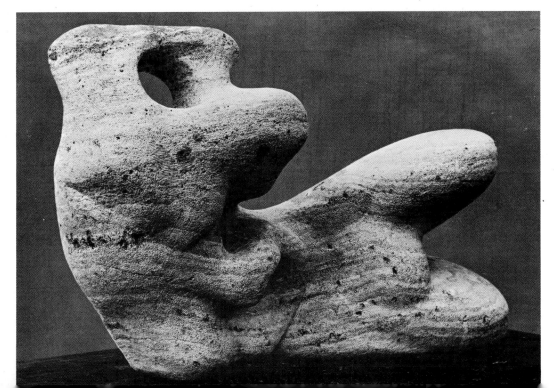

217

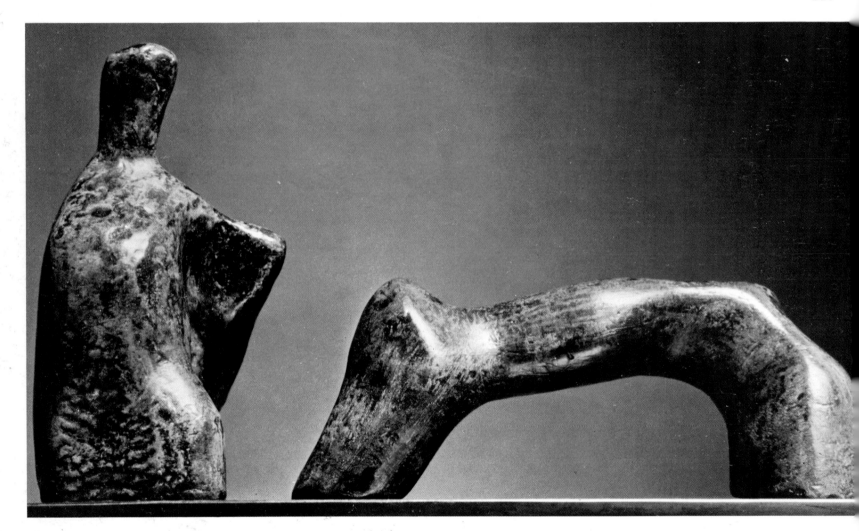

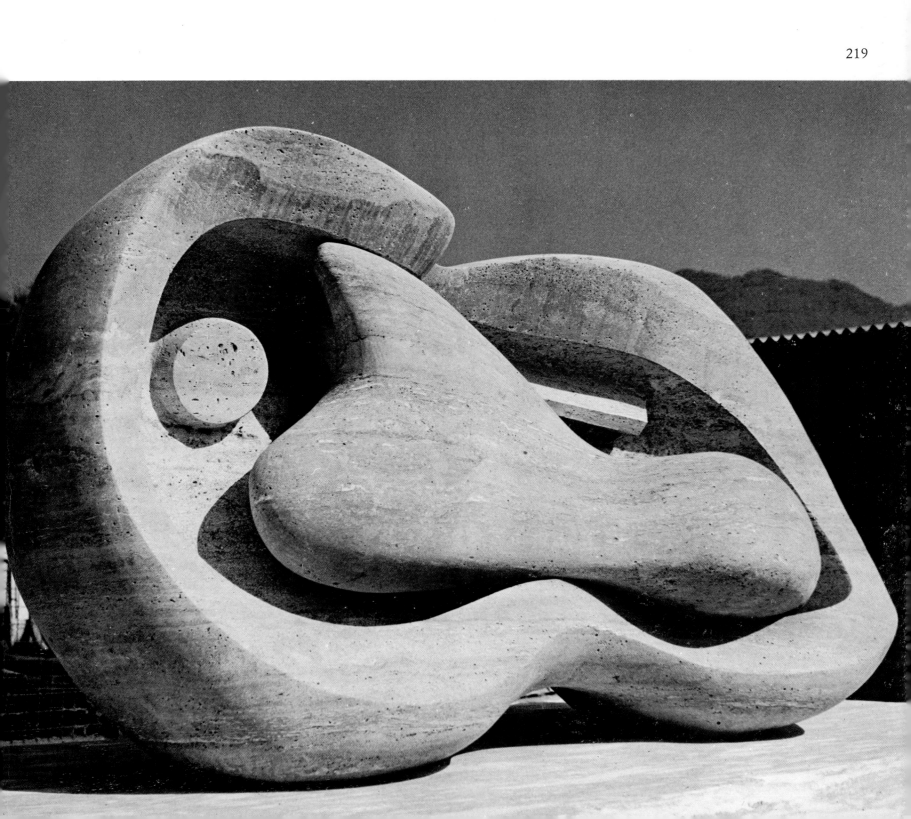

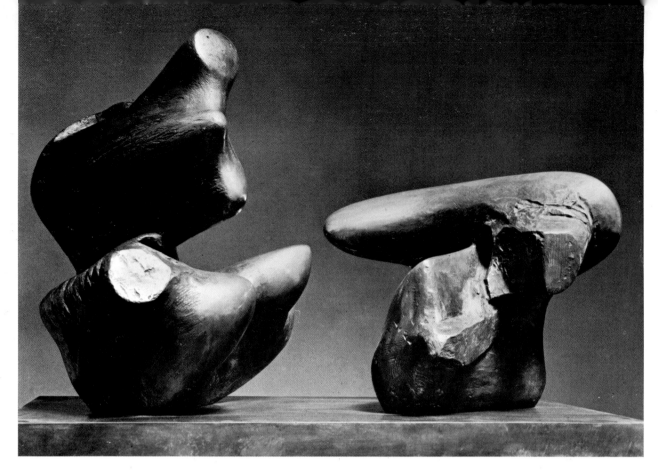

220

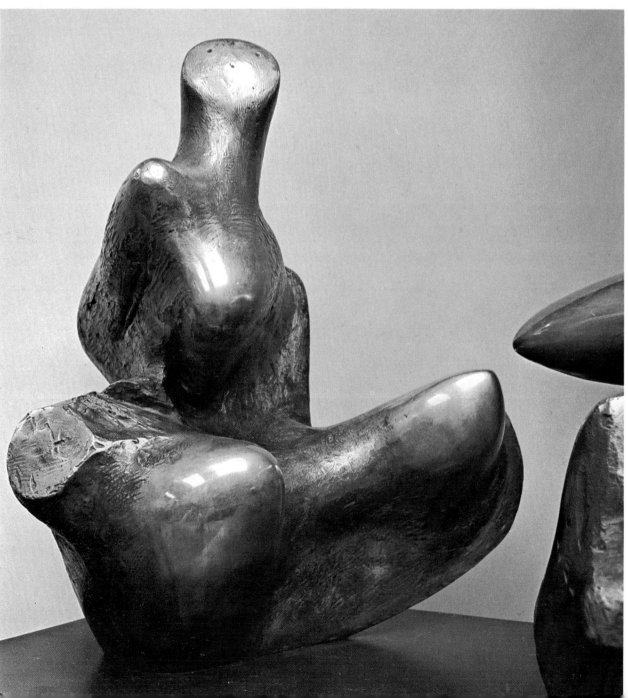

221

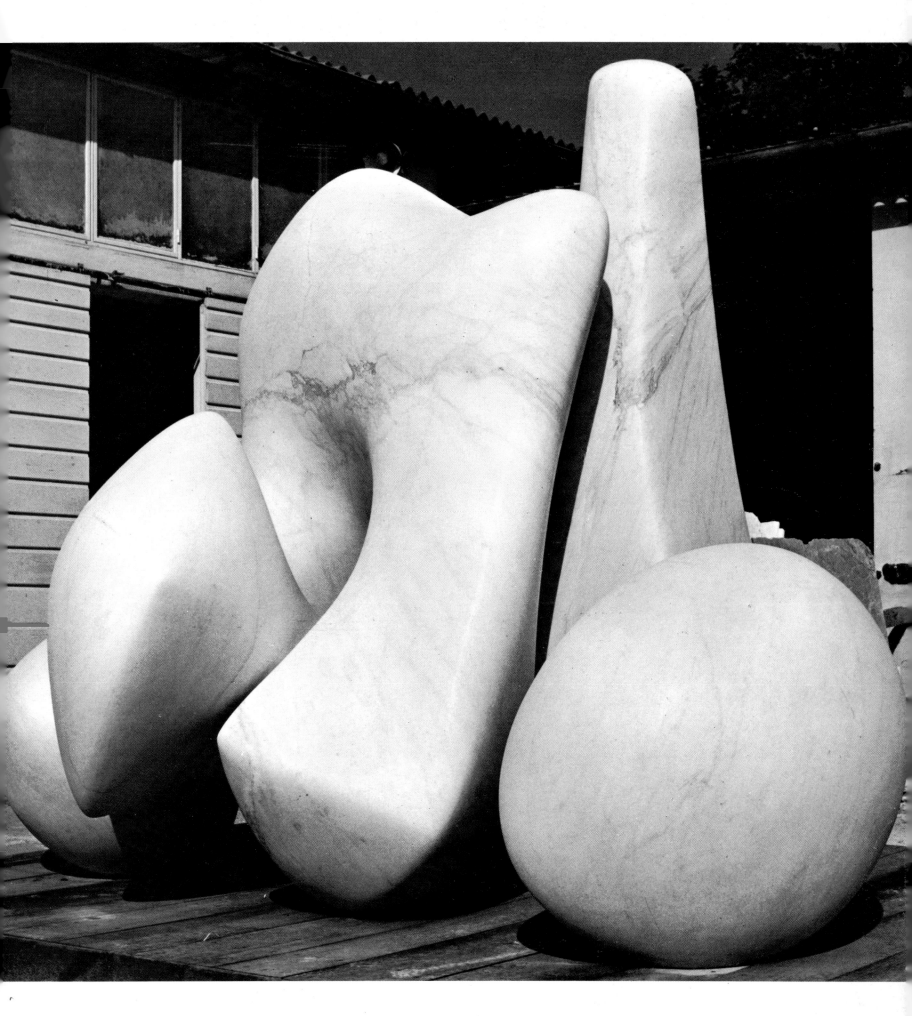

222

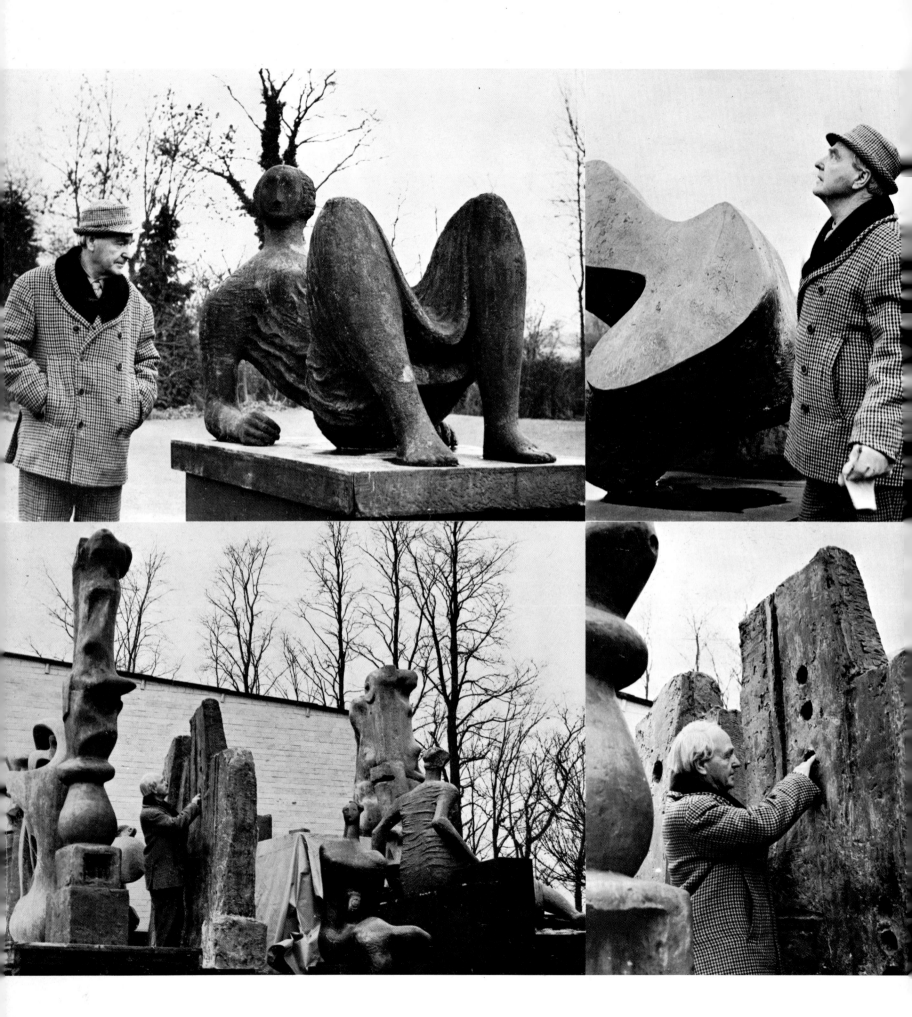